26,

THE SPIRIT OF PLACE

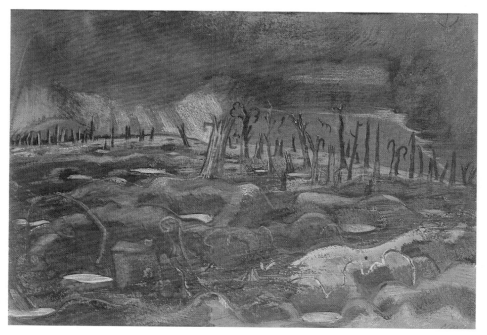

Paul Nash, *Meadow with Copse* (1917), ink, watercolour, body colour, chalks on grey paper

John Piper, *In Llanberis Pass* (1943), watercolour, pen, chalk

THE SPIRIT OF PLACE

*Nine Neo-Romantic artists
and their times*

Malcolm Yorke

Constable · London

The author acknowledges the assistance
of the Arts Council of Great Britain

First published in Great Britain 1988
by Constable and Company Limited
10 Orange Street London WC2H 7EG
Copyright © 1988 Malcolm Yorke
Set in Monophoto Photina 10pt
and printed in Great Britain by
BAS Printers Limited
Over Wallop, Hampshire

British Library CIP data

Yorke, Malcolm
The spirit of place : nine neo-romantic
artists and their times
1. Romanticism in art – Great Britain
2. Art, Modern – 20th century –
Great Britain
I. Title
709′.41 N6768.5.N3

ISBN 0 09 465170 1

CONTENTS

For my mother

IRIS PATTIE YORKE

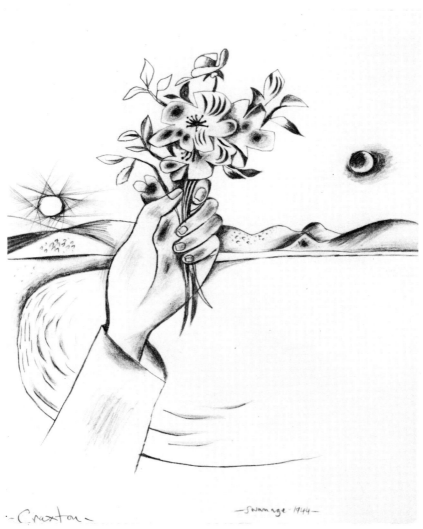

John Craxton, *Swanage* (1944), black crayon

ILLUSTRATIONS

All measurements given below are in inches with height before width

INTRODUCTION

William Blake, an illustration to Virgil's *Eclogues*
(1821), woodcut

T HE labels we use for art movements or groups of painters come from reviewers, art historians and, in some cases, from the artists themselves. Sometimes these labels can be useful, but too often they are misleading or blankly uninformative, and always outstanding individual painters evade them. However, the one I have inherited, 'English Neo-Romanticism', is actually more helpful than most.

Frequently during this century our native groups of painters have been defined by tagging 'English' or 'British' in front of a current Continental (usually French) appellation. So we have had English Impressionism, English Post-Impressionism, English Surrealism, English Constructivism, and so on. English Neo-Romanticism is not quite like this. There was indeed a similar movement based in Paris during the 1920s and 1930s whose chief exponents were mostly *émigré* Russians such as Tchelitchew and Berman, and their work did have some influence on the early works of English artists such as Michael Ayrton and John Minton. Yet, I believe this Parisian Neo-Romanticism to have been weaker in achievement than the Neo-Romantic movement which grew up in England during the 1930s and 1940s, and whose members wore the badge 'English' as a mark of pride rather than of artistic subservience. There might be a case for writing of 'British' Neo-Romanticism, rather than 'English', since two of the painters briefly working in this style, Robert Colquhoun and Robert MacBryde, were patriotic Scots. Also the Welsh landscape provided strong direct inspiration to Graham Sutherland, John Piper and several of their younger followers. Nevertheless, it is essentially an English-born and London-based group of artists we are to study and, on the whole, I think 'English Neo-Romantics' the most appropriate way to think of them.

Whether 'English' can be stretched to cover more than the nationality of the

artists is a debatable point, and one which our group of artists discussed at length. Is there an isolatable quality of 'Englishness' visible in paintings made by Englishmen? Nikolas Pevsner tried, as an objective German, to define our Englishness for us, but could find little in terms of climate, language or behaviour that had remained constant throughout our turbulent history, or any attributes which appeared consistently in our national character, or in our art. One thing did strike him forcibly, however, and that was: 'None of the other nations of Europe has so abject an inferiority complex about its own aesthetic capabilities as England.[1] This is not a new phenomenon.

Since Renaissance times English patrons have preferred to import their paintings and statuary from Italy, France or Holland, and foreign artists of the sixteenth, seventeenth and eighteenth centuries swarmed into London knowing they would be afforded more prestige than native-born artists. Hogarth chauvinistically tried to redress this injustice by taking as his subject matter all levels of London society, exploiting as he did so those gifts for blunt commonsense, story-telling, moralising and satire which he considered quintessentially English. Joshua Reynolds, on the other hand, tried to raise the status of English art by urging his students to emulate the Continental masters, particulary the Renaissance Italians, in order to learn their allegorical, 'Grand Style' of painting and so come into line with European art. Perhaps a more important contribution than his lectures, or his example, was the rôle Reynolds played in the foundation of the Royal Academy where art could be systematically taught and English painters could improve their status by presenting their works directly to the public.

By the early nineteenth century English art had acquired a strong voice of its own. At the time of the Battle of Waterloo Blake, Bonington, Calvert, Constable, Cotman, Cox, Lawrence, Palmer, Raeburn, Rowlandson, Ward and Turner were all alive and British art was pre-eminent in a way it never had been before, or since. Even the French were impressed. Bonington influenced French Romanticism and Delacroix, after seeing *The Hay Wain* exhibited in the Louvre in 1824, admitted, 'This Constable has done me a world of good.' Constable turned down the invitation to go to Paris and enjoy this adulation in person, saying, 'I hope not to go to Paris as long as I live. I do not see any end it is going to answer.'

Somehow the Victorians failed to capitalise on the gains made by Constable, Turner and their contemporaries. As Roger Fry wrote, 'By 1850 scarcely anything was left of this glorious promise; British art had sunk to a level of trivial ineptitude. Landseer had become the Monarch of the Glen, and Frith was teaching people to give up all this nonsense about art.'[2] We lapsed into an insular and complacent academicism, whilst French painting went from triumph to triumph.

John Ruskin (1819–1900), the most formidable art critic of the Victorian era, and the great champion of Turner, wrote nearly twenty years after that artist's death that English painters in 1870 seemed to 'abjure design, and the ideal and theological art, their strength being in portraiture, domestic drama, animal painting and especially landscape'.[3] Nevertheless, he strongly believed they should preserve their national characteristics and not become 'sentimentally German, dramatically

Parisian, or decoratively Asiatic'. Ruskin's most influential successor was Roger Fry (1886–1934), who did not share his enthusiasm for Turner and the Pre-Raphaelites, and who despised most of the literary subject matter Ruskin had listed as characteristically English. During Fry's youth all those wonderful 'isms' had come tumbling out of the studios of Montmartre and they established Paris, rather than Rome, or Vienna, or London, as the only city to be in if one was to keep up with artistic innovation. Fry believed that compared to the French ours was at best 'a minor school', one he characterised as 'primarily linear, descriptive and non-plastic'.[4] He notes with disapproval the 'ominous preponderance of the portrait' in English art, and the absence of complex figure designs, nudes and still-life paintings. So strong did his Francophilia become that he appeared to despise our whole 'Bird's Custard Island' and thought even its misty landscapes hardly worth a real painter's attention.*

Our Neo-Romantic painters heard Fry's lectures at the Queen's Hall, and all read his writings and those of his like-minded friend, Clive Bell, during their formative

Samuel Palmer, *Late Twilight*, inscribed 'The west yet glimmers with some streaks of day' (Macbeth) c1825, pen, brush, sepia, gum and varnish

* Though he did admire Constable, 'the one English artist who has added something to the European idiom of painting'.

years. Part of their struggle was to resist his powerful denigration of most English artists (including Blake and Turner) and his persuasive advocacy of all things French. They came round to thinking that perhaps some of our English limitations might actually be strengths – after all, they asked, what is so wrong about thinking in line rather than mass when working in two dimensions? Why is it so misguided to have dramatic literary subject-matter rather than search disinterestedly for the 'significant form' in a pile of apples and a bottle of wine? Why not paint our native English landscape rather than the life in Paris cafés? Michael Ayrton, the Neo-Romantic's most aggressively patriotic spokesman, states the virtues of English art with pride:

> I consider to be the main streams or characteristics of the British genius, the lyrical, the satiric, the mystical, the romantic, and the preoccupation with linear rhythms which are the bones and basis of our art, and have been for a thousand years.[5]

The Neo-Romantics showed no interest in satire, but otherwise they cultivated all the other characteristics Ayrton mentions. The isolation of England during the war years made this search for a national artistic identity seem all the more urgent and necessary.

The 'Neo' part of our label is meant to signify that these twentieth-century artists looked back with admiration to those early nineteenth-century English artists we have already mentioned who represented the peak of British painting. From these predecessors they borrowed techniques and subject matter, and derived pride and confidence from the knowledge that they were working within an established English tradition. Graham Sutherland expressed their conviction when writing of English draughtsmen that 'the more a poet sings in his genealogical tree the more he is in tune'.[6]* Of course, as they developed, and as Europe opened up again after the war, the Neo-Romantics began to look once more towards foreign sources for new ideas and their 'Englishness' became less striven for and less conspicuous in their works.

'Romantic' and 'Romanticism' are labels used in cultural histories in ways analogous to 'Gothic' or 'Baroque' insofar as they signify a roughly datable period and isolate certain stylistic features and typical subject matter. Germany, France and England all had their Romantic periods though the dates differ from country to country, as do the underlying philosophies and the relative strengths of the art forms (music, poetry, novel, drama, painting, architecture, design) through which Romanticism was made manifest. Rather than dwell on the interactions and differences between the national Romanticisms I propose to generalise, and that only briefly, about the English form since the Neo-Romantics turned exclusively to native models.

During the eighteenth century orthodox Christianity declined sharply as an

* He was quoting Cocteau.

inspirational source for painters and writers, especially in northern Protestant Europe. One of the causes may have been that the implications of the writings of Newton, Descartes, Locke, Hume and other analytical philosophers had begun to filter down to both creators and their patrons. All creation now appeared to be potentially accessible to objective analysis, logic and measurement – from the wide universe down to the human mind. Galileo seemed to demonstrate that the language of Nature was now mathematics, and that it was no longer necessary to interpret its messages through poetry or myth. If natural phenomena were explicable by purely physical laws it seemed there was no obvious rôle for God as their creator, preserver or regulator. There began to open up in the cosmos a God-shaped void. The Romantics sought to smash this clockwork mock-up of the heavens, to put magic and mystery back into things, and to turn the world adrift once more in a wild and unpredictable universe. Yet this world could not be one devoid of purpose or meaning – that would be unbearable – so they had to interrogate Nature, that is all those things in the world which were not created by Man himself, to see if there were hints given of a guiding principle, perhaps even of a designer. This time round, however, if one detected His presence, He might not turn out to be identical with the Jehovah of Genesis, or the Christian god of the New Testament.

Wordsworth read the book of Nature and found its message benign. It taught him moral and spiritual truths so that he was:

> . . . well pleased to recognise
> In nature and the language of the sense
> The anchor of my purest thoughts, the nurse,
> The guide, the guardian of my heart, and soul
> Of all my moral being.
> ('Tintern Abbey', 1798)

This urge to find a shaping hand behind the appearance of things led, in some cases, to visions and mysticism, in others to the manufacture of ramshackle codes of belief with bits taken from several sources, and in yet others to the resuscitation of gods long thought dead. Wordsworth heard 'Great Pan himself low-whispering through the reeds', and Edward Calvert, much to the alarm of High Church Samuel Palmer and his other painter friends, became a neo-pagan and set up an altar to Pan in his back garden. Blake whilst sharing the struggle to see 'A world in a Grain of Sand/And Heaven in a Wild Flower' thought the pantheism of Wordsworth and his followers little better than blasphemy – though his own beliefs and cosmogony were so unorthodox, eclectic and dense with private symbolism that we are still struggling to unravel them today.

As wars, earthquakes, social upheavals, reforms and repressions, religious schisms, scientific progress and rampant industrialisation proliferated in the early nineteenth century the quest for spiritual certainties took on an increased urgency. Cities grew apace and railways made the population mobile as never before. The 1851 census revealed that for the first time in England's history the urban population

exceeded the rural population. As the crowded cities increased in squalor a kind of nostalgia for the still uncontaminated countryside seemed to pervade the painting and poetry of the time: the rural folk might be less sophisticated, but surely they were also less corrupt? Wordsworth expressed this view in the Preface to *Lyrical Ballads*:

> ... in that condition the essential passions of the heart find a better soil in which they can attain their maturity, are less under restraint, and speak a plainer and more emphatic language; because in that condition of life our elementary feelings co-exist in a state of greater simplicity, and consequently may be more acurately contemplated, and more forcibly communicated; because the manners of rural life germinate from those elementary feelings, and, from the necessary character of rural occupations, are more easily comprehended, and are more durable; and, lastly, because in that condition the passions of men are incorporated with the beautiful and permanent forms of nature.

This view appealed to those townees who enjoyed all the comforts and diversions of the city, and surveyed the country from the windows of carriages, hotels, or the great country houses during fleeting visits. The actual peasantry were probably less convinced they dwelt in Arcadia, or that they were nearer to God in a sheep-fold. This Romantic, and essentially patronising, view of the rustic persists into twentieth-century Romanticism, and indeed goes further, as we shall see in the works of Nash, Piper and Sutherland where their landscapes are swept clean of all human inhabitants.

Nature's calm, health and inherent sanctity were available to all who sincerely worshipped her (by now she had become Mother Nature). Of course some were more attuned to her subtle revelations than others and took it upon themselves to make their insights available in more accessible forms: these priest-interpreters were the artists and writers. Ruskin believed in the detailed study of clouds, leaves, roots and so on, until the artistic imagination was able to take over and take off into the ecstatic depiction of things which went beyond material appearances, but which drew strength and truth from the artist's research into natural objects. Ruskin was convinced Nature had a body and soul, as Man did, 'but her soul is the Deity'. A supreme artist like Turner was therefore a prophet of God because the close attention he paid to the details of natural form eventually lay bare its soul for us in his pictures.

Samuel Palmer in a strange ecstatic letter to his father-in-law (December 1828) said he thought '*General* nature is there to refresh the senses and soothe the spirits of general observers,' but the 'thousand repetitions of little forms' in meadows, skies and sunsets present an especial problem for the artist who has to reconcile them 'with the unwinning severity, the awefulness, the ponderous globosity of Art'. He continues:

> After all, I doubt not but there must be the study of this creation, as well as

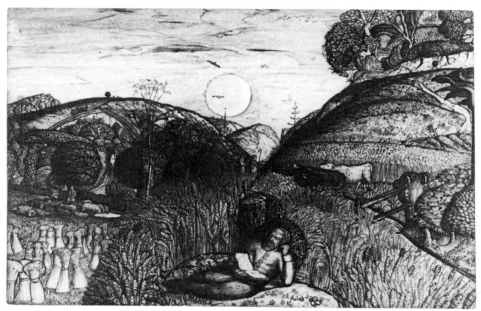

Samuel Palmer, *The Valley Thick with Corn* (1825), pen and brush with brown ink mixed with gum and varnished

art and vision; tho' I cannot think it other than the veil of Heaven, through which her divine features are dimly smiling; the setting of the table before the feast; the symphony before the tune; the prologue of the drama; a dream, and antepast, and proscenium of eternity.[7]

For Palmer Nature was 'a helpful handmaid and co-mate of art'; there to be studied, but then interpreted and enhanced to reveal the Paradise to come behind the shimmer of appearances. It is an exalted role for the painter to seek. None of our twentieth-century Neo-Romantics would feel comfortable writing in such terms, but even they constantly reminded themselves that the detailed close study of natural forms was a necessity; that these forms were to be 'paraphrased' or 'intensified', rather than copied; that it was the inter-relationship of Nature and Man which formed their main subject matter, and that Nature provided some kind of touchstone by which their pictures' validity could be tested.

Wordsworth, Palmer and Ruskin believed Nature to be a source of sanity and moral insight. The implications of the geologists' discoveries of fossils of extinct species, and Darwin's evolutionary theories whereby the least adaptable individuals perished, pointed to a less maternal view of Nature. Tennyson called her 'red in tooth and claw', and earlier the Marquis de Sade had found in her a fellow-spirit:

Nature averse to crime! I tell you nature lives and breathes by it; hungers at

all her pores for bloodshed, aches in all her nerves for the help of sin, yearns with all her heart for the furtherance of cruelty.[8]

It will be remembered that whilst Wordsworth set out to examine the lives of simple people in simple language, his friend Coleridge undertook to explore the exotic and supernatural in 'The Ancient Mariner'. Other Romantics in paint and words such as Henry Fuseli and Mary Shelley, took the same path to plunder the realms of nightmares, the subconscious, the macabre, madness, primitivism, eroticism and death. The insights they brought back from their communions with Nature were that she was either wilfully vicious, or implacably indifferent. These two opposing views of Nature as either spiritually uplifting or malign were still the options available for the Neo-Romantics and they depicted both – Graham Sutherland actually made a dramatic switch from the benign to the sinister interpretation within a few months in 1929.

Once the artist begins to see Nature in anthropomorphic terms as a gentle teacher, or a cruel mistress, or a stony-hearted despot, then he is already attributing human emotions to natural phenomena. So Wordsworth, for example, can begin a sonnet:

With how sad steps, O Moon, thou climb'st the sky,
How silently, and with how wan a face.

The sadness is, of course, Wordsworth's and not the moon's. Ruskin saw this practice of projecting our own moods and emotions on to flowers, trees, clouds or whole landscapes as morbid and misguided, 'a falseness in all our impression of external things', and labelled it 'the pathetic fallacy'. His opposition did not, of course, stamp out the practice and we shall see it still in frequent use by the Neo-Romantics who were determined to paint 'mind landscapes' rather than merely topographical ones.

As a cultural phenomenon English Romanticism might be said to begin around 1780 when Blake first exhibited in the new Royal Academy. By 1840, when Victoria was already enthroned, its strength had passed. A lady could write sharply to a friend in 1841: 'When I said romantic I meant *damp*!'[9] Even though Turner was still alive and creating his astonishing late works English art in general was, by 1850, well down its slide into the emptily picturesque, mawkish anecdotalism, border-to-border symbolism and exotic trifles – all weaker by-products of the vigorous Romanticism which had gone before. Meanwhile, in France the miraculous flow of new ideas was under way, so that it was quite natural for Roger Fry or Walter Sickert to turn to Parisian art as the only purgative possible for our Victorian excesses.

That is one possible reading of art history. Robert Rosenblum, and others, would not agree that Romanticism petered out around the 1840s. He would see this Romantic search for spiritual truths beneath the outward forms of Nature ('Art for life's sake') continuing unbroken throughout the nineteenth century and down, intact, to our own times.[10] Rosenblum sees the line clear through Blake, Turner, Friedrich, Palmer, Runge, Van Gogh, Munch, Hodler, Nolde, Marc, Kandinsky, Klee,

Ernst, Feininger, Sutherland, Nash, Mondrian, and finally to the American Abstract Expressionists Barnett Newman and Mark Rothko. In brief, he has made a counter-case for reading the history of modern art as a cumulative triumph for Northern European Protestant Romanticism, rather than retelling the old tale which makes Paris the headquarters of Modernism. His aim is to refute Gertrude Stein's provocative statement that 'Painting in the nineteenth century was only done in France and by Frenchmen, apart from that painting did not exist, in the twentieth century it was done in France but by Spaniards.' According to Rosenblum's interpretation of art history our chosen artists are not Neo-Romantics at all but plain Romantics; not the revivers of a lost tradition but the survivors of it.

By identifying characteristic subject matter and recurring motifs Rosenblum could extend the Romantic period down to the present day. Other writers have used the same strategy to push it backwards in time, so Marcel Brion, for example, identifies as progenitors of Romanticism Giorgione, Baldung Grien, Grünewald, Dürer, Rubens, El Greco, Watteau, Rembrandt, Altdorfer, Ruisdael and Caravaggio.[11] Eric Newton, an influential critic and friend of the Neo-Romantics, would concur and add Piranesi and Salvator Rosa to these proto-Romantics. Newton writes, 'We are driven to the conclusion that romanticism is a mode of feeling that can appear at any time in human history, but that only at certain periods and under certain conditions of cultural climate can it find a full and adequate means of expression. Romanticism is an attitude of mind in which any human being, at any time, may, by virtue of his humanity indulge.'[12] We shall argue that the years just before, during, and after the Second World War offered one of these periods when the conditions and cultural climate were conducive to Romantic painting.

Romantic art has a message to convey about Man's relationship with, and response to, Nature. To intensify the force of this message any heightening of colour, distortion of form, unusual viewpoint, exaggerated perspective, or eccentric method of facture is justified, but Rosenblum's inclusion of the abstract painters Newman and Rothko in his family of Romantic artists would have been incomprehensible to their forerunners. These earlier artists needed their subject matter to be recognisable because part of a painting's effect depended on the associations viewers brought with them from their own experiences of moons, or mountains, or whatever, either directly or from their reading. How else, the artist might argue, could these associations be challenged, modified or enlarged unless by comparison with the insights the painter had of the same phenomena? The Neo-Romantics too clung to figuration even when the tide of fashion was tugging them away – Fry's 'significant form' did not signify enough. Lorenz Eitner in his study of Romantic iconography claims that to ignore subject matter is to miss the whole *raison d'être* of Romantic painting:

The neglect of subject matter stems from the conviction the essential qualities of art reside in form, not in extraneous ideas; that form *is* meaning, not a vehicle for meaning. Whatever can be said for this view, it has the disadvantage of severely limiting the study of a period in which painting, for better or for worse,

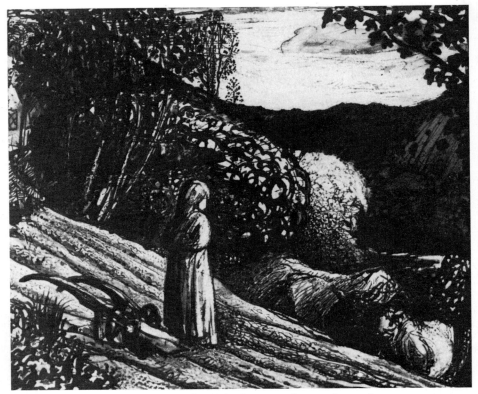

Samuel Palmer, *Landscape, Girl Standing* (1826), watercolour and gouache

contained a great deal of 'literature'. The artists of the nineteenth century had no doubt that subject matter could possess aesthetic significance. Much of their energy was consumed by the search for appropriate themes and the interpretation of those themes. To ignore this is to miss their intention; their work cannot be fully understood in stylistic terms alone. The present overemphasis on matters of form has inevitably warped the evaluation of events and movements in nineteenth century art.[13]

The subjects the Romantics chose to paint are well documented and where these traditional motifs are taken up by the Neo-Romantics we shall point them out. In passing, however, we might note the popularity of the sea in all its moods, the drama of clouds, moon, stars, sunrise and sunset, trees and mountains. Wild animals were popular and so were children, shepherds, savages and exotic countries. Men struggling against the overwhelming forces of Nature in shipwrecks, storms or avalanches, or against each other in battles, all appeared frequently. Man-made hovels, cathedrals, castles, towers and palaces appeared, provided only that

they were in ruins and Nature had already begun to claim them back. The Romantics taught us to look at all these things differently. In addition, features of contemporary life could be depicted provided they were dramatic enough: Turner, for example, showed trains and steamers slogging through foul weather or the Houses of Parliament burning down. Literature also served as an inspiration, providing it was macabre, poignant or stirring enough to rouse the artist's emotions. What they did not attempt so frequently were still-lifes, studio nudes, portraits and scenes of domestic life. All these priorities would be shared by the Neo-Romantics.

The art history term 'Romantic' suffers from its proximity to the non-specialist 'romantic' in our everyday speech, where it is constantly eroded and rebuilt in new contexts. The popular use still seems to retain some connection with strong emotions, but it can also be diluted sufficiently to describe a dress or to advertise a box of chocolates. Its demotic opposite 'classic' appears to be equally flexible and can be applied to a stroke in cricket, a horse-race or a Rolls Royce car. Either term can be used pejoratively or as a term of praise. Here, for example, is the painter-writer Wyndham Lewis expressing his preference:

> I always think of something very *solid*, and I believe it is a sensation I share with many people when the term 'classic' is employed, and of something very dishevelled, ethereal, misty, when the term 'romantic' is made use of. All compact of common sense, built squarely on Aristotelian premises that make for permanence – something of such a public nature that all eyes may see it equally – something of such a universal nature that to all times would it appear equal and the same – such is what the word *classic* conjures up. But at *romantic* all that drops to pieces. There is nothing but a drifting dust . . . which no logical pattern holds together.[14]

At its core the word 'classic' seems to retain a sense of the coolly rational; of obedience to established rules; a reverence for the past; and, in design terms, that willing subordination of the parts to the whole which nineteenth-century German philosophers thought stood in stern opposition to Romanticism's emotional frenzy, and its difficulty in seeing the woods for the dryads. Man, it seems, needs to view himself and his world in binary terms: 'romantic' and 'classic' are items on a list that could be extended almost indefinitely through subjective-objective, intuitional-intellectual, yin-yang, individual-collective, right brain-left brain, analogic-digital, concrete-abstract, unconscious-conscious, free-rule bound, night-day, and so on and on. I believe these are markers on a continuum rather than fundamental opposites, and no artist can be absolutely Romantic or Classical, try as he might. Cyril Connolly put it better: 'Classical and romantic: private language for a family quarrel, a dead quarrel over the distribution of emphasis between man and nature.'[15]

Looking back over the story of English painting up to the present century it is difficult to think of any artist who can be unreservedly labelled as more Classical than Romantic in style – it almost seems as though our culture engenders a perma-

nent dispostion towards the Romantic end of the spectrum. In this century, however, there have been examples of hard, disciplined, self-denying ways of painting that deserve to be called, on balance, Classical. T. E. Hulme and Wyndham Lewis called for a new 'dry' Classicism before World War One and tried to demonstrate it in Vorticism. Roger Fry offered another brand based on the works of the French Post-Impressionists, particularly Cézanne. Later still, Ben Nicholson preferred a hard-edged geometrical abstraction derived from Hélion and Mondrian. Each of these tried to slough off the literary associations of Romanticism and concentrate on the forms on the canvas rather than on any ostensible subject matter. 'It's all the same to me if I represent a Christ or a saucepan since it's the form, and not the object itself, that interests me' boasted Roger Fry.[16] No Romantic could have uttered those words. Yet, throughout the story we have to tell, we shall find the Neo-Romantic artist going over to this more austere form of picture-making which values structure and geometry over emotion and message. They seemed to need, periodically, to atone for their Romantic indulgences.

English writers and artists of the nineteenth century did not use the term 'Romantic' as a battle cry, nor did they consider the ferocious Classical versus Romantic debates in France and Germany had much to do with them. It was the critics who later spotted commonly held values and subject matter and so dubbed them all Romantics. Similarly the Neo-Romantics did not know who they were until the reviewers told them. As a group they issued no manifesto, had no subscription list, no joint exhibitions, no agreed meeting place, no leaders, no appointed spokesmen and no agreed programme. I doubt if they were ever assembled in one room all together. Yet from this distance, it is possible to see they collectively expressed some of the needs of their times.

A Bloomsbury reviewer, Raymond Mortimer, commented in the *New Statesman* of 28 March 1942 on the unusual variety of groups then at work in Britain such as the Post-Impressionists, Euston Road Realists, Surrealists, Abstractionists and 'the school which I tentatively call the Neo-Romantic'.[17] For Mortimer this meant Frances Hodgkins, Graham Sutherland, Ivon Hitchens, Henry Moore and John Piper. He thought them more traditional in outlook than the Surrealists and Abstractionists insofar as they admitted the claims of both the senses *and* the intellect.

> Nevertheless its experiments are more capricious and less concerned with rationalising the world of phenomena than most artists in the past have been: they are in revolt against the European tradition of humanism. The appeal of their art, I fancy is to mystics and particularly to pantheists who feel a fraternity, or even a unity, with all living things, to those with the 'sense sublime of something far more deeply interfused'. Their work can be considered the expression of an identification with nature.

Mortimer saw the Abstractionists, Surrealists and his newly baptised Neo-Romantics as responding with disgust to the war which was then, in 1942, 'agitat-

ing our civilization'. In their different ways 'all these artists avert their eyes from and thus condemn the civilization we now see in the apparent process of collapse'. In short, they were escapists, fiddling in their studios whilst London burned around them.

Robin Ironside used the full term 'British Neo-Romanticism' in a survey of British painting from 1939 which was published first as a brochure by the British Council in 1946, and later in 1948 as part of a book.[18] His interim definition of it was an art 'lyrical in inspiration which overcame the formal disciplines of Parisian influence', and resisted the pressures towards geometrical abstraction represented by the 7 & 5 Society under the chairmanship of Ben Nicholson. He also saw them as successful rebels against the Francophiliac preaching of Roger Fry and his arid dictum that 'The one constant and unchanging emotion before works of art had to do always with the contemplation of form and that this was more profound and significant spiritually than any of the emotions that had to do with life.'[19] Ironside felt strongly that Fry and Clive Bell had sent English painting up the wrong path to Cézanne's door. 'rather than that of Chagall, Rouault or Chirico to which the native temper might have been attuned'. Several of the Neo-Romantics did find their way to de Chirico, and Michael Ayrton pronounced Rouault the greatest living artist of the time.[20] Certainly Ironside was right to detect a resistance to the overpowering influence of the École de Paris and a deliberate re-evaluation of our native tradition. Nevertheless, Cubism and Surrealism had too much to offer modern artists for them to be ignored, and the giant Picasso influenced every one of the Neo-Romantics, for better or worse. These infiltrations from across the Channel will be a recurring theme of our story, until it ends with an invasion from a totally undefended and unexpected direction – by the New York movement, Abstract Expressionism.

Enough path-clearing and explication of our title: it is necessary now to indicate the boundaries of our enquiry. Who, for example, shall we call a Neo-Romantic?

The 1983 exhibition, 'The British Neo-Romantics 1935–1950', organised by Fischer Fine Art and the National Museum of Wales, gave me both inspiration and a starting point for this book. It contained works by twenty-nine modern artists though the organisers, mistakenly in my view, omitted Paul Nash. Lucian Freud and Francis Bacon both refused invitations to participate on the grounds that they were not, and never had been, Neo-Romantics. I would agree with them, and in Chapter 10 of this book attempt to demonstrate just how sharply their works are opposed to the humane values represented by the main Neo-Romantic painters. Others who were included seem strange choices – Josef Herman, for example, though a close friend of many of the Neo-Romantics was temperamentally closer to Chagall and Permeke than to English sources such as Palmer and Blake. William Scott may have felt Neo-Romanticism's fleeting allure but shudders at the memory: 'I was caught up in the wave of the English watercolour nationalist romantic patriotic isolationist self-preservation movement.'[21] The deep involvement of Ivon Hitchens with English landscape is indisputable, but after he left London in 1940 for Sussex he worked in isolation and his rejection of line in favour of broad swathes

of colour put him stylistically at odds with those painters who were most important to Neo-Romanticism. David Jones's romanticism is obvious enough, but it takes such an arcane, fey and idiosyncratic form that it is difficult to see it as related to any wider movement.

Katherine Church, Charles Murray, Alan Sorrell, Julian Trevelyan, John Aldridge, Ceri Richards, Bryan Wynter and early Victor Pasmore were all shown by this 1983 exhibition to have shared Neo-Romantic enthusiasms. Henry Moore too, though he had abandoned sculpture during the war years, continued to be interested in the merging of human forms and land forms – a preoccupation we have claimed is central to Romanticism. He also contributed a new graphic technique of using water-based paints over resistant wax crayons which all the Neo-Romantic groups adopted and adapted for their own ends. This exhibition also paid tribute to those etchers, Frederick Landseer Maur Griggs, Robin Tanner, William Larkins and Paul Drury, who worked under the direct inspiration of William Blake, Edward Calvert and, above all, of Samuel Palmer. However, all the artists we have named so far were shown by this exhibition to be peripheral to Neo-Romanticism in comparison with the central figures of John Piper, Graham Sutherland, Michael Ayrton, John Minton, John Craxton, Keith Vaughan, Robert Colquhoun and Prunella Clough.

When the ten central chapters of this book were already written and largely set into type there occurred another major exhibition at the Barbican Art Gallery, London, entitled *A Paradise Lost: The Neo-Romantic Imagination in Britain 1935–1955*. This attempted to make plain how the Neo-Romantic vision permeated theatre design, photography, guide-books, films, posters, advertisements, book illustration, poetry, Ministry of Information propaganda and even ornithology during this period.[22] The same central figures as in the 1983 show again dominated the cast list, though Nash was now included and Craxton received much more of the limelight. The organisers also gave Cecil Collins (b. 1908) a major rôle, though, it seems to me, he resembles David Jones in being an isolated visionary-seer who would probably have painted as he did no matter where or when he lived. The Neo-Romantics certainly painted 'mind landscapes' too, but these usually took their start from real places, whereas neither Jones nor Collins seem to have needed this stimulus to produce their most typical works. Another artist given prominence was Leslie Hurry (1909–1978) previously best known as a stage-designer of a weirdly overwrought and hysterical kind. I still think that view holds good, and that the writer-illustrator Mervyn Peake (1911–1968) and Michael Ayrton are both superior as depictors of the romantically macabre. The flower studies of Denton Welch (1915–1948) and the delirious near-abstract expressionism of Gerald Wilde (1904–1986) were also well-represented, but in neither case was it clear why. On the other hand Ceri Richard's (1902–1971) explorations of the sexualisation of landscape were rightly given prominence. These convulsive works took their inspiration from the poetry of Dylan Thomas, but the visual language owed nearly everything to Surrealism, Masson and Picasso. For our purposes, however, Richards remained an isolated figure, working in Cardiff during the key years of Neo-Romanticism in a style which borrowed little from our English tradition, and a great deal from the French.

The fact that each of these exhibitions offered different lists of artists who could be called Neo-Romantics is an indication of both the difficulty of defining the term, and also of how pervasive the Neo-Romantic vision was at its strongest. They also signalled that unless some firm limits were imposed on the scope of this book then it would be extremely difficult to give the movement any narrative shape. Firstly then, it was decided to confine discussion to Neo-Romantic painting and to mention other arts only incidentally. Secondly, there seemed to be a consensus in the literature and in the Fischer exhibition on those painters who were absolutely central to Neo-Romanticism during the 1930s and 1940s – the Neo-Romantic first team, as it were. I propose, therefore, to give most attention to these, beginning with the three elders of the group: Paul Nash (1889–1946), John Piper (b. 1903), and Graham Sutherland (1903–1980). From there, via a chapter which shows that this group had a social cohesion as well as an artistic one, we pass to a consideration of those younger artists who admired and learned from these three. Of this generation I believe Keith Vaughan (1912–1977), Robert Colquhoun (1914–1962), John Minton (1917–1957), Prunella Clough (b. 1919), Michael Ayrton (1921–1975) and John Craxton (b. 1922) to be the most important. This second wave of Neo-Romantics are more difficult to research than the first since they have received no attention from biographers and very little from recent critics or art historians. When these nine painters are grouped together as Neo-Romantics it is not intended, of course, to imply that this is all they were, or are. John Piper has evolved stylistically throughout his long life, yet has maintained a Neo-Romantic vision to this day, but the others moved through this phase and made new reputations in other modes.

It is difficult to pin-point changes in the way artists see things but the dates 1935–1950 which the Fischer exhibition sets for the span of Neo-Romanticism seem too narrow. They exclude Sutherland's Palmer-like etchings and Nash's Dymchurch seascapes of the 1920s, and stop short of the 1951 Festival of Britain and the rebuilding of Coventry Cathedral, both show-cases for the last stages of Neo-Romanticism. The Barbican exhibition's wider limits of 1935–1955 stop just short of the perceptible shift in cultural values which took place in British artistic circles around 1956. Here I refer to a much-publicised but short-lived move towards brutal realism in painting; an anti-romantic strain in poetry, novels, and plays; the first stirrings of Pop Art which took as its subject urban materialism rather than landscape, and the Tate Gallery's exhibition of 'New Art in the United States' which thrust Abstract Expressionism onto our notice. All these brash innovations helped push to the margins those traditional, genteel, literary, pastoral, and cultivated qualities which Neo-Romanticism stood for. Many of the painters on our list began to move abroad, especially to France and the Mediterranean, abandoning as they did so the Neo-Romanticism which had seen them through the harsh years of the 1940s.

Paul Nash used the term *genius loci* to describe the thing he was in pursuit of in his landscape paintings, and it is this phrase that has been translated to provide the title of this book. Nash provides a good starting point for a study of Neo-

Romanticism. He was born in Victoria's reign and died at the end of World War II, so living through some of the most interesting twists and turns in the development of modern British art. He had a life-long loyalty to Blake and Rossetti, but struggled to reconcile this English heritage with newer French fashions in Post-Impressionism, Cubism, Surrealism and Abstract painting. This was a dilemma which perplexed each of the Neo-Romantics who came after him. Nash took an active part in the art politics of his times, and whilst sketching in these shifting groupings there will be opportunities to introduce several critics, patrons, and artists who continue as supporting characters throughout this book. He lived through two wars, the Depression and other public events which impinged on his life and work so these too will have to be mentioned if we are to see his art in its fullest context. All this will, perhaps, make for a rather dense first chapter, but it allows us to indicate the depth of soil from which the flower of Neo-Romanticism grew.

REFERENCES

1. Pevsner, Nikolaus, *The Englishness of English Art*, a series of lectures begun in 1942 and later published (London 1956), p. 19.
2. Fry Roger, 'Reflections on British Painting' in *French, Flemish and British Art* (London 1951), p. 177.
3. Piper, David. *The Genius of British Painting* (London 1975), p. 7.
4. Fry, Roger, op. cit., p. 141.
5. Ayrton, Michael, *British Drawings* (London 1946), p. 58.
6. Sutherland, Graham, 'A Trend in English Draughtsmanship' in *Signature*, July 1936, p. 11.
7. Grigson, Geoffrey, *Samuel Palmer: The Visionary Years* (London 1947), p. 83f.
8. Clark, Kenneth, *The Romantic Rebellion: Romantic versus Classic Art*, (London 1973), p. 196.
9. Piper, John, 'British Romantic Artists', in *Aspects of British Art*, ed. W. J. Turner (London 1947), p. 191.
10. Rosenblum, Robert, *Modern Painting and the Northern Romantic Tradition: Friedrich to Rothko*, (London 1975).
11. Brion, Marcel, *Romantic Art*, (London 1960).
12. Newton, Eric, *The Romantic Rebellion*, (London 1962), p. 12.
13. Eitner, Lorenz, 'The Open Window and the Storm-tossed Boat,' *Art Bulletin*, December 1955, pp. 281–282.
14. Lewis, Wyndham, *Men Without Art*, (London 1934), p. 187.
15. Connolly, Cyril ('Palinurus'), *The Unquiet Grave: A Word Cycle*, (London 1944), p. 73.
16. Watney, Simon, *English Post-Impressionism*, (London 1980), p. 3.
17. Mortimer, Raymond, the *New Statesman*, March 28, 1942, p. 208.
18. *Since 1939: Ballet, Films, Music and Painting* by A. Haskall, D. Powell, R. Myers and R. Ironside, (London 1948).

19. Ironside, Robin, ibid., p. 155.
20. Ayrton, Michael, the *Spectator*, April 19 1946.
21. Catalogue *The British Neo-Romantics 1935–1950*, Fischer Fine Art Limited (London) and The National Museum of Wales, July–August 1983, p. 37.
22. *A Paradise Lost: The Neo-Romantic Imagination in Britain 1935–1955*, May–July 1987, Catalogue edited by David Mellor.

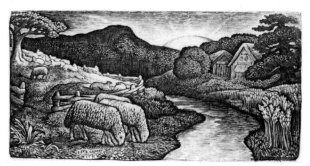

Edward Calvert, *The Sheep of his Pasture* (c1828), copper engraving

1

PAUL NASH

I^N April 1910, twenty-one-year-old Paul Nash wrote to his new friend the poet-playwright Gordon Bottomley:

> It's my secret weakness I scribble – can't help it *love* it, long and long to paint word pictures. I should cry like a kid I believe if I ever heard myself called a poet – a true poet . . . There, there's a confession for you.[1]

The confession was made because Bottomley had, surprisingly, mistaken the verse beneath Nash's drawing *Combat Between an Angel and a Devil* (1910) for the work of either Lascelles Abercrombie or Robert Browning:

> A place of gibbet-shapen trees and black abyss
> Where gaunt hills brooded dark and evil
> Girdled by dense wet woods and rushing streams
> A dread place only seen in dreams
> Of which there is no history but this
> That on yon' stony shouldered tor
> An angel fought a devil.

The drawing has a certain weirdness, but is otherwise as awkward and inept as the verse, with its badly drawn angel and a flying devil looking as fierce as a budgerigar. Eventually Nash realised that landscapes could be more emotionally charged if he left the people out of them, but at this stage he was under the spell of Beardsley, Burne-Jones, Morris, William Blake and above all, Dante Gabriel Rossetti, all of whom drew people, and extraordinary ones at that. For additional subject matter he turned to writers such as Tennyson, Gordon Bottomley, Keats, Algernon Blackwood, Whitman, Poe, Coleridge and George Borrow. Beyond this mixed group of Romantics and Georgians he avidly read what Anthony Bertram, his biographer, described as 'twaddle'. This persisted through his teens and early twenties, all this lush romantic escapism obviously meeting some urgent needs in the young man's

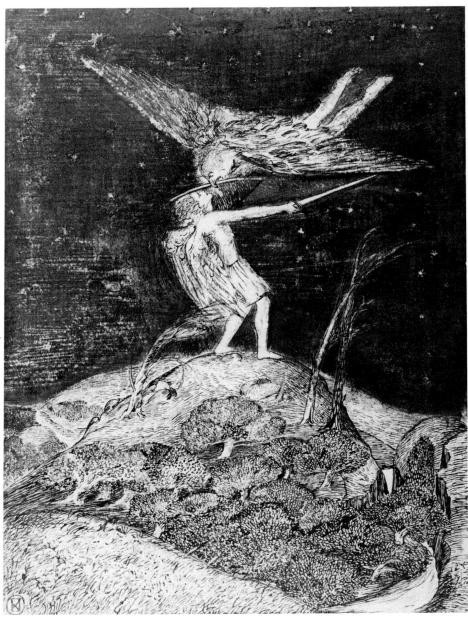

Combat Between an Angel and a Devil (1910), pencil, ink, wash

mind. It also, incidentally, laid down a store of imagery he could draw upon for the rest of his career.

Nash supplemented this rich artistic and literary diet with visions. Blake's visions of angels in a tree, Christ and the Apostles and the Ancient of Days had all been 'organised and minutely articulated beyond all that mortal and perishing nature can produce', but Nash's seem less specifically religious and, after childhood, less articulated. He seems to have had an awareness of something more like Wordsworth's 'presence that disturbs me with the joy/of elevated thoughts', but just once this took clearer shape. Running to grasp his nurse's hand he felt impelled to look behind him at the window. 'I looked over my shoulder at the space of sky. A cloud mounted up, parted, and I saw a figure in white lean out looking at me, it seemed, and holding up a warning finger.'[2] The sky would continue to be the setting for his visions throughout his life. He also had a Wordsworthian sensitivity to places, his first intuition of this coming to him in Kensington Gardens. 'Whatever happened to me there throughout my life I was conscious always of the influence of the place at work upon my nerves – but never in any sinister degree, rather with a force gentle but insistent, charged with sweetness beyond physical experience, the promise of joy utterly unreal.'[3] Towards the end of his life he began, but did not finish, his autobiography, *Outline*, and thought it important to record in it those childhood dreams he still remembered because, from these too, came motifs that reappeared in his mature works – the 'vast perpendiculars of changing dimensions', a sinister narrowing tunnel, and a repeated and delicious sensation of flying. Other childhood experiences of the 'cold and cruel' sea, of snakes, of woods and gardens also provided complex personal symbols for later exploitation.

A charged mental life like this is probably not unusual in imaginative children trapped in conventional middle-class families and suffering the petty tyrannies of a public school education. 'In those years,' he wrote of his schooldays, 'I suffered greater misery, humiliation and fear than in all the rest of my life.' And if one's life is fraught, boring and grey the kind of literature and the kind of picture one might turn to for escape in those pre-television days might be the kind the Pre-Raphaelite Burne-Jones said he wanted to paint:

> I mean by a picture a beautiful romantic dream, of something that never was, never will be – in a light better than any that ever shone – in a land no one can define or remember, only desire – and the forms divinely beautiful.[4]

Nash's brother John recalls that they were both 'saturated' by the Pre-Raphaelites as young men, but it was obviously the never-never medievalism of Rossetti and Burne-Jones which attracted them rather than the sharp-focus literalness of Millais or Holman-Hunt.

St. Paul's School failed to clear this fanciful lumber out of Nash's brain or to replace it with enough mathematics to get him into the Navy, or to follow his distinguished father into the Law, or indeed to equip him for any useful profession whatsoever. Without too much opposition, therefore, he was allowed to enrol for an

illustrator's course at Chelsea Polytechnic, hoping like his heroes Blake and Rossetti eventually to combine the two careers of writer and artist.

In a late essay, 'Aerial Flowers', Nash recalled the works he was producing at this early period:

> I lived the drama of the nocturnal skies, falling stars, moonrise, storms and sum-mer lightning. I shared with Samuel Palmer an appetite for monstrous moons, exuberance of stars. This strange greed may have been aroused by seeing pictures of Blake for, oddly enough, I did not set eyes on Palmer's designs until five or six years later.[5]

Over-worked and derivative as these early ink drawings are, they obviously showed enough promise to impress the painter William Rothenstein on one of his visits to the Polytechnic. On Rothenstein's recommendation Nash transferred to the Slade School in order to learn how to draw properly. This institution had been founded in 1871 as part of University College London by artists who were dissatisfied with the teaching in the Royal Academy Schools. Most of the progressive painters of the New English Art Club had been trained there before going on to pick up enthu-siasms for Monet, Manet and Degas*. Nash attended the Slade between October 1910 and December 1911, but with his reticent nature, conventional style of dress and lack of facility in drawing the figure he failed to impress his fellow students, or his formidable drawing teacher Henry Tonks (1862–1937). It was a good era for the school and Nash had Stanley Spencer, Mark Gertler, William Roberts, Edward Wadsworth and David Bomberg as fellow-students. Only with Ben Nicholson, how-ever, did he make a lasting friendship. Nicholson, who will reappear throughout this story as the polar opposite of Neo-Romanticism, was, at that time, undecided whether to be a writer, or an artist like the rest of his talented family. Whilst making up his mind he worked hard on the billiard tables. After three and a half terms he left to travel in Europe, returning only in 1917, and then departed again for the duration of the war to California.

Nash was as unimpressed by the Slade as his friend Nicholson and later warned his brother John against attending it, or any other art college. The place was like 'a typical English Public School seen in a nightmare' with the future Futurist, C. R. W. Nevinson, as the school bully. Even the famous Slade drawing style pro-mulgated by Tonks failed to win him over. This style was based on close observation of the nude figure which was then rendered in strongly modelled forms rather than by single clear contours on the grounds that there were no lines round receding planes in nature. Nash recalled it with no affection:

> A queer method of draughtsmanship was in vogue then. Everybody drew as if with a multiple pencil. Each line was reinforced again and again with nervous supports and followers. Curves and circles were a maze of concentrics.[6]

* When the New English Art Club was founded in 1886 members planned at first to call it The Society of Anglo-French Painters.

Graham Sutherland, *Red Landscape* (1942), oil on canvas

John Minton, *Death of Nelson* (1952), oil on canvas

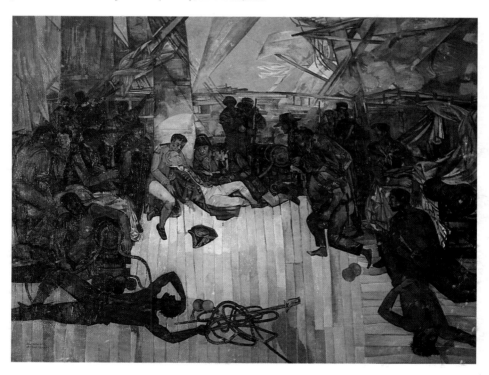

Michael Ayrton, *Winter Stream* (1945), oil on board

Robert Colquhoun, *The Lock Gate* (1942), oil on canvas

Rupert Lee, *Portrait of Paul Nash* (1913), pencil and pen

Temperamentally Nash needed tidiness, clarity, a lack of clutter, and in his search for flatter forms with single clear boundaries he found support in Blake's dogmatic statement that:

> The great and golden rule of art, as well as life, is this: that the more distinct, sharp and wiry the bounding line, the more perfect the work of art, and the less keen and sharp, the greater is the evidence of weak imitation, plagiarism, and bungling.[7]

Professor Tonks declared that 'The painter who is not a poet ought to be put in the stocks', but he could see no sign of either poet or painter in Nash. Nor could he find much to admire in foreigners (except Renaissance Italian ones), especially

those upstart French Post-Impressionists Roger Fry had exhibited in the Grafton Galleries in October 1910 and again in Ocober 1912. Tonks begged his students to stay away for fear of contamination, which showed something of the provincialism that Fry was trying to shake up.

Many of the 262 works in Fry's first exhibition were already a quarter of a century old and their painters (Manet, Van Gogh, Gauguin and Cézanne) safely dead. Matisse, Picasso, Vlaminck, Derain, Seurat and Friesz were presented as the latest manifestations of the new movement begun by these recent Old Masters. The second show added further works by Lhote, Van Dongen, Bonnard, Rousseau, Rouault, Redon and a selection of minor Fauves and Cubists. In addition there were a few Russians and a very mixed bag of English artists including Stanley Spencer, Duncan Grant, Eric Gill, Vanessa Bell, Spencer Gore and Wyndham Lewis, none of whom can have added much weight to Fry's main message that Cézanne's 'pure structural design' was the main breakthrough in modern art.

Fry defended his choice of French paintings with eloquence and passion claiming they ushered in a new classicism and, 'I do not mean by classic, dull, pedantic, traditional, reserved, or any of those similar things which the word is often used to imply . . . I mean they do not rely for their effect on associated ideas, as I believe Romantic and Realist artists do.'[8] These new painters were no longer concerned with mimetic skills or evoking literary sentiments and felt entirely free to rearrange colours, forms and perspective if it would serve their purpose. This deliberate crudity and aggression in their drawing and use of colour was deeply subversive of Edwardian beliefs about what 'real' pictures were and what role the artist should play in society. Indeed many people were still seething over the 1905 London exhibition of Impressionists. In his catalogue to the second exhibition Fry prophetically outlined where these discoveries might lead:

> These artists do not seek to imitate forms, but to create form, not to imitate life but to find an equivalent for life . . . in fact they aim not at an illusion but at reality. The logical extreme of such a method would undoubtedly be the attempt to give up all resemblance to natural form, and to create a purely abstract language of form – a visual music.[9]

Later, in 1914, Clive Bell pulled Fry's theories together in his book *Art* and gave us the term 'significant form' for the goal these French painters were seeking. Both Fry and Bell had an enthusiasm for 'primitive' art which seemed to Bell with its 'absence of representation, absence of technical swagger, sublimely impressive form' to embody those abstract virtues he valued. Picasso had already drawn upon African art for his *Les Demoiselles d'Avignon* in 1907, but in London such stuff was still for anthropologists only.

Many of the Impressionists and Post-Impressionists had visited England, and of course Paris represented *la vie bohème* for Victorian and Edwardian society and artists, but there seems to have been little cross-fertilisation of the newest ideas in painting. Sargent and Alma-Tadema were still the top people's favourites and

Augustus John and William Orpen were to remain the Slade's prize alumni long after the First World War. Fry was hurt that the cultured, leisured classes who had swarmed to his lectures on Italian Renaissance art did not treat his attempt to make Cézanne the tribal deity of modern art with equal respect. Indeed there was a disturbing foretaste of the way Hitler was later to slander modern German artists in the 1930s. The wood-engraver, Charles Ricketts, claimed to detect signs of madness in the painters and was supported by eminent doctors, including a Dr Hyslop who demonstrated to an audience of artists, including Fry, that these must be the works of the insane.[10] No support came from the staff of the so-called progressive schools such as the Slade or the Royal College, and, indeed, Fry was mocked there as the prophet who went about crying 'Cézannah, Cézannah in the highest!'

Nash later remembered the Slade students 'seething' with excitement and for the rebellious young painters Fry rapidly became a guru with his subversive message that painting need not be about morals or story-telling or imitating the skin of appearance. It is unlikely, however, that Nash was one of them since he left the Slade before the second, more radical exhibition, and he was still under the spell of Rossetti who had pronounced as early as 1864 that 'the new French school is simply putrescence and decomposition'. For the young Nash 'modern art' probably still meant the works in the Royal Academy Summer Exhibition.

One of the exhibitors there was Sir William Blake Richmond RA (1842–1921). Nash was introduced to this pillar of the Art Establishment in late 1911 or early 1912. This provided him with a tenuous link back to his admired Blake since Richmond's father had been George Richmond (1809–96), one of the 'Ancients' who clustered round Samuel Palmer in the days of his inspiration in Shoreham. This Richmond revered William Blake as much as any of the group, kissing his bell-pull when he visited the dying sage, closing Blake's eyes when he died, arranging his funeral and, as a final tribute, naming his son after him. Later Richmond compromised his youthful vision to become a heavyweight Victorian moralist and painter of the rich and famous. His son probably showed Nash original works by Blake and Palmer, and in return Nash proffered his own uncertain efforts. Since he had left the Slade these had been inspired by George Borrow's novel *Lavengro* and Oscar Wilde's *Salome*, and his own visions of starlit sea-cliffs and pyramids inundated by huge waves. He was still making art from art rather than from life. Richmond had a conventional outlook and thought 'Cézanne mistook his vocation. He should have been a butcher.' Later, when Fry had critically savaged the 'scented soap' historical pictures of Alma-Tadema in the Royal Academy, Richmond had fumed in print: 'Mr. Fry's position as a student of art, of connoisseurship and criticism is not strong enough to stand up against many more such suicidal egoisms . . . he must not be surprised if he is boycotted by decent society.'[11] Nevertheless, he did have the perspicacity to see what Nash needed. 'My boy, you should go in for Nature,' he boomed and set Nash some homework for the following Sunday. Having to look intently at nature rather than just using it as a generalised background to human events came hard to Nash, as he admitted:

At first I was unable to understand an almost devotional approach to a haystack and listened doubtfully to a rhapsody on the beauty of its form. Such objects, and indeed, the whole organic life of the countryside were still, for me, only the properties and scenes of my 'visions'. Slowly, however, the individual beauty of certain things, trees particularly, began to dawn on me.[12]

People are now eliminated from his drawings and he seems prepared to shake off the swoony suppressed sexuality of his Rossetti works, and the visionary subjects derived from Blake who had despised the whole of the 'vegetable world' in which Nash was now absorbed.

Nash quickly found his favourite places: an enclosed garden, a group of three elms he saw as Three Graces, and the two breast-like hillocks of Wittenham Clumps ('They were the pyramids of my small world.'). He wrote to reassure his friend Gordon Bottomley that this shift in subject matter did not mean abandoning his literary approach:

I sincerely love and worship trees and know they *are* people and wonderfully beautiful people – much more lovely than the majority of people one meets. Again I turned to the landscape not for the landscape sake but for the 'things behind,' the dweller in the innermost: whose light shines thro' sometimes. I went out to try and give a hint in my drawings of those sometimeses.[13]

That little streak of misanthropy would reappear in later life. He was also beginning here, and elsewhere in his writing, to exhibit that peculiarly English whimsy which leads to the milk-and-water paganism of *Peter Pan*, or the embarrassing fey-ness of the 'Piper at the Gates of Dawn' chapter in *The Wind in the Willows* – though in *Outline* he had professed, even as a child, to despise all things whimsical. He tried to paint trees as if they possessed a moral goodness and wisdom derived from their observations of our human follies. He addressed them in the verse equivalent of Dutch Elm Disease:

O dreaming trees, sunk in a swoon of sleep
What have ye seen in these mysterious places?
What images? what faces?
What unknown pageant thro' these hollows moves
At night? What blood-fights have ye seen?
What scenes of life and death? What haunted loves?

This is the 'pathetic fallacy' taken to bathetic extremes. However, he had found the basic problem for himself, and the other Neo-Romantics, to solve: how to imbue a landscape with emotional significance? How could one suggest that it is mysterious and morally charged even though it is empty of figures?

The works Nash produced in those few years after 'going in for Nature' are increasingly skilled and impressive. They are small-scale, in a mixture of pencil,

The Three (1911), pen, ink, chalk, wash

pen and water-colour, and are decorative, linear, almost pretty in style. They began to attract the attention of fellow artists and critics such as William Rothenstein, Herbert Read, and Roger Fry who asked him to help in the Omega Workshops and on the Mantegna fresco restorations at Hampton Court. One of the best of these early works is *Summer Garden* (1914) which Herbert Read described as 'Chinese in its delicacy, but very native in its primness'.[14] Nash seemed on the verge of a comfortable career supplying pleasant drawings of Home Counties scenery. Then came the war.

Before we consider that awful event and how it put iron into Nash's dainty art it might be useful to rough in those other kinds of contemporary British art which Nash, now practising pantheism in the gardens of Metroland, chose largely to ignore. Nash wrote to Bottomley that he found Fry, the leading figure in Bloomsbury artistic circles, 'dangerous to work with or for but a frightfully shrewd and brilliant brain and pleasant as a green meadow'. But he kept his distance and was not involved in the various sexual and artistic regroupings round the Bloomsbury set, nor did he attract the attention of the Sitwells or the other society patrons. The ex-Slade artists and the New English Art Club did not include him and he seems to have had little or no contact with Walter Sickert who was advancing Dégas as the Messiah to save English art, rather than Fry's contender, Cézanne.

For a time all these local groupings were swept out of the headlines by the brasher publicists of the Futurist Movement which began as an Italian literary faction but, by the time it stormed into London in 1912, had recruited the artists Boccioni, Carrà, Russolo and Severini. Marinetti, their chief spokesman, who thought of himself as 'the caffeine of Europe', had already fired off three manifestos. These glorified dynamism, steel, speed and aggression. 'We wish', wrote Marinetti, 'to glorify War – the only health giver in the world – militarism, patriotism, the destructive arm of the Anarchist, the beautiful ideas that kill, the contempt for woman . . . Art can be naught but violence, cruelty, injustice' – and so he raved on, sending delicious tremors through the London art world. Nevinson, the most important English convert, issued, with Marinetti, an English Futurists' Manifesto[15] denouncing most of those things Nash loved best, such as Oscar Wilde, the Pre-Raphaelites, the sham modernism of the New English Art Club, the Post-Rossettis and all such 'passéist filth'. Little wonder then that Nash ignored Marinetti's bugle call and his anti-Romantic demand that artists 'Kill the Moonlight!' The movement in England failed to survive the war which so appallingly embodied all their beliefs, though in its native Italy it lingered on to give a surface modernity to the style of Mussolini's Fascism, and in Russia it influenced such artists as Tatlin, Gontcharova and Malevich who wished to align revolutionary art with revolutionary politics.

Less easy to dismiss for English artists with any progressive intentions was Vorticism, an equally publicity-hungry movement. This too began as a literary crusade and though it claimed to be the only English 'ism' since Pre-Raphaelitism it was actually led by the Canadian-born Wyndham Lewis, American poet Ezra Pound and young French sculptor Gaudier-Brzeska, with Jewish-American sculptor Jacob Epstein in support. The native followers, Roberts, Wadsworth, Bomberg and Nevin-

son, were all known to Nash from his days at the Slade, and he must already have heard a great deal of Percy Wyndham Lewis who had studied there for three years and left, still only nineteen years old, to research all those things such as art, sex, literature and life about which Rugby School and the Slade had failed to teach him. Lewis travelled extensively in Holland, Germany, Spain and France, sometimes in the company of that other great ex-Slade bohemian, Augustus John. After seven years he returned to London to publish his stories and to lead British art into the twentieth century. He soon quarrelled with Fry over Omega Workshop commissions and thought him 'a shark in aesthetic waters and in any case, only a survival of the greenery-yallery nineties'.[16] After an early attraction to the Futurists' belligerence Lewis dismissed them all as hysterics and thought their concern to depict the movement of people or animals was merely 'imitative cinematography'. Impressionism he had long seen through as another form of boneless academicism slavishly imitating the surface of appearances, and Cubism, from which he undoubtedly borrowed a great deal, was condemned by him for its passivity before the same old tastefully boring still-lifes and posed models. Stealing the phrase from Fry he called for a new artistic language to be forged, 'abstract as music', but more logical, hard, solid, virile and intellectual than 'the cloud worlds' of Kandinsky and Klee. It can be seen that Lewis was a formidable and hard-hitting critic, though the paintings he made to illustrate his programme seem to me to fall short of the claims he made for them. He wanted to express energy in dynamic angles and sharp-edged planes, violent diagonals and interlocking forms derived from machinery rather than from landscapes or nudes. Following this logic he, Bomberg and Wadsworth all painted abstract, hard-edged pictures before the war began – but so, too, had their Bloomsbury rivals, Duncan Grant and Vanessa Bell.

Lewis must have represented the daring and modern for Nash's generation of Slade students but there is no sign that Nash felt tempted to join in their iconoclasm. Lewis remembered, 'Life was one big bloodless brawl, prior to the Great Bloodletting', but brawling was never Nash's style and he preferred always to adapt pioneering discoveries to his own private visions rather than march with the vanguard. He probably agreed with his reclusive friend Bottomley that even Lewis's magazine *Blast* was quickly stale 'and the pictures look theories that have gone cold too soon'.[17] Both Nash and Bottomley were temperamentally conservative, committed to a literary, fantastical, decorative Romanticism in which facture was subordinated to subject matter. These warring avant-garde artists rallying round Fry, Lewis and Sickert were, on the other hand, demanding a new austere classicism in which form was the prime concern. For example, blasting the bourgeoisie alongside Lewis was the young poet-critic T. E. Hulme (1883–1917). Anthony West in his book on John Piper describes Hulme as 'at once very English and an intellectual thug using his German aesthetic theories derived from Wilhelm Worringer* to advance the Vorticist cause and beat up Roger Fry and Clive Bell'.[18] Hulme believed that

* Worringer (1881–1965) continued to be influential in England and was quoted approvingly in the writings of Herbert Read, Paul Nash and John Piper.

the humanist tradition, dominant in European art since the Renaissance, was at last breaking up and that Romanticism, 'the last sloppy dregs' left by the Renaissance, was draining away. He could see, but deplored, the connection between Romanticism and man's instinct to look for God:

> By the perverted rhetoric of Rationalism, your natural instincts are suppressed and you are converted into an agnostic. Just as in the case of the other instincts, Nature has her revenge. The instincts that find their right and proper outlet in religion must come out in some other way. You don't believe in a God, so you begin to believe that man is a god. You don't believe in Heaven, so you begin to believe in heaven on earth. In other words you get romanticism. The concepts that are right and proper in their own sphere are spread over, and so mess up, falsify and blur the clear outlines of human experience. It is like pouring a pot of treacle over the dinner table. Romanticism, then, and this is the best definition I can give of it, is spilt religion.[19]

Like Fry, Hulme believed we were ready for a new classicism to show itself in social discipline and a new 'dry hardness' in the arts. He went further than Fry, who never really reconciled himself to abstract painting, and described the new art as geometrical with 'lines which are clean, clear-cut, and mechanical', sweeping aside all those outmoded virtues of beauty, grace, harmony and so on. As a poet, though a minor one, he also wanted to crush the 'damp' Romantic rubbish Nash was so fond of where one was 'always flying, flying over abysses, flying up into the eternal gases . . . the word infinite in every other line'. He pushed the 'urge to abstraction' rather than 'the urge to empathy'; the geometric rather than the organic; and Vorticism was the practical attempt to realise this programme.

In a wider, political view of Romanticism Hulme saw Rousseau's view of man as a perfectible creature if only his restraints were lifted, and the cult of individualism which flowed from that view, as dangerous nonsense:

> Here is the root of all romanticism: that man, the individual, is an infinite reservoir of possibilities; and if you so rearrange society by the destruction of oppressive order then these possibilities will have a chance and you will get Progress. One can define the classical quite clearly as the opposite to this. Man is an extraordinarily fixed and limited animal whose nature is absolutely constant. It is only by tradition and organization that anything decent can be got out of him.[20]

Charles Harrison sees Hulme's vision of the brave new world of classicism as the pessimistic creation of a reactionary imagination, 'the manic in flight from the organic', and knowing, as Hulme could not, that such views were to lead Lewis into supporting Fascism in the 1930s, one can agree with Harrison.[21] Nevertheless, this 'will to abstraction' will be a constantly re-emerging theme in our account of Neo-Romanticism. Even if the artists do not return to the wider implications of Hulme's new classicism they frequently feel the attractions of coolness, dryness,

and the harness of geometry when they are surfeited on the organic, or lose faith in their own subjective visions. One day Nash too would feel what Hulme called 'a desire for austerity and bareness, a striving towards structure and away from the messiness and confusion of nature and natural things'.

Meanwhile Nash was content to stay aloof from noisy progressives and loiter on the fringes of the newly founded (1914) London Group even though the war was suddenly upon him. At first this did not impinge upon his deeper feelings and, as a newly married man, he was merely irritated at having to attend training with the Artists Rifles. There he befriended the poet Edward Thomas who was developing a very similar view of nature to Nash's own. Eventually his turn came to be shipped to France as a twenty-eight-year-old second lieutenant in the Hampshire Regiment. He arrived at the Ypres Salient in early March 1917* during a lull in the fighting when a warm spring was soothing the earth's battle-scars with lilac, dandelions and the song of nightingales. In 'excitement and exultation' he began sketching in his usual decorative manner until, on 25 May, he fell into a trench, broke a rib, and was sent home three days before the Battle of Hill 60 in which most of his fellow officers died. He exhibited twenty-six drawings of the Ypres area in June at the Goupil Gallery and won considerable acclaim. On the basis of this, and some string-pulling, he managed to return to France as an official War Artist for the Department of Information. He was also provided with a batman and chauffeur to smooth his way.

By December he had enough chalk sketches to be able to return home to work them up into pictures. There was a profound change to be seen in the works produced from the second trip. It had rained steadily since August and turned the Front into the wire-entangled quagmire we know so well from films, photographs, autobiographies, the poetry of Owen, Sassoon and Rosenberg, and those very paintings Nash was now feverishly working on. Nothing he had seen or imagined could have prepared him for the fifty square miles of devastation or the hideous mass-grave of nearly half a million young men that was Passchendaele. On 16 November he wrote to his wife Margaret:

In the fifteen drawings I have made I may give you some vague idea of its horror. Evil and the incarnate fiend can be master of this war, and no glimmer of God's hand is seen anywhere. Sunset and sunrise are blasphemous, they are mockeries to man, only the black rain out of the bruised and swollen clouds all through the bitter black of night is fit atmosphere in such a land. The rain drives on, the stinking mud becomes more evilly yellow, the shell holes fill up with green-white water, the roads and tracks are covered in inches of slime, the black dying trees ooze and sweat and the shells never cease . . . They plunge into the grave which is this land; one huge grave, and cast up on it the poor dead. It is unspeakable, godless, hopeless. I am no longer an artist interested and cautious, I am

* The month before, nineteen-year-old Henry Moore had joined the 15th London Regiment, only to be gassed at Cambrai.

a messenger who will bring back word from these men who are fighting to those who want the war to go on for ever. Feeble, inarticulate, will be my message, but it will have a bitter truth, and may it burn their lousy souls.[22]

What Bertram called 'the pseudo-poetic and second-hand romanticism of his long adolescence' was over. Even his prose was now direct and stripped of affectation. He had a subject now, then unprecedented in British, or any other art, and a crusade, but the style to hand had been evolved to portray English elms clustered round the village duck-pond, not trees decapitated by shells or flooded craters full of corpses. This was no longer the 'pathetic fallacy' at work: man had now literally imposed his collective madness on the landscape and torn it asunder.

Back in England Nash studied the hasty chalk sketches made on black paper as the star-shells fell and the bombardments began. He decided to work in oils for the first time but tried to retain the sketches' simplicity in the interests of emotional directness. He was not equipped to depict the gassed, bayonetted and mad men he had seen at the Front, and anyway the censor would not permit it, so his bitter but simple truths had to be conveyed through the metaphor of landscape, showing its violated beauty and its hideous wounds. By May 1918 he was ready to exhibit 'Void of War' at the Leicester Galleries to almost unanimous acclaim. Of these works *We are Making a New World* (1918), based directly on a front-line sketch, is surely the best-known picture of World War I. Causey sees this as basically a Symbolist picture, but one which avoids the literary burden usually associated with the products of that late nineteenth-century French movement, and Nash succeeds 'by denoting his Symbolist intention by symmetry and details of stylisation which announce that this is no longer a Flanders landscape but *the* Flanders landscape'.[23] Nash had fulfilled Mallarmé's instruction: 'Peindre, non la chose, mais l'effet qu' elle produit.' Colour is neither realistic nor decorative and we are left to speculate whether the pallid sun will be engulfed by the blood-red tide of clouds, or rise above and disperse it. There are also signs here, and in other associated war pictures, that Nash has learned something about the use of angular forms, harsh rhythms and diagonals from the Vorticists, but the new robust style he has evolved to cope with his war experiences is now firmly his own – as he admitted in 1919:

My war experiences *have* developed me – certainly on the technical side. I think they have also discovered my sense of colour, which was very weak before the war. I have gained a greater freedom of handling due largely to the fact that I had to make rapid sketches in dangerous positions, and a greater sense of rhythm. I have been jolted.[24]

After the war ended he completed two more commissioned pictures of Flanders, *The Menin Road* (1918–19) and the more stylised *Night Bombardment* (1919–20), both fine bold works showing increasing confidence in the use of oils, but perhaps a shade too carefully composed and coloured-in to have the same impact as the magnificent 1918 works. These later works he completed in a shed, painting side

by side with his brother John who was working on his *Over the Top: First Artists' Rifles at Marcoing* and *Oppy Wood*, both impressive works based on John's experience at Cambrai and elsewhere in France. These Nash pictures are now amongst the chief treasures of the Imperial War Museum, founded by the Government in 1917.

Suddenly there was no more call for war pictures and Nash found himself 'a war artist without a war' – though twenty years later he was to become one again and be joined by younger Neo-Romantics all looking to him as an established master.

Nash has been very well served by critical biographers so there is little point in a detailed account of those questing inter-war years.[25] More germane to our wider story would be to consider the alternative routes open to an ambitious youngish artist like Nash who was suddenly deprived of a strong social purpose and a powerful subject matter to express.

Return to Rossetti medievalism was unthinkable. Futurism and Vorticism were no longer options since they failed to survive the war which embodied so many of the qualities they had praised, such as violence, will and technology. Hulme and Brzeska had been killed and Lewis, having come through the fire of war, realised that purist theories left something out:

> The geometrics which had interested me so exclusively before I now felt were weak and empty. *They wanted filling.* They were still as much present to my mind as ever, but submerged in the coloured vegetation, the flesh and blood that is life.[26]

Lewis's war pictures are awkward compromises, anecdotes, superficially decked out in angles and planes. As he admitted when he exhibited them, 'Experimentation is waived: I have tried to do with pencil and brush what story-tellers like Chekhov and Stendhal did in their books.' Nevinson, too, had lost his fire after ghastly experiences in the Red Cross and Medical Corps. He wrote in the *Studio* of December 1919:

> The immediate need of the art today is a Cézanne, a reactionary, to lead art back to the academic traditions of the Old Masters, and save contemporary art from abstractions, as Cézanne saved impressionism from 'effects'.[27]

As for the Bloomsbury coterie, 'they were all doing work of National importance,' snarled Lewis, 'down in some downy English county, under the wings of powerful pacifist friends; pruning trees, planting gooseberry bushes and haymaking, doubtless in large sunbonnets.'[28] They too had abandoned their abstract experiments, Vanessa Bell having discovered that nature was much richer and more interesting than anything one could invent.[29]

In Paris even Picasso had given up Cubism to paint bulky Neo-Classical bathers, portraits in the style of Ingres and drop curtains for Diaghilev's *Parade*. Braque, slowly recovering from his war wounds, was making Cubism serve more colourful and decorative purposes; and Matisse had moved to Nice to distance himself from the Paris scene and to concentrate on what he enjoyed best – nudes, flowers, sea

and sunlight. There was a general exhaustion and disillusion in the art world and a need to enjoy the simple sensual things of life again – which meant, in art terms, a return to figuration, and in social terms the onset of the frenetically 'gay twenties'. Only in Russia did austere abstraction splutter on into the twenties until it was crushed by official disapproval.

Wyndham Lewis came to Nash's post-war exhibition of pictures and offered to buy a drawing, but in some odd way this led to an exchange of peevish letters and the two men failed to become friends.[30] Lewis had a talent for putting people's backs up, and from this time they maintained a polite respect for each other's work, but kept their distances. Lewis continued to be a contentious but increasingly isolated figure in the London artistic and literary world throughout the 1920s and 1930s. Now, however, he drops from our story until he, the self-proclaimed Classicist with no interest in landscape painting, re-emerges in the late 1940s and early 1950s as the unexpected critical champion of the young Neo-Romantics.

Fry and Bell emerged again in this period of post-war lassitude with their belief in Cézanne unshaken, and their doctrine of painting which was pure, disinterested, un-literary, formal and which appealed to a separate 'aesthetic emotion'. For them, it seemed, the painter's grammar and accent mattered more than what he was trying to say so Bell could dismiss the war works of Nash, Lewis, Nevinson and all the others because they were 'not expressing what they feel for something that has moved them as artists, but, rather, what they think about something that has horrified them as men. Their pictures depart, not from visual sensation, but from a moral conviction. So, naturally enough, what they produce is mere 'arty' anecdote.'[31] With no other grouping strong enough to oppose them, the Bloomsburys inserted fingers into every pie. Virginia Woolf became influential as a novelist-critic, Maynard Keynes as an economist, Leonard Woolf as political scientist and publisher, Lytton Strachey as historian-biographer, Desmond MacCarthy as literary critic, and Vanessa Bell and Duncan Grant as painters. Their intertwining talents, life styles and love affairs set a fast pace for London's social and intellectual aspirants to follow, and to be excluded from their salons was to be cast to the outer fringes of modernity. Fry and Bell continued to drum out their message in books, reviews and lectures that 'at any given moment the best painter in England is unlikely to be better than a first-rate man in the French second class'. The pre-war opposition to modern French painting seemed to have disappeared. The Sitwell family organised a show of contemporary French works at Heals in 1919 (which Nash saw and reviewed) and shows of Matisse and Picasso and Van Gogh all occurred in the following few years. French Post-Impressionists were now to be seen frequently in the London galleries, though Cubist works did not seem to be so popular.

As an ambitious painter in search of a new direction Nash must have felt the presures on him to acquire a French accent, and in fact he made trips there in 1922, 1924, 1925 and 1930 – on this last occasion accompanied by Edward Burra. Nevertheless he resisted and agreed with Bottomley, who warned him against 'indoctrination' and wrote, 'The French have much more fine painting than we have, but the small bulk of our very great painting is finer than anything the French

Rocky Landscape or *The Waterfall* (1923), pencil, ink, watercolour

have to show.' Bottomley's reasons for this view are dated, but perceptive:

> Our painters have never been consummately expert and accomplished virtuosi in their technique and handling of materials, so that when the great moment comes they have to think it out and feel it out from the beginning and thus get their executions into harmony with their matter and avoid ready-made solutions: while the French are so virtuose, so full of professional adroitness and aplomb, that they can execute anything and beguile us by the beautiful manners and breeding of their execution into feeling that everything they do is right. I think, too, that it is this that gives them a mundane outlook and makes their art so poor in the element of fantasy – so that they have very little to show of such a spiritual world as Blake, Calvert in *The Cider Feast*, Rossetti in the little early water-colours like *The Chapel in the Lists*, Millais in *Ferdinand and Ariel* or *Mariana* and Crome and Cotman live in.[32]

Yes, agreed Nash, those French do take one in, especially when 'they are able to create a beauty independent of subject-matter suggestion'. Hogarth had complained in his day of the seduction of English artists by these cunning but specious Continentals, and it was a snare each of the Neo-Romantics had to fight his own way out of.

In spite of his patriotic declarations Nash did begin to ape French manners for

a time in the 1920s – a hint of Cézanne's open treatment in water-colours here, a suggestion of Derain's sturdy manner with landscape there, a touch of late Cubism in this angular form or the other. Yet, in his first book *Places* (1922), he could suddenly revert all the way back to Blake in mixing his seven wood-cuts with his own handwritten prose-poems. The first four show ponds and each illustration has a female figure, three of them naked. The last three have upright formats to emphasise the nave-like effects of receding avenues of trees – those vast perpendiculars and sinister narrowing tunnels of his childhood dreams. The woods menace and the women tempt to death in the icy black ponds, not to warm erotic embraces:

> grey teeth of an old fence
> look ghostly against dark waters
> Beyond a platform jutting out, a
> woman naked gleams in this shadowy place.

The Cubist facets and simplified forms may look superficially modern, but the story he tells is still 'La Belle Dame Sans Merci'.

One of the recurrent Romantic obsessions is with the sea: as an escape route, as a threat, as a mother symbol, and as one of the great sublime forces of Nature.

Dark Lake, Iver Heath (1920), wood engraving from Nash's book *Places*

Nash discovered it as a subject whilst he lived in Dymchurch, Kent, from 1921 to 1924. Causey remarks that 'the extraordinary degree to which he realised his emotions there in terms of place is unusual even for Nash and throws into relief his high nervous tension at this time.'[33] This tension came from several sources: his health was poor after the war and would remain so all his life; he lacked funds; the dominant Bloomsbury critics were not supporting him; and he was painfully uncertain how to develop his art now war was over. Finally, there was the isolation he was thrown into after the 'Derriman affair' when he had favourably reviewed his own and his brother's works under a pseudonym, been challenged, and had to apologise publicly. In 1921 he had some kind of nervous collapse and was unconscious for a week.

As a boy Nash had twice narrowly escaped drowning so it is not surprising that he pictures the sea as menacing and cold, whilst the land, especially the long sea-wall, hold rigid, but vulnerable, against its remorseless attack. In Dymchurch the elements were so simple as to be almost ready-made abstracts with a twelve-mile straight wall separating a flat marsh from a flat sea beneath a wide blank sky. In some of these stark pictures tiny figures appear on the sea-wall leaning against the wind. In its way the scene is almost as desolate as Vimy Ridge. The most uncompromisingly bleak of them all is *Winter Sea*, developed from water-colour to oil between 1925 and 1937. No bather could enter this sea of overlapping blades where the white light forms a receding path to the green-black sky. Nash is evidently using these powerful landscape works to discharge some deep conflicts within himself, though he is unlikely to have formulated it to himself in terms of, say, the wall and the sea symbolising the rational versus the irrational, control battling against destructive passion, the structured against the intuitive and so on.* Whatever his crisis was on this deeper level, Nash had worked through it by 1925 when he could announce decisively, 'I shall never work there anymore.' He could also reflect, 'A place like that and its effect on me – one's effect on it. It's a curious record formally and psychologically when you see the whole set of designs together.'[34]

After the Dymchurch period Nash produced several fine works, but for the most part he was seeking another strongly compelling subject and a voice to express it in until the end of the 1920s.

Fry wrote an influential book on Cézanne in 1927 ('a masterpiece', Kenneth Clark called it) and Nash can be seen trying to assimilate Cézanne, but also a wide variety of other artists including Duncan Grant. 'I am very puzzled what to do – I want to expand but do not see my way,' he confessed. He was not the only one. Charles Marriot, *The Times* critic, had written that English painting, unlike French, was about Safety First, our artists just keeping going slowly and cautiously plodding towards 'more and more highly organised design, or towards the exact expression of their sensibility'.[35] Nash, for example, had worked on his manner of painting, but as a designer he had stayed the same. Nash acknowledged the justice of this

* John Piper later did a series of works based on the same area (*Romney Marsh*, Penguin, 1950) but his breezy skies and churches never prompt speculation on a psychological level as Nash's works do.

and bemoaned his own lack of 'mental daring' or the ability to go too far, which the French seemed to have in abundance. He resolved to do better.

John Rothenstein begins his essay on Nash's younger brother John:

> Biographies of landscape painters often convey the impression that nature was their subject's inspiration and that their art was founded upon the study of landscape itself. The art of most landscape painters in fact, derives principally from the example of other painters.[36]

Even with somebody as receptive to the *genius loci* as Nash, this is still true. The landscape artist needs some guidance if he is not to be overwhelmed by 'the intricate disorder and the immensity of nature, by its infinite vastness and its infinite detail'. Nash was now in the position of needing a beckoning finger if he was to go forward. Two were raised almost simultaneously: the one enticed him towards the gaudy bordello of Surrealism, and the other towards the monastic cell of Total Abstraction. He tried the latter first.

After his over-decorated Rossetti period with its sickle moons, maidens' tresses and bosky hills Nash seemed to turn increasingly to more austere and angular subject matter, such as the sharply diminishing perspective of Dymchurch sea-wall or breakwaters stabbing into the sea. Then came platforms, diving stages, ladders, mirrors, fences, scaffolding, windows, screens and doors as if he was trying to hold down the exuberant fecundity of nature under a cold-frame of geometry. Several photographs of Nash at work show him with ruler or set-square in hand, dapperly dressed and seated at an immaculately ordered work-bench. A picture such as *Landscape at Iden* (1929) is typical with its emphasis on the rigid verticals and horizontals of screen, fence, stake, hedge, wall, woodpile and horizon – even the cloud bases are drawn with a ruler. The picture is set out like a chilly open air gymnasium; it is only much later that one notices the grey snake curled round one of the bars of the fence. The various items have been observed and abstracted from nature, but reassembled in a disquieting non-naturalistic way partly derived from his knowledge of the newly revived interest in abstract, hard-edged art in Paris and partly, Causey demonstrates, from Nash's study of an eighteenth-century manual on perspective, and lastly from the example of Chirico's *The Joys and Enigmas of a Strange Hour* (1913). As Rothenstein said, Nash was turning now to the example of other painters to get him out of his creative impasse.

Whilst still at Dymchurch Nash had begun wood-engraving and tried out in this small-scale medium completely non-representational works such as *Abstract No. 2* (1926). Earlier in 1924 in his ten blocks for *Genesis* he had tried to get away from a Blake-like illustration of the Days of Creation by basing each on a different geometrical figure – a crystal, prism, ellipse, pyramid, sphere, arc, dome and rectangle. The feeblest of these prints are in fact the most representational, for example, the 'Man and Woman' and 'Cattle and Creeping Things' with its gormless cow. In the same medium he made abstract patterned papers and book jackets finding it 'a relief to be rid of the responsibility of representation', and to turn to 'the

Landscape at Iden (1929), oil on canvas

geometrical planning of a textile or other form of industrial design'.[37] Abstractions need not, of course, be geometrical, but Nash was an old friend of Ben Nicholson's and under the early influence of Synthetic Cubism Nicholson had already painted his first abstract in 1924 (*Chelsea*), and then gone on to simplify his landscape works after seeing the naïve style of the ex-seaman Alfred Wallis. In the early 1930s he, and his second wife Barbara Hepworth, lived near the Nashes in Hampstead and brought back from their continental trips news of visits to the studios of Picasso, Miró, Calder, Giacometti, Moholy-Nagy, Arp, Mondrian and Hélion. By December 1933 Nicholson was making painted geometric reliefs and by the end of 1933 they became stark pure white. Nash could not ignore the work of his old friend and near-neighbour, especially as the austerity of his works appealed to something very ascetic in his own make-up. The group round Nicholson in Parkhill Road, Hampstead – Hepworth, Moore, Cecil Stephenson and Herbert Read (nicknamed 'A Nest of Gentle Artists' by Read himself)[38] – was beginning to provide a useful counterweight to the Bloomsbury and Sitwell cliques who were still seeing Cézanne and Post-Impressionism as the way forward for English art. Nash was within but nowhere near the centre of this Hampstead circle who had now moved on to the next generation of French art for their inspiration. He was not included in the 7

& 5 Society which Nicholson infiltrated and then pushed steadily towards dogmatic abstractionism. Yet Nash was ambitious and would have liked to be thought a progressive member of the avant-garde even though the Press was uniformly hostile to abstraction and there was no money in it.

Before the war Nash had decorated a few objects and pieces of furniture in the Omega Workshops, set up by Fry in 1913 to reform stodgy English taste and to give young artists a small salary so they could paint as they liked, independent of the Royal Academy's commercial grip. At the same time Fry believed real art, pure art, was a biological irrelevance and must remain so if we are to contemplate it disinterestedly rather than for its past associations, its moral message or its practical use. In this way pure art could never be harnessed for use by religion, by the state or by commerce. Nash, like all the Neo-Romantics in this study, gladly mixed the pure and the applied arts all his life, partly from the need to earn a living, but also from conviction that the separation was a false one. He made posters, textiles china, book illustrations, a guidebook to Dorset, a black-glass bathroom for the dancer Tilly Losch, and even a chocolate box for Cadburys. In 1932 he was elected to the chairmanship of the recently formed Society of Industrial Artists which derived its ideas of uniting the 'fine' and 'useful' arts from the German Bauhaus School. This gave Nash a public role and some power, but he still itched to do more to unite progressive painters in the face of critical hostility and public apathy.

On 12 June 1933 Nash had a letter published announcing 'the composition of a new society of painters, sculptors and architects under the name of "Unit One"', so named because all artists remained individuals, or units, but were united in mutual support. (It reveals something of the social composition of the art world in the 1930s that he chose *The Times* correspondence columns to reach them. Which channel would be used today, one wonders?) The eleven members were united only by an ill-defined interest in 'architectonic quality' and a pious determination 'to stand for the expression of a truly contemporary spirit, for that thing which is recognised as peculiarly *of today* in painting, sculpture and architecture', for, and here came a side swipe at Bloomsbury, 'Post Cézannism and "Derainism" have ceased to be of the first interest.' Apples had had their day. After that it seemed inept of Nash to claim the Pre-Raphaelites as an inspiring precedent.

The members of Unit One were architects Wells Coates and Colin Lucas, sculptors Henry Moore and Barbara Hepworth, and painters Nash, Wadsworth, Nicholson, Frances Hodgkins (later replaced by Tristram Hillier), Edward Burra, John Bigge and John Armstrong. Nash and Moore were the prime movers and Herbert Read, pen ever poised to introduce any progressive-minded groups in art, literature or politics, wrote the introduction to their first, and only, exhibition at the newly opened Mayor Gallery in April 1934. Braque, Léger, Herbin, Baumeister, Arp, Dali, Miró, Ernst and the young Francis Bacon (until then known only as a Bauhaus-influenced furniture designer) were shown alongside the Unit One people. A selection of the British works then went on provincial tour, the first such modernist works ever to do so.

Nash thought the group's purpose was to combat English painting's seven-year

cycle of returning either to Pre-Raphaelitism or to Impressionism, or 'the Nature cult in one form or another' – all temptations he must have felt more keenly than any of the others, especially Nicholson and the sculptors. In a rhetoric echoing Fry's he claims:

> Only the most stubborn can dispute that English art has always suffered from one crippling weakness – the lack of structural purpose . . . this immunity from the responsibility of design has become a tradition.

Now, with all the zeal of a convert, he rallies his fellows to 'a structural pursuit', and for imaginative explorations 'apart from literature and metaphysics'. Finally, in a Dymchurch image:

> The formation of Unit One is a method of concentrating certain individual forces; a hard defence, a compact wall against the tide, behind which development can proceed and experiment continue.

Within a year the wall fell down. By then Nash's asthma attacks were so sapping he could no longer prevent the group's dissolution. Besides, who could impose a 'structural pursuit' on Burra, or stop Armstrong or Hillier pursuing the 'metaphysics' of Surrealism – a direction Nash himself was to take very soon?

Abstraction was an international movement and became even more so when German refugees began to join Nicholson and Hepworth in Hampstead. First came Walter Gropius in 1934, then Moholy-Nagy, Naum Gabo and Piet Mondrian, all too purist for Nash who took no part in the international survey of constructive art that J. L. Martin, Ben Nicholson and Naum Gabo published as *Circle* in 1937. Nash was too acutely aware of his English heritage to join them, though he could get no nearer a precise definition of it than saying it was more interested in the spirit than the form, had a bright delicacy of colour 'somewhat cold but radiant and sharp in key', and a linear design perhaps derived from Celtic or Gothic idioms.

> If I were asked to describe this spirit I would say it is of the land; *genius loci* is indeed almost its conception. If its expression could be designated I would say it is almost entirely lyrical. Further, I dare not go; except to recount history and to state my faith. Towards the end of the eighteenth century, William Blake, then, and often now, called a madman, perceived among many things the hidden significance of the land he always called Albion. For him, Albion possessed great spiritual personality and he constantly inveighed against 'Nature', the appearance of which he distrusted as a false reality. At the same time, his work was immensely influenced by the country he lived in. His poetry literally came out of England. Blake's life was spent in seeking to discover symbols for what his 'inward' eye perceived, but which alas, his hand could seldom express. Turner, again, sought to break through the deceptive mirage which he could depict with such ease, to a reality more real, in his imagination. In the same way, we, today,

must find new symbols to express our reaction to environment. In some cases this will take the form of an abstract art, in others we may look for some different nature of imaginative research. But in whatever form it will be a subjective art.

This reads more like a programme for English Neo-Romanticism than hard-line Structuralism. His final paragraph confirms that his personal priorities bear no resemblance to Unit One's professed concern with structure at the expense of metaphysics, literature and poetry:

Last summer I walked in a field near Avebury where two rough monoliths stood up sixteen feet high, miraculously patterned with black and orange lichen, remnants of the avenue of stones which led to the Great Circle. A mile away, a green pyramid casts a giant shadow. In the hedge, at hand, the white trumpet of the convolvulus turns from its spiral stem, following the sun. In my art I would solve such an equation.[39]

Nash was by this time ripe for Surrealism where content took precedence over form. By now he had realised he was not cut out for abstract painting. In the few he tried such as *Lares* (1930), based on his fireplace, *Opening* (1931) and *Kinetic Feature* (1931), he still tried rendering abstract hard-edged shapes as if in illusionistic space and so got the worst of both worlds. 'I made no headway in that direction,' he admitted and from now on he was 'for but not with' the abstract painters, as he explained in the first edition of Myfanwy Evans' magazine *Axis* in January 1935.

André Breton published the Surrealists' manifesto in 1924 but Nash does not seem to have become very interested in the movement until seven years later when he favourably reviewed a London exhibition by Giorgio de Chirico (1888–1978) – 'The Columbus of the unconscious', Nash called him.[40] By then Surrealism was already old hat in Zurich and Paris; de Chirico had been expelled from the movement and now disowned all those splendid 1910–19 pictures for which he is still best known. These works are rendered in a deadpan academic style but are about 'the sensation of something new, of something that previously, *I have not known*', their maker explained. Nash must have admired the disquiet and feeling of imminent drama that de Chirico instilled into a deserted piazza or a long cast shadow across an arcade. 'The troubling connection that exists between perspective and metaphysics' was an insight Nash had probably arrived at by himself, and was to exploit again in a series of 'Room' pictures during the 1930s. De Chirico soon banished even the statues from his deserted squares as being too dramatically human and, in yet more vertiginous perspectives, placed stuffed dummies and assemblages to provide human equivalents, changing the figure into *nature morte*. Nash in the same quest for human presence without human appearance sought his equivalents in logs and stones and trees.

Max Ernst (1891–1976) was an admirer of early de Chirico but differed from him in wanting to compose 'with violence' works which would uncover the evil in men's psyche as well as the good. In 1933 Nash praised Ernst strongly in a

review, and picked out motifs which were paralleled in his own works at this time: 'the disconcerting association of birds with flowers, suns with forests – suns which look like targets, forests which more resemble seas.'[41] Temperamentally, however, Nash was not attracted to Ernst's violence, eroticism and pessimism, though his *Wood of the Nightmare's Tales* (1937) owes something to Ernst's punning visions. Ernst was also a technical innovator in his books of collages from nineteenth-century prints, his 'frottage' rubbings from textured surface, and his 'decalomania' trick where thick paint was sandwiched between paper and canvas so that when the paper was peeled off it left unpredictable marks on the canvas – as in his war picture *Europe After the Rain* (1940–42). All these have now become routine ingredients in foundation art courses or even infant school art lessons, but at the time they must have stimulated Nash to relax his always tight technical control. Later he used the collage technique for wartime propaganda such as *Follow the Führer* (1942), but without Ernst's mad wit or savagery.

Magritte (1898–1967) was the third Surrealist Nash admired and learned from and in this case the admiration was returned, Magritte dubbing Nash 'The Master of the Object'. There was nothing left to 'automism' or chance in Magritte's images, each of which played with the concepts of reality and paradox in a philosophical manner and eschewed all painterly effects. There were links here with those works by Lewis Carroll and Edward Lear which Nash had loved as a child. Causey demonstrates that Magritte influenced some of Nash's work, particularly the *Harbour and Room* (1932–6) in which the Nashes' bedroom during a holiday in Toulon seems to be invaded by lapping waves, a black steamship and the night. It is a disturbing theme and one he explored in several versions, playing with the basic idea of the interpenetration in one image of two equal but widely disparate realities. In the water-colour *Empty Room* (1935), the left-hand wall becomes the Ballard Cliffs with the waves, choppier now, coming in towards us across the floorboards. In front of the locked door to the right is set a sawn-off tree trunk (it has no roots) which, Causey speculates, is a Romantic symbol of death. In *Three Rooms* (1937), the lowest of the three is again flooded as far as the horizon where the sun is setting; the second room is transformed into a grove of trees with a locked door in the far wall; and the topmost is penetrated by clouds. Causey traces precedents for these remarkable pictures to Wadsworth harbour scenes, Picasso, de Chirico, Magritte and an eighteenth-century book on perspective which Nash owned.[42] Out of this mixture of literary, artistic and natural ingredients he managed to make something simultaneously modern in its daring, archetypal in its subject and traditionally English in its water-colour medium.

Surrealism saved Nash from that self-denying and formal side of himself that would pursue structure as an end in itself, and gave him the courage to throw together widely different objects in the same image. Another new influence, that of his friend the American poet Conrad Aiken, a neighbour at Rye, led him back to the poetic interests of his youth, suppressed since his wartime experiences. 'He helped to bring Paul back to his real world, the world of poetic vision expressed in the dream, often the fantasy,'[43] his wife recalled. Nash's dreams, however,

emerged under very tight control: there was no dabbling in the lewd nightmares of Bellmer or Dali for him, and he could not unbend enough for the 'pure psychic automatism', or the unbuttoned 'dictation of thought, in the absence of any control exercised by reason and outside any aesthetic or moral pre-occupations' that were part of André Breton's original 1924 definition of Surrealism. As he pointed out himself, he could not abandon his sense of design and the feeling for paint itself,[44] nor the intellectual control necessary to select from the amorphous mass of sub-conscious images. Most of the other English Surrealists working then or later were equally decorous and self-controlled, giving little away either because their sub-conscious was rather sparsely stocked, or because they stifled any darker revelations under layers of good taste and technique.

People had been virtually absent from Nash's pictures since the youthful Rossetti period; now, in middle-age, misanthropy seems to have set in and even Surrealism could not turn him away from landscape towards the figure. He wrote to a friend:

I don't care for human nature except sublimated as puppets, monsters, masses formally related to Nature. My anathema is the human 'close up'. I speak chiefly as an artist – apart from that I'm not much more tolerant.[45]

It would take the younger generation of Neo-Romantics to people the English land-scape again.

When the International Surrealist Exhibition was held in London in June 1936 Nash was on the organising committee together with Roland Penrose, Henry Moore and Herbert Read who saw no contradiction between his support for the Surrealists and his equally enthusiastic promotion of the *Circle* abstractionists. Nash exhibited five collages, two 'designed objects', one 'found object' and four oils – *Harbour Room* (1932–6), *Encounter in the Afternoon* (1936), *Mansions of the Dead* (1932) and *Land-scape of the Megaliths* (1934). The dates indicate that Nash had probably considered his work to be Surrealist for some years and indeed Margot Eates claims his *February* of 1927, in which a cleaver is shown stuck into a log shaped like a dog's head, is his first Surreal painting.[46] Amongst other contributors to the Surrealist Exhibi-tion were Burra, Eileen Agar, Cecil Collins, Graham Sutherland and Henry Moore. Bacon's work was rejected as not surreal enough and Piper and Nicholson did not enter, remaining true to their abstractionist principles. The reverberations from the exhibition could be seen registering immediately in the creations of Nash, Moore, Julian Trevelyan, John Tunnard, John Armstrong, Merlyn Evans and Ceri Richards, but they also continued to surface for years in the works of the younger Neo-Romantics, several of whom attended the show as teenagers. In his opening speech Read declared that 'Surrealism in general is the romantic principle in art', which leads us to recall that the exploitation of dreams and the subconscious is not new. Coleridge and De Quincey had taken opium and Fuseli eaten pork at supper to make their dreams more vivid and Blake, Palmer, Shelley and John Martin had all had revelations of the super-real. There was obviously an inner world and Freud had arrived between the Romantics and the Surrealists to confirm their

Swanage (c1936), photographic collage and watercolour

intuitions that this inner realm was every bit as real as tables and chairs.

The 1936 exhibition was the second biggest stone dropped into the duckpond of British art since the Post-Impressionist shows of a quarter-century earlier. Fry would have loathed the vulgarity and literary nature of the 400 works on display, but he had died two years earlier.* With Fry's call for an art 'pre-eminently objective and disinterested' obviously in mind, Nash wrote: 'The constipated negativism of our dismal Mandarins has set up such a neurosis in the timid minds of English painters and writers that they dare not freely express their true selves, their real selves, their surreal selves.'[47]

Breton, Eluard and Salvador Dali attended the exhibition to demonstrate to the parochial English that Surrealism was a way of life, not just a way of looking. Dali had to be rescued from his diving-suit before he asphyxiated; a lady circulated with her face covered in flowers; and Dylan Thomas served cupfuls of boiled string,

* Nash records how his old teacher, Henry Tonks, 'had the courage of his bad taste to say at the time of Fry's death that from the point of view of British painting he felt as though Hitler and Mussolini had passed away.'

politely enquiring, 'Weak or strong?' Later he went off with the flower-headed lady and contracted an embarrassing disease. Goings-on like these boosted the attendance to 1500 per day, which must have been galling to the abstractionist faction. However, Read had later to admit that most people 'went there to sneer, to snigger and to giggle and to indulge generally in those grimaces by which people betray the shallowness of their minds and the poverty of their spirit. If the success of this exhibition is significant it is merely significant of the decadence of our society.'[48] It was not only ignorant sensation-seekers who came, laughed and departed, however. Many politically committed artists saw through Surrealist claims to be revolutionary or seriously aligned with Communism, and radical young critics like Anthony Blunt (later revealed as a Soviet agent) debunked its claims to novelty:

> Take Blake's anti-rationalism, add Lamartine's belief in the individual, stir in some of Coleridge's faith in inspiration, lard with Vigny's ivory tower doctrines, flavour with Rimbaud's nostalgia, cover the whole with a thick Freudian sauce, serve cold, stone cold.[49]

Dr Johnson in writing of the English Metaphysical poets of the seventeenth century complained that in their conceits or comparisons 'the most heterogeneous ideas are yoked by violence together'.[50] Surrealism, similarly, depended on mixing together what had not been linked before to see if there was a bang. Pierre Reverdy the poet wrote:

> The image is a pure creation of the mind. It cannot arise from a comparison but from the *rapprochement* of two more or less distant realities. The more the two realities which are brought together are remote and accurate, the stronger the image will be – the more it will have emotive power and poetic reality.[51]

Nash tried this in *Event on the Downs* (1934) with a giant tennis ball dominating a landscape, and in *Landscape from a Dream* (1936–8) rather over-did things with a clutter of mirrors, screens, floating spheres and a stuffed hawk on a cliff-top. A less forced conjunction occurs in *Pillar and Moon* (1932–49) where a simple strong design allows mysterious echoes to be set up, back and forth, between the stone ball on top of a pillar and the full moon. Nash termed these potent encounters 'strange meetings'.

Another development of the surreal conceit is to metamorphose objects into other objects they can be made to resemble – so lips become a red plush sofa or, Breton tells us, 'A tomato is also a child's balloon. Surrealism, I repeat, having suppressed the word "like".' Nash seeing the (rather obvious) similarities between undulating stone walls and waves, or between piles of logs and waves, or rolling hills and a heaving sea fuses the two elements in *Stone Sea* (1937), *Wood Sea* (1937) and *Wood Against the Tide* (1941). When, as a War Artist, he came to sketch, photograph and study wrecked German aeroplanes in a dump near Oxford, the killers killed,

these mounds of scrap metal again called to mind his obsessive image of the incoming, threatening tide. Instead of painting breaking waves, as he did in Dymchurch, he now made a visual pun and painted waves of the broken and called it *Totes Meer* (1940–41). Here the flyers are grounded and only a hunting owl is on the wing. Later, after Belsen was opened, yet another layer of association could be added to the title Dead Sea. Over this congealing, creaking sea of metal gleams a cold moon, divided into light and dark sections like the T'ai Chi. Its light casts jagged shadows on to the English shore which is raked back in steep perspective. Here all Nash had learned from his research into structure, symbolism, the magic of place, the surreal metaphor and his own preferred range of subdued, cool colours comes triumphantly together. *We are Making a New World* (1918) became the definitive World War I picture, but I think *Totes Meer* is greater insofar as it still has a brutal first impact, but also continues to reverberate in the mind and reveal new subtleties of detail and meaning long after the first encounter. Without the experience of Surrealism Nash would not have been able to paint it.

Now Nash became sensitised to the previously invisible. Who, he asks, but a proto-surrealist would have built a duplicate Marble Arch on the trackless heights of a Dorset moor? (*Creech Folly*, 1935.) The whole town of Swanage is a freakish assembly of objects with the true surreal 'power to disquiet', Nash informs us, though typically he has nothing to tell us about the actual inhabitants of the place.[52] In the fantasy of this piece and his interest in the buildings and street furniture

Totes Meer (1941), oil on canvas

of the seaside town he is exploring territory that John Piper and John Betjeman were to take over and make their own later. He also anticipates the war-works of Piper and Sutherland in describing 'instant ruins' and their mystical reversion to Nature:

> ... the room of a partly demolished house, where the front wall has been pulled down, so that now the sun and moon traverse the floor and walls as in a wood, and the dilapidated uprights and broken sections of door-frames, obscured by shadows or mutilated by shafts of light, take on the semblance of tree forms; the sentinels, perhaps, of a forest land.[53]

He could now look at archaeological digs where the white bones were 'disposed in elegant clusters and sprays of blanched sprigs and branches', or where the skulls appeared as clutches of monstrous eggs in a giant bird's nest.

Having found his new subject matter Nash felt free to play further tricks with it in the interest of evoking 'disquiet', a favourite word. A frequent strategy, learned perhaps from Magritte, was a drastic shift in scale. So, a floating fungus can become the size of a cross-channel ferry (*Voyages of the Fungus*, 1937), or a door knob and doll's head can dominate a coastline (*Environment of Two Objects*, 1937). Earlier, in illustrating the seventeenth-century speculative philosopher Sir Thomas Browne's *Urne Buriall and the Garden of Cyrus*, he achieved what Graham Sutherland called 'a poetic and imaginative achievement without equal today in the country'.[54] Browne begins by describing archaeological discoveries and then moves on to speculate about burial customs and immortality.* He also pointed out that all natural forms 'do neatly declare how nature Geometrizeth' and reveal, particularly through the quincunx form, God, the ordainer of mathematical order behind the flux of appearance. Nash tried to show this in his illustrations which range from mock antiquarian to pastiche Picasso. However, one particular sentence in Browne's discursive meditations stirred Nash's imagination deeply:

> Before Plato could speak the soul had wings in Homer which fell not but flew out of the body into the mansions of the dead.

To portray such an elevated subject he depicted the souls as tiny aeroplane-like creatures on plates, skimming and resting on the shelves of what seem to be bookcases or the divisions in egg-boxes but made gigantic as they tower in the clouds; finally the souls diminish away down a corridor of hop-poles. It is Nash at his best, working from a poetic literary source and utilising observed objects in a daring and unexpected way. A 'literary' picture this might be, but there is no translating it back into verbal equivalents. Rothenstein, whilst maintaining Nash had little innate imagination, or image-making facility, so that he had to rely on past English artists or writers to trigger him off, had to admit:

* John Piper also illustrated the last chapter of this strange work in 1946.

The Soul Visiting the Mansions of the Dead (1932), watercolour

His acute and calculating intelligence, his poetic insight and his impeccable taste made Paul Nash a wonderfully effective medium for transmitting literary emotions into visual terms; for finding the exact equivalents for Mansions of the Dead and for Sunflowers weary of Time.[55]

Another preoccupation of Nash's during the 1930s was with 'equivalents'. Part of his disillusion with abstraction was that it failed to provide 'an equivalent for life' in Fry's phrase, and in a review of his friend Ben Nicholson's abstract reliefs he complained that 'there seemed not so much as a reference, nothing even equivalent' to life and the external world.[56] In his *Equivalents for the Megaliths* (1934), *Objects in Relation* (1935) and *Landscape of the Megaliths* (1934) he is trying to make gigantic geometrical figures or enlarged flints have the dignity, scale, and presence of the original stones without having to make a transcript of their appearance, or draw upon their literary or antiquarian associations. In spite of his frequent depiction of Stonehenge, Avebury, Sinodun or Maiden Castle, Nash, unlike Piper, had little knowledge of, and not much interest in, their archaeology: in fact, he felt anybody in the vicinity of Stonehenge 'airing archiological [*sic*] small talk should be fined five shillings and hustled into the highway with the utmost ignominy conceivable'.[57] He 'encountered' the Avebury megaliths as part of his 'imaginative research', as more mundane researchers might visit some hoary sage, but the multi-layered gloss that Digby and others later put on Nash's use of these archetypical relics would only have aroused his impatience.[58] He had the deepest suspicion of 'the psycho boys' and their attempts to probe his visions and pin them down with words.

As early as 1912 Marcel Duchamp had exhibited 'ready-mades', such as a bottle-rack or snow shovel, to cock a snook at the traditional view of art as being about imitation and craftsmanship. Art, he declared, was a philosophical or intellectual decision – a urinal is a work of art if the artist recognises it as one, says so, and signs it. These 'brain facts' were banal manufactured items wrenched from their functional settings and placed alongside other items (paintings and sculptures) which were merely trying to *imitate* the appearance of reality. This Gallic witticism was not taken up by English artists who typically wished their *objets trouvés* to be made, not by lathes or presses, but by Nature herself so that bits of rural litter could be elevated to the status of 'found art'. Nash submitted a weathered log to the London Surrealist Exhibition ('a superb piece of wood sculpture, like a very fine Henry Moore') and eventually anthropomorphised it into the *Marsh Personage*. He also wrote an article for *Country Life* on 'The Life of the Inanimate Object' quoting the Psalms, Herbert Read's *Art and Society* on animism or animatism in primitive art, and Wordsworth's *Prelude* to show he was not alone in finding natural objects powerfully endowed with personality.[59] Some found objects were too big to haul back to the studio, such as megaliths or fallen trees, so Nash captured them in sketch-books or, after 1931, with his camera. Once in his possession each could take on whatever persona it dictated to his imagination, but most typically this was the 'monster'. Two fallen elm trees inspired a series of

monster pictures in 1939 and also the following explanations by Nash:

Let me be clear upon that point. We are not studying two fallen trees that look like animals, but two monster objects outside the plan of natural phenomena. What reference they have to life should not be considered in relation to their past – therein they are dead – they now excite our interest in another plane, they have 'passed on' as people say.[60]

The first log he sees in these fanciful terms:

The horse in William Blake's interpretation of 'the sightless couriers of the air'. Blind and 'blake' stretched out its pallid mask, and its long back and neck lay flat; and its legs, of which there were five or six, jerked out with epileptic force as it bore the cherubim through the startled skies. Did it then crash to earth, fusing its image with the rigid tree?

The second log has a more recent, but equally specious, genealogy:

Something about its headlong purpose recalled Picasso. It was certainly bovine and yet scarcely male. Surely this must be the cow of Guernica's bull. It seemed as mystical and dire.

Apart from the fact that Nash's various fallen elms and rotten stump monsters (*Minotaur*, 1939; *Monster-Pond*, 1941) look very tame indeed to a generation now immunised by video-nasties and the television news, the mention of Blake and Wordsworth and primitive art by Nash prompts one to ask in what sense did he 'believe' this nonsense? Surely compared with the visions of Blake or the intimations of Wordsworth we find here a grown man pretending to believe in fairies? Romanticism's earnest search for spiritual meaning in Nature has now degenerated into whimsicality.

In March 1940 Nash was appointed as a temporary, non-pensionable War Artist at £650 per annum attached to the Air Ministry. With hindsight his wartime 'monsters', such as the wreckages of German planes, should chill us more and indeed in *Totes Meer* they undoubtedly do so. Nash avoided drawing the scorched, or heroic, pilots and made their planes his 'objective correlative' (in T. S. Eliot's phrase) for his emotions about the war, just as he left out the 'poor bloody infantry' in his World War I pictures. Now, however, Nash could not refrain from applying the same anthropomorphism to planes that he was simultaneously applying to fallen elm trees; so a still-smoking plane on its back is titled *The Death of the Dragon* (1940). For *Vogue* he wrote an article on 'The Personality of Planes' in which he assured his gentle readers that each had its own psyche: the long-nosed Blenheim had a shark's face and the Hampden looked like a pterodactyl.[61] Cosily personalised, the English planes could then be shown 'watching', 'sunning', 'waiting', 'at play' or sitting for their portraits in their 'nests' or 'lairs'.

Fortunately we have the bleak *Totes Meer*, the more factual and well-known *Battle of Britain* (1941) and its more simplified, but I think superior, companion piece, *Battle of Germany* (1944) to prove that Nash could abandon his whimsicality and still rise to the big subject when it was thrust upon him. Nash had to press this last work on a reluctant War Artists' Committee and even Kenneth Clark, his patient advocate there, had to admit, 'Alas I can't understand it . . . it is sad to find myself so little able to appreciate what is new . . . I am a natural blimp, must grow accustomed to my moustache.'[62] The colour is unusually full-strength and arbitrary for Nash in this work, with a quiet though baleful moon low on the left in a grey-blue sky which contrasts with the angry red sky to the right. The two halves are separated by a black, spreading, column of smoke. These two contrasting halves are stitched together by the way the descending parachutes on the right pun, back and forth, with the moon to the left, rather like he had done in *Pillar and Moon*. It is a war picture in which no combatants appear and once more the elements of fire, earth, sea and sky carry the burden of his feelings. Alan Ross sums up Nash's achievements in these two battle pictures: 'On the whole Nash painted syntheses and symbols of the crucial air conflicts, tactical wall charts raised to the level of icons.'[63]

Nash believed passionately in art as a powerful propaganda weapon, 'appealing to the eye quickly, striking and leaving an impression before any power can prevent the impact'. As soon as Britain entered the war Nash set up the Arts Bureau in Oxford, where he was then living, to collect lists of artists who could be useful to the Government as propagandists. Piper, Betjeman and Clark were co-opted, but soon Kenneth Clark's Government-supported War Artists' Advisory Committee (WAAC) took over its functions and recruited Nash. It must have been a puzzle for them to know how to use an artist who showed so little interest in people, buildings or machines. Their suggestion that he depict the war in the air was an inspired one – he could combine his long obsession with the 'peopled sky' and his fervent belief that art could be useful. His wrecked planes series, he said, was 'to make you feel good (or, if you're a Nazi, not so good)' and 'I would like to give a feeling of *dreadful fantasy* something suave but alarming . . . I would get inside this business and frighten somebody or bust.'[64] Once more, after the lean years of the twenties and thirties, he had been given a strong idea, a purpose and a social role.

Unfortunately, Nash's bronchial asthma got steadily worse and his relationships with the Air Ministry deteriorated. They thought his planes not technically accurate enough and resented his endless demands for photographs. Other bureaucrats were irritated by his complaints, his barmy suggestions ('A Ministry of Imaginative Warfare'), his naggings for materials, a priority telephone number and reproductions of his own works and, above all, his requests for money. The correspondence files in the Imperial War Museum are thick with his demands. Nash appears in these letters to be at the end of his tether: tetchy, self-centred and sick. But, one realises, it is not exactly for himself he is demanding respect and support, but for the sake of his Art, for which he is only a vehicle. For that demanding Mistress any troubles to himself, or whole Ministries full of harassed officials, even in the middle of the Battle of Britain, were worth while. Sutherland showed the same prickly pride in

his dealings with officialdom, though Piper seemed much less contentious.

The war continued but Nash's strength was running out and he was disappointed by the reception his pictures received from the Royal Air Force and the public. He turned away to more private themes. These still involved the moon, clouds and the drama of the inhabited sky, as they had always done since the days of *Angel and Devil* in 1910. A key picture here is the collage *Rose of Death* (1939). In his last essay, 'Aerial Flowers' (1945), he explains the title:

> When the War came, suddenly the sky was upon us all like a huge hawk hovering, threatening. Everyone was searching the sky expecting some terror to fall; I among them scanned the low clouds or tried to penetrate the depth of the blue, I was hunting the sky for what I dreaded most in my own imagining. It was a white flower. Ever since the Spanish war the idea of the *rose of death*, the name the Spaniards gave to the parachute has haunted my mind, so that when war overtook us I strained my eyes always to see that dreadful miracle of the sky blossoming with these floating flowers.[65]

Now he made flowers huge as barrage balloons fill the sky in *Sunset Flower* (1944) and *Flight of the Magnolia* (1944) (cf. Wordsworth's lines in *Ruth*: 'He told of the magnolia spread/High as a cloud, high over head!') These images were 'encountered', Nash tell us, 'as a direct result of my imagining in my subconscious search for flight expression. They are, I suppose, equivalents of some sort.'[66] One of these inhabited skies, *Cumulus Head* (1944), takes the form of a woman's mysterious head, so he had come round full-circle to the Rossetti-inspired pictures *Our Lady of Inspiration* (1910) and *Vision of Evening* (1911). He wrote to Bottomley that he had fallen in love with Rossetti all over again and could stand bare-headed before his watercolours, though not the later oils. He had also renewed his enthusiasm for Palmer and Calvert, even trying in *Bright Cloud* (1941) a Palmer title and method of watercolour handling. Blake too he re-read as he worked on his autobiography, *Outline*, getting things tidy as death infiltrated his body's defences. He seriously considered using as an opening quotation and explanation of his title Blake's great justification of his own, and perhaps England's, linear art:

> How do we distinguish the oak from the beech, the horse from the ox, but by the bounding outline? How do we distinguish one face or countenance from another but by the bounding line and its infinite inflections and movement . . . Leave out the line, and you leave out life itself; all is chaos again, and the line of the almighty must be drawn out upon it before man or beast can exist.[67]

Bottomley was delighted that his friend had returned to his roots, to the literary, English, inspiration he had drawn upon before the First World War. As England became isolated in the Second World War other younger artists, as we shall see, found these roots could still provide nourishment. As Bottomley wrote in some triumph:

You tell me to take heart because you are now on the short way home (to the kingdom in which we first met); so I feel entitled to remind you I once wrote to you that the best place for an artist to work is in his own parish, but that it is not enough for him until he has gone right round the world and entered it from the other side! Was I truly a prophet?[68]

Nash had always been an outstanding water-colourist of a rather carefully drawn, dry and controlled kind, but now he began to use this most English of media in an open, looser, more luminous way with no preliminary drawing. At last he had slipped his line, as it were. An interest in Chinese painting may have helped slacken the discipline of line and structure, but for whatever reason during the last winter of his life he completed a series of gloriously Turneresque sunsets and vistas which are the very essence of English landscape and weather. Michael Ayrton, then making his bumptious entry into art reviewing at the age of twenty-four, wrote of these last works:

These, I think, are not yet successful. In the present exhibition (at Tooth's) the sultry purples and shrill yellows of the studies of the sun descending are somewhat turgid and lacking in depth. The economy of means, so successful where the tones of wash do not depart too far from the colour of the paper, becomes posterish where it creates harsh contrasts but Mr. Nash will doubtless solve the equation, and we may look forward to some exciting results.[69]

For most of his career Nash had kept a tight rein on his oil colours, taking local colours much as he found them but mixing in white to give a subdued rather chalky range of ochres, greens, indian reds, pinks and blues. Beside his works Sutherland's look gaudy and Piper's frenzied. Now in the last years he began a more painterly and full-hued series of works showing complex echoes to and fro between earth and sky, left and right, moon and sun, tunnel and grove, myth and reality. *November Moon* (1942), *Landscape of the Summer Solstice* (1943), several versions of *Landscape of the Vernal Equinox* (1943–4), *Landscape of the Summer Moon* (1944) and *Landscape of the Moon's Last Phase* (1944) all feature Wittenham Clumps, those hillocks he had found so personally significant when Sir William Blake Richmond had told him to 'go in for Nature' way back in 1912. Nash's landscapes had never been merely topographical, just attempting to record what his eyes saw; there had always been another stratum of meaning derived either from his reading or his own psychological depths.* Now his urgent concern with his failing health and his reading of Sir James Frazer's *The Golden Bough* combined to give an added force to these works, particularly the Baldur story, where the annual death of Baldur, the earthly counterpart of the sun, is necessary for the sun's rebirth and so for the continuing fertility of the crops. There was also a continuity re-established with his earliest

* This is why he emerged as a more interesting painter than his brother John who had equal technical facility but never 'Surrealised' his landscapes as Paul did.

Rossetti-inspired night pictures: 'Now I am re-opening my research – renewing the problem of light and dark and half-light.'[70] Not, that is, how to *paint* these light conditions – that was the Impressionists' task – but to discover their deeper *meanings*.

Nash's last finished oils were *Eclipse of the Sunflower* (1945) and *Solstice of the Sunflower* (1945). Sunflowers had first appeared in his work when he illustrated Sir Thomas Browne's treatise in 1932; then their complex seed-heads had been seen as natural examples of the mystical figure, the quincunx, but at the last they bear an enormous weight of reference, to life and death, the revolving seasons, fertility rituals, good and evil, and more as we can see from Nash's gloss on the Solstice picture:

> In the Solstice the spent Sun shines from its zenith encouraging the Sunflower in the dual role of sun and firewheel to perform its mythological purpose. The Sun appears to be whipping the Sunflower like a top. The Sunflower wheel tears over the hill cutting a path through the standing corn and bounding into the air as it gathers momentum. This is the blessing of the Midsummer Fire.[71]

Eclipse of the Sunflower (1945), oil on canvas

Two more Sunflower pictures, *The Sunflower Rises* and *The Sunflower Sets*, were planned though not completed, but their titles tell us these were no Van Gogh blooms in a jug but mind-flowers with their roots in myth. Like Blake, whose poem 'Sun-flower weary of time' 'had grown gigantic' for him, he is here struggling towards a coherent expression of meanings he cannot formulate in any other way, and inevitably failing. G. W. Digby probes the cross-cultural archetypes which underlie these last enigmatic works, calling up the Chinese classic *The Secret of the Golden Flower*, Whitman, Donne, Meister Eckhart, Boehme and Jung, though he thinks it unlikely Nash ever read any of them. Digby concludes:

When Paul Nash wrote of one of these pictures, 'I cannot explain it. It means only what it says,' he was apparently ignorant of the archetypal nature of the symbols he was using. Yet in what sense was he ignorant of them? In an intellectual sense, perhaps; but in some other, perhaps no less fundamental way, he certainly was not. For if he had not experienced the symbols, he could not have painted these pictures as he did. 'The most essential thing is not the interpretation and the understanding of fantasies, but always the experiencing of them' (C. G. Jung). Understanding is also necessary, but commentary and elucidation must always take second place to this. The life-giving experience is not only enshrined in the work of art, but is there as a flint from which again the spark may be struck.[72]

Nash might have begun his career as a literary artist in the sense that his images were illustrations to his reading, or were paraphrasable into verbal equivalents with no great loss. But, by these last Equinox and Sunflower pictures, he was the channel for deeply complex meanings pushing to be given a form and shape. After the First World War the intense emotions he had tried to put in his pictures of the violated fields of France went inwards. Back in reticent English peace-time society his feelings could only emerge in symbolic forms (the sea against a wall, snakes, ladders, cages, open windows), ample pickings for the 'psycho boys', though Nash preferred not to have them explained to him. One of his most obvious and persistent concerns is with death, and the nearer it approaches him in the two wars, his own illness, the death of his beloved father, and in the speculations of Browne, the more intense and symbolically complex his works become.

Powerful emotion then is the energising force behind Nash's creativity, but he is no expressionist, and allows it to emerge only under severe control, held in by line, kept low-key in colour, lacking sensuousness in the handling of pigment, and elliptical in symbolism. To prevent the unbuttoned 'emoting before Nature' he so deplored in much of British art, he turned in the fallow periods of the 1920s and 1930s to Paris for guidance. He adopted, for a time, the restraining discipline of geometrical abstraction, but this proved too severe and little of worth struggled through. Surrealism beckoned him to the other extreme, towards the flagrantly irrational and self-indulgent, so that he had to modify its doctrines severely to suit his own puritanical vision. He gained something useful from both, however. Pre-

dating these, but persisting all his life, were two other sources of inspiration: his wide but eccentric reading, and the deep attachments he felt for certain rural places in the south of England. When all these were in working equilibrium, and he at last unleashed his full colour range, then we were given those rich, profound works of his final years.

At the end he must have realised what all those ladders, scaffolds, open windows, upward paths, rising hills and sunflowers 'seeking after that sweet golden clime/ Where the traveller's journey is done' really meant. And why he, who had never been allowed in an aeroplane because of his health, had always looked to the peopled sky and been obsessed by flight towards it.

But it is death I have been writing about all this time and I make no apology for mentioning it only at the end, because everything written here is only the preliminary of my theme . . . Death, about which we are all thinking, death, I believe, is the only solution to this problem of how to be able to fly. Personally, I feel that if death can give us that, death will be good.[73]

Within months he was in flight to the Mansions of the Dead.

REFERENCES

1. Abbott,C. C. and Bertram, A. (eds.), *Poet and Painter: Correspondence between Gordon Bottomley and Paul Nash 1910–1946* (Oxford, 1955), p. 40.
2. Nash, Paul, *Outline: An Autobiography and Other Writings* (London, 1949), p. 45.
3. Ibid., p. 36.
4. Quoted in 'Rossetti'. *The Great Artists* Vol. 1, Part 17 (ed. J. Gaisford) (London, 1985), p. 523.
5. Nash, Paul, 'Aerial Flowers' in *Outline*, p. 260.
6. Nash, Paul, in first draft of *Outline*, quoted by Andrew Causey, *Paul Nash* (Oxford, 1980), footnote p. 16.
7. Blake, William, *A Descriptive Catalogue*, No. XV (London, 1809).
8. Fry, Roger, 'The French Post-Impressionists' (1912) in *Vision and Design* (London, 1920), p. 158.
9. Ibid., p. 157.
10. Woolf, Virginia, *Roger Fry* (London, 1940), p. 156.
11. Ibid., p. 186.
12. Nash, Paul, *Outline*, p. 94.
13. Nash, Paul, letter to Bottomley, 1 August 1912, in *Poet and Painter*, p. 42.
14. Read, Herbert, *Penguin Modern Masters: Paul Nash* (London, 1944), p. 8.
15. 'Manifesto of Vital English Art', published in the *Observer*, 7 June 1914, signed by Marinetti and Nevinson.
16. Quoted in preface to 'Nash and Nevinson in War and Peace', catalogue to Leicester Gallery exhibition, November 1977.

17. Nash, Paul, letter from Bottomley, 2 October 1914, in *Poet and Painter*, p. 75.
18. West, Anthony, *John Piper* (London, 1979), p. 35.
19. Hulme, T. E., *Speculations: Essays on Humanism and the Philosophy of Art*, ed. Herbert Read (London, 1924, reprinted 1965), p. 118.
20. Ibid., p. 116.
21. Harrison, Charles, *English Art and Modernism 1900–1939* (London/Indiana, 1981), p. 97.
22. Nash, Paul, 'To His Wife' in *Outline*, p. 210.
23. Causey, Andrew, *Paul Nash* (Oxford 1980), p. 79.
24. Nash, Paul, in *Weekly Despatch*, 16 February 1919, quoted by Causey, p. 73.
25. There are substantial works by Herbert Read (1944), Anthony Bertram (1955), Margot Eates (1973), Andrew Causey (1980).
26. Rothenstein, John, *Modern English Painters: Sickert to Moore* (London, 1957 edition), p. 277.
27. Ibid., p. 363.
28. Harries, Meirion and Susie, *The War Artists* (London, 1983), p. 1.
29. Spalding, Frances, *Vanessa Bell* (London, 1983), p. 163.
30. Rose, W. K. (ed.), *The Letters of Wyndham Lewis* (London, 1963), pp. 106–14.
31. Harrison, Charles, op. cit., p. 146.
32. Gordon Bottomley, letter to Paul Nash, 28 February 1922, in *Poet and Painter*, p. 133.
33. Causey, A., op. cit., p. 112.
34. Ibid., p. 112.
35. Ibid., p. 139.
36. Rothenstein, John, *Modern English Painters*, Vol. II (London, 1984 edition), p. 159.
37. Causey, A., op. cit., p. 130.
38. Read, Herbert, 'A Nest of Gentle Artists', *Apollo*, Vol. LXXVI No. 7 (London, September 1962), pp. 536–40.
39. Nash, Paul, *Unit One* (London, 1934), pp. 79–81.
40. Nash, Paul, *The Listener*, 29 April 1931, p. 720.
41. Nash, Paul, *Week-end Review*, 17 June 1933.
42. Causey, A, op. cit., p. 282.
43. Ibid., p. 195.
44. Bertram, Anthony, *Paul Nash: the Portrait of an Artist* (London, 1955), p. 235.
45. Nash, Paul, *Fertile Image*, ed. Margaret Nash (London, 1951), p. 13.
46. Eates, Margot, *Paul Nash: Master of the Image* (London, 1973), p. 40.
47. Nash, Paul, 'Surrealism and the Illustrated Book', *Signature* (London, March 1937).
48. Read, Herbert, *International Surrealist Bulletin*, quoted in *The Story of the Artists' International Association 1933–1953*, ed. L. Morris and R. Radford (Oxford, 1983), p. 41.
49. Blunt, Anthony, *Spectator*, 19 June 1936.
50. Johnson, Samuel, *Lives of the Poets*, 'Cowley', Vol. I (Oxford, 1952), p. 14.

Originally published 1779–81.

51. Reverdy, Pierre, *Nord-Sud*, March 1918, quoted by G. H. Hamilton in *Painting and Sculpture in Europe 1880–1940* (London, 1981 edition), p. 543.

52. Nash, Paul, 'Swanage, or Sea-Side Surrealism', *Architectural Review*, April 1936.

53. Nash, Paul, 'Unseen Landscapes', *Country Life*, 21 May 1938.

54. Sutherland, Graham, 'A Trend in English Draughtsmanship', *Signature* (London, July 1936).

55. Rothenstein, John, *Brave Day Hideous Night* (London, 1966), p. 45.

56. Nash, Paul, 'Ben Nicholson's Carved Reliefs', *Architectural Review*, October 1935.

57. Nash, Paul, letter to Audrey Withers, autumn 1927, quoted by A. Bertram, op. cit., p. 237.

58. Digby, Wingfield, *Meaning and Symbol in Three Modern Artists* (London, 1955), p. 148f.

59. Nash, Paul, 'The Life of the Inanimate Object', *Country Life*, 1 May 1937, p. 496.

60. Nash, Paul, 'Monster Field', reprinted in *Outline*, p. 245.

61. Nash, Paul, 'The Personality of Planes', *Vogue*, March 1942.

62. Harries, M. and S., op. cit., p. 179.

63. Ross, Alan, *The Colours of War* (London, 1983), p. 84.

64. Bertram, A., op. cit., p. 279.

65. Nash, Paul, 'Aerial Flowers' in *Outline*, p. 262.

66. Ibid., p. 264.

67. Blake, William, *A Descriptive Catalogue, No.XV* (London, 1809).

68. Abbott, C. C. and Bertram, A., op, cit., p.212.

69. Ayrton Michael, *Spectator*, 27 April 1945.

70. Causey, A., op. cit., p. 330.

71. Ibid., p. 334.

72 Digby, Wingfield, op. cit., p.186.

73. Nash, Paul, 'Aerial Flowers', *Outline*, p. 265.

JOHN PIPER

ROM about 1937 onwards Paul Nash was a good friend of John Piper, though they differed markedly in personality, and in many of their opinions. One thing they did share was a similar upbringing, both being from comfortable middle-class backgrounds, and both being sent to public schools as day-boys. Nash went to St. Paul's and Piper to Epsom College where he missed overlapping with Graham Sutherland by one term, though he does remember Sutherland's name and caricatures of the Kaiser in his Latin textbook. Nash's father had been Recorder of Abingdon and Piper's father was also in the legal profession, being a solicitor with his own firm who followed the arts as a passionate amateur and encouraged his three sons to do so as well. The senior Nash eventually had to accept that his son Paul was so innumerate that he would never make a career in law, banking, or even the Navy, and so had supported Paul (and his brother John) in his desire to be an artist. Piper's father put up sterner resistance, insisting that in those uncertain post-war years John ought to have some solid qualifications and should serve his time as an articled clerk in the family offices. He failed the final examinations, but it was only on his father's death in 1926 that he was free to make a belated full-time start as an artist. He went first to Richmond School of Art, where Henry Moore was a student-teacher, and then to the Royal College which he left after two years, again without qualifications, in order to marry another student called Eileen Holding.

Piper Senior's tastes ran to conventional Royal Academy works which he bought or copied, but he also took his son to see the glass at Chartres which 'knocked him sideways' and, in 1921, on a tour of Northern Italy. As a boy, Piper had been dropped off at the Tate Gallery whilst his mother went shopping, and his father also encouraged him to visit the Tate during his lunch-hours as a clerk, since the gallery was just round the corner from their chambers in Vincent Square. The Tate Gallery had been open since 1897 but had never achieved the independence Henry Tate had planned for it. It was still, in the 1920s, an annexe of the National Gallery and overburdened with mediocre English works it was forced to accept from the Royal Academy under the terms of the Chantrey Bequest. There was virtually nothing on view of modern European works. All this was to change under the 1938–

Self Portrait (1982), gouache, ink, pastel, watercolour

64 directorship of John Rothenstein – but that is to get ahead of our story, and by then Piper would be a Tate trustee himself with sufficient power and prestige to help influence policy for the better.

So what could the young Piper get from this then rather stuffy institution? It had two outstanding treasures: its Turners and its Blakes. Turner remains an inspiration to Piper still today, sixty years later, but at that time he was not a fashionable figure. Piper commented in a recent book: 'He [Turner] was a great abstract painter but never a pure and total one, and I loved him from the age of ten when it was anything but popular except with connoisseurs and cranks.'[1] Turner's contemporaries had recognised him as a prodigy when he began exhibiting at the Royal Academy aged fifteen (in 1790), and by the age of forty he was acknowledged as the first genius of his day. After his death he had perhaps too many wishy-washy imitators for the next two or three generations to see him clearly. Clive Bell thought him 'an after-dinner painter', and as late as 1934 Roger Fry could admit that Turner's vagueness and romantic drama may have appealed to him as an unformed youth, but the same works had little to offer a more mature judgement. Turner was all adroitness and dextrous picture-making, but before Nature he never 'probed further than the first gasp of wonder'. He was a competitive picture manufacturer and for this 'he had an enormous repertory of pictorial recipes', so Fry wonders

'whether Turner ever did have any distinctively personal experience before Nature'.[2] Not until after Fry's death did the first scholarly biography of Turner appear[3] and the re-evaluation of his achievement really get under way. This was aided by the accidental discovery of thirty-four rolled and tatty canvases in the Tate and fifty more in the National Gallery cellars which turned out to be, when cleaned, from Turner's last great period when form dissolved and light became pure sensation. These semi-abstract works seemed to chime in with the taste of the times. Rothenstein showed some of these works in early 1939 just as Piper began to write his book on English Romanticism, and just before the national treasures were whisked away for wartime safe-keeping. In 1946 a selection from Turner's vast output of oils, water-colours and sketches toured Europe and America to great acclaim, before returning for the 1951 London exhibition where the critics and public at last caught up with the opinion Piper had held as a lad before the First World War.

Unlike Turner, Blake had only a modest reputation during his lifetime, his one exhibition being a humiliating flop, but he did have a few discerning admirers amongst fellow artists such as Fuseli, Lawrence, Palmer, Richmond and Linnell. Rossetti was one of the few nineteenth-century artists to see his worth and after that Blake's re-evaluation seemed slow to begin until the 1920s when Sir Geoffrey Keynes and Lawrence Binyon published important studies. Even today he is not highly regarded outside the English-speaking world – again the young Piper seems to have been ahead of his time. During his youth, in 1918, the Tate and several other galleries clubbed together £7,665 to acquire the 102 illustrations Blake had completed, late in life, for Dante's *Divine Comedy*. At the time this had seemed an extravagance to the English Press. For an aspiring artist, however, they had several important lessons to teach. Here colour was used emotionally and symbolically, not mimetically as it was in those Academy works Piper Senior liked so much. Blake was also against the 'obscuring demons' of modelling by naturalistic light and shade and the creation of illusionistic space. Blake had been driven to invent his own mixed-media techniques because for him the whole Italianate oil-painting tradition, followed by Reynolds and others, led to the mere imitation of appearances. He spurned such counterfeiting with 'the utmost disdain'.

> Venetian, all thy colouring is no more
> Then Boulster'd Plaster on a crooked whore.

Piper, who was to become an outstanding mixed-media colourist himself, remembered this lesson and later, if he felt moved to paint a lemon church spire against a viridian sky, went ahead and did so if it made pictorial sense. Like Nash, Piper was also bowled over by Blake's poetry, though, as he said, he found it a bit frightening and inscrutable. Piper aspired to be a poet himself but, unlike Nash, was evidently rather good at it and published two volumes decorated with his own vignettes – though he seems relieved both are now virtually unobtainable! Blake drew the two arts together for him, both on the page and in pronouncements such as:

Poetry consists in bold, daring and masterly conceptions; and shall painting be confined to the mere sordid drudgery of facsimile representations of merely mortal and perishing substances, and not be, as poetry and music are, elevated into its own proper sphere of invention and visionary conception?[4]

Blake used words and pictures to teach ('It is an Endeavour to Restore what the Ancients called the Golden Age'). However, as much as he might simplify his language or his linear images, they could not carry across to most readers the immense burden of meanings he expected them to bear. He mixed in abstractions (Pity, for example) with real people (Newton, Nelson, Milton); real events (The French and American revolutions) with places which were both real and symbolic (Albion, Jerusalem); embodied concepts such as Man's four elements in the figures Los, Urizen, Luvah and Tharmes; and changed the usual association of things around so that Satan became an admired figure and Reason the faculty of an idiot. None of the Neo-Romantics aspired to Blake's role as poet-artist-visionary-social-critic-philosopher, and though they all read his works it is doubtful if any devoted the time and reading necessary to tease out Blake's complex meanings through the long prophetic books. They were artists looking for artistic leads and Sutherland probably spoke for most when he stated:

That this theological ideography at times adulterated the inherent spiritual quality of the designs themselves, there can be no doubt; and in this sense the literary significance intended can hold little interest for us.[5]

Blake would remain their prophet and a magic name, but it was to his more accessible and less wordy follower, Samuel Palmer, that most of them turned for direct pictorial inspiration.

Not only was the young Piper educating himself in England's Romantic heritage in words and pictures, he was continuing to explore its architecture which had obsessed him since early youth. By the age of fourteen he claims to have explored every church in Surrey. He knew enough about local history, stained glass and ecclesiastical antiquarianism to be made secretary of his branch of the Surrey Archaeological Society at fifteen. This close, knowledgeable involvement with the fabric of his English environment continues still today when there can be few churches, castles, great houses or historic towns left for him to explore. The pursuit of his hobby meant collecting guidebooks, initially those illustrated by the engraver F. L. Griggs (1876–1938) who was later to play a significant part in this story by passing on his enthusiasm for Samuel Palmer to Graham Sutherland. Piper soon became impatient with the narrow earnestness of these historical guidebooks. From the earliest days Piper seems to have eschewed historical snobbery, believing a good Victorian gin palace worthy of more attention than a poor Saxon church. 'The sense of history is an apology for the absence of a sense of beauty,' he later declared and steered a steady course between those who wished to turn England into a coast-to-coast museum and those developers who would make it a continuous housing

estate. As his convictions grew firmer he began making his own guidebooks on the places he cycled to.

Graham Sutherland was also enthusiastically reading these guidebooks at the same time, as were many others who travelled by car, bus, train, bicycle or on foot out of the towns into rural areas to explore our 'English heritage'.* These guidebooks followed the lead of the eighteenth- and nineteenth-century writers on the picturesque in offering the countryside for aesthetic appreciation. Apart from gazing out over spectacular views, this meant studying the architecture of churches, castles and the great country houses with their landscaped estates, and responding to them by contemplating them, photographing or painting them, or writing about them in lyrical poetry and prose. For the guidebook writer and reader the countryside remained unpopulated, its modern inhabitants going about their work invisibly. Deep down these books, including Piper's own later works for Shell, are based on a myth about the 'real' England, feeding our nostalgia for a pre-industrial, pre-Reformation past as unreal as those little visions of a pastoral Paradise made by Palmer in Shoreham.

These explorations of Turner, Blake, antiquarian guidebooks and crumbling buildings do not mean Piper was living entirely in the past. He was also playing the piano in a dance-band, making wood-cuts in the style of Paul Nash, reading widely in D. H. Lawrence, Aldous Huxley, James Joyce and Wyndham Lewis (though the latter's brand of modernism in painting held little appeal). On art he read T. E. Hulme, Herbert Read and, of course, Fry. He remembers finding Fry's lectures fascinating too. Following these pointing fingers he soon found French art, one of Fry's favourites, Jean Marchand,† then Segonzac, and more importantly Rouault who, with his limited but full-strength colours made more dramatic by the strong black outlines derived from stained glass, remained a Piper favourite. The earlier Impressionists never seemed to appeal to him as 'there wasn't much point in breaking out of the anecdote to get involved in a perpetual celebration of the hey-day of middle-class pleasures'.[6] Matisse too, for all his colour and modernity, was still essentially rooted in this bourgeois hedonism. Piper, then, was sifting through the works of his elders and betters, as all young artists must, to see what he could adapt to his own use.

With the abundance of printed material on modern art now available to us we tend to forget that for the young English painter trying to educate himself in the 1920s and 1930s there was a real problem of access to other artists' works. *The Studio* magazine was full of worthy but rather academic reproductions and articles, and even books on Fry's much publicised Post-Impressionists were in short supply.

* During the 1930s guidebooks such as *The Face of Britain, The Pilgrim's Library, English Life, British Nature Library, The British Heritage, Highways and Byways in Britain* and the *Shell Country Guides* all appeared to encourage people to explore the countryside and take pride in their past. In 1926 the Council for the Preservation of Rural England was founded, followed by the Youth Hostel Association in 1930, the Federation of Ramblers' Associations in 1936, the Green Belts Acts of 1938, and the National Parks Commission in 1949.

† 'M. Marchand is a classic artist – one might almost in these days say a French artist, and count it as synonymous,' (Fry in *Vision and Design*, p. 184.)

The only hope was to get hold of foreign periodicals such as *Revue Blanche* or *Cahiers d' Art* and the only sure source in London of these treasures was Anton Zwemmer's bookshop in Charing Cross Road. This had been founded in 1922 by an immigrant Dutch bookseller very sympathetic to modern art and literature. Moore, Piper and many others were frequent visitors, standing undisturbed reading works they could not afford to buy. Later all the Neo-Romantics would find their way there, avid for the latest news from Paris and hoping to exhibit in the gallery Zwemmer opened nearby. Another significant encounter at this time was with the Ballets Russes in their 1925 and 1926 seasons at the Coliseum. The cheaper seats were packed with art students agog over Derain's drop curtain for *Boutique Fantastique*, and Picasso's curtain and décor for *The Three Cornered Hat*. After this Picasso became such a big star in Piper's firmament that he kept a clippings book on the Spanish master and assiduously copied reproductions of his works. In 1927 his vision widened further with an introduction to Braque, and later Léger, Hélion and Calder became good friends on visiting terms.

Three things emerge from this account of Piper's delayed but intensive self-development period. First, his need to reconcile his genuine love for the landscapes and architecture of England with his growing determination not to make academic facsimiles of them in paint. Second, his intellectual agility in seeking out, under-standing and absorbing the more advanced thinking of the period – which in effect meant School of Paris thinking. And third, Piper's enormous versatility is already emerging: later it would sweep ever wider to include art criticism, stage design, ecclesiastical furnishing and garment design, stained glass, photography, television programmes, textiles, pottery and even firework displays.

After seeing an exhibition of Picasso's collages in Paris Piper decided that this medium seemed the immediate way forward. It was a new skill to conquer, it was modern, and one could still represent landscape with it. From 1932 to around 1938 he therefore explored *papier collé*, making views through windows where the curtains were doilies, or seaside scenes using blotting paper, scraps of music manu-scripts or overprinted debris from the Curwen Press. Many of the later ones he made on the spot, taking scraps from a portfolio, tearing them, pinning them down, flutter-ing in the breeze, then returning to the studio to work over them with glue, ink and brush. For the time they were aggressively witty and modern, even though they were still firmly tied to the stimuli of a particular place such as Dungeness, Littlehampton or Newhaven – all those marginal places Nash had explored a decade earlier with his more conservative techniques. Neither his collages nor his sub-Christopher Wood oils of houses or lumpy girls by the sea brought in enough money so Piper had to exploit his other talent for words with what he called his 'pot-boilers'. He wrote art and theatre criticism for *The Nation and Athenaeum* and later in the *Listener* and *New Statesman*, and from 1936 articles on places and buildings for the 'Archy' or *Architectural Review*. In these journals he generously commended to the public's attention the works of his contemporaries such as Ivon Hitchens, Frances Hodgkins, Ben and Winifred Nicholson and Victor Pasmore. This, together with the works he was also showing at the Lefevre Gallery and with the London

Group, brought him to the attention of London's emerging new wave. These were as Paris-besotted as ever Fry or Sickert had been, but their idols were the generation after the Post-Impressionists. Under the heady but varied influences of Picasso, Braque, Hélion, Léger, Mondrian, Arp, Brancusi and Kandinsky several English artists were now marching towards abstraction. Piper, inflamed by their enthusiasm, turned his back on English landscape, and marched with them, and in the first ranks too.

Nash had not invited Piper to join Unit One in 1933, to Piper's disappointment, but in January 1934 he was compensated by being elected to the 7 & 5 Society, which in turn excluded Nash as being too surrealist. As its most literate member Piper was soon made secretary. The 7 & 5 had originally been founded by a very mixed group of seven painters and five sculptors but by the time he joined all the original Anglicised Fauves and Post-Impressionists and the lyrical individualists like David Jones and Frances Hodgkins had been turned out of the nest by the cuckoo-like Ben Nicholson. He and his henchmen and henchwomen, including now Piper and

Abstract 1 (1935), oil on canvas

his wife, ensured that the club's final exhibition as a group, at the Zwemmer Gallery in 1935, was completely non-figurative – the first purely abstract show in England. Piper contributed works heavily indebted to Hélion, and his wife, Eileen Holding, showed white constructions made from dowelling and plywood which equally obviously owed much to the perfectly white geometrical reliefs Nicholson had achieved by 1933.* Like his mentor Mondrian, Nicholson still claimed to embody a 'poetic idea' in each of these austere works.

In January 1935 Myfanwy Evans published *Axis 1* as a quarterly shop-window for abstract art. She had been on a tour of the Paris masters' studios and Jean Hélion had urged her to start an English equivalent of their *Abstraction-Création* magazine. This was the organ of an international association of non-figurative painters, founded in 1931 with Nicholson, Hepworth and Wadsworth as English representatives. The young Miss Evans demurred thinking Herbert Read would have more prestige as editor, especially as his *Art Now* (1933) had brought him into prominence as one of the more sympathetic thinkers on modern art. In the end, however, she was persuaded to try and ran it, with Piper's help, on a shoestring and a list of only 200 subscribers. The idea was to get their message across to a largely indifferent populace more concerned with unemployment and the Depression than the latest fads in Paris and Hampstead. Those few members of the general public who did follow events were often antagonised by them, baffled by Unit One and the 7 & 5 and convinced that abstract art was probably a foreign plot – just look at all those odd names, Kandinsky, Lissitsky, Malevich, Moholy-Nagy, Gabo and so on.†

Herbert Read was allowed first innings after the magazine's editorial and defined their aim as 'a geometrical art which is entirely contained within the relationships of forms, colours, lines, surfaces, without any suggestion of natural objects'.[7] Geoffrey Grigson followed to deny this and point out that forms could be biomorphic as well as geometric, like Arp's and Miró's and indeed Piper's. Grigson preferred Piper's work to Nicholson's since the latter said 'no' rather than 'yes' and created works derived too much from art itself, floating free and disinfected from life. The schisms were already appearing by page ten of the first edition.

They were all united, however, in condemning Fry and Bell for their 'peevish pinched formalism' and 'etiolated cliquish amateurism'. Piper particularly now resented the Bloomsburys' pressure to make him a mental expatriate and their conviction that one had to live on the banks of the Seine before one could hope to paint a modern picture. All this was good healthy iconoclasm, but not quite fair to Fry and Bell whose influential advocacy of non-literary painting and 'significant form' had cleared the ground for their own beliefs and practice, and whose admiration for primitive art had sent Henry Moore along the right path.

Surrealism was their other common foe; a mere 'literary pursuit producing garrulous and inquisitive pictures from a fictional subconscious which like bad poetry

* Since Malevich's 'Suprematist' painting *White on White* (*c.* 1918) white had seemed the colour of revolutionary modernity in art and architecture.
† Actually the Russians were already suppressing their revolutionary art as being too free and bourgeois-conformist. Several of the artists came to Paris or Berlin in order to continue their work.

say too much and leave no room at all for self-expression', thundered Myfanwy Evans: 'With all its apparent scope and new ground for exploration the subconscious mind is a more limited subject for painting than a blank wall.'[8] Throughout the eight issues of *Axis* Abstraction and Surrealism are presented as the only possible, but totally opposed, options open to the really up-to-date artist. Piper had attended the 1936 Surrealist Exhibition but had not been seduced, feeling he ought to abide by the party line and reject the 'fun and games'. Only Henry Moore was prepared to admit they were not irreconcilable opposites:

> The violent quarrel between the abstractionists and surrealists seems to me quite unnecessary. All good art has contained both classical and romantic elements — order and surprise, intellect and imagination, conscious and unconscious. Both sides of the artist's personality must play their part. And I think the first inception of a painting may begin from either end.[9]

The twin heroes of the *Axis* group were Hélion, then a painter of metallic, shield-like shapes which appear to overlap and shift above their flat colour-grounds, and Picasso, though an article by Piper seems to complain that he does not stay in one spot long enough for the troops to rally behind him. The works of Braque, Arp, Léger, Gris, Gabo, Moholy-Nagy, Calder, Miró, Erni, Mondrian and Kandinsky were all reproduced in black and white and England's avant-garde is represented by Nicholson, Hepworth, Arthur Jackson, Piper, Eileen Holding, Moore, Wadsworth, Ceri Richards, Peter MacIntyre and Jessica Dismorr. Not all of these artists have stood the test of time, nor have some of the writers who supported them.

As one reads through the eight issues of *Axis* a shift in stance becomes obvious: a loss of nerve about the purest abstractionist dogma and a realisation that something, perhaps warmth and humanity, perhaps a social role for painting, has seeped away. Surely there is something strangely antiseptic about those white painted reliefs of squares and circles that Nicholson was producing? Piper and Geoffrey Grigson express this unease in a joint article entitled 'England's Climate'.[10] No good painting is appearing now, they fear, because the humanist element in European art, there since its inception, is missing. Surely, they plead, '*Life* grows out of a good sculptor's or painter's work.' Constable, Blake and Palmer produced integrated, wholesome work (and they reproduce some to prove it), and look at Fuseli — 'he could understand at once Blake, Constable, Goethe, Milton, Dante, Shakespeare and the great painters behind him,' but within thirty years of his death such a rich resource for picture-making was lost. We no longer grow from that kind of rich cultural mulch in 'the gay, white armour of [our] studios'. We are terrified of the National Gallery. We need to get painting back to its roots in art, life and society. With a despairing flourish poet and painter end:

> Great art comes from great living; great living comes from our common humanity promising or filling out or still defining a high moral shape to which each peculiar person can decently relate himself. I believe that men may have to wait a hundred years before such a shape is renewed.

The relationship of art and morality is a complex and controversial one. Fry in his *Essay on Aesthetics* (1909) had claimed that morally desirable art was invariably inferior. Art presents emotions in and for themselves to be contemplated disinterestedly, whereas morality condemns emotions which do not lead on to good actions. Tolstoy, taking the opposite view that art should be morally improving, had been led by his own logic to condemn the works of Raphael, Beethoven and Michelangelo, and ultimately his own novels. This debate suddenly came into focus in the very last article of the final issue of *Axis* in winter 1937 where Robert Medley reviewed the notorious show of 'Degenerate Art' in Munich. Here, in Hitler, was a leader who claimed he had found a positive social role for art, given it a moral purpose, and made both compulsory. Zhdanov in Russia was making the same kind of authoritarian decisions at about the same time. Yet, later in England, Churchill, an amateur artist every bit as talentless and die-hard in his artistic views as the failed water-colourist Hitler, refrained from interfering with 'advanced' English art, even after the war began. Perhaps he lacked the Russians' and Germans' conviction that art could actually change how people thought and behaved.*

Since the impending war was to force Piper, and indeed all artists of whatever style, into considering the wider purpose of their work and how it related to their beleaguered nation's needs it seems worth a diversion at this point to consider Hitler's view of how German artists might go about 'defining a high moral shape to which each peculiar person can decently relate himself', in Piper's and Grigson's words. As the Nazis assumed power they closed the most famous and progressive school of design in Europe, the Bauhaus, and steadily excluded experimental or expressionist artists from teaching posts or public commissions. In a way German art of the 1930s *was* dangerous and extreme, full of savage social comment and the unbridled emotions of expressionism. Our own milk-and-water surrealism and bloodless abstraction look very detached beside it. Josef Goebbels and Professor Adolf Zeigler, President of the Reich Chamber of Arts, weeded out from the museums and studios all Jewish and 'Bolshevik' works and set them up for ridicule alongside a great deal of genuine rubbish and works by the insane. The artists pilloried included Jankel Adler, Chagall, Corinth, Feininger, Kokoschka, Klee, Grosz, Dix, Beckmann, Kandinsky, Ernst, Maholy-Nagy, Mondrian, Schmidt-Rottluff and Picasso. A selection of 730 works of the 1600 seized was made and shown in the Degenerate Art exhibition which Medley had reviewed for *Axis*. This touched a deep vein of philistinism in the populace and two million flocked in to sneer and mock (rather as the English in lesser numbers had to the Post-Impressionist and Surrealist exhibitions). The unproblematic Hellenic-Aryan nudes, heroic leaders, belligerent soldiers, fertile mothers and willing workers produced by realist academic painters were set up elsewhere in the 'Great Exhibition of German Art 1937'. In his opening speech to this show Hitler inveighed against art which only spoke to minorities; the creation and control of 'modern' art by Jews; the multiplicity of slogans, clichés

* Modern art did not thrive under Franco or Mussolini either, but neither suppressed it in the savage way Hitler did.

and catchwords used to label the successive waves of these anti-traditional movements (Futurism, Cubism, Dadaism, etc.); and above all the aspirations of modern artists to be in an international movement cut off from any 'integral relationship with an ethnic group'.[11] What the National Socialists wanted was the rejection of the School of Paris and the rebirth of an unsullied German Art, 'clear, logical and true' that 'was the supreme expression of national (völkisch) existence'.

Interestingly, Hitler himself saw this new optimistic art as relating backwards to the German nineteenth-century Romantics such as Caspar David Friedrich (1774–1880) and Otto Runge (1777–1810).[12] This is a bogus lineage, but strangely parallel to the voluntary turning back to Romantic forebears by English painters such as Sutherland, Nash and Piper around this time. Actually the works produced to Nazi theories were in the most international of all styles – that of nineteenth-century academic realism.

Kenneth Clark, patron of many of the Neo-Romantics both as a private individual and as chairman of WAAC, could see a different ancestry for Hitler's state-directed art. In discussing the French classical artist David's masterpiece *The Death of Marat* (1793) he makes this observation:

> It proves that totalitarian art must be a form of classicism: the State which is founded on order or subordination demands an art with a similar basis. Romantic painting, however popular, expresses the revolt of the individual. The State also requires an art of reason by which appropriate works may be produced as required. Inspiration is outside State control. The classical attitude towards subject matter – that it should be clear and unequivocal – supports the attitude of unquestioning belief. Add the fact that totalitarian art must be real enough to please the ignorant, ideal enough to commemorate a national hero, and well enough designed to present a memorable image and one sees how perfectly *Death of Marat* fits the bill.[13]

If Clark's analysis is correct (and I find it persuasive, especially after looking at the sculpture and architecture produced to Hitler's demands), then we must give credit to the British Government and the WAAC that the art produced during the nation's time of peril was, by and large, romantic in nature and no artist felt coerced into abandoning his own individual style or viewpoint. Piper himself was to produce the most romantic of all the war works once he had abandoned his own abstractions and broken away from Nicholson.

The works Piper had reproduced in *Axis* he later described as 'constructions with straight and bent rods and discs on a different plane from, but near the surface of, the picture, which in itself was often varied in its own surface (for instance smooth enamelled areas were neighboured by coarse sandpaper areas). I had not met Alexander Calder about this time for nothing.'[14] He had also learned something from Nicholson – perhaps the use of scribbled texture to add variety of surface – but most of all from Hélion in the use of upright, overlapping forms in limited colours. 'Abstraction' at this period meant something severe, hard-edged, geometric, in

severe colours and exquisite taste.* The gestural, lyrical or decorative were frowned upon. This cool, uncluttered look was widely imitated in applied design and architecture so that what was supposed to be classically timeless soon acquired a dated look as fashions in textiles, interior decorating and furniture moved on. Some of Piper's abstracts have disappeared, others are in private collections, and a few are still kept around his house at Fawley Bottom, near Henley-on-Thames. He moved there in 1935 with his new wife, the editor of *Axis*, Myfanwy Evans, having first asked her, 'I'm afraid I never take a holiday. Do you mind?'

Piper's dissatisfaction with his constructions grew. A friend of his, the critic Eric Newton, reviewed Nicholson, Hepworth and Moore at their most abstract and asked if they had not lost half the artist's interesting problems when they threw away the apple and kept the sphere:

> And no doubt 'constructive art' will act as an emetic by eliminating the irrelevant attractions of apples and thighs and leaving us only spheres and cylinders to sharpen our aesthetic wits on. But an emetic cannot nourish. It can only get rid of bad nourishment.[15]

Piper was now ready to fill the void. He states categorically that he never had any intention of remaining an abstract artist and he undertook it primarily as a discipline. 'I was a splashy, scatterbrained painter before I took it up,' he said recently. He certainly did not take it up for the money since none sold and he and his new wife had to depend on his writing talents and the generosity of his mother to keep them afloat. His sudden and total reversion to painting the English landscape therefore evoked easy jibes from the remaining abstractionists that he was seeking easier markets. For a time the atmosphere was bitter, and Nicholson and Barbara Hepworth, now living and working together in Hampstead, resented his apostasy.

Later their hero Jean Hélion also fell from grace. He was a German prisoner of war for two years before escaping. The experience taught him older priorities: 'You don't dream about angles or surfaces and so on. You dream about women, bread, smokes and trees. And as soon as I escaped, my first drawings were of trees, women passing by, and bread and smokes.' His former admirers left him isolated during the 1940s as he worked in a figurative style. Today he reflects: 'They all had a taste for the convent, including Ben. He wanted to obey strict formulas. He was at ease with them. He had great talent and thanks to that, he made, with his very limited means, a lot of lovely pictures. But I was disgusted with that limitation.'[16]

The Hampstead purists received additional support and prestige as refugee artists began to arrive from Europe. Paris was no longer safe for the German avant-garde as war loomed, so they came to London. Those 'degenerates' who remained behind such as Schad, Dix, Schlemmer, Baumeister and Nolde went into 'inner emigration' and were lost to modernism. Gabo came, and Moholy-Nagy, Breuer, Gropius and

* D. H. Lawrence complained: 'Most puerile is this clabbing of geometric figures behind one another, just to prove the artist is being abstract, that he is not attempting the reproduction of the object' (the *Listener*, 29 March 1933).

Mondrian, all to be welcomed by Nicholson, Herbert Read, Moore and their circle, now minus Piper. Mondrian, on entering Nicholson's aseptic whitewashed studio (copied from Mondrian's in Paris), saw a fine beech tree through the window: 'Too much Nature,' he declared with thin humour. Nicholson, Naum Gabo and J. L. Martin produced an international survey of 'constructive art' in 1937 called *Circle* with contributions from most of these exiled Europeans. Understandably, as mainly Jewish refugees from the racially obsessed Hitler, they strongly stressed the internationalism of modern art and claimed the interrelationship of all forward-looking trends in all artistic and scientific fields. London had briefly become the headquarters of the European counter-culture, though most of these pioneers were to move on to the safer haven of New York when bombs began to fall. As usual Herbert Reed wrote an enthusiastic article for *Circle*, but the Pipers were not invited to contribute their views.

They were busy with their own rival publication and establishing their position with the less narrow-minded and puritanical modernists. *The Painter's Object* also appeared in 1937 minus any contributions from Nicholson or Hepworth. Those who did contribute seemed to be tackling some very unorthodox topics – so de Chirico wrote about Gustave Courbet; Moholy-Nagy offered a film scenario ('Once a Chicken, Always a Chicken'); Hélion discussed Poussin and Seurat; and Ozenfant offered 'Serial Art'. The newly completed *Guernica* was reproduced and Picasso was obviously still everybody's hero though his recorded sayings were enigmatic ('Man invented the alarm clock.' 'Abstract art is only painting. What about drama?'). Now, however, the Pipers gave Surrealism a fairer hearing than they ever did in *Axis* with Ernst writing on his *frottage* technique, Paul Nash on 'Nest of Wild Stones' and 'Seaside Surrealism', and then Graham Sutherland with a prose-poem to Birnham Rocks. Piper's own contributions are an essay on 'England's Early Sculptors', and 'Lost a Valuable Object'. The first is a patriotic hymn to our English forefathers of the eighth to thirteenth centuries who could work within formal conventions yet achieve something 'personal, lucid and popular: not in the least highbrow', which he admits 'is a capacity the present day artist envies and strives for'. Their characteristics as English artists were 'a sense of authority animated by a strong linear rhythm'. Then, skipping half a dozen centuries, he claims, 'Not again until Blake did this especially English genius show itself so well: this genius for making a line at once create a shape and enrich it with meaning as part of a whole design.'[17]

The second essay is more a personal act of defiance and self-justification, as usual superbly written and deserving to be quoted whole, but in essence he states that the Cubists destroyed the object for painters, smashed it to fragments and posted it to oblivion. Dadaists and Surrealists have failed to re-find it, and Abstractionists forbid themselves such frivolous games. And yet, he asks, are not the antics of Nash, Moore, Arp and Miró all attempts to seek it out?

In spite of these varied activities there is one striking similarity of the Surrealist and the abstract painter to the object: *they both have an absolute horror of it in its proper context.* The one thing neither of them would dream of painting is a

tree standing in a field. For the tree standing in the field has practically no meaning at the moment for the painter. It is an ideal: not a reality.[18]

For his own part Piper felt the need to paint pictures again which contained recognisable objects (and he describes these as near-rooms, or near-seashores), as facts, as realities, and not as ideals.

The tree he set out to paint, however, turned out not to be in a field after all. He turned back to his youthful hobby of collecting old guidebooks, especially those which followed the theories of Burke on the Sublime or Gilpin and Price on the Picturesque. Inspired by their plates he produced *12 Brighton Aquatints* (1939) with a Foreword by Lord Alfred Douglas (1870–1945), Oscar Wilde's nemesis. Not only was his introducer wildly out of fashion, but so was Piper's taste in late Victorian yellow brick and Edwardian lodging houses – after all half the staff of the Bauhaus were in London! This production and his articles in the *Architectural Review* attracted the attention of one of the few individuals around with similarly idiosyncratic tastes: John Betjeman, poet and editor of the Shell Guides to the English counties.

Nash had written and illustrated the *Shell Guide to Dorset* (1935) and concentrated his attention on the castles, forts and tumuli which hummock the whole county. The actual living inhabitants of the place get scant notice compared with Swanage's surreal street furniture: 'the people who live there, my God and the people who come there on the buses and steamers – beyond belief,' winced Nash.[19] Piper was much more tolerant and gregarious by nature and when he teamed up with Betjeman he found a fellow-spirit who could match his 'church crawling' and be just as enthusiastic about rood screens, branch-line railways, iron railings, Nonconformist chapels, warehouses, Victorian pubs and all the neglected crannies of little villages in minor counties. Philip Larkin, a poet with a similarly chauvinistic view of the world, wrote approvingly of Betjeman, 'If the spirit of our century is onward, outward and upward, the spirit of Betjemen's work is backwards, inwards and downwards.'[20] Larkin also remarked how Betjeman was a living contradiction to T. S. Eliot's dictum that 'Poets in our civilization, as it exists at present, must be difficult.' These same remarks could, with justice, be applied to Piper's work in paint rather than words.

Betjeman remembered their antiquarian rambles: 'It was all a lark in those days. There were no scholars.' He also had to puff to a halt now and then and protest to the lean and indefatigable Piper, 'I can't do more than ten churches in a day, old boy.' Nash, who took all things to do with art far too solemnly, was disgusted that the two of them giggled so much over their finds. Beneath the jokiness, however, they had the serious intention of welcoming the best wherever they found it and of bringing it to the attention of as many people as possible. This concern with humanity and the quality of life raised their joint researches above mere antiquarianism and made it more into a campaign against planner's blight and second-hand Bauhausery. Betjeman's *First and Last Loves*,[21] which Piper partly illustrated, shows them united in a deep nostalgia for all that was well-made, of whatever period, and against current historical or architectural snobberies. Both poet and

painter gladly accepted the label of 'Nostalgic' since, as Piper says, nostalgia for something means love for it, and if that is intense then it is worth having. Piper also illustrated J. M. Richard's *The Castles on the Ground* (1946), a sympathetic picture of all that was British and best in that 'enchanted jungle', the middle-class suburb with its 'Jerrybethan' semi-detacheds and trim gardens.[22] After all, these estates were what most Englishmen had been fighting for, not Stonehenge, or Salisbury Cathedral, or Blenheim Palace.

The only other guidebook writer to catalogue Britain's building heritage more thoroughly than Betjeman and Piper was the German-born Nicholas Pevsner who, for all his Teutonic thoroughness, lacks the Englishman's eye for the bizarre detail. An entry, almost at random, for Salford in Oxfordshire gives a flavour of their style:

> *Salford.* Stone village with some reputable modern development. Church by street, not so easy on the eye since the roof was renewed in 'compo' tiles. Architectural details and mouldings good, especially south porch. Round at the back of the church is a feeble relief carving (12th century) of Sagittarius shooting his usual beast.[23]

This is accompanied by Piper's photograph of a tree nailed full of enamel advertisements for tobacco and tea, with the Betjeman caption 'A Tree of Knowledge at Salford.' The Oxford and Shropshire guides they did together (written in 1939 but not published until 1951), and those Piper continued to write or edit after Betjeman resigned in 1967, are full of that guileless enthusiasm, wit and idiosyncratic scholarship we value in our popular cricket commentators or gardening experts. These small (9 inches × 7 inches) books were not the only ways Piper was then exploring the topography and architecture of his native land. He always had too much energy to be doing only one thing at a time.

In the paintings which followed on from his abdication from abstraction he set out to depict the great country houses of England and Wales, a task no major artist had undertaken since Constable and Turner's time.* Contemporary novels were often set in these seats of ancient privilege, though after the war was over this declined as death duties bit deeper into the estates and the National Trust assumed ownership. Visual artists, however, rarely undertook them as subjects, perhaps considering the theme too played out, and the thoughts inspired by crumbling strongholds too near the Ozymandian cliché that the mightiest works of man decay. Nevertheless Piper did tackle Stowe, Stourhead in Wiltshire, Hafod in Wales and Vanbrugh's great burned-out Seaton Delaval Hall on the Northumberland coast. These are all technically interesting after the impersonal finish of the abstracts. *Autumn at Stourhead* (1939) might be seen as a transitional work between the recent abstracts and his mature style: here are strong vertical flat forms in the same limited colour (black, white, pale yellow, indian red, light blue) he had used in the non-figurative *Painting 1935*. It looks like a design for a ballet curtain. By 1942 when

* Turner and his contemporaries had sold thousands of engravings of such views, or folios of them with such titles as *Select Views of Gentlemen's Seats*.

Seaton Delaval (1941), oil on wood

he painted *Seaton Delaval* everything is looser: there had been a thick undercoat of white applied to the wood panel and then on top of this haphazard texture thin colours have been wiped in mixtures it is no longer possible to describe precisely since they merge and overflow form boundaries quite arbitrarily. Nash had made careful line drawings and then filled them in, but Piper reversed this process, flicking in black lines and details on top of colour areas to pull them together. If one looked at the picture a section at a time it would appear quite abstract, but no longer of that hard-edged, clear-coloured variety he made before – now his personal gestural marks came through freely, unlike the anonymity of his Hélion-derived surfaces. Half the picture is in darkness, but this does not necessarily mean it is night; nor do the strong brushmarks imply it is bad weather; and there are no clues as to what century is depicted. The low viewpoint, random-seeming colours and textures, silhouetted roof-line, and sudden clusters of detail pulled out of the gloom are there to impress us with the *drama* of architecture (after all Vanbrugh was also a playwright), rather than its topographical interest. Piper's water-colours too are now agitated in surface with much use of wax-resist, pastels, oil pastels, chalk, inks and a whole repertoire of devices to make the picture pulse with energy.

Now he is released from the restraints of abstraction his works in all the media seem to have great gusts of enthusiasm blowing through them – a characteristic which is still as evident today though Piper is now well into his ninth decade.

The *Brighton Aquatints* and great houses paintings brought Piper's work to the attention of Sir Osbert Sitwell (1892–1969), himself the owner of Renishaw Hall near Sheffield. He invited Piper to illustrate his five-volume autobiography with drawings of Renishaw and its environs. The Sitwells, Osbert, Edith (1887–1964) and Sacheverell (b. 1897), came from the same monied and leisured class as the Bloomsburys with whom they competed as patrons to promising musicians, writers and artists.* Young aesthetes like Kenneth Clark swarmed to their salons thinking, 'It was wonderful to find people so liberated from accepted thought and values – particularly from those of Bloomsbury, and the domination of Roger Fry and all that muddy-coloured pseudo classicism.'[24] Like the Bloomsbury crowd they made modest talents stretch a long way by influence and publicity. One of their major 'stunts' was *Façade*, a key work in the history of ballyhoo, and meant to rival Cocteau's *Parade* (1917) which had music by Satie and décor by Picasso. The Sitwells' performances in 1922, 1923 and 1926 had music by their protégé William Walton and a curtain by Frank Dobson with a hole in it through which Edith could read her poetry. Sometimes Constant Lambert took a share of the readings, bellowing through a Sengerphone – a kind of megaphone mostly used by sea-captains for directing their crews during stormy weather. *Façade* brought the Sitwells some of the notoriety they craved like a drug and it suitably provoked the few philistines who noticed it. It also inspired the young Noël Coward to include a sketch in his review *London Calling* (1923) of Henrietta Whittlebot and her brothers Gob and Sago reciting doggerel, which effrontery earned him their lifelong enmity. He dismissed them as 'two wiseacres and a cow'. Their arrogance, physical peculiarities and extreme touchiness laid them open to many similar attacks and they managed to carry on vicious verbal cross-fire with equally strong-willed people such as Wyndham Lewis,† F. R. Leavis and Geoffrey Grigson ('egregious little poetaster') for decades.

John Piper never joined in this Sitwell-baiting. He provided the curtain for the 1941 revival of *Façade* at the Aeolian Hall, giving it a wildly romantic aspect across Renishaw lake by moonlight to the right of the gaping mouth in the centre, and rampant red foliage and a view of the stable-block to the left. Edith knitted him a pullover, and Osbert seemed to Piper 'infinitely knowledgeable and wise, with sudden anecdotes about a world that I have never known – the Asquiths and the Keppels and the hostesses and artists of the times.'[25] Renishaw with its peace, good food and coal fires fuelled from the Sitwell mines provided a cultured refuge from

* William Walton, Wyndham Lewis (before they quarrelled), Tchelitchew, Rex Whistler, Bill Brandt, Cecil Beaton and Dylan Thomas amongst others.
† W. H. Auden wrote in 'A Happy New Year 1933':
 The Sitwells were giving a private dance
 But Wyndham Lewis disguised as the maid
 Was putting cascara in the still lemonade.

the more arduous war work he was also doing at this time. The weirdly-turretted hall and estate with a Gothic folly, wilderness and lake gave him scope for more atmospheric water-colours in his darker, looser new style. After the war he accompanied Osbert to his Italian castle, Montegufoni, to do yet more drawings of its Baroque façade, dark lemon-house, grotto and Court of the Dukes of Athens for the later volumes of Osbert's ornamental autobiography.

These comfortable interludes at Renishaw were snatched from longer periods of work as an official War Artist. Piper's obsessions with the delapidated fabric of old houses and the roofless shells of churches made Kenneth Clark, chairman of WAAC, think of Piper as the ideal artist to depict those instant ruins caused by the Luftwaffe's bombs. It seemed important to Clark's committee that the worst wounds inflicted on our towns should be recorded, both by factual topographical artists and by 'fine' artists such as Piper and Sutherland, the moment they were inflicted. It seems odd to think that Piper's paintings of a gutted House of Commons* or a roofless Wren church in Newgate Street or the bombed Georgian crescent in Bath could act as a cultural tonic, or offer solace to anyone, except perhaps our enemies. However, when these works and many others were published in a little booklet *Blitz* (OUP, 1942) they sold well. The originals were displayed on the walls of the National Gallery (all the masterpieces having been tucked up safely in a Welsh mine for the duration) from July 1940 onwards and attracted large crowds, often swelled by those who came to hear Myra Hess's lunchtime piano recitals. In a capital where nearly all the commercial galleries were closed the art-hungry populace were enthusiastic about pictures which depicted the struggle they were all sharing. They could see what the works were about and could feel the relevance to their own lives in a way not possible with 'abstract' artists. Clark did not ask Nicholson or Pasmore or others of their persuasion to participate in WAAC's programme but anyway, as Henry Moore pointed out, 'They didn't want to do it – why should they? They didn't want to connect their art with the war; their objective was to be *pure* artists, to be above emotion – once you begin to connect then you're not pure.'[26] Nicholson himself, now settled away from the bombing in St. Ives, made a plea for war for art's sake:

About abstract art: I have not yet seen it pointed out that this liberation of form and colour is closely linked with all the other liberations one hears about. I think it ought, perhaps to come into one of our lists of war aims.[27]

Piper's first two war-works for the WAAC in 1940 were near throwbacks to his hard-edged, limited-colours abstractions. This was appropriate enough for the bunker corridors leading to Bristol's Air Raid Precaution (ARP) Headquarters and its control room. Within weeks, however, he was having to use his more emotionally expressive style to cope with the holocaust of Coventry. This city was a centre of

* Piper's greatest exemplar, Turner, had also depicted the Houses of Parliament in flames (16 October 1834), though this was the predecessor to Barry and Pugin's Gothic masterpiece. On that occasion the crowds had cheered the flames.

aircraft production and on 14 November 1940 the Luftwaffe came equipped to destroy it. Incendiaries lit the way for wave after wave of bombers. After ten hours of pounding one third of the houses were uninhabitable and a hundred acres of the city centre were flattened. Piper was near enough to reach the city by daylight – when the dazed or hysterical homeless were streaming away through the cordons which already surrounded the city. Using his WAAC artist's permit he got through to the centre. The human misery was beyond his powers to depict but the bombed cathedral could be made a symbol for all the anguish of that long night. He described it with an artist's eye:

> The ruined cathedral a grey, meal-coloured stack in the foggy close; redder as one came nearer, and still hot and wet from fire and water; finally presenting itself as a series of gaunt, red-grey façades, stretching eastwards from the dusty but erect tower and spire. Outline of the walls against the steamy sky a series of ragged loops. Windows empty, but for oddly poised fragments of tracery, with spikes or blackened glass embedded in them. Walls flaked and pitted, as if they had been under water for a hundred years. Crackle of glass underfoot. Inside the shell of walls, hardly a trace of woodwork among the tumbled pile of masonry, stuck with rusted iron stays.[28]

It is an exact transcript of the painting he made from a handy solicitor's office opposite the site. One day he would be one of those responsible for raising a new cathedral adjoining the shell of the old.

The success of this work led to more drawings and paintings of violated churches in London, Bath and Bristol, though even the unflagging energies of Piper could never cope with the 15,000 ecclesiastical buildings of all denominations which were damaged by bombs. The Methodists alone, for example, lost 800 chapels.[29] In the very darkest days of the war, when the cities were taking such a pounding and invasion from the air and across the Channel seemed an imminent possibility, Collins, the publishers, commissioned a series of booklets on all aspects of British life and culture to remind people of just what we were defending. Michael Ayrton wrote on British drawings, David Low on cartoons, H. J. Paris on water-colours, John Russell on portraits, Cecil Beaton on photography, and Major Guy Paget on that quintessentially English genre, the sporting print. Very appropriately Piper was asked to tackle *British Romantic Artists* (1942).[30] This small but inspiring book is really the set text for our present study. Piper is still rightly proud of it.

Perhaps the greatest difference between the Classical and the Romantic artist lies in the approach of each to particulars. Fry had observed:

> Also one might add as an empirical observation that the greatest art seems to concern itself most with the universal aspects of natural form, to be the least preoccupied with particulars. The greatest artists appear to be the most sensitive to those qualities of natural objects which are the least obvious in ordinary life precisely because, being common to all visible objects, they do not serve as marks of distinction and recognition.[31]

Lansdowne Crescent from the ruins of Lansdowne Chapel, Bath (1942), watercolour on cardboard

Earlier that other striver after classical idealism, Joshua Reynolds, had written in his Discourses: ' . . . this deposition to abstractions, to generalizing and classification is the great glory of the human mind.' Blake, sweeping aside paradox, scribbled in the margin: 'To Generalize is to be an Idiot,' and continued, 'To Particularize is the Alone Distinction of Merit. General Knowledges are those knowledges that Idiots possess.' Later Ruskin was to add his voice to the call for the minute study of particulars as a means to glimpsing the universals behind them. Piper revered both Blake and Ruskin and began his book with this fighting statement:

> Romantic art deals with the particular. The particularization of Bewick about a bird's wing, of Turner about a waterfall or a hill town, or of Rossetti about Elizabeth Siddal, is the result of a vision that can see in these things something significant beyond ordinary significance: something that for the moment seems to contain the whole world; and, when the moment is past, carries over some comment on life or experience besides the comment on appearances.[32]

For the Romantic, then, universality is only achieved by observing particulars with extraordinary intensity: only this way can one see the world in a grain of sand, and heaven in a wild flower. After the era of Locke and Newton, where the

universe behaved correctly according to the general rules deduced by the geometrical minds of philosphers and mathematicians, there came the anarchic Romantics preferring to cut the universe adrift and needing to chart it afresh. Concrete things, whether geographical strata, gems or people, thus need to be seen close up, with what Pascal called *esprit de finesse*. Seen with fervour rather than detachment, it soon becomes obvious that landscape, for example, cannot be relegated to a decorative background for pompous historical or religious subject matter: it is well worth the painter's undivided attention. Piper links the major painter and writer of the Romantic period:

> By the end of the century Turner was beginning to believe, with Wordsworth, that painting, like poetry, 'is the image of man and nature', that it should express 'an overbalance of pleasure', 'the spontaneous overflow of powerful feelings' and that it should 'Illustrate the manner in which our feelings and ideas are associated in a state of excitement' (Preface to the *Lyrical Ballads*). This was the Romantic victory.[33]

'Sublimity' had originally been a literary concept, but Burke's *A Philosophical Enquiry into the Sublime and the Beautiful* (1757) made it of interest to painters too who set out to find the terror, obscurity, power, darkness, solitude and vastness he saw as the characteristics of the Sublime. Piper sees this work as a last attempt by a classicist to codify and quantify, and so contain, the overflowing feelings upon which Romanticism was based; an attempt to recognise absolute standards by which emotions and sentiments in the face of nature might be judged. Along with their sketching tackle and Claude glasses the emerging flocks of tourists packed their Burke essay, Gilpin's catalogue of picturesque views,[34] and Uvedale Price's similar work[35] which drew the seeker's attention not just to the sweeping prospect but also to the foreground detail, for 'even the tracks of wheels (for no circumstance is indifferent) contribute to the picturesque effect of the whole'. With this luggage the tourists sought all the 'horrid' waterfalls and crags of Wales and the North, the newly built ruins in carefully informal estates, and the gothicised country villas, though, Wordsworth complained, many remained in 'absolute dominion to the eye', failing to penetrate beyond appearances to the realisation that:

> One impulse from a vernal wood
> May teach you more of man
> Of moral evil and of good
> Than all the sages can.[36]

These then were the kind of ideas in circulation when Girtin, Turner and Constable were young men in their twenties.

Piper writes with love and enthusiasm on Wilson, Gainsborough, Cozens, Loutherbourg, Girtin, Cotman and on Constable who, he thinks, was parochial but

made that his strength. His highest praise, however, is reserved for J. M. W. Turner, the greatest innovator of all the Romantic painters. But how did those astonishing late Turners, many of which had just been unearthed in the National Gallery and Tate cellars, fit into Piper's stipulation that Romantic painting dealt with the particular? Had not Turner's contemporaries scoffed that these were 'pictures of nothing, and very like'? No, they were pictures of light, claimed Piper, 'veiled light, or misty light, or full light or blinding light. To a public used to looking at solid, if ruinous castles on hill-tops well described by means of lines and washes, it was natural that Turner's visions should seem like 'pictures of nothing' rather than – what they more nearly resemble – pictures of everything.' This is not to resort to Ruskin's defence of them as being just as *naturalistic* as his earlier works but with the dimming of form revealing greater natural *truths*—this seems sophistry to Piper who sees them as 'visionary, intense and prophetic'. But, writes Piper:

> Ruskin in what he said of the later works was exaggerating an important truth: that Turner never really became a totally 'abstract' painter. His pictures were never of 'nothing'. The richness of nature was always at his back, and his vision was always derived from reality, even when he was most a visionary.[37]

Piper's survey sweeps on over Bewick's precise little visions and Fuseli's theatrical paraphernalia, and takes time to give full tribute to Blake's genius ('No word description of Blake's art is adequate; no approach to it is reasonable but the approach of acceptance'). Then on to Palmer and the Ancients at Shoreham, dedicating their lives to 'Poetry and Sentiment' and pitting their visions of an England 'where shepherds piped upon their pipes, and the clouds dropped fatness' against the harsher realities of the Industrial Revolution.

Apart from Turner, 'whose batteries went pounding on till 1851', Piper thinks the Victorians frittered away all the great conquests the Romantic painters had made. This blight came from smugness, materialism and the artists' pursuit of fame by providing their new middle-class patrons with a smooth finish and a good story – the kind of pressures which sullied Millais' precocious talents. Reynold's scheme to raise the status of painters to that of gentlemen by giving them a Royal Academy had worked too well. Piper can find merit in the Pre-Raphaelites, however, and obviously enjoyed Rossetti as much as Nash did. Fry's campaign to introduce Post-Impressionism into English art where our romanticism 'had become vulgarized and provincial' was necessary, 'but in the long run it was applied with too much austerity by the more adventurous painters. The accent on design, form, structure, which they began to press home, and the suppression of literary interest and atmosphere, tended to squash all that was most natural to English painters, and produced a new and artificial academicism.'[38] Then follows a brief round-up of contemporary Romantics such as Frances Hodgkins, Nash and Sutherland. Nash, he thought, 'has often identified the romantic with the remote – of time or place . . . the dry architecture of geology and antiquarianism has inspired him,' which really applies more justly to Piper himself than to his friend. He also admires the 'certain strangeness'

The Tithe Barn, Great Coxwell, Berks (1940), Indian ink and watercolour

of Sutherland who 'paints the elements, and the more elemental natural forms: tumbled rocks, organic tangles of gorse on sea walls, the sun falling behind a volcanic pile of mountains.' It is a generous tribute to a man he never felt close to on a personal level.

Piper included in the book a reproduction of a 1938 water-colour by Nash showing a view from Piper's kitchen window at Fawley Bottom, made on one of Nash's social calls. Nash could not see why Piper thought it Romantic, nor why Piper had also reproduced Constable, Steer and Sickert.

> But when all is said I do not like the word Romantic applied to that which in its best and truest expression in English art should be called Poetic.
> [12th January 1943][39]

Piper's reply both shows how far apart the two were after their respective experiences of Surrealism, and also reveals the kind of debate then current in artists' circles, even as war raged across Europe. It deserves quoting at some length, as an argument and because it reveals the position Piper had arrived at in 1943 and which he has held to since.

Well, Constable may not be romantic; but if not how do you account for 'The world is wide; no two days are alike, nor even two hours; neither were there ever two leaves of a tree alike since the creation of the world,' and a thousand or so remarks of the same kind? But what do you mean by romantic, and what do I? Do you mean only Blake, Fuseli, S. Palmer, John Martin at their *queerest*? ('Queerest' not meant derogatorily, but as dealing with the 'unusual' or 'inspired'). If you don't include the English illustrators of the sixties whom do you include? And if, including them, you don't include Sickert who held the fort of inspired illustration against all comers – including Roger Fry and yourself – if not, why not? To me, similarly, Ernst, Dali, you at your most surrealist are not *ever* as romantic as Rouault, Braque, and you searching with calm excitement for the reality that will clinch the bargain of your vision on the Chiltern slopes or the Dorset Downs. And I don't care what Herbert Read may say, or all the boys with double-barrelled foreign names and addresses in St. John's Wood. The value of abstract painting to me, and the value of Surrealist painting to me are (paradoxically, if you like) that they are *classical* exercises, not romantic expressions. They are disciplines – even dreams can be disciplinarian – which open a road to one's own heart – but they are not the heart itself. I doubt if under their complete domination one masterpiece will ever be created. After an abstract period – what a relief one feels! The avenue at Stadhampton, or the watercress beds at Ewelme are seen with such new intensity! But if one abstracts them finally, so that those posts are areas of colour, and the waterfall into the watercress bed becomes like a Ben [Nicholson] relief, then the result can be hung perhaps in Cork Street, but not hung against one's heart. And so, too, with classical old, domineering old Surrealism.[40]

After praising Nash's water-colour as a bit of Romantic particularity he concludes:

Do I confuse ROMANCE and POETRY?
Do you confuse ROMANCE and FANTASY?
Why should either of us call either of them a *confusion*?

Nash did, of course, confuse Romance and Fantasy, but lacked Piper's depth of reading or knowledge of nineteenth-century art to make a convincing reply.

Piper's influential little book rewrote the history of English painting to make it a story of romanticism handed on from generation to generation. Even our weakest period, the Victorian, was only a trivialisation or vulgarisation of this romantic English way of seeing. The modern painters he mentions are seen as both heirs to this tradition and the strong revivers of it – so even Nicholson's work can be recruited since it has 'a Classical appearance but a Romantic soul', and the book can end with a flourish which links Sutherland's work directly to Wordsworth's poetry. As Ayrton comments in his Introduction to *Aspects of British Art*, 'One is hard put to it to think who, other than Reynolds, could be included in a hypothetical companion volume of "British Classical Artists".'

Other writers during, and just after, the war were also reinforcing this persuasive view of our English art as always having been lyrical, emotional and literary rather than preoccupied with formalism. Kenneth Clark, Eric Newton, Geoffrey Grigson, Keith Vaughan, Robin Ironside and Michael Ayrton all wrote in this vein, as did Betjeman and Sackville-West when describing the works of Piper and Sutherland in the popular *Penguin Modern Painters* series. By implication, and sometimes directly, they also conveyed the view that the recent incursions of continental Constructivism and Surrealism had distorted the true native vision. Only Herbert Read seemed to oppose this view in print.

Writing this influential book, and debating Romanticism, Surrealism and Abstraction with fellow artists, were only two activities during Piper's war years. He was exceedingly busy, making this perhaps the most fertile period in his long and prolific career. He was on the WAAC's list of 'fine' artists, that is those who would respond to bomb damage 'which is picturesque in itself', whereas their 'topographical' artists were meant to make factual records rather than strive for works of art. So at Coventry Cathedral, for example, Randolph Schwabe made objective documentary drawings while Piper made his freer emotional responses. In the bombed cities such artists as Muirhead Bone, Vivian Pitchforth, Dennis Flanders and many others were recording skilfully, but flatly, those same scenes of destruction which were to stimulate Piper and Sutherland so much and to bring their first taste of public esteem. The need to record buildings which were as yet undamaged also suddenly became the artists' task when the enemy began the so-called Baedecker Raids, named after the famous guidebooks.

Quite early in the war Churchill had accepted the principle of reprisal raids on non-military targets – though not everybody agreed with him, and Bishop George Bell vigorously opposed the idea in public and in the House of Lords. Sir Arthur 'Bomber' Harris of the Royal Air Force was eventually persuaded that 'the main and almost the only purpose of bombing was to attack the morale of the industrial workers'.[41] On 28 March 1942 Harris ordered an experimental fire-bombing raid on the historic town of Lubeck. It was not a vital target, Harris later admitted, but nevertheless half the town was destroyed. Hitler, in a fury, retaliated with the Baedecker Raids aimed at English towns and buildings of outstanding beauty, usually in towns with little industry and consequently weak defences. On 24 April 1942 Exeter was bombed, then Bath, Norwich, York and Canterbury, some of them twice. The RAF replied by wiping out 600 acres of Cologne. Later still, in 1945, during the fire-bombing of the civilian centre of Dresden as many as 135,000 people may have died. In a time of moral chaos like this all the artist could usefully do was record the nation's architectural treasures as quickly as possible before they disappeared. Piper made accurate topographical drawings for the WAAC and from 1940 for the Pilgrim Trust's 'Recording Britain' scheme. On the recommendation of Kenneth Clark he was also commissioned by Queen Elizabeth to make water-colours of Windsor Castle which was thought vulnerable to air attack. This task deferred Piper's call-up for the RAF indefinitely. As usual Piper did his homework and wrote to Betjeman, 'I follow unworthily in the footsteps of Paul

Sandby* who did two hundred water-colours for George III which I am instructed to look at earnestly before starting' (23 August 1941).[42] He completed twenty-six paintings of the castle and environs in 1941–2. In these he reined back his love of mixing media and exaggerated colouring in the buildings but could not resist the temptation to dramatise the threat from the skies, knowing from his Constable studies that the sky is, in Constable's words, 'the keynote, the standard of scale and the chief organ of sentiment'. An oft-repeated anecdote tells how King George VI, no great aesthete or conversationalist, could only respond to the works shown to him with, 'Very poor weather you seem to have had, Mr Piper.'

Piper recorded not only the damage war inflicted on England, but also some of its more positive aspects, such as the unloading of locomotives sent by our American allies for scrap metal, and other unusual cargoes in Cardiff and Southampton docks. In Cardiff he worked on a dockyard panorama, sketching – because of spy mania and the need for privacy – from the top floor of a refrigerated warehouse, 'a rather sinister place. . . . 18 storeys of nothing but meat, all covered with icicles . . . one knew one was alone with all those thousands of frozen carcases – very Kafka-esque. Francis Bacon might have made something of it but it didn't appeal to me.'[43] Near Woburn, Bedfordshire, he observed experiments with bomb shelters and 'window blasting'. These paintings tell us little about the scientific experiments but the circle of ruined shelters in the middle of a derelict brick field lit by moonlight does attain an uncanny Romantic presence reminiscent of Nash's megaliths. Other subjects such as a fossilised tree dug up in a fen during land reclamation proved intractable to art. All these works kept Piper's tools sharp and his eyes running over previously unavailable, or unregarded, subject matter. Some are visual journalism and others have something more. Fortunately the war also left him time to paint subjects nearer to his heart and of his own choosing.

Having researched his book on Romantic British artists Piper seems to have set himself a programme of following in their footsteps and tackling the same subjects, both in tribute and emulation. With Geoffrey Grigson, poet-editor of *New Verse*, he explored the awesome limestone canyon of Gordale Scar in Yorkshire. Grigson, like Betjeman and Piper, was an enthusiast for all things English – wild flowers, ruins, Palmer, Gerard Manley Hopkins and old guidebooks. As Piper drew they reminded each other of Wordsworth's lines:

Then, pensive Votary! let thy feet repair
To Gordale chasm, terrific as the lair
Where the young lions couch; for so, by leave
Of the propitious hour, thou may'st perceive
The local Deity.

Many Romantics had tackled this subject including the poet Thomas Gray, Turner in 1808 and 1816 and Girtin in 1799, but the most famous work of all was the

* Paul Sandby (1725–1809) was the doyen of topographers during Turner's youth and was also one of the founders of the Royal Academy.

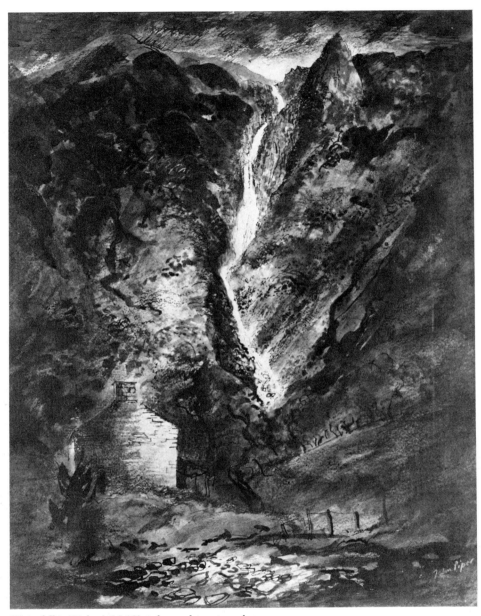

Waterfall in Wales (c1940), ink, wash, watercolour

gigantic (*c.* 11 feet × 14 feet) one by James Ward (1769–1859). Piper knew this from his early lunchtime explorations of the Tate and had reproduced it in his book. He worked from much the same angle as Ward, but omitted the fanciful stags and bulls from the foreground which Ward had used to give scale. Both painters play up the turbulent sky, shadowed crags and tumbling falls and take similar liberties with the actual scene, but Piper's is nowhere near a pastiche and could only be a twentieth-century painting. The scrapings, draggings, scratches and dribbles make it as much about paint as it is about geology. Kenneth Clark, usually rather resistant to modern works, bought it.

Next in 1944 Piper visited Wales, a country he had known as a child and one to which he was to return all his life (his wife, Myfanwy, is of course Welsh). Here he was conscious of following Palmer who went there in 1835 and 1836, the second time with Calvert, and the young Turner who visited five times between 1792 and 1799.[44] Wordsworth went and so did the Italian-trained but native Welshman Richard Wilson (1714–82) who did not swoon before picturesque waterfalls but shouted, 'Well done, water, by God!' Wilson, Piper considered, had taught all the English painters 'the salutary pleasures of exploring romantic hollows and folds in hills, damp valleys and distant exciting mountains screened by foreground trees'.[45] Sutherland painted in Wales almost annually from 1934 onwards so given his example, and Piper's, the younger painters were soon travelling west too. Attracted by the ruggedness of Snowdonia, rather than the smaller-scale scenery of Pembrokeshire, the Pipers began by hiring cottages there but soon came to own their own. The architecture of geology gave Piper a new structural interest and the foulness of the weather new challenges. He seemed to enjoy rough weather almost as much as Turner did and kept detailed notebooks to supplement his sketches. Near the summit of Glyders, for example, he notes:

> Mist blowing across all day: visibility about 15–20 yards only; curious sensation in presence of gigantic boulders, giant coffin slabs, pale trunk-shaped rocks, disappearing into grey invisibility even at close range. The affectionate nature of the mountain is not changed by the acute loneliness and closed-in feeling induced by the mist: but atmosphere of an affectionate cemetery.[46]

Piper was impatient with myth and had no belief in Nash's *genius loci*, though he admitted that as he climbed through the mist 'each rock lying in the grass held a positive personality'. It must reflect the differing natures of the two men that Nash's imagination led him to discover 'monsters' in the lush southern counties whilst Piper found on the bleakest mountain-tops only the sense of an 'affectionate cemetery' – and for church-crawling Piper cemeteries held no fears at all. His paintings of the Llanberis Pass or the screes, corries and rock slabs of Snowdon are conscious efforts to capture the terror at the heart of the Sublime. They are impressively atmospheric works taking on the big subject in a way Nash or Sutherland, or any of their younger followers, could never have attempted.* Ruskin, who tended to

* Sutherland wrote: 'Landscape without the imprint of men, that is to say landscapes which are not gardens or tilled fields – grand landscape – can be awfully boring' ('Thoughts on Painting').

see mountains as either cathedrals, or women with 'heaving bosoms and exulting limbs', informed the readers of *Modern Painters* (and Piper was one) that, 'mountains are to the rest of the body of earth what violent muscular activity is to the body of man. The muscles and tendons of its anatomy are, in the mountain, brought out with a force and convulsive energy, full of expression, passion and strength.' Ruskin drew geology obsessively in the hope of uncovering the hand of God, and Piper too began to anatomise the gaunt body of the land. These are pictures full of menace and foul weather, yet also conveying something of that irresistible force, which pulls men towards these harsh high places.

On a slightly smaller scale he attempted another favourite Welsh subject of Palmer and Turner, that of waterfalls. There are many of these works in all media, each an attempt to show how 'the wild cataract leaps in glory'. There was also a series of ruined barns and cottages, very close in subject and technique to Palmer's *Barn with Mossy Roof* (c. 1828). Those Piper produced in 1941–2 are less particularised than his war-damage buildings, perhaps because they were not for official patrons and were examples of the 'pleasing decay' he preferred to instant bomb damage. They are darker and have more wrist and graininess than Palmer's careful dotting and scribbling techniques, but Piper obviously shares some of his predecessor's interest in texture and colour as we see in Palmer's notes:

> Useful to know by this if in a building with many angles against the sky one wants to neutralize the keenness of the light against one or more of them to do it by this lace work which enriches the building and makes it more solid. Also on the walls grow the most dotty things what a contrast! and they may be near large clumps of chesnut [sic] trees perhaps with leaves as long as a man's forearm, also *soft* velvet moss on *hard* brick wall moss *green* wall *red*. (1824 sketch-book)[47]

More exercises in the picturesque followed with paintings of ruined abbeys (Rievaulx, Birnham, Byland, Llanthony), derelict castles and more big houses, especially Hafod in Wales. The Welsh connection was kept up in his illustrations to verse anthologies,[48] an article on Nonconformist chapels, and *The Mountains*, a limited edition of the poems of R. S. Thomas in which Piper's drawings were wood-engraved by Reynolds Stone in the nineteenth-century guidebook manner.

Piper continued to pay homage to the Romantics he had written about in his book. Constable he imitated in a Stonehenge drawing and a view of Salisbury Cathedral through overhanging trees. In 1951 he was the obvious choice to illustrate a new edition of Wordsworth's *Guide to the Lakes* using ingenious black and white marbled collage to suggest the textures of scree and lake. Blake received the tribute of direct quotation in Piper's backcloths for the Sadlers Wells' ballet *Job* which was revived in 1948. Above all he kept his admiration for Turner, taking on many of his landscape subjects and, like Turner, moving towards a freer, less detailed style based on colour harmonies and paint surface. To bring alive the spirit of a place on canvas any combination of media and method of application was justified

Byland Abbey, Yorkshire (1940), aquatint, hand coloured

– Turner had used his cravat and his bare hands, 'the smallest and dirtiest hands on record' according to his earliest biographer, G. W. Thornbury. After all, as Piper declared, 'intensity is all that matters in painting'[49] and his technical virtuosity was subservient to that end.

Piper obviously drew great strength from the English Romantic tradition of landscape painting and saw himself as heir to its riches. He did a great deal by example and writing to turn the attention of his contemporaries towards their common past and to provide a counterweight to the 'constantly wagging finger of the German (and his student the British) Art Historian' who cowed the British into believing that all our past and present art and architecture was inferior to French or other continental examples. Above all the Anglophobia of Roger Fry and Clive Bell irritated him. 'I despised a lot of his [Fry's] criticism . . . he was over-elaborately keen to publicise modern French.' He also told me he thought Fry's own paintings 'stinking awful', and, greatest offence of all, Fry disliked Turner and dismissed Cotman as 'vastly overrated' and his paintings as having an 'underlying sentimental vulgarity'.

After Fry's death Herbert Read emerged as the senior critic who pleaded the case for avant-garde painting before the indifferent jury of the British public. But he too, and the most uncompromisingly modern painter, Nicholson, bowed the knee to all things French (to the ludicrous extent of both wearing berets!). Myfanwy Piper thought there were two main enemies for progressively minded artists in the 1930s and 1940s; those who hated all art since Monet; and those who blindly

followed wherever the *Ecole de Paris* led. The latter were the most dangerous because they had power in the art world. 'You don't want to look at that stuff,' said Duncan Macdonald* of the Lefevre Gallery during an Ivon Hitchins' exhibition. 'Come up and see my Derains.'[50]

Fry's literary executor, Kenneth Clark, did his best to temper Fry's Francophilia and to encourage artists such as Nash, Piper, Sutherland and the younger Neo-Romantics who represented a more accessible (to him) modernism than Nicholson's. The wartime isolation of Paris and the broken state of its art after the war all helped to loosen the French domination of English painting. Once Piper knew he no longer *had* to make obeisance then he could freely admit that yes, of course, French painting had a lot to teach English painters. He admired Picasso all his life, met Braque and several other masters in their Paris studios and entertained Léger, Hélion and Calder in his home. One thing he learned from Cubism, 'the great grey and beige scaffolding of 1912' as Breton called it, and its later developments in the 1920s, was discipline. Piper always needed to be reminded of the straight line if he was not to dissolve his pictures into flurries of brush strokes, abstract textural effects and rainbow patches. He took similar lessons from Poussin and Claude. This was the severe, rational side of French art which acted as a curb on him, but where could he find a French painter to match and confirm his own lyrical gifts of bold colour, vivacity and spontaneity? Wyndham Lewis pointed out the obvious and only candidate: 'Dufy himself could not handle water-colour and wash with more deftness and bravura than he.'[51] Piper acknowledged the parallels thinking Dufy's work both 'larky and intelligent', though Dufy lacked Piper's ability to suggest the sombre moods of weather and architecture.

There seems little need to supply further details of Piper's career since the late 1940s. He has continued to travel the length and breadth of Britain, and France and Italy too, though he has never flown. Each picture is given as its title the name of the place which inspired it, 'meaning that there was an involvement *there*, at a special time: an experience affected by the weather, the season and the country, but above all concerned with the exact location and its spirit for me.'[52] Even if the paintings are worked up years and miles from the original site of his sketches this immediacy of response is what Piper is trying to re-imagine and then re-create. Somebody called him a deep traveller: he does not just set up an easel in a pretty village but explores all the buildings there, good and bad, sacred and secular, and runs a knowledgeable eye over the agriculture, flowers, geology, churchyard railings and lettering on shop fronts. There is no spiritual dimension in all this, none of Nash's anthropomorphism or Sutherland's sense of sinister things lurking in the undergrowth, only a straight-forward sensuous enthusiasm for what he sees. In this sense he might be called a less imaginative painter than the other two and would probably not deny it. 'My aims in painting', he wrote, 'are to express a personal love of country and architecture, and the humanity that inhabits them, and to increase my own understanding and nourish my own love of the work of other

* Macdonald supported the Bloomsbury painters Bell and Grant, but later he also gave assistance to Colquhoun and MacBryde.

The Thatched Barn (c1941), gouache, watercolour, ink

painters of the past and present.'[53] He quotes with approval Ruskin's dictum: 'There is nothing I tell you with more earnest desire that you should believe than this – that you will never love art well till you love what she mirrors better,' and Piper sees his own abstract period as a falling away from this high but simple ideal.

Piper believed there was a lifetime's work to be had from the English Romantic landscape tradition, though naturally it had to be adapted to twentieth-century sensibilities and experiences. By the mid-1950s most of his fellow Neo-Romantics had lost this belief and gone off down more fashionable avenues, some of which turned out to be dead-ends. Piper's determination to preserve a continuity with our nation's cultural past has been seen by some critics as retrograde and anachronistic. One writes of him changing the modern world into 'costume drama',[54] and, presumably in a reference to his narrow range of subject matter and distinctive style, of 'another Suffolk tower well and truly Pipered'. Another, in what seems to me a total misreading of Piper's zest and energy, complains of his 'inky-black pessimism which drove him to shout for the last forty years, "Repent for the modern age. Repent for using the colour pink. Repent for living in cities and liking it." '[55] Piper can afford to ignore them all, and cheerfully does so.

Nevertheless, for one who claims to love his fellows, his landscapes and buildings

do appear unnaturally deserted. One can believe that wartime streets were empty during the blackout and that his obscure village churches may not be visited from one weekend to the next, but not that he could find the whole of Brighton uninhabited or come across a tourist-free vista in Venice or Rheims Cathedral. Sutherland's landscapes too are devoid of people, and we have seen that Nash's were because, we speculated, he was uneasy drawing people and probably did not care for them all that much anyway. But with Piper neither of these reasons is true. He has drawn from the nude as a discipline all his life; done many 'variations' upon works by Poussin, Cranach, Raphael, Giorgione, Mantegna and Titian, all involving figures; and exhibited drawings from photographs of a woman in black underwear – a kind of datedly 'naughty' subject. More recently he has painted some frankly embracing couples to accompany *Indian Love Poems* by Tambimuttu. Obviously too he is no misanthrope, as everyone who is anyone in art, music, literature, ballet, theatre, architecture or crafts seems to have found their way to Fawley Bottom. Nor could he have achieved so much in theatre design, pottery, mosaic, tapestry and glassware if he did not have a talent for getting on with his collaborators.

The answer must lie in the demands of the pictures themselves. He avoids making works cluttered up with people in T-shirts, or driving last year's motor car, or carrying Marks and Spencer's shopping bags because he is trying to let something timeless emerge, something emanating from the stones of the place that pre-dates, and will post-date, the specific afternoon he sketched there, a something he has called its 'spirit'. Turner and Palmer would have understood.

'Literary painter' was the charge most frequently levelled at Nash, but for all Piper's wide reading and skilled writing the usual epithet hurled at him is 'theatrical'. H. J. Paris, writing about the war drawings, thought, 'It is always a bit stagey, owl-hooted, bat-haunted, and as though something had gone wrong with the footlights.'[56] Alan Ross thought the war-works resembled ballet backcloths, 'to the extent that it is sometimes difficult to associate them with real events. Even the bombed churches are of backdrop thinness . . . and the insult to them is essentially aesthetic.'[57] Some of these criticisms may have been made with the benefit of hindsight since Piper had not then made his reputation as a designer for Aldeburgh, Sadlers Wells, Glyndebourne and Covent Garden. Obviously there is some justice in this criticism, though it might be chronologically more accurate to say his stage sets look like his paintings, and a comment he made in 1953 reveals that was his own view and practice:

In designing décor, it seems to me there are two workable general principles: to base designs on complete imaginative visions, if one has any, or to re-assort facts from visual appearance and painting practice. Being defective as an imaginative vision-seer I took the second course. Each scene was in fact a re-assortment of the parts of pictures I have painted or hope to paint.[58]

Piper's use of a black backdrop sky to throw a façade into relief and his curious

'spotlight' effects on significant detail are probably taken back into his paintings from his stage experience. 'Theatrical' seems a charge that will stick, though why it should necessarily be seen as an offence I fail to see. Piper would happily plead guilty, as he tells us:

> I always had a feeling for an empty stage that wanted filling with something; I've had it ever since I was about twelve. I remember feeling how marvellous it would be to create something when the curtain went up – there it was. Quite oblivious, I'm afraid, of the people who were going to take part in it![59]

The people still have not made their entrances, but the point is that it *is* people who are waiting in the wings, not God, or Pan, nor a *genius loci*, nor a 'standing form', nor a flock of fairies. And when the play begins it will have to be full of large passions, energy, laughter, love and death because no sordid little domestic drama could survive against magnificent sets like these.

REFERENCES

1. Ingrams, Richard and Piper, John, *Piper's Places: John Piper in England and Wales* (London, 1983), p. 21.
2. Fry, Roger, *French, Flemish and British Art* (London, 1951) pp. 197–204.
3. Finberg, A. J., *The Life of J. M. W. Turner* (Oxford, 1939).
4. Blake, William, *Descriptive Catalogue* (London, 1809).
5. Sutherland, Graham, 'A Trend in English Draughtsmanship', *Signature*, July 1936, p. 9.
6. West, Anthony, *John Piper* (London, 1979), p. 55.
7. Read, Herbert. 'Our Terminology', *Axis*, No. 1 (London, 1935), pp. 6–8.
8. Evans, Myfanwy, 'Dead or Alive', *Axis*, No. 1, p. 3.
9. Moore, Henry, 'The Sculptor Speaks', the *Listener*, 18 August 1937, p. 449.
10. Piper, John and Grigson, Geoffrey, 'England's Climate', *Axis*, No. 7, pp. 5–9.
11. Chipp, H. B., *Theories of Modern Art: A Source Book for Artists and Critics* (Berkeley, California, 1968), p. 474f.
12. Ibid., p. 478.
13. Clark, Kenneth, *The Romantic Rebellion: Romantic versus Classic Art* (London, 1973), p. 32.
14. Piper, John, Catalogue to Tate Gallery Retrospective Exhibition, November 1983–January 1984, p. 1.
15. Newton, Eric, *In My View* (London, 1950), p. 59.
16. 'Jean Hélion at 81', *Art and Artists*, June 1985, p. 21.

17. Piper, John, 'England's Early Sculptors' in *The Painter's Object* ed. Myfanwy Evans (New York, 1970, reprinted from 1937 Bodley Head original), p. 123.
18. Ibid., p. 70.
19. Bertram, A., *Paul Nash: Portrait of an Artist* (London, 1955), p. 223.
20. Larkin, Philip, *Required Writing* (London, 1983), p. 208.
21. Betjeman, John, *First and Last Loves* (London, 1952).
22. Richards, J. M., *The Castles on the Ground* (London, 1946).
23. *Oxfordshire: A Shell Guide* (London, 1938), p. 51.
24. Pearson, John, *Façades: Edith, Osbert and Sacheverell Sitwell* (London, 1980), p. 190.
25. Ibid., p. 375.
26. Harries, M. and S., *The War Artists* (London, 1983), p. 161.
27. Nicholson, Ben, 'Notes on Abstract Art', *Horizon*, October 1941.
28. Piper, John, leaflet to Tate Gallery Retrospective Exhibition, p. 2.
29. Calder, Angus, *The People's War: Britain 1939–1945* (London, 1971), p. 552.
30. Republished with several of the others mentioned in one volume, *Aspects of British Art* ed. W. J. Turner (London, 1947). Page references here and in the Ayrton chapter are to this volume.
31. Fry, Roger, 'Retrospect' (1920) in *Vision and Design* (London, 1920), p. 195.
32. Piper, John, 'British Romantic Artists', p. 161.
33. Ibid., p. 162.
34. Gilpin, William, *Observations Relative Chiefly to Picturesque Beauty*, 1786.
35. Price, Uvedale, *Essays on the Picturesque*, 1794.
36. Wordsworth, William, 'The Tables Turned'.
37. Piper, John, 'British Romantic Artists', p. 174.
38. Ibid., p. 206.
39. Bertram, A., *Paul Nash: Portrait of an Artist* (London, 1955), p. 132.
40. Piper, John, Catalogue to Tate Gallery Retrospective Exhibition, p. 38.
41. Calder, A., op. cit., p. 330.
42. Piper, John, Catalogue to Tate Gallery Retrospective Exhibition, p. 99.
43. Harries, M. and S., op cit., p. 204.
44. Wilton, Andrew, *Turner in Wales* (Mostyn Art Gallery publication, 1984).
45. Piper, John, 'British Romantic Artists', p. 165.
46. Piper, John, leaflet to Tate Gallery Retrospective Exhibition, p. 3.
47. Lister Raymond, *The Paintings of Samuel Palmer* (Cambridge, 1985), Notes to Plate 16.
48. *English, Scottish and Welsh Landscapes*, ed. J. Betjeman and G. Taylor (London, 1944).
49. Barber, Noël, *Conversations with Painters* (London, 1964), p. 66.
50. Piper, Myfanwy, 'Back in the Thirties', *Art and Literature*, Winter 1965, p. 136.
51. Lewis, Wyndham, the *Listener*, 6 April 1950.
52. Piper, John, in preface to 'European Topography' catalogue, Marlborough Gallery, London 1969.
53. Piper, John, in 'Painters' Progress' catalogue, Whitechapel Art Gallery, London,

May–June 1950.
54. Feaver, William, the *Observer*, 18 December 1983.
55. Januszchak. Waldemar, *Guardian*, 2 January 1984.
56. Paris, H. J., 'English Water-Colour Painters' in *Aspects of British Art*, p. 109.
57. Ross, Alan, *Colours of War* (London, 1983), p. 50.
58. Piper, John, in *Arabesque* (1953), quoted by S. John Woods in *John Piper: Paintings, Drawings and Theatre Designs 1932–1954* (New York, 1955), p. 17.
59. Barber, Noël, op. cit., p. 60.

*GRAHAM
SUTHERLAND*

GRAHAM SUTHERLAND came from the same comfortable middle stratum of Home Counties society as Nash and Piper. His father too was a lawyer, and later a civil servant. The family was musical and several aunts painted watercolours. Sutherland was born a few months earlier than Piper in the London district of Streatham, but was soon moved out to grow up in Surrey and Sussex and to spend his summer holidays at Swanage in Dorset. In spite of having a younger brother and sister he seems to have been a rather solitary child with interests in geology and natural history. Though he showed no unusual precocity he began to draw early and copied the illustrations from editions of the classics, particularly those by Arthur Rackham, a family friend. Like Piper he was also inspired by the Macmillan *Highways and Byways* guidebooks.

After preparatory school he went, like Piper, as a day-boy to Epsom College but showed no sign of academic promise and left before his sixteenth birthday. In 1919 he was sent north to serve an engineering apprenticeship at the Midland Railway workshops in Derby. However, on one occasion he was trapped inside a shunting engine boiler which brought on his lifelong claustrophobia, and it also became plain that, like Nash, he was a mathematical dunce, so very wisely, after one year, he left. It was not all loss since he gained a feeling for machines which he never lost and which he fully exploited as a war artist. Later he wrote:

> I have always liked and been fascinated by the primitiveness of heavy engineering shops with their vast floors. In a way they are like cathedrals. Certainly they are as impressive as most cathedrals I've seen and a good deal more impressive than some.[1]

Piper could never have expressed such an irreverent sentiment!

Freed now to choose another career Sutherland applied to the Slade School of Art, but it had no vacancies. Instead he went to Goldsmith's College, a less specialised institution founded in 1891 in New Cross, South London. Sutherland stayed there until 1926 taking the usual courses in life-drawing, composition, oil painting and so on, but also picking up very diligent work habits from friends who sometimes

Number Forty-nine (1924), etching

began work in the studios before 7.30 a.m. The college seems to have been less turbulent and more ploddingly academic than the Slade, and less disturbed by rumours of new Parisian fashions. Sutherland recalled being shown Matisse and Cézanne reproductions by one tutor but he and his friends, with the arrogance of youth, dismissed them as 'superficial' and 'inept'.

During the 1920s there was a British revival in fine print-making techniques. In wood-engraving miraculous things were being achieved by Gill, Ravilious, Gibbings, Farleigh, Raverat, Hughes-Stanton, Hermes, Macnab and many more, including of course Paul Nash with his *Places* (1922) and *Genesis* (1924). There was an equally booming market for those print-making with metal. Etching was taught thoroughly at Goldsmith's even if it was rather 'hidebound' in Sutherland's opinion. His friends there, Paul Drury (1903–87), Robin Tanner (b. 1904), William Larkins (1901–74) and Edward Bouverie Hoyton (b. 1900) all became outstanding etchers once they had found more inspiring teachers outside the school.

Etching is basically a fiddly time-consuming method of making small monochrome images in series. Samuel Palmer liked etching because it spared one 'the dreadful death-grapple with colour which makes every earnest artist's liver a pathological curiosity'. It also appealed to the mechanical tinkerer and risk-taker, as Palmer explained:

But the great peculiarity of etching seems to me to be that its difficulties are not such as to excite the mind to 'restless ecstasy', but are an elegant mixture of the manual, chemical and calculative so that its very mishaps and blunders (usually remediable) are a constant amusement. The tickling sometimes amounts to torture but, on the whole, it raises and keeps alive a speculative curiosity – it has something of the excitement of gambling, without its guilt and its ruin.[2]

The acknowledged master of this craft in Sutherland's youth was Frederick Landseer Maur Griggs (1876–1938) – 'He had a palm as delicate as gossamer,' Sutherland remembered. It was his drawn illustrations to the thirteen volumes of the *Highways and Byways* guidebooks which had inspired both Piper and Sutherland as boys. When the older man offered both friendship and technical advice Sutherland was flattered to receive it. He and Paul Drury spent the Christmas of 1926 with Griggs learning about inking plates and printing them. Above all he helped to augment their growing enthusiasm for Palmer.

At first the Goldsmith group had looked to past masters such as Rembrandt, Dürer, Whistler and Millet. Sutherland's own early works show these sources very clearly; *Sluice Gate* (1924) and *The Philosophers* (1924) are both indebted to Rembrandt, and *Greenwich* (1923) is very near in feeling to Whistler's 1859 etchings of Thames-side subjects. Then in autumn 1924 William Larkins showed his friends a Palmer print, *The Herdsman's Cottage*, which he had bought in Charing Cross Road. This tiny work ($3\frac{13}{16}$ inches × 3 inches) came as a revelation to them all. Sutherland recalled:

I remember I was amazed by its completeness, both emotional and technical. It was unheard of at the school to cover the plate almost completely with work and quite new to us that the complex variety and multiplicity of lines could form a tone of such luminosity.[3]

After these densely worked late etchings of Palmer's they traced his *oeuvre* back to the inspired oils of the Shoreham period (1826–34), and the sepia drawings from about 1825 onwards, and found these equally rewarding in their emotional power and their technical aspects. Sutherland studied them intently:

The landscapes were daring and drawn from unexpected viewpoints: *The Girl in the Ploughed Field** astonished me with its total disregard for conventional composition. The drawing is almost what we today call naif.[4]

None of this was news to Griggs who had loved Palmer's works since he was a schoolboy. From 1915 onwards this veneration had been reflected in Griggs' own etchings and drawings. Through the First World War, the Depression and the

* This is probably the sepia drawing now known as *Landscape: A Girl Standing, c.* 1826 (Tate Gallery), see page 120.

The Village (1925), etching

General Strike years he continued to etch a medieval pastoral England where all was peace; labour was sweet, dignified, and its own reward; and the Catholic church spread its canopy over all. This anachronistic day-dream world appealed to Sutherland's group, and the nostalgic Catholicism of Griggs also struck a chord with Sutherland himself since he too was now a convert. He had met a chic and pretty fashion student at Goldsmith's, Kathleen Barry, embraced her religion, married and moved to Farningham in Kent, not far from Palmer's 'Valley of Vision' at Shoreham.

Palmer's name suddenly seemed to be everywhere in the English art world. Two other eminent etchers and Palmer enthusiasts, Frank Short and Martin Hardie, joined with Griggs in 1923 to publish editions of five previously unpublished plates of Palmer's. Then in 1925 *The Followers of William Blake* by Lawrence Binyon appeared, which covered the works of Linnell, Calvert and Richmond as well as Palmer. In 1926 a comprehensive exhibition at the Victoria and Albert Museum, 'Drawings, Etchings and Wood-cuts by Samuel Palmer and other Disciples of William Blake', revealed new treasures.* Later, when Sutherland's generation had

* Palmer was represented by 75 drawings, 17 water-colours, 24 illustrations to Homer and Dante, and 69 etchings.

worked through their Palmer periods, the advocacy of Kenneth Clark, and Geoffrey Grigson's book, *Samuel Palmer: the Visionary Years* (1947), were to keep Palmer's work before the eyes of the younger Neo-Romantics. Later still, the efforts of Raymond Lister and others would prevent Palmer's reputation from sliding back into the obscurity in which Griggs found it at the turn of the century.

Sutherland's allegiance to Palmer's style lasted only a few years, but by the end of that period younger painters such as Vaughan, Minton and Craxton had caught the enthusiasm from him. He later recalled how fiercely he must have preached: 'Between the years 1927 and 1930 I was very conscious of the English tradition and rather aggressive about it. I used to think, for instance, of Samuel Palmer as being essentially the English Van Gogh, which is not so far-fetched in retrospect, because of course he painted suns and moons and so on.'[5] It was this deliberate harking back to Blake and Palmer rather than seeking contemporary Parisian models which earned our group of painters the label Neo-Romantics. It seems a pertinent question to ask at this stage, therefore, just what these nineteenth-century artists could offer ambitious young painters in the 1920s, 1930s and 1940s.

Palmer is often pigeon-holed as a disciple or follower of Blake, and it is true that he revered the older man as an artist and seer. Yet the differences between them, at first sight, are more obvious than the similarities. On a personal level Blake was a radical thinker on politics and religion, strongly egalitarian and totally didactic in his approach to art. Palmer, on the other hand, was an orthodox High Church Anglican passionately opposed to the relief of Catholics and Dissenters, and a political conservative who deplored the Reform Bill of 1832. He firmly turned his easel away from the rick-burning, machine-smashing peasantry of Kent to paint a mythical England where the yokels ploughed with oxen, strolled home singing hymns by moonlight, and happily worked in fecund landscapes where the crops recalled Thomas Traherne's vision: 'The corn was orient and immortal wheat, which never should be reaped, nor was ever sown. I thought it had stood from everlasting to everlasting.'[6] Virtually all his pictures are of landscapes, whilst Blake's ideas were channelled through the human figure, usually nude.

Blake's figures were not based on life-studies, though he had done these competently enough in the Royal Academy Schools, but were derived from the works of other artists. He was after platonically ideal forms, not realism, not sensuality and not eroticism, and in the search for ideal beauty the study of Nature had no part to play since it was unrefined and too full of specifics. (Though elsewhere, as we have seen, in the matter of knowledge he believed 'To Particularize is the Alone Distinction of Merit.') 'To Learn the Language of Art Copy for Ever is my Rule,' he wrote, but he meant by that copy the already idealised figures of such great artists as those of classical antiquity and Michelangelo – in this at least he agreed with Reynolds. These artists he knew only at second-hand from engravings or copies of the kind that Palmer was employed to make during his Italian honeymoon (1837–9). From these sources Blake adopted a highly stylised language of gesture and facial expression and slowly enlarged it to involve the whole body as he entwined his figures or hurled them up, down and across the pages of his books,

Pecken Wood (1925), etching

all hammily over-acting their ecstasies and anguish. Fry, who was insensitive to linear works, thought 'Blake translated Michelangelo into mere line, line which does not evoke volume at all, but remains pure line; and he lets his lines wave about in those meandering, nerveless curves which were so beloved by Celtic craftsmen long before. He shows in this a strange atavism which may not be unconnected with his mental malady – for personally I cannot doubt that he was the victim, but a very happy victim of a well recognized form of mental disease'.[7] Nevertheless, Fry admitted that 'his disposition of forms are so significant they cause profound emotions without reference to what they represent,' which is not how Blake would have conceived them at all.

Sutherland admired Blake and saw himself as a follower in the same tradition, but the stumbling block was Blake's contempt for the 'Vegetative Kingdom' of scenery and natural objects. In his *Annotations to Wordsworth* Blake notes, 'Natural objects always did and now do weaken, deaden and obliterate imagination in me' – it was the essential difference between the poet from London and the poet from Cumbria. Nature for Blake was a symbol or it was nothing. This seemed to Sutherland a weakness, at least in the early works: 'Had he nourished his conceptual ideas by familiarizing himself with the ways of nature, his art might have reached the perfection of its maturity at an earlier period.'[8] For Sutherland it was always

necessary to work 'parallel' to Nature for 'we are deceived if we work contrary to our inclinations or to nature'.

Curiously the most seminal of Blake's works, for the purposes of our Neo-Romantic story, are in a wholly untypical medium (wood-cut) and of a wholly uncharacteristic subject (landscapes). In 1820 Dr Thornton, a noted physician and botanist, needed illustrations for his school edition of the *Pastorals* of Virgil and, on advice, commissioned Blake to make seventeen wood-cuts. His publishers ridiculed the results: 'This man must do no more', they told Thornton and turned to safer hands. At this, several artists including Thomas Lawrence, James Ward and Palmer's father-in-law John Linnell put pressure on Thornton to retain Blake's little gems. This he did, apologising to his readers as follows:

> The illustrations of this English Pastoral are by the famous BLAKE the illustrator of Young's *Night Thoughts*, and Blair's *Grave*; who designed and engraved them himself. This is mentioned as they display less art than genius, and are much admired by some eminent painters.[9]

These tiny works (approximately $1\frac{3}{8}$ inches × 3 inches) knocked Calvert and Palmer all of a tremble. Here is Palmer's reaction:

> They are visions of little dells, and nooks and corners of Paradise; models of the exquisitest pitch of intense poetry. I thought of their light and shade, and looking upon them I found no word to describe it. Intense depth, solemnity, and vivid brilliancy all coldly and partially describe them. There is in all such a mystic and dreamy glimmer as penetrates and kindles the inmost soul, and gives complete and unreserved delight, unlike the gaudy daylight of this world. They are like all that wonderful artist's works the drawing aside of the fleshly curtain, and the glimpse which all the most holy, studious saints and sages have enjoyed, of that rest which remaineth to the people of God.[10]

These were the little glimpses of Paradise Palmer himself wished to provide in his paintings and etchings. Blake confirmed his own conviction that the only way to see was to see religiously.*

Sutherland's first etching in the Palmer manner is *Cudham, Kent* (1924) where the setting sun, dipping behind a barn and trees, makes dense shadows. *Barrow Hedges Farm* of the same year is even more densely cross-hatched, and *Number Forty-nine*, also 1924, showing a tumble-down thatched cottage is another favourite Palmer subject.† In *Crayfields* (1925) the sun sets behind hop-poles and there

* Palmer's first allegiance had been to Turner. Palmer first showed work at the Royal Academy when he was fourteen and on that occasion saw Turner's *The Orange Merchantman at the Bar* (1819), 'and being by nature a lover of smudginess, I have revelled in him from that day to this. May not half the Art be learned from the gradations in coffee grounds?'[11]

† All works mentioned are reproduced in *Graham Sutherland: The Complete Graphic Works*, introduced by Roberto Tassi (London, 1978).

appears the first of those enormous stars which proclaim they signify more than mere lights in the evening sky. The fullest extent of Palmer's influence is seen in *The Village* (1925) where every bit of the plate has been heavily worked and every texture differentiated with a myriad of marks. A woman kneels in the foreground with a basket of potatoes and nearby are a harrow and a plough – a mannerism of Palmer's was to litter foregrounds with rural implements. Ploughed furrows and a hedge lead the eye past barns to oast-houses and a church tower then up into the dusky sky where birds are gathering. The reverential hush deepens further in *Pecken Wood* (1925) and *St. Mary's Hatch* where peasants carry sheaves home past the graves of their ancestors in the churchyard. One impression of this plate Sutherland inscribed with a quotation from Psalm 14, 'Lord who shall dwell in Thy tabernacle? Who shall dwell in Thy holy hill?' *Lammas* (1926), *May Green* (1927), *Michaelmas* (1928) and *Meadow Chapel* (1928) are similarly pious landscapes of the mind which take over from Palmer, Blake, and Griggs properties which are meant to function symbolically such as white doves, single huge stars, praying or working figures, churches and chapels, sheep, fruit trees and corn sheaves, and over all the encroaching shadows of twilight. These are technically skilful and sincerely reverential works by the young Sutherland, but they are made in a borrowed style and depict a never-never Christmas card land which was anachronistic even when Palmer first created it. Sutherland seems here to have adopted Palmer's motto of 'The Past for Poets, the Present for Pigs'.

Then, in 1929, a marked change of mood came into the etchings. *Hangar Hill* (1929) plays tricks with perspective, taking a viewpoint from about the level of a barn roof and bending tree trunks over tightly to enclose a stooped figure in an arch. *Cottage in Dorset* (1929) also emphasises dramatic perspective lines, and though we have yet another white bird flying to the dark woods behind the narrow building it no longer seems to remind us of the Paraclete. Then come three etchings which cannot be interpreted in terms of Palmer's vision of the world, though they are still densely textured and dark in tone. In *Wood Interior* (1929–30) the trees are no longer in compact leafy clumps but have thin trunks which begin to curve with the menace of snakes, and in *Pastoral* (1930) two of these have whipped over like white tentacles, groping towards a shattered stump that begs to be seen in animistic terms. Around this time he had befriended Paul Nash and perhaps he had taken a hint from the older artist's fondness for 'monsters' and 'presences' lurking in trees. In this year too, in April, Sutherland became the father of a son, but after a very anguishing three months the baby died. The Sutherlands decided to have no more children.[12] Whatever the cause of it, there is a palpable shift in the etchings of 1929: they are no longer Christian in feel and neither are they optimistic. It is as though Palmer's sun had finally set and a chill had crept into Arcadia.*

The Garden (1931) is the last etching we need consider, though it is a significant one. Sutherland had built up quite a reputation at home and abroad in this specialised world of print-making and was selling his works in editions of eighty-five

*One friend who did not abandon the Palmer manner and vision was Robin Tanner whose book *Wiltshire Village* (Collins 1939) is illustrated with the most exquisitely nostalgic etchings and drawings.

The Garden (1931), etching

through the Twenty-one Gallery, exhibiting them with the Royal Society of Painter-Etchers and Engravers, and having them accepted in the Royal Academy Summer Exhibition every year from 1923 to 1930. He was also teaching the craft two days each week at Chelsea School of Art. Then things began to go wrong. First in October 1929 came the Wall Street Crash which spoiled the rich American market for fine prints. Then the Royal Society refused to exhibit *The Garden* in its annual show because it was too stylised, the perspective was odd, and the central rose tree seemed too large, rhythmic and self-contained in its own nimbus of light – in short, it was not traditional enough. 'What is Sutherland up to? I wish he would leave Nash alone,' grumbled F. L. Griggs, seeing his former disciple slipping away towards modernism.[13] Sutherland, who was a proud and sometimes prickly man, left the Society (or was expelled for not paying his subscription) and, like Nash and Piper, turned to more commercial means of earning his keep. He designed glassware, stamps, tapestries, crockery and posters for Shell-Mex and London Transport. Amongst these 'The Great Globe, Swanage' poster for Shell shows clear Nash influence in subject matter and in the dry spare handling of foliage and simplified clouds. So does the 'Brimham Rock' poster about which he wrote a poetic essay for Myfanwy Piper's *The Painter's Object* showing he was already seeing rock formations in terms of human heads, and those rocks which stood in water as 'unmentionable bathers'. These works brought him to the notice of Kenneth Clark who soon became a shaping force in Sutherland's career.

Nash provided one link between his Palmer period and his more mature style and Sutherland gratefully acknowledged this. His teaching at Kingston College and Chelsea (where he now moved from etching to book illustration) also brought him into contact with more progressive contemporaries such as Henry Moore and Ceri Richards. Sutherland had previously tried a few Palmeresque water-colours or gouache landscapes, but now he felt the need to conquer oil-painting as well as to find his own outlook on life. He diligently copied landscapes, tone by tone, though he later destroyed these exercises as failures. A few were exhibited at the time with the London Group and the New English Art Club, but somehow the pretty scenery of Kent, Devon, Dorset and Sussex did not seem to provide the spark he needed.

At last in 1934, aged thirty-one, Sutherland hit upon a subject matter and a way of seeing it that he could make uniquely his own. 'From the moment I set foot in Wales I was obsessed,' he wrote. Unlike Piper he was not attracted by the Sublime vistas of Snowdonia ('Can you imagine anything more boring than mountain gorges?' he asked his friend Douglas Cooper), nor did the picturesque cluster of buildings at St. David's Head appeal to him. Rather it was the small intricate valleys, twisty lanes and wooded inlets of the country north and south of St. Bride's Bay which enthralled him. This liking for the intimately enfolding view is a feature of Sutherland's work – as it had been of course with Palmer in the Shoreham paintings of valleys and walled gardens.*

* Oddly, however, when Palmer visited Wales in 1835 and 1836 he was hunting the Sublime, trying to widen his scope by tackling subjects such as Snowdon, great waterfalls and Tintern Abbey.

Like Nash and Piper Sutherland was a gifted writer. He analysed what Wales meant to him as a painter in a famous letter addressed to a patron, Sir Colin Anderson, a shipping tycoon and friend of Kenneth Clark, which was published in *Horizon* in 1942.[14] By that date his Pembrokeshire pictures were widely admired and several of the younger Neo-Romantics had accompanied him on his yearly pilgrimages to this area the Welsh call 'Little-England-Beyond-Wales'. Pembroke was sufficiently different, he tells Anderson, foreign but accessible and unthreatening. It was a miniature landscape full of intricate detail where the ground rises and falls from plains to conical peaks, to marsh, to terraces and down into the sea at St. David's Head. It is densely strewn with primitive hut remains, rocks, cromlechs, goats' caves, cairns and scanty fields each with a spear of rock at its centre. Nearer the sea the land is fissured by steep little valleys reminiscent of Shoreham:

These valleys possess a bud-like intricacy of form and contain streams, often of indescribable beauty, which run to the sea. The astonishing fertility of these valleys and the complexity of the roads running through them is a delight to the eye. The roads form strong and mysterious arabesques as they rise in terraces, in sight, hidden, turning and splitting as they finally disappear into the sky. To see a solitary human figure descending such a road at the solemn moment of sunset is to realize the enveloping quality of the earth, which can create, as it does here, a mysterious space limit – a womb-like enclosure – which gives the human form an extraordinary focus and significance.

Though Sutherland claimed to suffer all his life from claustrophobia he seems in his pictures to be decidedly more agoraphobic as he strives to capture this 'bud-like', 'womb-like enclosure'. Unlike Nash and Piper, who made pictures full of sky, Sutherland often forces the horizon upwards to exclude it, increasing this powerful sense of burrowing into the land. Later of course in the tin-mines of Cornwall he did this literally, making us feel 'the enveloping quality of the earth' in the most palpable way.

Having plunged down 'a green lane buried in trees' Sutherland stumbled upon another magic place – a small cove:

I wish I could give you some idea of the exultant strangeness of this place – for strange it certainly is, many people whom I know hate it, and I cannot but admit that it possesses an element of disquiet. The left bank as we see it is all dark – an impenetrable damp green gloom of woods which run down to the edge of low blackish moss-covered cliffs – it is all dark, save where the mossy lanes (two each side) which dive down to the opening, admit the sun, hinged as it were, to the top of the trees, from where its rays, precipitating new colours, turn the red cliffs of the right-hand banks to tones of fire. Do you remember the rocks in Blake's 'Newton' drawing? The form and scale of the rocks here, and the minutiae on them, is very similar.

The crepuscular hush in Palmer's pictures was very like Wordsworth's

It is a beauteous evening, calm and free;
The holy time is quiet as a Nun
Breathless with adoration.

But something melancholy and rather sinister is beginning to creep into Sutherland's sunset works. He is now noticing an impenetrable damp green gloom, strangeness, disquiet, the contrasts between life and decay all around, and 'the horse's skull or horns of cattle lying bleached in sand' and 'the half-buried wrecks and the phantom tree roots, bleached and washed by the waves'.

'The quality of light here is magical and transforming,' he writes; it explodes 'as if one had looked into the sun and had turned suddenly away'. This magical light enabled Sutherland to experiment with a range of intense colours usually absent from our moist green countryside: magenta, orange, egg-yellow, lemon, purple, raspberry and lime, more like the tints of junk food than jewels. These glowing patchworks were looped round and stitched together by a rambling black line and punctuated by jagged black areas of shade – the overall effect being reminiscent

Low Cliff with Trees (c1942), watercolour

of coals in fire. Sometimes the darkness spread and engulfed the whole. As Sackville-West put it, 'Sutherland's obsession with darkness resulted in a bass octave of so fuliginous obscurity that some of his finest inventions, such as Sir Kenneth Clark's *Landscape with Sullen Sky* can be properly distinguished only in very bright daylight and cannot be reproduced satisfactorily at all.'[15] The same writer, who was also a music critic, thought these inky shadows 'made a second tune, like contrapuntal music', and indeed Sutherland himself was now making very frequent use of the word 'rhythm' to talk about his approach to painting.

These water-colours bear no relationship to the genteel English tradition in that medium for, as Sutherland said, Pembroke had cured him of any desire to paint 'scenic' pictures with foregrounds, middle distances and horizons, and nicely clustered trees in the Claude manner. He now preferred to come in close to his subject matter, containing it all within the rectangle of the paper rather than implying continuity beyond the frame. He turned his back on the sea, averted his gaze from the sky and stalked the woods and shoreline collecting roots and gorse, or sketching eroded rocks, spiky hedges, mossy walls, or noting how the overhanging hedges of the steep lanes 'pinch the setting sun'. Even when napping on the warm shore he made discoveries:

My eye, becoming riveted to some sea-eroded rocks, would notice that they were precisely reproducing in miniature, the forms of the inland hills.

Piper, painting not so many miles away, made the same discovery:

In paintings of North Wales, as of many mountain areas, a rock in the foreground often shows the same form and, in its fractures and the way it lies, the same direction as the whole mountain or range in the distance.[16]

Sutherland was not an open-air painter; these things were 'stuff for storing in the mind' and then, back in the studio in Kent, they were given time to marinate in the subconscious, shedding irrelevancies and accreting powerful emotional associations. 'For me it was always a question of starting with the concrete and re-creating something more concrete,' and on another occasion he declared, 'I found I could express what I felt only by paraphrasing what I saw.' These then are not pictures of Wales but of an inward territory – though Sutherland could always give a map reference for the bend in the lane, or produce the bit of driftwood, which sent him down this inward path.

When Sutherland began to paint back in the studio from his notes and recollections he started to produce 'personages', a word he probably borrowed from Nash. Shadows, he noticed, 'had a presence; certain conformations of rock seemed to go beyond just being a rock, they were emanations of some kind of personality'.[17] Like Nash, he claims not to be making similes but something more real:

It is not a question so much of a 'tree like a figure' or a 'root like a figure' –

it is a question of bringing out the anonymous personality of these things; at the same time they must bear the mould of their ancestry. There is a duality: they can be themselves and something else at the same time. They are formal metaphors.[18]

The personalities which were emerging were far from benign. In *Gorse on a Sea Wall* (1939), a three-pronged pallid claw spirals towards us out of a darkness shot with mustard and purple. A bloated corpse-like form surfaces out of the ocean depths of *Green Tree Form: Interior of Woods* (1940).* In *Horned Forms* (1944), lurid orange, acid yellow and deep red serve only to emphasise the pallor of the 'Presences', their fierce horns tipped with purple. A melodramatic ink drawing, *The Blasted Oak* (1941), shows a single-clawed monster screaming in anguish or rage. How much more lurid and expressionistic these creatures are than Nash's 'monsters', and how unpleasing his 'decay' is compared with Piper's. He has stumbled on the same discovery Dylan Thomas made – that Nature works implacably and simultaneously to create and destroy:

> The force that through the green fuse drives the flower
> Drives my green age; that blasts the roots of trees
> Is my destroyer.
> And I am dumb to tell the crooked rose
> My youth is bent by the same wintry fever.[19]

Even the justly famous *Entrance to a Lane* (1939) does not offer pleasure round the next bend – look at those sharply centrifugal black shadows which act independently of all light sources; the scratching black foliage which might also be winged creatures swarming in from the top; and the troubling ambiguity of certain details such as the whitish form on the left, the brown flame shapes on the far bank, and the shape like a tilted eye at ground level. Half close the eyes and all recession disappears, the forms flatten and rear up – Sutherland, as Keith Vaughan noted, had 'destroyed perspective' in order to enhance the disquiet he sensed in all about him.

Sutherland wanted to paint precise forms but evoke imprecise connotations and cited poetry as a precedent: 'Coleridge said that poetry gives most pleasure when generally and not perfectly understood . . . So in painting it might be argued that its very obscurity preserves a magical and mysterious purpose.'[20] He was ready to look for confirmation of his views in other artists too. Nash of course had made his contacts with the *genius loci*, and believed with Sutherland that 'the unknown is just as real as the known, and it must be made to look so'. Nash had also isolated the *objet trouvé* from its natural setting and given it a sinister personality and, as Sutherland acknowledged, led him 'to think of certain objects in nature as being sanctioned as fit and possible subjects for a picture'. Nash of course had taken this liberating insight from the Surrealists and, for a moment, it looked as if Sutherland

* The first of his paintings bought by the Tate for 50 guineas in 1940.

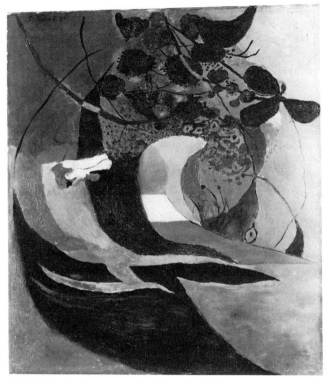

Entrance to a Lane (1939), oil on canvas

would turn to them too. At Roland Penrose's invitation he submitted two minor works to the 1936 International Surrealists' Exhibition and went along to admire the exhibits of Arp and Picasso, and particularly Miró's *The Reaper*. The rest he thought 'far too smooth and very badly done', and the circus atmosphere must have put him off. Similarly Cubism offered nothing, and Nicholson's brand of abstraction failed to touch him. He was unwilling to sacrifice the rich associations which recognisable forms carried with them, for as he pointed out, 'A button and a buttock have two different meanings, beyond their differences of shape.' Sutherland had not been invited to join either the 7 & 5 Society or Nash's Unit One and because he lived in Kent he had not become absorbed in the 'nest of gentle artists' gathered round Herbert Read in Hampstead. Nor was he politically minded enough to join the anti-Fascist grouping of the Artists' International Association founded in 1933. Sutherland enjoyed society, but in artistic terms was very much a loner and preferred to lead rather than become beholden to others.

The London showing in October 1938 of Picasso's *Guernica* and its sixty-seven preparatory studies did make a big impression on him, however. Here was something which confirmed his hunches and showed him how to realise them:

Picasso's *Guernica* drawings seemed to open up a philosophy and to point a way whereby – by a kind of paraphrase of appearances – things could be made to look more vital and real. The forms I saw in this series pointed to a passionate involvement in the *character* of the subject whereby the feeling for it was trapped and made concrete. Like the subject and yet unlike. Everything I saw at this time seemed to exhort me to a greater freedom . . . Only Picasso, however, seemed to have the true idea of metamorphosis whereby things found a new form through feeling.[21]

Sutherland now began to read more widely in *Cahiers d'Art* about what was happening in Paris, but he still made no effort to go, though he could well afford to now after successful exhibitions at the Rosenberg and Helft Gallery (1938) and another at the Leicester Gallery in 1940. He had left it too late to change his mind anyway as Europe was now cut off by war.

Kenneth Clark, as part of his avowed ambition to keep young British artists alive and working, recruited Sutherland as a War Artist alongside Piper and Nash. Clark's prestige at this time was enormous and his practical support as a public and private patron was worth a good deal. He had worked at Oxford's Ashmolean Museum, studied in Italy with Berenson, been appointed Fry's literary executor on his death in 1934 and then, in that same year, been installed as Director of the National Gallery at the age of twenty-nine. As Surveyor of the King's Pictures from 1934 to 1944 he became close to the new Queen, Elizabeth, after 1937, and was able to suggest Piper for the Windsor water-colours, as we have seen. His vast social circle encompassed Bloomsbury, the Sitwells, business tycoons, theatre people such as Noël Coward, politicians such as Chamberlain and Churchill, writers of the stature of Wells, Huxley and Connolly, musicians, academics, aristocrats, aesthetes, and of course selected artists who were swept into this rich milieu at Clark's house in Portland Place. Like Fry before him his tastes were founded on a deep knowledge of Renaissance and French art and his lectures on these and other topics rapidly thrust him into the position of grand panjandrum of culture that Fry had once occupied. Like Fry he admired the Post-Impressionists and had an impressive collection of his own, including Cézanne, Matisse and Bonnard. His only blind spot seemed to be abstract art which he thought spiritually undernourished and out of contact with reality. In 1935 there was a brisk exchange of letters with Herbert Read on this topic in the *Listener*, Read of course maintaining, with Nicholson, Moore, Hepworth and Piper in mind, that all the best artists of the day were abstractionists.[22] Eric Newton, another influential critic and supporter of the Neo-Romantics, sided with Clark. The result was an honourable draw.

When the National Gallery was empty of its treasures Clark could turn his abundant energies to other things. Apart from the WAAC he was influential in founding the Council for the Encouragement of Music and the Arts (CEMA)* which eventually

* CEMA was founded in January 1940 and given a sum of £50,000 from Government funds to take the arts to the people in the provinces as well as the already privileged capital – 'the best to the

metamorphosed into the Arts Council; he was Head of Films in the Ministry of Information for a period, then became Head of Publicity; he was a member of the radio programme *The Brains Trust*, and a constant speaker on platforms and radio upon all aspects of art to a population hungry for beauty during those drab war years.

When the National Gallery closed in 1939 Clark moved his family out of London to Upton House in Gloucestershire. Sutherland's teaching job finished when Chelsea Art School was evacuated to Northampton and his Kent home became surrounded by distracting military preparations to face an expected invasion by the enemy. He and his wife were therefore glad to become Clark's house guests at Upton during the first years of the war. Henry Moore also moved there for a time, and the music critic Eddy Sackville-West (later to sit for a Sutherland portrait and to write a *Penguin Modern Painters* book on the artist in 1943) was also a guest. Clark had liked the Sutherlands from first acquaintance and was glad to take them under his protective wing along with many other artists. At the end of the war he loaned Sutherland money to buy his White House at Trottiscliffe so his support was of the most practical kind as well as artistic.

From this comfortable Gloucestershire base Sutherland set out to fulfil the commissions he received from the WAAC. These were very varied indeed. Like Nash he began by painting aircraft but with no great success, and then his subsequent works can be grouped under the headings of bomb damage in Swansea, the City of London and the East End round Canning Town and Silver Town; next came open-cast coal-mines in Abergavenny; then stone-quarries in Derbyshire, tin-mines in Cornwall, iron foundries in Cardiff, gun manufacture in the Woolwich Arsenal, and finally a brief visit to France to draw flying-bomb sites and wrecked locomotives. Each of these presented new challenges in painting terms, but also in the difficult conditions of noise, heat, darkness and speed under which he had to work. His technique, developed in Pembrokeshire, of using gouache and chalks and inks for subsequent elaboration in the studio now came into its own. He produced 150 works of various kinds, at first as small individual commissions, and then in the tax year 1941–2 he earned £435 for his work, in 1942–3 £450 and in 1943–4 £786 15s. 8d. – not at all bad. His letters to the WAAC secretary E. M. O'Rourke Dickey, neat and to the point after Nash's nagging scrawls, asked for petrol coupons for his car so he could keep the crowds off (some resented him drawing newly bombed houses), protect his work from rain, and avoid the claustrophobia he got on trains and buses. This was granted. Later, however, he ran into a noose of red tape over his claim for £17 expenses incurred over seventeen days. He forcibly expressed his resentment at having to use twenty-nine clothing coupons to buy pyjamas, braces, boots, cap-badge and shirts to go with his Home Guard battledress. These letter files at the Imperial War Museum open up like time-capsules from another world, as well as giving insights into the artists' and bureaucrats' priorities in our time of maximum danger.

most'. The *Daily Express* protested, 'The Government gives £50,000 to help wartime culture. What madness is this? There is no such thing as culture in wartime.'

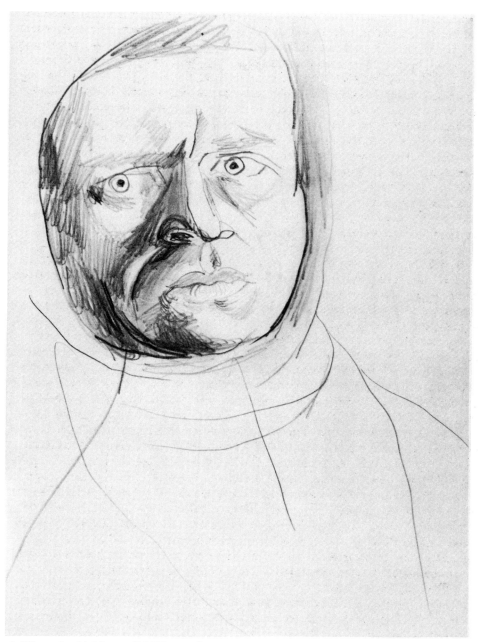

Self Portrait with Mumps (1945), pencil

Sutherland set off for Wales to record bomb damage in some trepidation about whether he could switch from depicting the 'disquiet' of Nature to more straightforward reporting. He was also uneasily conscious after seeing the destruction in the cities that 'one cannot escape the fact that some of us were protected.'*²³ Unlike Nash he had no faith that the work he was doing could influence the war effort in the slightest, though this did not stop him working hard at it. The best of his early works were a series of bombed or burning farmhouses which have lurid or black skies in the Piper manner and dwell on the textures of walls and beams. The subject and textural interest might remind us of Palmer, but there is much more freedom and urgency about Sutherland's brush now and the margin-to-margin density of detail in the Palmeresque etchings is gone for ever. He found after all that his task in front of a bombed house was not fundamentally different from that in front of a lightning-struck tree or a lobster's claw. It was basically to find the appropriate form to embody the artist's emotion. This is a commonplace discovery but it seemed to clarify something for Sutherland, as he explains:

It's the force of the emotion in the presence of such a subject which determines and moulds the pictorial form that one chooses . . . the forms of ruin produced by a high explosive force have a character of their own . . . One day one will feel moved by the purely explosive character of one's subject and wish to get rid of this sensation in a picture. At another time, the sordidness and the anguish implied by some of these scenes of devastation will cause one to invent forms which are the pictorial essence of sordidness and anguish – dirty-looking forms, tormented forms, forms which take on an almost human aspect, forms, in fact, which are symbols of reality, and tragic reality at that . . . in either case the forms which the artist creates will transcend natural appearances.²⁴

When the bombardment of London began the Sutherlands returned to their Kent home and Sutherland journeyed up by train to London to record the devastation, commuting with his inks and drawing book as others might with *The Times* and a packet of sandwiches. Later he took a camera, as Nash and Piper did, because it was quicker and called less attention to his presence in sensitive areas. He began to wander the City:

I will never forget those extraordinary first encounters: the silence, the absolute dead silence, except every now and again a thin tinkle of falling glass – a noise which reminded me of the music of Debussy.²⁵

Soon his eye began to pick out those 'formal metaphors' he had sought in the organic and geological details of Pembrokeshire – a lift-shaft, for example, he drew many times.

* Some War Artists were killed, but none in Britain. Thomas Hennell, Albert Richards ('the one real discovery of the war,' said Sutherland) and Nash's ex-student Eric Ravilious all died in service.

Devastation 1941, East End Burnt Paper Warehouse (1941), oil on wood

> . . . in the way it had fallen it was like a wounded animal. It wasn't that these forms *looked* like animals, but their movements were animal movements. One shaft in particular, with a very strong lateral fall suggested a wounded tiger in a painting by Delacroix.[26]

He saw the smashed machinery dangling through floorboards as 'entrails', but also as extraordinarily beautiful. Burned rolls of paper he made to look like the sawn-off logs from which they were originally derived. It was less easy to think in these poetic metaphors when he moved to the densely populated East End areas which the Luftwaffe blitzed repeatedly from September 1940 to May 1941. Sutherland was moved by the long façades of the working-class terrace houses, miraculously still standing in spite of their flimsy structures. His drawings of them suggest empty stages and in these depictions of urban destruction his work came very close to Piper's. Once more, to convey their poignancy Sutherland had to think in terms of metaphor: 'They were great – surprisingly wide – perspectives of destruction seeming to recede into infinity and the windowless blocks were like sightless eyes.'[27]

Throughout the war the Sutherlands managed to keep slipping away to Wales for him to paint less devastated scenes, to refresh his spirit, and to work on his war sketches. On several occasions he was joined by Ayrton, Craxton and Freud and took the opportunity to pass on his views on landscape painting to these admirers. The grimmer side of Wales at war was forced on to his notice, however, when he was asked to paint in the Cardiff steelworks. Now all his sunset colours could be deployed again in the flow of molten iron, flames belching from furnace

doors, glowing crusts of slag and the plop and seeth of boiling metal. Again Sutherland worked with a comparison in mind.

> As the hand feeds the mouth so did the long scoops which plunged into the furnace openings feed them and the metal containers pouring molten iron into ladles had great encrusted mouths.[28]

In this dramatic black and red inferno the steel-men risked their lives teeming superheated metals, feeding the voracious furnaces and tapping their outflow. They began to appear in Sutherland's pictures, small anonymous figures like wraiths amongst the smoking ladles and gigantic moulds. These are ready-made dramas and Sutherland, perhaps remembering his days in the Derby loco sheds, made the most of them.

A contrasting commission took him away from all this flame and heat down the dripping tunnels of tin-mines in Cornwall where the only illumination was from acetylene lamps in the men's helmets. Here were the same tubular enfolding forms he had sought in the overgrown lanes of Pembrokeshire, and the same undulating and dividing byways with which he could play tricks of perspective. Here he found a world of 'such beauty and such mystery' he would never forget it – it was 'stupendous and thrilling to a degree', he wrote to the Clarks. He enjoyed the challenge of a new subdued range of earth colours and the textures of wet rock walls, but he could not ignore the existence of the miners themselves since his very safety depended on their presence and good will. From being the representative generalised figures of miners they began to emerge as individuals as he drew their portraits. This assignment widened Sutherland's scope in an important way, making him confront, for the first time, the possibility of using figures as the starting point for his work.

For the three or four weeks he worked in Cornwall he stayed with his old etching companion Edward Bouverie Hoyton who introduced Sutherland to Ben Nicholson and Barbara Hepworth, now well established in St. Ives and working alongside such people as the refugee Naum Gabo and the art-writer Adrian Stokes. Sutherland told Clark he found Nicholson 'very agreeable and pleasant', but his reactions to Nicholson's work are not recorded and no sign of its influence appears in his own.

During this same year, 1942, Henry Moore also went down a mine to draw, and the year before he had gone underground in London itself to make his famous 'Underground Sleepers'. A comparison of the two artists' works is instructive. Moore was returning to his Hampstead studio one night and was delayed in the Underground by an air raid at Belsize Park. Rather to his surprise he became interested in the lines of people bedding down for the night there along the tube platforms, either because they had already lost their homes or because they feared the bombs on the surface. One of Moore's obsessions as a sculptor was the reclining figure, and here before him were lines of them as far as the eye could see. He had abandoned sculpture for the war period as being too cumbersome and unsaleable but, as he told Herbert Read, 'Drawing keeps one fit, like physical exercises.' He returned on

Two Miners Drilling (1942), water colour and crayon on board

subsequent nights to the underground platforms to look, and to sketch furtively on the backs of envelopes, fearing that to draw openly would offend the people ('It would have been like drawing in the hold of a slave ship'). These notes were later made up into about a hundred large drawings and it was these which really, for the first time, gave Moore a wider audience than the enlightened few – though many Londoners were baffled or insulted by them, failing to see their own feelings and situation portrayed there. The illustrator Edward Ardizzone and artist Felix Topolski also drew in the Underground, showing individualised chirpy Cockneys

adapting with grumpiness or humour to new and difficult circumstances – these were obviously better reportage and easier to relate to than Moore's.*

Moore's drawings are in his newly discovered mixture of wax-crayon with ink or colour-wash on top which gives a weathered, mottled texture as if the flesh had already been turned into carved stone. It was a technique all the Neo-Romantics, including Piper and Sutherland, eagerly made their own. Moore's figures inhabit a tunnel structure with no hint of rails or advertisements and are wrapped in shroud-like garments. They could represent any of the suffering misplaced peoples of Europe or, since their dress and setting lacks all specificity, any group at any time in history. 'Monumental' would be an obvious word to describe them since they give the lie to Fry's complaint, and Ayrton's boast, that English drawing is always linear and never plastic. Opinion on these works was divided between those, like Keith Vaughan, who found them humane and moving and admired the way Moore had gone beyond 'the obvious and the apparent', and those like Douglas Cooper who dismissed them as mere 'art for art's sake' and accused Moore of projecting his own personality first and treating the sleeping and miserable people as models for new sculptures.[29] Kenneth Clark admired them unreservedly and asked Moore to work as a War Artist for WAAC.

Moore volunteered to return to his native town of Castleford in Yorkshire and go down the pits where his relatives had worked whilst he was growing up. It was not an easy option as the coal industry was still seething with bitterness from the days of the 1926 General Strike. Absenteeism, strikes and inefficiency continued to reduce the level of production throughout the war, even after December 1943 when 'Bevin Boys' were drafted in as an alternative to military service. The open-cast mining Sutherland was asked to draw was another strategy to force more coal out of Britain's soil. Moore knew the miners' grievances and the grim nature of their work in these unmechanised, unsafe and still privately owned pits, but it was no part of his purpose to proselytise or glamorise: he was there to make art. The experience forced him away from his usual theme of reclining females and made him study in cramped close-up the male body in action. Two weeks of sketching underground gave him material enough for three months' studio work, after which he asked to be released to concentrate on his own work. The mining drawings are generally considered, even by Moore himself, to be inferior to the Underground ones; they are certainly less interesting as human documents than Sutherland's drawings of tin-miners.

In spite of their missions all over the country, Nash, Piper, Sutherland and Moore still brought their works back to Clark in London for exhibition on the walls of the National Gallery, or to publishers for reproduction in magazines like *Horizon* or patriotic little booklets about the war effort. Clark was determined that these major talents now emerging should also be seen outside the capital. In summer 1941 he opened an exhibition of work by Piper, Sutherland and Moore in Leeds. All four men, plus Colin Anderson and their respective wives, travelled up by train,

* The works of Moore, Topolski and Ardizzone are printed together in *Blitz* (Introduction by J. B. Morton, OUP, 1942).

Limestone Quarry: Working at the Cliff Face (1942), gouache

drinking wine on the way, relaxing and photographing each other.* Clark also helped organise a film about their war work, *Out of Chaos*, which toured the cinemas as a second feature and helped to recruit further admirers (and some detractors).

After his time underground Sutherland emerged to study open-cast coal produc-

* Two of these photographs appear in Berthoud (p. 64) and in Kenneth Clark's *The Other Half* (London, 1977) p. 36.

tion. Here two motifs in particular seemed to fascinate him: the great fanged mouths of the dragline buckets scooping up and vomiting out the earth, and secondly the conical ochre hills this earth was piled into. This assignment, and his next in Buxton's limestone quarries, brought Sutherland into weirdly man-ravaged landscapes where geology was revealed naked as men steadily scraped, blasted, drilled and levered their way below any surface which could support grass, trees or any living thing. Men were dwarfed out of sight by the vast coal workings, but Sutherland came in close again to depict them toiling up slabs of limestone steps or drilling rock preparatory to blasting. Against the vast indifference of geological strata Sutherland needed a human focus, and after his time in the tin-mines he felt equipped to include the figure in his drawings.

Next in 1944 came more furnaces and menacing machines as he drew gun-making in Woolwich Arsenal, and then in November of that year Sutherland made his first trip abroad. The journey was a frustrating bureaucratic muddle but he did get to draw locomotives in a bombed marshalling yard near newly liberated Paris. Whatever locomotive expertise he retained from his Derby apprenticeships days he suppressed in the interest of stressing the pathos of these overturned dinosaurs buried snout-first in bomb craters. Finally he was taken to the sites from which flying-bombs ('doodle-bugs') had been launched, sometimes up to one hundred in a day, to terrify London. These were inside caves, but so successfully had the RAF attacked them that 'the bombs had made holes in the top of the hills. It was fascinating to look up inside the caves and see the blue sky. . . .' The landscape was as ravaged and desolate as that Nash drew at Ypres in World War One, but Sutherland's reaction was cooler, more ironic: 'A lot of Germans had been killed inside the caves and there was a terrible sweet smell of death in them . . . there were bits and pieces of people knocking about, and I did draw some, but they were not allowed to be shown; and I think probably rightly.'[30]

This ended his work as a War Artist. The experience had shaken him up even though he had seen no fighting or been in any more danger than any other civilian. Each year he had been able to escape to Pembroke so that he maintained an unbroken steady progression in his landscape work which he continued after the war, but he had also been privileged to see landscape from deep inside or with its counterpane of soil thrown back. Above all the war had brought him in from his solitary contemplation of humanised trees and rocks to encounter real humans; suffering, toiling, brave people he came to admire. They forced themselves into his works, making Piper's and Nash's stubborn avoidance of them seem even more noticeable and perverse.

Like Piper, Nash and Moore, Sutherland had found the time and energy during the war to pursue other interests. He had designed a ballet (*The Wanderer*) for Frederick Ashton in 1940 and, more importantly, illustrated two books. The first, *Poems 1937–1942*, was by David Gascoyne, a precocious writer whose first volume, *Roman Balcony* (1932), was published when he was only sixteen years old, and by nineteen he had become one of the chief explicators of Surrealism in England. Herbert Read had suggested Sutherland as illustrator to Tambimuttu, the unor-

thodox editor of *Poetry London* who was to publish the book in 1943 with Peter Watson's financial support.[31] The five illustrations in black, grey and red-pink show extreme versions of Sutherland's current preoccupations, so the cover has four pyramidal peaks backed by flames but pierced right-to-left by an arrow. Another shows two facing monoliths influenced perhaps by Nash or Hepworth, and elsewhere horned forms, rocks, a comet and winged insects. The second set of illustrations were three lithographs for the May 1943 edition of *Poetry London No. 9* where he followed Blake's practice of hand-writing the lines to intermingle with the image. The lines are from *Hieroglyphikes on the Life of Man* (1638) by Francis Quarles, a contemporary of Nash's favourite Sir Thomas Browne, and equally preoccupied with man's mortality. Sutherland's four-colour lithographs have a suppressed violence and dramatic force which makes them superior to his work for the Gascoyne volume in my opinion, though Kenneth Clark thought the earlier ones 'the most complete realization I have seen of your landscapes of the spirit'.[32]

In 1944 the European conflict slowly turned the Allies' way. Sutherland's spirit rose perceptibly and he began to take artistic risks. *The Lamp* (1944) shows a cheerful attempt at the still-life manner of Picasso and Braque, and *Smiling Woman*, *Woman Picking Vegetables* and *Woman in Garden*, all of 1945, show him trying to extend his range into less anguished and complicated subject matter, and also to involve

The Blazing Taper on Lofty Hills, inspired by the poetry of Francis Quarles (1943), four colour lithograph

people as the main element in the composition. He reworked his *Entrance to a Lane* in several versions, and tried spiky stooks of corn as if determined to see how far he could handle Palmer's subjects in a modern un-Arcadian idiom. The Pembroke tree-forms, estuaries and rocks continued though with greater freedom in handling than ever before. Several of these works were shown in a mixed exhibition at the Lefevre Gallery in April 1945 and were well received, but the most eye-catching work on show was by a newcomer: Francis Bacon's *Three Studies of Figures at the Base of a Crucifixion* (1944). Whereas Nash, Piper and Sutherland had striven to project their human anxieties on to the organic and inorganic forms in landscapes, Bacon went direct to the naked human body to express even stronger feelings of disgust, sexual inversion, rage, cruelty and isolation. Any cruelty or sexuality in Sutherland's works emerged only through a screen of metaphors, but in Bacon they were tactlessly direct and shocking in the way he reduced the body to a sack of meat with various orifices, the most horrific of which was the screaming mouth.

Bacon's Crucifixion was not a religious work – it was *a* crucifixion rather than *the* crucifixion, and to the extent that it revealed more than Bacon's own psyche it might be said to reflect the bestiality of the war rather than to offer any hint of salvation. Sutherland, on the other hand, was a Catholic convert and was at this time pondering the problem of how to paint *the* crucifixion in an age of scepticism when church art had mostly sunk to the level of kitsch. This task came about because Moore's 'Shelter Drawings' had attracted the attention of an enlightened cleric, The Revd. Walter Hussey, who then commissioned Moore to sculpt a *Madonna and Child* for St. Matthew's, his Victorian church in Northampton.* Next he wanted a painting for the opposite transept and asked Moore who amongst Stanley Spencer, Piper, Sutherland, Matthew Smith, Ben Nicholson and Barbara Hepworth would be best suited to the task. Moore wisely replied, 'Of those the only one who might do something of the quality you require is Graham Sutherland.'[33] Hussey suggested an *Agony in the Garden* which was perceptive, knowing Sutherland's admiration for El Greco's version of the subject, and Sutherland's own penchant for making even plants writhe in anguish. Sutherland chose to attempt the even more harrowing theme of the Crucifixion and began to stalk the subject slowly and obliquely.

Sutherland needed, as usual, to find a metaphor to unlock the image for him: a direct approach was inhibited by his knowledge of all his predecessors' treatments of the subject, and by a peculiar reticence of his own which he confessed to Keith Vaughan: 'It is an embarrassing situation, to say the least of it, to contemplate a man nailed to a piece of wood in the presence of his friends.'[34] He returned to the spiky forms he had found in many of the Pembroke landscapes and began in a series of thorn tree pictures to enlarge and exaggerate their cruel sickle curves. 'As the thorns rearranged themselves, they became, while still retaining their own pricking, space-encompassing life, something else – a kind of "stand-in" for a Crucifixion and a crucified head.'[35] This series occupied him for two years as he explored thorns growing from two stems, then from one, their viciousness accentuated by

* He also commissioned at various times music from Benjamin Britten and Michael Tippett and a picture of the church itself from Piper.

giving them placid green or blue backgrounds. The thorns then clustered into head shapes, each successive version more relentlessly discomforting. Michael Ayrton, whilst objecting to the 'seemingly arbitrary use of small patches of orange' to make the blue and green 'sing' in his big *Thorn Tree* (1946), nevertheless spoke for many of the younger painters when he claimed the picture 'also makes it clear that he is the most important painter of his generation in this country'.[36]

Nature supplied the thorns ('to me they were the cruelty'), and then a recently published book of photographs of the Nazi death camps provided a contemporary reference he could build upon for Christ's tormented body.

> The whole idea of the depiction of Christ crucified became more real to me after seeing this book, and it seemed to me possible to do the subject again. In my case, the continuing beastliness and cruelty of mankind, amounting at times to madness, seems eternal and classic.[37]

No artist can tackle this subject without being aware of earlier versions by other artists. Sutherland, who seemed obsessed by the physical suffering of Christ as a man rather than the redemptive aspects of his sacrifice, found Italian and French treatments too decorative, but in the German sixteenth-century painter Grünewald's great Isenheim and Tauberbischofheim altarpieces he found images which spared the spectator nothing, and prefigured in the emaciated Christ those cadavers in the mass graves of Belsen.* He had learned a great deal about the distortion of forms to serve emotional, expressive ends from a study of *Guernica*, and must also have been aware that Picasso himself had made drawn variations of Grünewald's masterpiece in 1932, and had in 1930 made a *Crucifixion*. Michael Ayrton's attacks on Picasso as the colossus who dominated but destroyed world art evidently irritated Sutherland extremely. In April 1946 Sutherland went to Paris and began to open his mind to French influences as he had never done before.

On 16 November 1946, three years after Hussey had proposed the idea, the *Crucifixion* was revealed to the public. Kenneth Clark, who had unveiled Moore's *Madonna and Child*, this time declined the invitation to do the same for the *Crucifixion* on the grounds that people would think he was operating a clique. He was probably also sensitive to his nickname of 'The Earl of Moore and Sutherland' which had been in circulation since his early support of these two artists. The *Crucifixion* is a powerful work within the traditional canon but unmistakably modern in its distortions and colouring. The body is corpse-grey, symmetrical except for the head which is twisted to one side on a far from convincing neck, and the stomach muscles and rib cage have been schematised. Sackville-West thought the nipples became eyes and the lines across the waist a nose and mouth – which Sutherland denied, but once pointed out it is difficult to reject this interpretation.[38] The crown of thorns is needle-sharp and the wounds naturalistically rendered in contrast to the unspecified background which is a rich purple-blue with seemingly random black patches

* Apart from the reversal of the crossed-over feet Sutherland's Christ is in the exact pose of the one in Grünewald's Tauberbischofheim altarpiece.

and drawn rectangles in black and white. The blue-black contrast, Sutherland explained, meant for him the dual nature of the crucifixion, its balance between tragedy and salvation, the horror of the flesh's suffering and the glory of the spirit's redemption – though so terminal are the figure's agonies that the possibility of resurrection looks remote. Red-ochre box-forms, perhaps rocks, are to each side of the cross, and the feet are distanced from the viewer by a white rope stretched between posts. This last detail he might have derived from his friend Bacon's use of railings and platforms in his pictures, but it seems to me an unfortunate echo of those ropes museum curators use to keep us from touching the exhibits.

Kenneth Clark was, of course, at the unveiling, as were Moore and Piper. A very generous article was written by Piper praising the work for its 'remarkable balance kept between reality and abstraction', and the way it fitted so well into the site. 'The Crucifixion is by a great imaginative painter – perhaps the greatest alive in England today,' he claimed.[39] Douglas Cooper thought, 'Only one other professing Christian artist of this century, Rouault, has handled this great theme with as much skill and real feeling'.[40] But Quentin Bell, now representing the second generation of Bloomsbury, complained of 'the loudly shouted misquotations' in the work.[41]

Whilst working on the Northampton *Crucifixion* Sutherland also painted a *Deposition* (November 1946) which is a tangle of Picasso-derived limbs and smudged Bacon faces. Better is the *Weeping Magdalen* (December 1946) in which the distraught figure is so thrown backwards by her grief that her head hangs upside down as if her whole body was a wave breaking against the cross. Similar expressive contortions occur in both the Virgin and Magdalen on the Isenheim altar *Crucifixion*, and in the wailing mother in Picasso's *Guernica*, but however derivative Sutherland's might be it is a powerful, expressive form he has created. A *Christ Carrying the Cross* which reached its final form in 1953 shows two heavy thugs mistreating a fallen Christ. The scene seems to be set in the south of France on some kind of shady terrace backed by palms and covered in lattice-work. It reveals in its amorphous figures Sutherland's admiration for the works of Francis Bacon. Later came a small *Noli Me Tangere* for Chichester Cathedral where Hussey was now Dean*; a sculpted gold cross intended for Ely Cathedral which was never installed; another large Crucifixion (1960–63) for St. Aidan's Church, Acton with, this time, a vermilion background; and finally the Coventry Cathedral tapestry of *Christ in Glory in the Tetramorph*. We must say more of this vast (72 feet × 40 feet) work later.

These works gave Sutherland the reputation of being England's foremost painter of religious icons; one who could treat a traditional subject respectfully, but still not compromise his modernity. This reputation bears closer investigation, as does the relationship of orthodox Christian belief to those occult insights offered by Neo-Romantic paintings.

Sutherland's first reaction on being given a commission to make a religious picture seems to have been to brood over previous versions of the subject in the history

* In 1964–5 Piper made a *Trinity* tapestry to hang behind the high altar for Dean Hussey.

of art. We have seen how he found inspiration for crucifixions in Grünewald and Bacon and photographs of Belsen, and he tells us how in designing the Coventry tapestry he ransacked the past from Egyptian art to the present day.[42] Secondly, he seems to look for a triggering metaphor – the thorn bushes of Pembrokeshire were magnified and honed by him until they '*became* the cruelty'. What Sutherland selects from the past and from reality is governed, of course, by his own predisposition to favour certain forms and experiences – in short his own psychology. Before 1929 we have seen he sought in Palmer's art and in English landscape inspiration for those cosy little Paradises in his etchings. After that date a distinctly more acerbic view of life is evident. One might deduce from Sutherland's work that he was obsessed by cruel forms in a hostile world. A Nativity or Virgin and Child by Sutherland would be impossible to imagine. When painting a Crucifixion the artist also had to emphathise with the suffering man hanging there:

> I don't normally think in overtones, political, religious or social. People sometimes say, 'Do you mean this to be so-and-so?' 'What is the symbolism behind this?' Generally there is none. If I paint a crucifix, my concern is to invent a series of forms on canvas which are the equivalent of and sum up my feelings for *that* particular form. Just weight and how the body moves in pain.[43]

I believe the Coventry Cathedral tapestry to be a less successful work than his other religious works because he was asked to portray, not a suffering, scourged or dead Christ, but one in calm majesty and glory. Temperamentally, Sutherland was incapable of feeling his way into such a state, no matter how many Byzantine mosaics or French tympana he looked at. The best, and most typically rhythmic and spiky parts of the whole work, are the four panels representing the Evangelists where the Lion, Calf, Eagle and Angel are all in cramped but vigorous movement.

Henry Moore was undoubtedly right to tell Hussey that nobody else could fulfil his commission other than Sutherland. To the challenge of reworking traditional themes in a contemporary accessible idiom Stanley Spencer had responded by domesticating Christ's life into a bit of Cookham-on-Thames gossip. Eric Gill had veered between flat hieratic Crucifixions which looked archaic, and those which were outrageous since they incorporated his own peculiarly erotic obsessions.[44] The Bloomsbury painters Duncan Grant and Vanessa Bell had funked the issue by resorting to pastiche Italian Renaissance, plus a dash of Post-Impressionist colour.* Earlier still the Pre-Raphaelites had painted carefully researched archaeological tableaux, but in the century before that where were our painters of public icons? Ruskin had noted the gap in 1870: 'The English abjure design, and the ideal or theological art, their strength being in portraiture, domestic drama, animal painting and especially landscape.'[45]

The one ingredient which might be expected to be on hand when religious pictures are made is belief. Sutherland, as we know, was received into the Catholic

* Decorations at Bewick Church near their Charlestone home, Sussex.

Church on 21 December 1926. He recalled:

> I kept on for a long time being highly observant of the ordinances of the Church. Then, when I started to get claustrophobia, I found I couldn't go to church without considerable distress – I felt I was hemmed in and couldn't get out. I have never abandoned it . . . but one is bound to speculate on certain things which have a relationship to science, which, of course, the Church has until recently not acknowledged.[46]

These seem to be the words of a less than fervent worshipper. Later, near his death, he seemed to have arrived at a curiously eclectic faith which is practically God-free:

> Although I am by no means *devout*, as many people write of me, it is almost certainly an infinitely valuable support to all my actions and thoughts. Some might call my vision pantheist. I am certainly held by the inner rhythms and order of nature; by the completeness of a master plan.[47]

By middle-life Sutherland attended church on Good Friday and sometimes on Christmas Eve. This is not to deny he could have been a deeply devout man in his private self, but his public pronouncements alone seem to stress the physical rather than spiritual empathy he felt with Christ, and his explanations of his own beliefs are diffident. Does this lack of zeal make his religious pictures weaker? Or more representative of his generation's doubts and experiences of a cruel age? The observer must answer for himself.

Nash was not a painter of religious subject matter and nowhere, that I can discover, discusses his faith or lack of it. We might speculate that for many of his generation the old cliché that 'God died on the Somme' held an essential truth. His search for the *genius loci* and his dying exploration of the Baldur myths show him trying to infuse his pictures with much more than a record of appearances, but they hardly constitute a faith by which he might live, or die. John Piper was accepted. alongside his wife, into the Church of England in 1939 and has since provided windows, tapestries and other furnishings for numerous churches and chapels, and has made pictures of, literally, hundreds more. His love of the *fabric* of the Christian church could not be more evident, but his reverence for the spirit of it does not, I think, come across in his drawings. This separation of faith and work would not have been understood by Blake, or by James Ward who prayed on his knees most fervently before daring to put brush to canvas. An ecstatic letter such as the one by Palmer quoted in the Introduction could not have been written by any of the artists studied here. Over a century of scientific materialism, Darwinism, Freudianism, steady religious decline, two wars in which the commandments to love thy neighbour and not to kill were in abeyance, all had intervened to make such fervently expressed and mystically conceived certainties appear embarrassing to many modern readers. When the devout nineteen-year-old Palmer first met Blake the old man was propped up in bed working on the Dante engravings:

Thorns (1945) pen, ink, black chalk, grey and green wash and gouache

He said he began them in fear and trembling. I said 'O! I have enough of fear and trembling.' 'Then,' said he, 'you'll do'.[48]

This awed apprehension is not the modern style, which runs more to Sutherland's disclaimers about his devoutness, or his seeming flippancy in finding contemplation of 'a man nailed to a piece of wood in the presence of his friends' embarrassing. If the heights of fervour is to be shunned, then so too are the spectacular depths of despair which engulfed people like Ruskin when the rocks on which his faith was founded crumbled to reveal, not the shaping hand of God, but tell-tale fossils.

Our Neo-Romantics are, then, by comparison with their predecessors reticent, diffident, less convinced they have urgent and important truths to impart through their work. They have less idea, perhaps, of what it is they are looking for. Yet their works tell us the Romantic search for spiritual or moral values behind or through the appearance of Nature is still being pursued. They write of their struggles to capture a 'personage', a 'presence', an 'essence', a *'genius loci'*, a 'form', a 'monster', or to preserve the *frisson* of a first encounter. Nash's ladders and birds and sunflowers yearn upwards towards a 'peopled sky'. At their most successful these pictures push back our modern cynicism for a moment – could there be a flicker of truth in those animistic old beliefs that a spirit could inhabit a tree; that a standing stone could be holy; that snaking roots could be malign? The glimpses of the numen we are offered are not reassuring: they only confirm our fears that the twentieth century is a cruel place to be marooned in. Samuel Palmer drew oak trees (the archetypal English tree), striving to make them appear as dignified as Milton's *'monumental* oak', dwelling on 'the grasp and grapple of the roots, the muscular belly and shoulders, the twisted sinews'. Sutherland's *Blasted Oak* is charred, branchless, leafless, hollow and hanging on by a single claw-root whilst screaming. No doubt it is the same cry of rage, or fear, that Velasquez's *Pope Innocent X* utters as he is dragged into the middle of the twentieth century by Francis Bacon.

In April 1947 Francis Bacon helped Sutherland cut away the tendrils which still tied him to English Neo-Romantic painting. Bacon himself had little respect for this tradition and had always felt himself to be a European since his misspent youth in Ireland, Berlin and Paris. Bacon urged his friend to explore the south of France and since they both shared a passion for gambling ('the painter's vice', thought Sutherland) they explored the casinos of the Riviera together. Sutherland also found new subject matter offered by spiky palms, cicadas, cacti, vines, gourds and maize, all under a sky even more dazzling than those he had imagined behind the cruel thorn heads. He returned again in summer, this time with Lucien Freud, and they joined Bacon at Monte Carlo. More sketch-books were filled with banana leaves, mantises, pallisades and pergolas to be worked over later back in Kent. More importantly he met Matisse in Vence, then already infirm, and best of all Picasso at his Vallauris pottery. Sutherland saw Picasso regularly for the next ten years and became a friend – something every one of the Neo-Romantics, including Ayrton, would have envied. Kenneth Clark had given the Sutherlands an introduction to Somerset Maugham at the Villa Mauresque, and from this encounter came another

change of direction, to portrait painting. After the drab war years a whole new glamorous world was beckoning.

In effect this brings us to the end of the story of Sutherland as an English Neo-Romantic painter, except for a little flourish of paintings at the end of his life. Now his range would widen and his ambition turn towards achieving an international reputation. Douglas Cooper in writing the first major study of Sutherland's work in 1961 maintained that he only matured when he had transcended 'the limitations and provincialism' of English art and forced his way into the European, that is French, mainstream. He left behind the 'mannered, genteel, inelegant hybrids' produced by his contemporaries trying to combine an English vision with badly misunderstood versions of Parisian practice. Cooper's damning footnotes make it clear that he had Wyndham Lewis, Moore, Nash and Piper in mind. The 'reactionary influence' of Palmer had retarded Sutherland's development for at least five years; only when he began to learn from Picasso and Matisse could he shake off his provincialism and open up into brilliant colours, surer handling and a more penetrating vision. Nevertheless, Cooper for all his scorn for 'the artistic backwater' of English painting with its inbred traditions, had to admit:

> Sutherland's pictures transmit characteristically English feelings: an attitude to nature which is ambivalent in its reverence, suggesting at once fascination, awe, and horror; a certain fear of vast open spaces and of the peculiarities of natural formations and growth; a love of luxuriance and the mystery surrounding the impenetrable; a pantheistic acceptance of the cycle of growth, fruition and decay.[49]

Other writers, and I would align myself with these, felt that Sutherland lost something when he transplanted himself and his art to France. True, he developed a new lightness and brilliance of colour; new methods of presenting his *objets trouvés* frontally and in a shallow picture space; and he increased the size of his works – but these innovations are not necessarily gains. It could be argued they are seen at their most advantageous when applied to the reworking of older themes such as the Thorn Heads of 1950–51 and the Thorn Trees of 1954–5, and finally to the last Pembroke works of 1967–80.

Once in France Sutherland virtually abandoned landscapes to concentrate on still-lifes. He brought indoors the tough roots, hard-shelled fruits and armoured insects of southern France, put them on a table top against a plain background, and in the unwavering light made dazzling and decorative use of those colours Cooper lists as 'acid pinks and mauve, light blue and orange, scarlet, emerald and chrome yellow, colours which he used arbitrarily to create radiant, exquisite and pleasing effects.' Some of these still-lifes look totally benign, especially the gourds and maize ones. Soon, however, Sutherland's penchant for the sinister reasserted itself and he began to manufacture his own maleficent 'presences' from organic fragments. These stood or lay across the picture plane, isolated against mauve or yellow or blue backdrops; or, in the case of the best-known one, *Standing Form*

Against Hedge (1950), like sculpture on a pedestal in front of a square of bougainvillaea. Whereas in the earlier *Blasted Oak* or *Association of Oaks* he had been content to leave the spectator to interpret the looming forms as he wished, now Sutherland began to stage-manage his creations. In a way that referred back to Wyndham Lewis's combination of the organic and mechanical in his Vorticist period, Sutherland gave his forms flanges and machine-like facets, but also bark, carapaces, husks, nodules and orifices that might just be holes left by torn-off branches. They would have worked well as stand-ins for the Eumenides in T. S. Eliot's *Family Reunion*. He called these creations 'forms', 'monuments', 'presences', each 'emotionally modified from their natural prototype', and intended 'to catch the taste – the quality – the essence of the presence of the human figure'.[50] They were meant to give us the shock we might get from coming unexpectedly upon a real person in a garden or room – though there is no suggestion the surprise would be a pleasant one or that they would be invited to stay on for tea. Their three-dimensional solidity, tactile qualities and human scale were all stressed to enhance their presence, and Sutherland was even driven to sculpt a few in order literally to grasp their physical substance.

Simultaneously with these substitutes for the threatening human presence Sutherland was grappling with the problems of making images of real individuals. The head is, after all, just another *objet trouvé*, as he remarked, and the lined faces of his first two sitters, Somerset Maugham (1949) and Lord Beaverbrook (1951)* did not seem very much removed from the eroded rocks and bleached roots of his Pembroke studies. His approach to both was very similar in its impartiality, the multiple studies, the photographs, the search for an 'essence', and then the hard work in the studio away from the distracting presence of the actual motif. He set himself to become 'as absorbent as blotting-paper and watchful as a cat', submitting to the discipline of 'accepting rather than imposing'. He was now seeking that Romantic particularisation, which Piper had identified for us, where the artist looks so long and hard at his subject that it begins to hum with significance, like a dynamo with electricity. There were two valid strategies open to the modern portraitist who was interested in more than photographic likeness, claimed Sutherland:

One, which I admire enormously, is the real paraphrase such as Picasso does, which to me is marvellous, because the likeness is always preserved. The other is to make a straight attempt at what you see, and that is my course. It is much the same practice, on the whole, which I used in my war drawings . . . to make as clear a presentation as one's gifts allow for what one sees in front of one's face. I think if one does that, sometimes the thing comes full circle, because if the thing is intense enough, in itself it becomes a kind of paraphrase.[51]

We might examine just one of the forty or so portraits Sutherland painted to

* The Bloomsburys were still sniping and Quentin Bell described the *Beaverbrook* as 'looking very much like a diseased toad bottled in methylated spirits' (*The Listener*, 14 February 1952).

see how this intensity sometimes alarmed his powerful aristocratic or glamorous sitters. The commission to paint Winston Churchill's portrait as an eightieth birthday present came in 1954. By then Sutherland had become the most conspicuous English artist on the international scene. He had represented Britain at the 1952 Venice Biennale; had a well reviewed show at the Musée d'Art Moderne in Paris; and mounted large exhibitions in Amsterdam, Zurich, New York and back in London at the ICA. Not all the English reviewers accepted Herbert Read's and Kenneth Clark's high estimations of his work in the catalogue to his Tate Gallery retrospective in 1953: a significant number of critics seemed determined to cut him down to size. They sniped away at his monotonously frontal compositions, meagre paint quality, and the influence of Francis Bacon. Nevertheless, when Jennie Lee suggested to an all-party committee that Sutherland be commissioned to paint Churchill for a fee of 1000 guineas it seemed to everyone an obvious and suitable choice. Sutherland began to accumulate his sketches, photographs and notes in the usual way, not unduly alarmed by Churchill wanting to sit in his Garter Robes, or by his trying to tell the artist how to paint, or by his instructions that his double chin and wrinkles be played down. He also casually mentioned that Lady Churchill had 'put her foot through' an earlier portrait of him by Sickert to which she had taken a dislike. Both painter and sitter were under strain at this time, Sutherland because of the so-called 'Tate Affair' which kept his name in the popular press and lost him several friends, including Piper and Moore,* and Churchill because he was under pressure to make way for the younger Eden as leader of his party and as Prime Minister.

Churchill emerges as a monster of vanity from all accounts of this episode. Sutherland's portrayal obviously fell far short of his own self-image. 'It makes me look half-witted, which I ain't,' he said, and in one of several lavatorial comments, 'Here sits an old man on his stool, pressing and pressing.' John Rothenstein, the Director of the Tate Gallery, by then very bitter about the part Sutherland had played in the gallery's affairs as a trustee, tried hard to keep out of the controversy which followed the portrait's public unveiling on 30 November 1954, but Churchill sought him out to complain:

> I think the time has come for an artist to give some consideration to the *subject* of a portrait, instead of looking over the wilderness of his subject hoping to discern there some glimmer of his own genius.[52]

The portrait disappeared from view and it was later disclosed, in 1978, that it had been burned within the year, though its ultimate destination was supposed to be the House of Commons.

It is difficult to see, from reproductions of the work, what made Churchill so

* This was a complex scandal involving several strong personalities, the abuse of power, allegedly misappropriated funds, and the Tate's policy in buying foreign works. The best accounts of it seem to be in Berthoud, and in John Rothenstein's *Brave Day, Hideous Night* (London, 1966). Sutherland does not emerge with credit from either version.

petulant and so dictatorial in his treatment of art he disliked. His power, physical weight and a pugnacious readiness to rise and do battle are all admirably captured. One might have expected Maugham, Beaverbrook, Sackville-West or Konrad Adenauer to make objections against the violation of the *amour propre* in their portraits, but none did. The one obvious fault is in the indecisive treatment of the legs, and as John Craxton pointed out this was not the first or last time:

> Do you see how Sutherland always had problems with the bottom of his pictures? All of them trail off. The tops of them are always very concise and tight. It was one of those things he had to learn to live with. If you like a pun, then Graham's flaw was at floor-level – it always floored him. It's what's known as the Goldsmith's ground plan.[53]

Sutherland was naturally hurt by Churchill's vandalism. Oddly enough Douglas Cooper, for many years his chief advocate as 'the only major artist who has emerged in Great Britain since the death of that nowadays much overvalued Turner', also destroyed Sutherland's portrait of him after a quarrel in 1975. Cooper also withdrew his critical support, denigrating the later works as weak and repetitive. A more loyal supporter throughout his entire career was Sir Kenneth Clark, but again Sutherland's cool-eyed portrayal of him (as well as his fee) troubled a sensitive ego: 'The portrait makes me look like a snooty dictator – which I'm not at all,' and also it made him look uncharacteristically 'haughty and belligerent'. Craxton reports staying with the Clarks and finding the canvas in an upstairs cupboard, but eventually it found its way to the National Portrait Gallery.

In 1955 Sutherland finally made his main home in Menton on the Côte d'Azur. Now he could paint the green vistas through his own garden, boughs of apples, palm trees, or go indoors and paint in his studio in colours as dazzling as Matisse's. Alternatively, he could head for the kitchen to paint brass scales carefully in balance, or take a stroll to look at the brilliantly tiled fountains in the local villages. In time he moved away from his sinister and equivocal 'presences' to enjoy the good things around him. Animals interested him now as never before. In paint and lithographs he created a whole menagerie of eagles, ants, monkeys, bats, snakes, armadillos, rams, ibises, mice, gigantic toads (much admired by Picasso), beetles, and in fourteen illustrations he shows us the life cycle of the bee. None, it should be noted, are cuddly or domesticated. In time he became the Ted Hughes of paint, and like the poet, who invented 'Wodwo' when he ran out of real species, Sutherland brought into being *The Captive* (1963/4), a kind of cross between Blake's Behemoth and a zoo hippo.* It is stamping and restless in a barred cell and has chains on its front legs – a reminder that Sutherland's view of the natural world was still fundamentally a grim one, even though the sun shone on his back and his palette blazed with reds and greens and yellows.

Sutherland gradually became, like Moore and Piper and Nicholson (now also

* This also exists in a different form as a lithograph, *Chained Beast* (1967).

in exile in Switzerland with his third wife), a Grand Old Man and honours flowed his way. The Tate and the Churchill rows kept his name in the papers, as did the vandal who slashed his *Origins of the Land* picture at the Festival of Britain. Similarly the commission to make the world's largest tapestry for Coventry Cathedral, and the subsequent delays and squabbles, kept the gossip columnists busy rather than the art critics. By now he had a rather glamorous lifestyle and sold most of his work outside England, particularly in Italy where an enormously enthusiastic following of patrons and critics had sprung up following his Turin exhibition in 1965. At home in England he seemed to have achieved fame without respect: the critics continued to sniff at the post-war work, and the younger painters had moved on to Abstract Expressionism, Realism, Pop or whatever, and no longer needed him as a father figure. It must have been galling that his friend Francis Bacon had now outstripped him in critical reputation, and prices.

The adoring Italians persuaded Sutherland to take part in a television film about his career and in August 1967 took him back to Pembroke to potter about with a sketch-book in front of the cameras. To his astonishment he found the light there just as intense as it was in Menton and realised he had been a fool to leave Wales in 1947 believing he had exhausted its pictorial possibilities. Consequently he returned for six or seven weeks every year until his death in 1980, taking his sketches back to Menton to be worked up into large, powerful oils. These exploit the more painterly handling and clear colours he had developed in France, but apply these to his old interests in rocks, roots, rusting chains, thickets and flotsam. Some works repeat the dark colours and actual scenes of early works (*Road at Porthclais with Setting Sun*, 1979), but others moved away to expose new objects in shallow space, or tackled a whole picture in one range of colour, say greens in *Path Through Wood* (1979), or pinks, or browns in *Bird over Sand I* (1975) and *II* (1976). He still liked to blur the distinctions between the mineral and organic, and sinister figures put in an appearance in *The Conspirators* (1977). One work shows the artist himself hunched up with his sketch-book, before a thicket running impenetrably wild and snaky beneath a pale sun (*The Thicket*, 1978).[54] These are large works, full of big simple forms which contain rich intricacies within themselves, and are obviously based on more consciously geometrical frameworks than his early looseknit works. Critically unfashionable these late works may be, but I find in them powerful evidence that Sutherland had returned to the fountain-head of his original inspiration and found it still flowing.

REFERENCES

1. Sutherland, Graham, in *Conversations with Painters* by Noël Barber (London, 1964), p. 48.
2. Lister, Raymond, *The Paintings of Samuel Palmer* (Cambridge, 1985), p. 23.
3. Sutherland, Graham, 'The Visionaries', introduction to 'The English Vision' catalogue, William Weston Gallery, October 1973.

4. Letter to Berthoud, January 1980, in Roger Berthoud, *Graham Sutherland: A Biography* (London, 1982), p. 52.
5. 'Landscape and Figures', Graham Sutherland discusses his art with Andrew Forge, the *Listener*, 26 July 1962, pp. 132–5.
6. Traherne, Thomas (1637–74). *Centuries* ed. H. M. Margolioth (London, 1960), p. 110.
7. Fry, Roger, *French, Flemish and British Art* (London, 1951), p. 176.
8. Sutherland, Graham, 'A Trend in English Draughtsmanship', *Signature No. 3*, July 1936, p. 10.
9. Raine, Kathleen, *William Blake* (London, 1970), p. 182.
10. Ibid., p. 183.
11. Letter to Mrs Robinson, 9 December 1872, in Geoffrey Grigson's *Samuel Palmer: The Visionary Years* (London, 1947), p. 7.
12. Berthoud, Roger, op. cit., pp. 62–4.
13. Griggs, F. L., undated letter to Paul Drury, quoted by Gerard Hastings in unpublished MA thesis '*Neo-Romanticism: its Roots and its Development*' (Aberystwyth, 1984), unpaginated.
14. Sutherland, Graham, 'A Welsh Sketchbook', *Horizon*, April 1942, pp. 225–35.
15. Sackville-West, Edward, *Graham Sutherland* (London, 1943; revised edition 1955), p. 7.
16. Woods, St. John, *John Piper: Paintings, Drawings and Theatre Designs 1932–1954* (New York, 1955), p. 13.
17. 'Landscape and Figures', the *Listener*, 26 July 1962, p. 132.
18. Hayes, John, *The Art of Graham Sutherland* (London, 1980), p. 20.
19. Thomas, Dylan, 'The force that through the green fuse drives the flower', *Collected Poems 1934–1952* (London, 1952), p. 8.
20. Sutherland, Graham, 'Thoughts on Painting', the *Listener*, 6 September 1951, pp. 376–8.
21. Cooper, Douglas, *The Work of Graham Sutherland* (London, 1961), p. 17.
22. See *The Listener*, 2, 9, 16, 23 and 30 October 1935.
23. Tassi, Roberto, *Sutherland: The Wartime Drawings*, trans. J. Andrews (London, 1980), p. 20.
24. Sutherland, Graham, 'Art and Life', the *Listener*, 13 November 1941, p. 657.
25. Tassi, Roberto, op. cit., p. 19.
26. Ibid., p. 19.
27. Ibid., p. 19.
28. Ibid., p. 104
29. Cooper, Douglas, op. cit., p. 27.
30. Tassi, Roberto, op. cit., p. 148.
31. Gascoyne, David E., *Poems 1937–1942*, Nicholson and Watson, Editions Poetry London, 1943.
32. Letter from Clark to Sutherland (1 January 1944) quoted in Berthoud, op. cit., p. 108.
33. Berthoud, Roger, op. cit., p. 114.

34. Vaughan, Keith, *Journal and Drawings* (London, 1966), p. 83.

35. Sutherland, Graham, 'Thoughts on Painting', the *Listener*, 6 September 1951.

36. Ayrton, Michael in *Spectator*, 22 February 1946, p. 192.

37. Sutherland, Graham, letter to E. Mullins published in the *Daily Telegraph Magazine*, 10 September 1971.

38. Sackville-West, Edward, op. cit., p. 11.

39. Piper, John, *Picture Post*, 33, No. 12, 21 December 1946.

40. Cooper, Douglas, op. cit., p. 34.

41. Bell, Quentin, the *Listener*, 14 February 1951, quoted in Roger Berthoud, op. cit., p. 151.

42. Révai, Andrew (Ed.), *Sutherland: Christ in Glory in the Tetramorph* (London, 1964).

43. Barber, Noël, op. cit., p. 46.

44. Yorke, Malcolm, *Eric Gill: Man of Flesh and Spirit* (London, 1981), pp. 121–2.

45. Piper, David, *The Genius of British Painting* (London, 1975), p. 7.

46. Berthoud, Roger, op. cit., p. 56, no date given.

47. Ibid., p. 56, letter to author dated January 1980.

48. Grigson, Geoffrey, *Samuel Palmer: The Visionary Years* (London, 1947), p. 19.

49. Cooper, Douglas, op. cit., p. 2.

50. Ibid., p. 46.

51. In interview with Andrew Forge, the *Listener*, 26 July 1962, p. 134.

52. Rothenstein, John, *Time's Thievish Progress* (London, 1970), p. 136.

53. Craxton, John, quoted by Gerard Hastings in unpublished MA thesis 'Neo-Romanticism: its Roots and its Development' (Aberystwyth, 1984), Chapter V, footnote 19.

54. Many of these late paintings are reproduced in Rosalind Thuillier's *Graham Sutherland: Inspirations* (London, 1982). The originals are in Picton Castle near Haverfordwest, Pembrokeshire.

<p style="text-align:center">4</p>

THE BACKGROUND

Artists, like the rest of us, are members of a society and subject to its temptations, fashions, pleasures and pressures. However diffuse Neo-Romanticism might appear to be as an artistic movement it can still be shown to have rough geographical boundaries, to have its own market-place, and to be sustained by a spreading network of friends, gallery owners, patrons, reviewers and hangers-on. This chapter is an attempt to locate Neo-Romanticism in its place and time, and to show how the ideas of the three senior painters, Nash, Piper and Sutherland, were made available to the younger painters who looked up to them as leaders.

When George Orwell reviewed Malcolm Muggeridge's book, *The Thirties*,[1] he exclaimed, 'What a decade! A riot of appalling folly that suddenly became a nightmare, a scenic railway ending in a torture chamber.' From this distance it certainly looks an unappetising time in which to make a living. There was a rumbling discontent throughout our deeply divided society and increasingly chilly breezes were coming from Europe where, as David Gascoyne wrote at Christmas 1938:

The warning flags hang colourless a while;
Now midnight's icy zero feigns a truce
Between the signs and the seasons, and fades out
All shots and cries. But when the great thaw comes
How red shall be the melting snow, how loud the drums.[2]

Myfanwy Piper recalled how she, and the artists in her circle, reacted to these ominous times: 'We tried to detach ourselves but it was not possible. There was a perpetual mixture of exhilaration and uneasiness. The fear and the horror of war constantly took the attention of the only people who had an understanding of or interest in modern art and literature. The rest were indifferent to both culture and the threat of extermination.'[3] By 'the rest' she presumably meant either the poor, who were too preoccupied with unemployment, means tests and hunger marches to worry about the Constructivism versus Surrealism versus Realism battles, or the frivolous rich dashing off to yet another weekend in a country house or a party

Osbert Lancaster's Landscape with Figures III Fitzrovia, published in *Horizon* January 1942

in Venice, just as if they were still living in the twenties. What was distracting the intellectuals was a new creed issuing from the East. As they saw capitalism flounder into the Depression years they turned admiring and hopeful eyes towards Russia, where there seemed to be a rational plan to ensure full employment under an economic system which did in practice guarantee 'to each according to his needs, from each according to his ability'. Social justice would prevail at last as the class system, the Church and inherited privileges were swept into the dustbin of history.

The Communist Party of Great Britain reached its peak membership of 18,000 by 1939, but its intellectual influence was much wider than this small, publicly committed group would suggest. In the art world, for example, its egalitarian ideas led to the foundation, in 1933, of the Artists' International. Later 'Association' was added to the title to make it appear less blatantly left-wing. This was a loose federation of Academicians, Bloomsburys, Sunday painters, Realists, cartoonists, Surrealists and incompetents, though the Abstractionists were denied any central role because their appeal was not populist enough. The idea was to give the artists a sense of social purpose in taking Art to the People; to establish artists' status and rights as a trade union might; and above all to oppose, by means of their art, Fascism wherever they found it. The chief spokesman for their point of view was the Marxist art-historian Francis Klingender. In Germany and Russia, at least in the early days, left-wing politics had advanced hand-in-hand with revolutionary art, but being both British and orthodox Stalinist, the AIA took as its motto: 'Conservative in art and radical in politics'.

There was an exhibition held in Oxford in 1983 which celebrated the best years of the AIA.[4] This revealed a peak of activity through the 1930s (though no masterpieces), then a lull as the war made Uncle Joe everybody's hero, and a long post-war decline as the Russians suppressed artistic freedom in their own country and coerced its intellectual followers abroad. The Cold War set in and the political clause was dropped from the AIA's constitution in 1953. After that it lost its way and its purpose and was dissolved in 1971. Moore, Nash, Piper and Nicholson were never deeply involved with the AIA at any time, though during the 1930s each donated works to raise funds for the struggle in Spain, or signed petitions for and against things, or loaned their growing prestige to various socialist causes without in any way committing their works, which remained introverted and on private themes. Sutherland remained aloof from all political activity. Herbert Read, now an anarchist, popped up frequently, writing, speaking and organising events, but the more patrician figure of Kenneth Clark was not to be seen on AIA platforms.

A left-wing artistic movement with a less international outlook was announced in 1937 when William Coldstream wrote to the *Listener*:

The slump has made me aware of social problems, and I became convinced that art might be directed to a wider public; whereas all ideas which I had learned to regard as *artistically* revolutionary ran in the opposite direction. It seemed to me important that the broken communications between the artist and the public should be built up again and that this most probably implied a movement towards realism.[5]

The outcome of this was the short-lived Euston Road School staffed by Coldstream, Claude Rogers, Graham Bell and Victor Pasmore. The pictures produced were earnest, carefully observed and rather dowdy views of city life which provide a marked contrast to the subjective, highly coloured visions of the English countryside being offered by the Neo-Romantics. As bridge-builders to the public there is no evidence that realistic depictions of tramcars, or Bolton terraces, were any more efficacious than Piper's theatrical views of country houses.

The British Left gathered adherents from all classes during the 1930s and at last they found a crusade and outlet for their idealism in the Spanish Civil War of 1936–9. There Fascists could actually be killed rather than just booed or jostled as they were when Mosley's Brownshirts took to the streets of London. This conflict aroused the intellectuals of Europe every bit as much as the Greek struggle for independence had fired Byron and his Romantic contemporaries in the 1820s. In round numbers 40,000 foreigners joined the International Brigades, with the 2,000 British volunteers amongst them suffering appalling casualties of 500 killed and 1,200 wounded.[6] It was an old-fashioned war with both sides largely relying on guts, foot-slogging and rifle-power, rather than those specialised skills the coming world-wide conflict would demand in such areas as radar, rocketry, codes, submarines, aerial combat and atomic physics. When the German Condor Division of Heinkels and Junkers destroyed the undefended Basque village of Guernica, by

dropping incendiary bombs on it during the evening of 26 April 1937, it was seen as an abuse of modern technology, and public opinion tipped further towards the Republican side. Picasso's painting *Guernica* helped to keep the memory of this outrage fresh. However, the English artists who saw this work, either in Paris, or in London where it was displayed during October 1938, seemed to take most to heart its expressive use of bold distortions rather than its political reference. Writers flocked to Spain in plenty, but no major British artist ventured there, or saw it as a fit subject for painting. No matter how much sympathy flowed their way, the Republicans eventually went down to defeat and the survivors, like Orwell, limped home made bitter and baffled by the divisive role of the Communists on the Republican side and the Russians' half-hearted support. The disillusion deepened over the next few years as news came in of the Moscow show trials, the Soviet-Nazi Non-Aggression Pact, and the invasion of Finland.

If real politics during the 1930s seemed to polarise to right or left then, Myfanwy Piper found, 'the art politics of the time were intricate, quickly changing and hard to grasp.'[7] Paris seemed to be in continuous disorderly debate over topics most English artists knew little about, and at home the Abstractionists, Surrealists, Neo-Romantics and Euston Road Realists first attracted, then lost, their supporters. Only society portrait painters earned opulent fees so most artists were forced to teach and to take up commercial art. Often they came to believe their posters for Shell or fabrics for Heals were taking 'real' art to the people. Critics such as Clark and Read bickered in the serious papers and *The Studio*, the only English magazine aimed at professional artists, ran articles on 'Why Modern Art is Primitive'. In 1937 it allowed a 'man-in-the-street' to demonstrate to its readers that 'Modern Art is a Sham'. In the same issue a eulogy on 'Italian Art Under Fascism' amply displayed to readers all those virtues of craftsmanship, beauty, optimism, dignity of labour and 'the epic of life and progress' which the 'man-in-the-street' had found so dreadfully absent in modern art. The editor wholeheartedly agreed with him.[8]

In more authoritarian regimes, however, such debates had already been snuffed out. The Reich Chamber of Culture suppressed those artists who used non-academic styles, depicted subjects which were not uplifting by Nazi standards, or made unflattering social and political comments in their works. Many, especially Jewish artists and intellectuals, fled to London where the more 'advanced' were welcomed by Herbert Read and his Hampstead circle who were struggling to establish similar ideas in England. Unfortunately, the London art world did not know how to make these refugees feel safe and at home, nor how to employ their talents, so most moved on to a warmer welcome in New York. There they helped to prepare the time-bomb of Abstract Expressionism, which would be shipped back to Europe after the war was over and would shake our art to its foundations. A second wave of refugees followed the same get-away route as France fell and the Nazis approached Paris, but when they arrived in that city they found the two Spaniards, Picasso and Gris, still at work. Surprisingly, considering Picasso's opposition to Fascism in Spain and his 'decadent' style and subject matter, he was left to paint unmolested – just as he had been throughout the First World War.

In Russia the shut-down of innovative art had begun even earlier. Chagall, Antoine Pevsner, Gabo, Kandinsky, Poliakoff and Tchelitchew all left to donate their gifts to Berlin or Paris, though Malevitch returned and perished. By the mid-1930s Zhdanov and Radek had drawn up the rules for producing 'Socialist Realist' art so rigidly that all traces of Constructivism and Suprematism were eliminated from officially approved Soviet art. The close similarity of the demands made upon their artists by Fascist and Communist regimes for 'Swastickle art' has often been noted before: to please their masters artists had to avoid socially, sexually or politically deviant subject matter and express optimistic faith in collective man's perfectibility: what he should become, not what he is. Exemplary myths must be provided of Man the hero-soldier, Woman the fertile mother, and both as happy workers harnessing the forces of nature to material ends. The classical virtues of authority, dignity, clarity, discipline and high moral seriousness were all to be endorsed and set forth in a literal style. To call this progamme of wishful thinking Socialist Realism, or any other kind of realism, is to abuse the normal use of the word. Yet, in their own way, these iron rules for the production of totalitarian art pay a huge compliment to the power artists have to subvert or uplift their audience's ideas. In England we could feel complacent at this time that free artistic debate continued unmolested by nothing more organised than a sneering press, market forces and a philistine or indifferent populace. On the other hand, we also needed to recall that in Suprematism, Constructivism, Abstraction, Dadaism and Expressionism the Russians and Germans had had an avant-garde so far in advance of our own cautious pioneers that they were well over the artistic horizon whilst we were still picking over the ideas of the Post-Impressionists.

The declaration of war in September 1939 seemed to lance the boil. All these artistic and political wrangles could be set aside because now we had a shared enemy and work to be done. Cyril Connolly recorded in *Horizon* the relief of the intellectual at being able to 'shed the burden of anti-Fascist activities, the subtler burden of pro-Communist opinions'. With a coalition Government in power even local party politics were in abeyance. The older, established artists moved out of London and were set specific tasks by the WAAC, which gave them the sense of social purpose all artists crave for. The big public collections were dispersed into safe storage, and the art schools were evacuated, though they had already stopped recruiting at the outbreak of war. Two thirds of the commercial galleries in the West End closed since it seemed foolhardy to risk all one's stock of masterpieces to one direct hit. The import of foreign works, on which so many galleries depended, now ceased. As an artistic centre London began to look distinctly hollow, though very soon it was the only one still functioning in Europe – apart, that is, from those in neutral countries.

The younger Neo-Romantics came to London because at least there were still a few commercial galleries open (the Leicester Gallery, Lefevre, Zwemmer) where one could see the older artists' work and where one might get a showing in a mixed exhibition. If there were official commissions to be picked up, or private patrons to be found, then London was the only place for them. Nash was now a sick and

solitary man in Oxford, and Piper only called in occasionally from Henley or his WAAC travels, but Sutherland, who was a gifted teacher, seems to have made an effort to contact the younger painters who admired him, and even invited Craxton and Freud to accompany him on sketching expeditions in Pembroke. For the most part, however, the younger painters in our group were left to their own amusements and their own company. Several factors made them a cohesive group during the war years and before we consider them individually it would be instructive to map out the tight little milieu they shared in the beseiged city of London.

Wartime London seems to have been two cities: one for the day and a different one for the night. The daytime one was a place of strain and fatigue as people struggled to maintain business as usual whilst simultaneously coping with unexploded bombs (UXBs), craters and glass in the streets, endless queues, incendiaries and erratic supplies of gas, electricity, water, coal, transport and other essential commodities. Rationing of food, clothing and petrol was severe and led to a lively black market. Movement across country was slow, cold, uncomfortable and not encouraged ('Is your journey really necessary?' asked the posters). Newspapers were flimsy and voluntarily reticent about any events of real importance; sport was virtually at a standstill; there was no racing; and at the start of the war nearly all the theatres closed down for a time. In the terrible winter of 1942, even baths had to be limited and no more than five inches deep in order to conserve fuel. Add to all these miseries the need to lug a gas mask around and do voluntary work in the Home Guard or fire-watching service on top of a full working day (often seven days a week in vital areas), and one begins to get the impression of a totally joyless drudgery. Yet the number of suicides fell, drunkenness decreased and full employment returned. A real thirst for beauty grew in the drab utility world so that films, ballet, theatre, concerts, lectures, art exhibitions, magazines and books were all avidly sought after as never before, or since. The young Neo-Romantics in spite of the dearth of art materials and their austere living conditions managed to produce an impressive body of quality work – and who can blame them if some of it looked escapist?

London at night was sometimes worse and sometimes better than by day. German bombers preferred to raid at night and did so 354 times during the whole war. From 7 September 1940 they returned for seventy-six consecutive nights, apart from one night when the sky was overcast. London's ack-ack guns blazed out, shrapnel fell to earth, searchlights probed the sky, flares went up and down, incendiaries sparkled greenish-white, high explosive bombs whooshed red and yellow, and the silver barrage balloons swung at the end of their tethers to deter dive-bombers. Down by the docks the fire-services hosed millions of gallons over blazing timber, pepper, rum, paint, rubber and oil. How J. M. W. Turner would have loved every minute of it! On nights like this one retreated to the deep underground tube stations, or to the garden Anderson shelter, or if caught in the open, to the vast public shelters, but wherever one went there was little hope of sleep.

To avoid giving the bombers guidance no lights had to be shown. Blackout of all windows was strictly enforced, pedestrians carried dimmed torches, and traffic

edged forward without headlights. Accidents increased in this dangerous murk but nobody welcomed moonlight when it came since a full moon was a Bomber's Moon. City-dwellers for the first time began to read the sky as intently as sailors or shepherds. The only people to read more into moonlight than its potential danger were artists. Sutherland said it gave the feeling 'of being on the brink of some drama', and Bill Brandt, the photographer, thought it 'fantastically beautiful' and with no traffic in the streets he could hold twenty-minute exposures. The new moonlit ruins began to remind critics of de Chirico's disquietingly deserted vistas, but London's were made doubly surreal by the weird effects of bomb-blast leaving façades with no backs, exposed baths, or fireplaces with vases standing on the mantelpiece when the whole roof and upper floors had disappeared. This sinister moon began to appear in Piper's black skies; Sutherland's flimsy terraces lay open to its pallid light; and Nash's iron sea in *Totes Meer* rolled in beneath it. The younger Neo-Romantics took it over as a prop in their own works, the moon appearing almost as frequently in them as it had over Palmer's spires and cornfields and lonely towers – but whereas his moon had cast an amber glow over the homeward-wending rustics these wartime moons were chill and the city-scapes they illuminated were empty of all life.

Night-bound London had its gaiety too, of course, even if this was a little hysterical at times, and then, as now, most tastes were catered for somewhere or other if one knew where to look. Artists and writers needed to meet their kind to swap gossip, relax and talk shop. For many of the survivors this period now seems to bring back memories of shared ideals and a kind of gang warmth. Robert Hewison makes a useful distinction between the two Bohemias where artists found their temporary retreats between the weariness of daytime London and its night-time of bombs.

> Here is a group of writers, poets, painters, musicians, actors (plus the necessary complement of hangers-on, mistresses, entrepreneurs, patrons and journalists), all of varying talent and achievement who collectively experience a specific set of emotional and economic conditions. There is only the vaguest awareness that they constitute a group or that they hold any ideas in common, yet they unconsciously reflect a joint experience in the art to which they are committed. The limitations and difficulties shape and stimulate ideas. That is Bohemia the state of mind. But the group must be fairly small, its members must meet each other regularly, and in a limited area. That is Bohemia the place.[9]

And the place was called Fitzrovia. This is a district with no administrative reality bounded on the east by Tottenham Court Road, on the south spilling over Oxford Street into Soho, on the west petering out before Cleveland Street and Newman Street, and ending in the north by about Howland Street. Charlotte Street is its spine. This area has had a long association with artists since Constable, the Pre-Raphaelites, Whistler, Sickert, Augustus John, Wyndham Lewis, the Euston Road Group, Duncan Grant and Vanessa Bell had all set up studios there when premises

were cheap. Fry's Omega Workshop had operated from 33 Fitzroy Square to attract both the aristocracy and the literary giants of the day such as Virginia Woolf, W. B. Yeats, H. G. Wells and Arnold Bennett as customers. However, the young wartime artists did not come to find studios, or to work, or to pick up historical echoes: they came to drink in the pubs. To single young people living in bed-sitters in Notting Hill or Bayswater or Kensington those licensed premises offered light and warmth and society – and if the next bomb had your name on it, well you might as well go in good company rather than on your own huddled over a one-bar radiator. Wine and spirits were scarce and expensive so private house parties were difficult to arrange, but the draught beer in the pubs though weak, was only sixpence a pint in 1936, though this price had doubled by 1944.

The well-trodden 'crawl' round the Fitzrovia pubs has been mapped in nostalgic detail by veterans such as Ruthven Todd[10] and Julian Maclaren-Ross,[11] and their eccentric inhabitants (including these two) described by several writers. Our tour, therefore, need not linger over-long. The Fitzroy Tavern (nicknamed Kleinfeld's) had been the first pub to gain popularity, but by the beginning of the war had been superseded by The Wheatsheaf where each night Mrs. Stewart downed her Guinness whilst doing crosswords against the clock, and where Dylan Thomas had stolen Caitlin, his future wife, from the libidinous clutches of Augustus John. Other stops during an evening's boozing were The Bricklayer's Arms (called The Burglars Rest because thieves broke in and drank themselves unconscious), the York Minster (The French), The Duke of York, The Beer House, The Black Horse, The Marquis of Granby and then on to The Highlander which stayed open until eleven o'clock, half an hour later than the others because of London's archaic drinking laws. One might then need a sobering coffee at the Café Madrid or Coffee 'An, or, if one had the money, some food at Mme Buhler's, or Schmidt's or Bertorelli's or any of the other cosmopolitan eating places in Charlotte Street or Soho. Determined drinkers could join clubs which operated in the afternoons, or beyond normal drinking hours in the evening, such as Club Eleven, Caves de France, Jubilee, Walley's, The Mandrake, or the one where Dylan Thomas and Maclaren-Ross passed their afternoons when they should have been writing patriotic documentary films, The Horseshoe Club. Maclaren-Ross describes some of the other refugees from work or reality.:

> . . . bookies' touts or ageing Lesbians sitting on leather settees and sometimes some elderly character such as an art critic famous when President of the Union for subtle deadpan wit, of whom Dylan was particularly fond. I personally found this man a thumping bore, with his strange furry cap of hair, round staring eyes, and thread-like lips from which issued at long intervals a tiny insect voice; one strained one's ears in vain to catch some smart crack that never came, but then of course his Oxford days lay far behind.[12]

The Colony Club in Soho became a favourite bolt-hole for Colquhoun, MacBryde, Craxton, Minton, Freud and Francis Bacon who later (1959) painted a portrait of its coarse but tolerant proprietress Miss Muriel Belcher. More deliberately arty was

The Gargoyle, further down Dean Street at number 23, which was founded in 1922 by the rich dilettante David Tennant in order to mix Art and Society. Ruthven Todd explains, 'The hope was that the gilded pollen of the latter might rub off against the bare pistils of the former. The idea was too seldom fulfilled.'[13] At least while waiting to be discovered by some monied mandarin the artist could look through the smoke at Matisse's *Studio, Quai St. Michel* (1916) and the magnificent *Red Studio* (1911) – which an American eventually snaffled for £600!

Many of the denizens of Fitzrovia had connections with the arts. Queen of the tap-rooms was Nina Hamnett (1890–1956), an artist of a pleasant but minor talent who found life (meaning drink, sex and gossip) more interesting than painting, so that by the outbreak of war she had virtually ceased working. Nevertheless, the younger artists including Minton, Colquhoun, MacBryde, Freud and Craxton bought her drinks when they could afford to and listened to her stories. Craxton told her biographer, 'She was a kind of mascot for them, a link with the artistic world of Paris from which they were completely cut off by the war.'[14] She had known Modigliani, Zadkine, Picasso, Brancusi and everybody else in Montparnasse, dined at the Boeuf sur le Toit, and danced till she dropped at La Rotonde (often taking her clothes off to do so). In England too she had posed for and worked alongside Sickert, Wyndham Lewis, Augustus John, Gaudier-Brzeska and been the mistress of Roger Fry. Between her love-affairs and drinking she had illustrated a book on London's statues with a text by Osbert Sitwell, done murals for the Jubilee Club and dashed off two volumes of autobiographical tittle-tattle full of the most outrageous name-dropping.[15] When Dylan Thomas introduced her to Ruthven Todd she baffled even that worldly character by exclaiming in her hearty 'county' voice, 'You know me, m'dear. I'm in the V & A with me left tit knocked off,' which turned out to be a reference to a Gaudier-Brzeska nude she had modelled for.

Hamnett's rival was Betty May, an ex-model of Epstein's, who entitled her ghosted autobiography *Tiger Woman*. Another ex-model in alcoholic decline was Sylvia Gough who had worked with Orpen and Sargent. An artist with real ability but even less grip on life was Gerald Wilde, a former student of Sutherland's at Chelsea, who was led round the pubs of Fitzrovia by the Ceylonese poetry editor, Tambimuttu. He would take a hat round, collecting on Wilde's behalf, then lock Wilde in a room until he produced a saleable canvas or two, or broke his way out in search of alcohol. Lucien Freud's portrait of Wilde (1943) shows how apt his surname was.[16]

It was Tambimuttu who successfully diagnosed and named the illness from which most Fitzrovians suffered: Sohoitis. He warned the writer Maclaren-Ross: 'If you get Sohoitis you will stay there always day and night and get no work done ever. You have been warned.'[17] But the warning came too late for its recipient as he was too far gone. Other writers such as Paul Potts, Paul Kavanagh and Brendan Behan also succumbed to the downward pull Fitzrovia exerted. Louis MacNeice's poem 'Alcohol' was published in *Horizon* magazine in January 1943. Its first verse reads:

On golden seas of drink, so the Greek poet said,
Rich and poor are alike. Looking around in war,
We watch the many who have returned to the dead,
Ordering time-and-again the same-as-before.

And its last:

Take away your slogans; give us something to swallow,
Give us beer or brandy or schnapps or gin;
This is the only road for the self-betrayed to follow –
The last way out that leads not out but in.

It was a road Colquhoun and MacBryde were to stagger down, betraying their gifts.
Several of the writers managed to extricate themselves from Fitzrovia long enough
to achieve a respectable body of work during the 1930s and 1940s, and then go
on to achieve fame elsewhere. Amongst these were George Barker, Alan Ross, John
Heath-Stubbs, William Empson, Rayner Heppenstall, Sidney Grahem and
Humphrey Jennings.*

Fitzrovia's most famous bar-fly was, of course, Dylan Thomas who for much of
the war lived with his wife and child in a single room in Chelsea, decorated only
with reproductions of Moore's Shelter drawings. From there he journeyed into Soho
each day, ostensibly to work on documentary film scripts, but in reality to drink.
Sometimes his wife joined him, but in retrospect she hated Fitzrovia's promiscuity
and its sheer waste of human potential. Looking like 'an unmade bed' with a fag
on his lip (exactly as Michael Ayrton portrayed him in 1945 and again in 1947),
he soon became one of the tourist attractions of the area and hangers-on waited
for him to pass from inspired rhetoric, to boring aggression, and then to sickness
as the pints sank down. Dirty Dylan, The Ugly Suckling, the Disembodied Gland
and the Fucking Cherub were a few of the nicknames he gloried in – and probably
invented to boost his little tough-guy self-image. During the early part of his career
he had been publicly mothered by Edith Sitwell. After a thirties lull she had now
re-emerged to great acclaim with her poems about the blitz and the atom bomb
(*Street Songs* 1942, *Green Song* 1944, *The Song of the Cold* 1945, and *The Shadow
of Cain* 1947). Thomas let it be known he thought she wrote 'virgin dung'. Other
targets for his venom were homosexuals, people in uniform, and Wordsworth.

Not all the visitors to Soho were as insecure or doomed as Thomas. One might
find Augustus John there slumming from the Café Royal in Piccadilly, or George
Orwell and Louis MacNeice over from the BBC, or any of the numerous novelists,
poets and journalists taking a break from the chaos in the Ministry of Information

* Jennings (1907–50) was a painter, surrealist, poet, film-maker for the Crown Film Unit and one of
the founders of Mass Observation in 1937. For our purposes, however, his most interesting enterprise
was his accumulation of extracts from writers of all kinds to record the coming of the Machine Age
during the years 1660 to 1886. This was finally edited and published after his death as *Pandaemonium*
(London, 1985). It is a vital source-book for the study of the Romantic period, showing as it does both
the exhilaration of progress, and the human and imaginative price we had to pay for it.

Michael Ayrton, *Dylan Thomas* (1945), charcoal

situated in the nearby London University Tower.* Other, more exotic drinkers included the befeathered Zulu racing tout Prince Monolulu, Iron-Foot Jack, and Aleister Crowley, a megalomaniac magician once called The Great Beast or Frater Perdurabo, but now reduced to a pathetic heroin and drink addict. Add to these a sprinkling of real and fake aristocracy, Australian and Canadian servicemen, black GIs, and various freedom fighters in uniform from Poland, France, Holland, Czechoslovakia, Norway or anywhere else the jackboot had stamped. By October 1944 there were 80,000 of our British forces gone AWOL and many of them found

* The model for Orwell's Ministry of Truth in *1984*.

their way to this area to join the pimps, black-marketeers and indigenous no-gooders for which it had always been notorious. Given this volatile mixture it is not surprising that brawls were frequent.

Other areas of London had Bohemian pretensions too. Theodora FitzGibbon describes the wartime life in Chelsea in her book *With Love*,[18] but by the 1940s this area had ceased to be progressive and housed mostly old Academicians or pseudo artists and writers, including Cyril Connolly, whom Virginia Woolf, a bigger snob than even Connolly himself, disliked because he 'smelled of Chelsea'. Bloomsbury, though adjacent to seedy Fitzrovia, was of course far above it in social pretensions. Hampstead before the war had some fame as Herbert Read's 'gentle artists' found cheap studios there, but the war dispersed them to safer areas in the country. Colquhoun, MacBryde and Minton had studios in Notting Hill, as did Wyndham Lewis later, and the refugee painter Jankel Adler. The Old Swan pub there was popular on Sundays when bus and tube trains were too infrequent to carry the artists into Fitzrovia and Soho for their drink and social life. Broadcasting House employed many writers and musicians, and occasionally artists such as Piper and Ayrton, during the war years, so another cluster of nearby pubs earned their places in the memoirs. The George (nicknamed The Gluepot because it was difficult to pull the musicians out of it), The Stag's Head and The Dover Castle (Whore's Lament) all had their *habitués*. One attraction the Fitzrovia-Soho Bohemia had over all these rivals, however, was that it was the sexual centre of London. There prostitutes came in bevies to service the services, but, more importantly for the younger Neo-Romantics, it was also the main meeting place for the capital's homosexuals.

Nash, Piper and Sutherland each had a strong-minded and supportive wife. They also had settled home lives and little need to play the bohemian artist – indeed by the 1940s they were beginning to mingle in the society of Kenneth Clark and his circle of well-bred friends. Only Piper had children, and of the next generation only Ayrton had a family, acquiring three stepdaughters when he married Elizabeth Balchin in 1950. The other men were homosexuals. Apart from Keith Vaughan's obsession with the male nude as a subject this did not, and at that period could not, find open expression in their work, and only needs to be mentioned as a factor which helped to make them a close social group and brought them into contact with certain sympathetic patrons. Before the Wolfenden Report of 1957 homosexuals were an embattled minority who had to resort to private clubs and clandestine arrangements to achieve any kind of relaxed social life. The provinces were less tolerant than the capital so that talented young men like Colquhoun and MacBryde naturally made their way south to be welcomed, as it were, with open arms, into a ready-made sub-culture. This social clique could instantly put them in touch with other artists, and wealthy patrons, and open up contacts in publishing, theatre, ballet and music where homosexuals held many of the key positions. This network was established and working efficiently well before the war and had irritated Herbert Read, Geoffrey Grigson and Paul Nash sufficiently for them to invent the label 'Homintern' for this powerful self-promotion and self-help group. It was obviously no handicap for an artist or writer to be homosexual in wartime London. Robert

Medley's autobiography *Drawn from Life*[19] reveals what it was like for a painter, and John Lehmann's novel *In the Purely Pagan Sense*[20] shows the excitement of being a rich, literary homosexual during this hectic period when war blurred class distinctions, uprooted young men from their backgrounds and the company of women, and threw them all into the blacked-out capital to huddle together as the bombs rained down.

'He that hath wife and children hath given hostages to fortune, for they are impediments to great enterprises, either of virtue or mischief,' wrote Francis Bacon – the Elizabethan scholar, not his distant descendant the painter. Cyril Connolly, obsessively searching to discover why he never realised his own high potential, listed, in his book *The Enemies of Promise*,[21] other impediments: drink, talk, day-dreams, journalism, worldly success, domesticity, sex and politics. Only Dylan Thomas seems to have been felled by worldly success, but otherwise Fitzrovia's artists and writers seem to have fallen victims to every one of these with the two exceptions of politics and 'the pram in the hall'.

Fitzrovia's pleasures were varied but not refined. The artists felt at home there because, as Connolly sneered, 'all painters are artisans – bricklayers.' They relaxed in its bawdy good-fellowship, but did not think it a fit subject for their art. All the younger painters were townees, born and bred, but felt impelled to paint a rural England very far removed from that bohemian underworld they inhabited in London. Only Lucian Freud and Francis Bacon would eventually make this seedy level of society their main subject matter. The poets of Soho and Fitzrovia also enjoyed the excitement of the area without feeling they need write about it. Thomas and his cronies such as George Barker (when he returned from his war-years in America), W. S. Grahem and Geoffrey Grigson were producing surreal Neo-Romantic poetry dense with violent, sexually charged imagery, full of sound and fury, but signifying very little in terms of the social and political realities of the time. They, and the 'New Apocalypse' poets round J. F. Hendry and Henry Treece, were consciously 'anti-cerebral' and in revolt against the politically committed poetry of Auden and his friends during the 1930s. Auden himself, and Isherwood, were now safely in California, but the remains of their group were still around in London working for the BBC or in publishing. Except when slumming for gastronomic or sexual purposes these people stayed aloof from Fitzrovia in their own exclusive soirées in the better districts of West London. Amongst these Dylan Thomas looked, and was made to feel, like a mongrel at Crufts.

This socially pretentious clique is of interest to us here because its members were the chief patrons of the Neo-Romantic painters during and just after the war. They were such a close fraternity because they came from similarly monied backgrounds and had been educated in the same private schools and the same two universities so that they held in common very similar values and attitudes towards the arts. Cyril Connolly, whilst recording every humiliation of the spirit and every perversion of normality which their education imposed upon them, obviously, at the same time, enjoyed its privileges, and came away from it arrogantly assured that his own genius and the old-boy-network would see him through to wealth and fame. Still,

from his experiences he could evolve his 'Theory of Permanent Adolescence' which 'is the theory that the experiences undergone by boys of the great public schools, their glories and disappointments, are so intense as to dominate their lives and to arrest their development. From these it results that the greater part of the ruling class remains adolescent, school-minded, self-conscious, cowardly, sentimental, and in the last analysis homosexual.'[22] One assumption shared by this generation educated during the 1920s and 1930s was that English painting and post-Elizabethan literature were inferior to those of the Continent, and of France in particular. We may take Connolly as a typical figure here – though he was at Eton with Anthony Powell, George Orwell, Henry Green, Harold Acton, Rupert Hart-Davies, Peter and Ian Fleming, Alan Pryce-Jones, Freddy Ayer, Oliver Messel and John Lehmann.[23] His schooling was largely in the literature of dead languages, but his under-the-desk reading seems to have been Mallarmé, Verlaine, Rimbaud, Valéry, Laforgue, Huysmans, Baudelaire and Proust, with the occasional snigger over Wilde or Firbank and the drawings of Beardsley. From their public schools the gilded cohorts passed on to more of this word-oriented education in the same company at Oxford (MacNeice, Spender, Day-Lewis, Auden, Connolly, Waugh, Green, Greene, Household, Grigson, Eliot, Warner, Sackville-West, Humphrey Jennings, Kenneth Clark, Betjeman, Osbert Lancaster, John Strachey, Claud Cockburn, Brian Howard, Christopher Hollis, Robert Byron, Harold Acton, Peter Quennell, Alan Pryce-Jones and Peter Watson), or Cambridge (Upward, Comfort, Empson, Cecil Beaton, Isherwood, John Lehmann, Anthony Blunt). From university those who were more interested in the arts than in running the country moved into London to dominate the intellectual life there and to become the self-appointed spokesmen for English art and literature – to the irritation of people like F. R. Leavis and Orwell who took life and art much more seriously. Obviously they were all highly sophisticated wordsmiths but their education had given them no visual training whatsoever. For all their enthusiasm for Marxism and Modernism they were, in their approach to the visual arts, essentially conservative and timid. Auden and Spender felt most at ease with Euston Road Realism; Kenneth Clark thought abstract art 'arid' and Nicholson's work merely tasteful decoration; Connolly and Lehmann whilst using their magazines to keep the 'modernist' debate open showed very little sympathy or openness to Dadaism, German Expressionism or Constructivism. In the temporary absence of Parisian 'modernism', Neo-Romanticism's mixture of Post-Cubism, Surrealism and native traditions suited the tastes of this élite very well.

In the 1920s and 1930s several of these 'Sonnenkinder'* had hung around the fringes of Bloomsbury (itself a Cambridge clique), or the Sitwell salons, or Lady Otteline Morrell's or Lady Cunard's at-homes, acting out the roles of Dandy or Aesthete with Brian Howard and Harold Acton setting the newest fashions. Or they joined the cosmopolitan Arty-Smart set in their peripatetic parties round the fashionable resorts of Europe.† Many took Continental trips, ostensibly in the foot-

* A term used to describe this generation (mostly born between 1901 and 1911) in Martin Green's *Children of the Sun: A Narrative of 'decadence' in England after 1918* (London, 1977).
† A window into this hectic society is offered by Sir Francis Rose's memoirs *Saying Life* (London, 1961).

steps of their aristocratic forebears who had gone on Grand Tours in search of culture and the Sublime, but more often they were in search of sexual experience in the more permissive European capitals. This led Auden, Isherwood and Spender to Berlin (Paris was too fashionable and full of their Francophile acquaintances), but there they were forced to notice that beyond the gay bars the world was turning ugly and Fascism was feeding on the country's unemployment and bankruptcy. Their previously lyrical poetry began to take on a more socially conscious edge and urged their generation towards involvement and Marxism. The 'Pansy Left', as Orwell called them, began to find Bloomsbury's aestheticism and uncommitted scepticism distinctly *passé*. One or two, such as Philby, Burgess, Maclean and the art-historian Anthony Blunt, took the new message sufficiently seriously to become Communist agents. Many more went to fight in Spain – though Connolly took care he travelled well behind the lines in comfort with Lord Antrim. Literature, and art as sponsored by the AIA, suddenly seemed to have found a social role and the ability to make things happen. However, when the war with Germany was declared Auden sent back the message from California that poetry has no influence on events after all and we must just love each other or die, because

Art is not life, and cannot be
A midwife to society.

Stephen Spender looked back on this period in 1951 and concluded:

We were divided between our literary vocations and our urge to save the world from Fascism. We were the Divided Generation of Hamlets who found the world out of joint and failed to set it right ... The impulse to act was not mistaken. But the action we took may not have been of the right kind. It was, for the most part, the half-and-half action of people divided between their artistic and their public conscience and unable to fuse the two.[24]

The outbreak of war suddenly simplified all these arguments about what action one might voluntarily take by making action compulsory, even if it was only fire-watching. It also cut this group off from the artistic internationalist (meaning French) modernism they supported so avidly. Connolly's resentment of this isolation found splenetic outlet in his essay 'England not my England' where he despises the food, climate, countryside, cities and ugly misshapen natives of his own 'Cabbage land' full of lobelias and tennis flannels. The attack is every bit as extreme as Roger Fry's dismissal of our 'Bird's Custard Island'. For Connolly the closed world of artistic London during the war was 'a five year sentence in gregarious confinement'. In spite of this he reached the apex of his career as editor of *Horizon*, which Stephen Spender helped edit and Peter Watson financed. This was dedicated to the preservation of international modernism, though in the circumstances they often had to make do with the English variety. 'War artists we are not,' Connolly told his readers. 'Our standards are aesthetic, and our politics are in abeyance ... At the moment

Robert McBryde, *The Backgammon Player* (1947), oil on canvas

Keith Vaughan, *Finistère: Group of Fishermen* (1951), oil on canvas

civilization is on the operating table and we sit in the waiting room.' Left-wing politics were exhausted and, he now believed, all the political art of the 1930s had failed 'for it accomplished none of its political objectives, nor did it evoke any literary work of lasting merit.' By 1941 *Horizon* was obviously becoming something of an old boys' magazine and Connolly admitted, 'Naturally there is a tendency to associate with the groups of progressive writers in their thirties to which the editors by age and temperament belong.' In effect this meant numerous essays on Flaubert, Gide, Stendhal, Villon, Anatole France and just about every French writer, living or dead, that Connolly's friends were keen on. By December 1945 he had to take a New Year resolution 'to have fewer French articles'. Connolly's biographer, David Pryce-Jones, thought:

> Had there been no war, the contents of *Horizon* might have proved much the same. The editorial policy of the magazine remained thoroughly idiosyncratic. Leftists felt as betrayed by his failure to follow the party line as once homosexuals had done by his abandonment of the Homintern. As a rule, critics were suspected of envy, well-wishers of insincerity, which in either case served to justify doing what he would anyhow have done.[25]

Connolly took a questionnaire survey of his readership in 1941 and found only 15 per cent were over forty years of age. Most were men of the middle or lower middle classes (£200–£1000 per annum income) and many were teachers, though now serving in the Forces. Even Connolly had to respond to some of their demands and open up the magazine beyond the magic circle of Spender, Auden, MacNeice, Betjeman, Orwell, Herbert Read, Grigson, Quennell and Day Lewis.

New voices began to appear, including, as we have seen, articles by Sutherland and Piper (who also made the first cover design). Sutherland had a dozen works reproduced during the life of the magazine, more than any artist except Picasso. Piper, MacBryde, Colquhoun, Moore and Freud were also shown, as were the Euston Road Realists, Ben Nicholson, Hepworth, Frances Hodgkins, Gerald Wilde and David Jones. The young John Craxton seems to have been a favourite and had six works included – three more than Francis Bacon. Besides giving the Neo-Romantics access to a wider audience in this way, Horizon published articles by Geoffrey Grigson on English Romantic art and poetry, and reproductions of Blake, Palmer and Fuseli, which helped to show readers how the modern English artists were drawing in sustenance from their native roots. Picasso dominated the news of foreign art, followed by Braque, and after the war Duchamp Masson, Matta, Giacometti and the Greek artist Ghika were all featured. Paul Klee was the subject of respectful articles by Jankel Adler, Ruthven Todd and Robin Ironside after his death in 1940. Only Augustus John's tedious reminiscences took the shine off Connolly's modernist pretensions a little.

The only serious rival to *Horizon* in scope and popularity with the thinking public was John Lehmann's *New Writing* which by 1940 had become *Penguin New Writing*. He set out, at least in the earlier issues, to keep the political debate alive for 'to

live *through* our time and to master it, we must live *in* it to the fullest possible extent.'[26] Before the noose tightened round England he also managed to keep it going as an international literary magazine with contributions from Chinese, Italians, Russians, escaped Germans and Eastern Europeans. Once this source dried up he was thrown back on the old-boy network of Spender, Day Lewis, MacNeice, Auden, Sitwell and so on. To be fair he did also publish a lot of new young writers, amongst them Keith Vaughan who responded to Lehmann's call for essays on 'The Way We Live Now'. Vaughan was also the first artist to have work reproduced in the magazine (army camp scenes in No. 13)[27] and eventually had more pictures reproduced (fifteen) than anybody. He was also taken on to the editorial board. Soon the magazine became a kind of portable gallery for Neo-Romantic art as Piper and Sutherland were shown three times each, Minton eleven, Ayrton nine, Craxton six, MacBryde three and Colquhoun twice. In addition Vaughan wrote extensively on art and I suspect Ayrton of contributing at least some of the anonymous 'Art Critic' features. Lehmann became a personal friend of many of these artists, bought their pictures, and employed them to illustrate the books he published. As with *Horizon* this publication helped the public to think of neo-Romanticism as the up-to-date style of the 1940s. Their attitudes and values were also disseminated on the arts pages, and in spring 1943 Keith Vaughan contributed another key text in the rewriting of English art history as a story unfolding Romanticism.[28] Eventually, in issues 35 and 36, the younger Neo-Romantics had some kind of group identity bestowed upon them when photographs of Craxton, Minton, Colquhoun, MacBryde, Vaughan and Ayrton appeared.[29] *Picture Post* then introduced them to a wider audience and added Prunella Clough to the gang.[30]

Yet, in spite of its support for Neo-Romantics, *Penguin New Writing* was shot through with a nostalgia for all things French. By 1947 the English artists' struggle to form a national style during the war years no longer seemed very impressive, at least to the young painter Lawrence Gowing (b. 1918). He told *Penguin New Writing*'s readers that all our artists this century had been no more than refiners or broadeners of French discoveries:

One wonders if it has ever been fully recognised that English painters almost without exception, even among the academic, work today so much in the light of French achievements of the past hundred years that they are practising virtually a French art. England is in the nature of a Roman province isolated from its capital by barbarians. It is a strange, unhappy moment. The intelligent submission had been so nearly complete. And now there is a complicated residue of feeling, part nostalgia and part disillusionment, for the days when one managed to ignore the geography of the matter, when a painter could persuade himself that England was a Mediterranean island, Paris and the Midi just two annexes to his London painting-room, when in all the endless discussions the name of an English painter, unless it was Sickert's, so seldom passed one's lips.[31]

Gowing, for one, was ready and eager to re-assume this comfortable vassalage as soon as Paris was ready to lead again.

In spite of the editors' difficulties in getting hold of paper supplies, these and other little magazines had enormous circulations amongst bored servicemen, or civilians avid for reading matter now that 400 libraries had been bombed out of existence. With their literary connections through Connolly, Lehmann, Grigson, Kenneth Clark and Herbert Read (now a director at Routledge) the Neo-Romantics were frequently asked to illustrate novels, classics and volumes of poetry throughout the 1940s. These literary outlets, plus the widely shown paintings for WAAC and their reproduction in official booklets, helped to make Neo-Romanticism seem the representative visual style of this period of our history. That it was figurative, 'modern' without being 'difficult', romantic, and patriotically depicted contemporary events such as the blitz or our English countryside, all ensured its popularity. With Nicholson in voluntary isolation in St. Ives Neo-Romanticism *was*, in effect, English modern art to most of the patrons and the public.

War ended in Europe on 8 May 1945. The bells rang out, the blackout curtains came down, and bonfires and fireworks gave people the exuberant light they had craved for so long. It took the atomic bombs on Hiroshima and Nagasaki to bring the wider hostilities to a sickening stop. Neither this event, nor the opening of the Japanese and German death camps, was a subject that any artist in England could cope with imaginatively – there are limits, one must admit, beyond which art cannot venture. Those who had served abroad now returned with high expectations of a fairer society with more jobs, more houses, more public ownership and more care for the sick, poor, old and young. In July 1945 the electorate installed a Labour Government with a mandate to fulfil these expectations. Part of that Government's stated policy was to continue and extend the state patronage of all the arts begun in wartime with such schemes as WAAC and CEMA. After the war CEMA became the Arts Council with Kenneth Clark serving on the Art Panel, and later as the Chairman. Its function was to give financial assistance to British artists at home, whilst the newly formed British Council, with Herbert Read on its Art Panel, was to spread the fame of British art abroad by means of touring exhibitions. Both amassed their own collections of paintings particularly rich in Neo-Romantic works, and helped consolidate the reputation of this style both here and abroad.

Gradually, something like normality returned to the London art world. The Tate Gallery and Imperial War Museum took their pick of the 10,000 war pictures accumulated by WAAC and the remainder were dispersed round the provincial and Commonwealth galleries. No other country now had such a rich heritage of war pictures, thanks to enlightened Government policy in both wars. A picture per month was returned to the National Gallery walls, though the Tate, which had been bombed, had to delay its reopening until 1946. West End galleries opened again and were prepared to show young British painters until they could stock up from the Continent – in the late forties there always seemed to be an exhibition somewhere in London showing the Neo-Romantics, either solo or in mixed groups. Art colleges reopened and looked around for youngish but established painters to

teach in them: many of the Neo-Romantics obliged. A report of 1946 showed just how badly staffed, equipped and organised most of England's 240-odd art training establishments were.[32]

But one question preoccupied artists, dealers and critics: how had the School of Paris survived the Nazi occupation, and in particular, what had Picasso been up to?

Kenneth Clark and John Rothenstein, as Directors of the National and Tate Galleries, were bundled into a bomber in October 1944 and sent to newly liberated Paris to find out. They were also commissioned to pick up any bargains before the Americans got their hands on them. Clark had only limited sympathies for truly modern paintings at the best of times, but his reactions to Picasso's wartime productions were scathing. Picasso, he said (inaccurately, as we know), had spent his time on Cupid and Psyche works and 'a number of the worst landscapes I have ever seen. Nature, in the Claudian sense, had no appeal to Picasso whatsoever.'[33] The crying children paintings which were shown in England as evidence of Picasso's mental anguish over the German occupation were all done well after it, wrote Clark.

> This is the kind of nonsense that makes a critic 'feel good'. In fact great artists seldom take any interest in the events of the outside world. They are occupied in realising their own images and achieving formal necessities. As is well known, the images that are the basis of 'Guernica' occur in drawings that antedate by over a year the bombing of the Basque town.

In an interview in *Lettres Françaises* on 24 March 1945 Picasso contradicted this ivory-tower view of the artist by declaring he had joined the Communist Party:

> What do you suppose an artist is? Is a painter an imbecile who has nothing but eyes, nothing but ears if he is a musician, a lyre at every level of his heart if he is a poet, nothing but muscles if he is a boxer? Quite the contrary, he is a political being, constantly aware of what is going on in the world, whether it be harrowing, bitter, or sweet, and he cannot help being shaped by it. How would it be possible not to take an interest in other people, to withdraw in some ivory tower so as not to share existence with them? No, painting is not interior decoration. It is an instrument of war for offence and defence against the enemy.[34]

This was, perhaps, an attempt to break out from the autobiographical themes which seem to have preoccupied him after *Guernica*, and to seek a more public role. As John Berger explained, this came to nothing since the Communist Party in both France and Russia did not know how to reconcile its pride in such a famous convert* with its reactionary hatred of his 'decadent' work.[35] Unfortunately, apart from the

* Two months after Paris was liberated Picasso was guest of honour at the Salon d'Antomne 1944 with seventy-four paintings and fifteen sculptures on show. A year later he and Matisse were invited to exhibit at the V & A Museum.

peace dove posters, Picasso's political pictures are feeble things. Perhaps in this case Clark was right after all.

Back in England Connolly, anxious to reassure *Horizon*'s Francophile readership that French art was still the world's best, asked Daniel-Henry Kahnweiler, Picasso's dealer, to report on Paris's rising stars. 'In my opinion,' he replied, 'no painter of importance has appeared since 1940.'[36] All the younger artists were merely popularising the discoveries of pre-war Fauvism and the even older Cubism, he thought. Only Matisse seemed to be moving serenely forward. Paris was evidently still exhausted after its ordeal and Rothenstein confidently pronounced the whole School of Paris dead.[37]

Britain was anxious to show the previously occupied countries of Europe that she had made good use of the freedom she had hung on to so perilously. With the cultural vacuum left in Europe by the war Britain was also poised to become the leader of European cultural and artistic life. And if Europe today, why not the world tomorrow? Accordingly a travelling exhibition of 'Fifty Years of British Art' was assembled and despatched around the devastated capitals of Europe in 1946–7. In Brussels, Amsterdam, Copenhagen, Berne, Vienna, Prague, Warsaw and Rome the works of Lewis, Nicholson, Moore, Nash, Sutherland, Piper, Ceri Richards, Edward Burra and several more were gratefully received and warmly praised. The French critics, perhaps uneasily aware of their own nation's current artistic bankruptcy, and that the School of Paris had been represented for the past six years by one giant Spaniard whilst their native painters were mostly in exile in New York, were not prepared to concede any further loss of cultural territory and gave the show a lukewarm reception. Besides, they had been conditioned by events in Paris since the turn of the century to equate innovation with progress and both with worth. The English painters on show were obviously not great innovators and the latest ones even took a pride in looking back to their nineteenth-century Romantic ancestors! The Neo-Romantics may have borrowed a few superficial features from Cubism and Surrealism, but to French eyes they could hardly be seen as vital contributors to the onward march of Modernism.

Rothenstein took the opportunity to keep the flag flying by sending the Tate's newly cleaned Turners round Europe very soon after, to show we had a heroic past as well as a bright future. Later the Festival of Britain invited the world to come and see what we could do on our home ground. The Neo-Romantics had done well out of the war, emerging with enhanced reputations, and much in favour with Establishment patrons and State-run cultural bodies. What had been forgotten was the group of School of Paris painters and German 'decadents' who had fled to New York. There they had been working alongside younger American artists in that rich and unscathed city and preparing a new cultural domination. By the time this happened, as we shall see, Neo-Romanticism had just about run its course. Those who had gone back to Blake and Palmer and Turner for hints on how to interpret their English landscape were by then dispersed over the sunshine lands of the Mediterranean, or painting in totally new ways, or dead, or beginning the long slide into what Tambimuttu had called Sohoitis.

REFERENCES

1. Muggeridge, Malcolm, *The Thirties: 1930–1940 in Great Britain* (London, 1940).
2. Gascoyne, David, 'Snow in Europe', *Penguin New Writing*, No. 3, February 1941.
3. Piper, Myfanwy, 'Back in the Thirties', *Art and Literature*, Winter 1965, p. 149.
4. 'The Story of the AIA 1933–1953' by Lynda Morris and Robert Radford, Museum of Modern Art, Oxford, April–May 1983.
5. Coldstream, William, 'How I Paint', *The Listener*, 15 September 1937, pp. 570–72.
6. Thomas, Hugh, *The Spanish Civil War* (London, 1968 edition), pp. 796–7.
7. Piper, Myfanwy, op. cit., p. 143.
8. *The Studio*, Vol. CXII, No. 525, December 1936 and Editorial Vol. CXIII, No. 527, February 1937.
9. Hewison, Robert, *Under Siege: Literary Life in London 1939–1945* (London, 1977), p. 56.
10. Todd, Ruthven, 'Fitzrovia and the road to the York Minster, or Down Dean Street', a booklet with map for an exhibition at Parkin Fine Art Ltd, London 1973.
11. Maclaren-Ross, Julian, *Memoirs of the Forties* (London, 1984 reprint of 1965 original).
12. Ibid., p. 131.
13. Todd, Ruthven, op. cit., p. 19.
14. Hooker, Denise, *Nina Hamnett: Queen of Bohemia* (London, 1986), p. 105.
15. Hamnett, Nina, *Laughing Torso* (London, 1932) and *Is She a Lady?* (London, 1955).
16. Gowing, Lawrence, *Lucian Freud* (London, 1984 edition), plate 19.
17. Maclaren-Ross, Julian, op. cit., p. 138.
18. FitzGibbon, Theodora, *With Love: An Autobiography* (London, 1982).
19. Medley, Robert, *Drawn from Life* (London, 1983).
20. Lehmann, John, *In the Purely Pagan Sense* (London, 1976).
21. Connolly, Cyril, *The Enemies of Promise* (London, 1938).
22. Ibid. (edition of 1961), p. 271.
23. Lehmann, John, *The Whispering Gallery: Autobiography I* (London, 1955), p. 115.
24. Spender, Stephen, *World within World* (London, 1951), p. 202.
25. Pryce-Jones, David, *Cyril Connolly: Journal and Memoir* (London, 1983), p. 228.
26. Lehmann, John, editorial to *Penguin New Writing*, Vol. I No. 8, June 1941.
27. Vaughan, Keith, *Penguin New Writing*, Vol. I, No. 13, June 1942.
28. Vaughan, Keith, 'A View of English Painting', *Penguin New Writing*, No. 31, 1947.
29. *Penguin New Writing*, ed John Lehmann, No. 35 (1948), No. 36 (1949).
30. *Picture Post*, Vol. 42, No. 11, 12 March 1949.

31. Gowing, Lawrence, 'French Painters and English', *Penguin New Writing*, No. 29, 1947, p. 148.
32. *An Arts Enquiry: the Visual Arts*. A Report sponsored by the Dartington Hall Trustees, published by Political and Economic Planning (PEP) (Oxford, 1946).
33. Clark, Kenneth, *The Other Half: A Self Portait* (London, 1977), p. 72.
34. Jaffé, Hans, *Pablo Picasso* (London, 1980), p. 140.
35. Berger, John, *The Success and Failure of Picasso* (London, 1965), pp. 172f.
36. Kahnweiler, Daniel-Henry, 'The State of Painting in Paris in 1945', *Horizon*, Vol XII, No. 71, November 1945, p. 337.
37. Rothenstein, John, *Brave Day Hideous Night* (London, 1966), p. 140.

JOHN
MINTON

JOHN MINTON emerged as the representative figure of the second generation of Neo-Romantics, not so much because of his painting or anything he wrote or said, but because of his life-style. He was reticent about his childhood though it is known his father was a successful solicitor whose wife left him when Minton was still a child. There were three boys, the oldest of whom was mentally handicapped and lived in an institution where John was made to visit him. The youngest was closer to John but he was killed, aged nineteen, during the D-Day landings. After preparatory school in Bognor Regis and secondary education at Reading School Minton arrived at St. John's Wood School of Art in 1935, aged eighteen.[1] Patrick Millard (1902–77) was then the Principal, busy passing on his enthusiasm for Palmer's engravings and drawings and encouraging the students to emulate his mazey linear style. Millard painted one of the earliest portraits of Minton, showing him holding a violin and already looking melancholy. After a year Michael Ayrton became a fellow student and the two soon became firm friends. Together they read James Thrall Soby's *After Picasso* and visited the 1936 Surrealist Exhibition in London. Both the book and the exhibition seemed to confirm their youthful hunches that the way forward for art was not through Cubism, but through the depiction of human emotions and people in strange and dramatic settings.

By 1938 they had left the School and gone to Paris, to share a studio, attend life classes, sample bohemian life (though neither was short of money), and look for a master to learn from. Anyone meeting them might have been struck by the precocity of the eighteen-year-old Ayrton's conversation and width of experience but less by his drawings which were still unformed, whereas Minton already drew elegantly and seemed destined to be the greater artist of the two, once he had found his own subject matter.

Ayrton spent some of his time in Paris visiting the studio of Georgio de Chirico, the Italian painter of deserted urban vistas and melancholy window dummies, so much admired by Paul Nash. However, the best of de Chirico's 'Metaphysical' works had been completed by 1920, and by 1938 he had regressed to stodgy pseudo-classical subject matter, an academic manner, and paint 'uncomfortably suggestive of ice-cream', as Nash had to admit in a review in 1931. The Surrealists had by

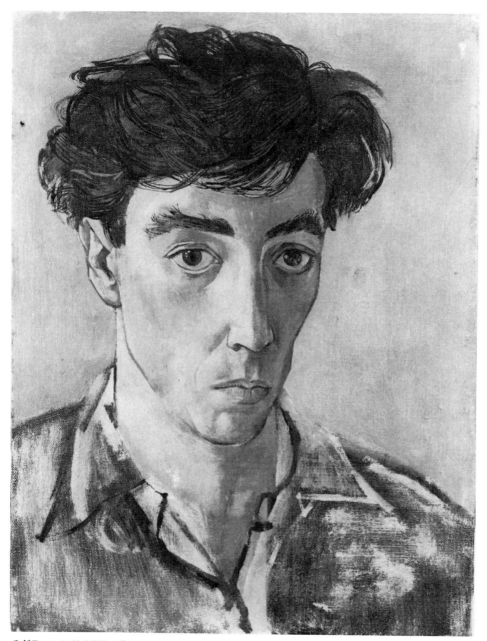

Self Portrait (1953), oil on canvas

now disowned him. I do not know if the two youngsters followed up their interest in Surrealism by visiting Dali, Tanguy, Ernst or Breton who were all still around the Paris cafés until 1939 when they fled to New York, effectively killing off European Surrealism as they went. Ayrton and Minton knew enough about their theory of 'psychic automatism' to play the Surrealist's game of 'The Exquisite Corpse' – a kind of visual Consequences where one artist draws a head, folds it over and passes the paper to his partner who draws the neck and arms, folds it over and passes it back, and so on, until the feet are reached and the paper unfolded. The idea is that the conscious mind is sealed off and accident is allowed to play its part in creation. The results usually look silly, like the left-overs from a party.*

An artist who had learned both from the Surrealists and from de Chirico's best *Scuola Metafisica* period was Eugene Berman (1899–1972). Having read about him and his fellow Neo-Romantics (or 'Neo-Humanists' as they were sometimes called) in James Thrall Soby's *After Picasso* the two youngsters eagerly sought him out.[2] Since there is evidence that this Parisian Neo-Romantic group influenced their English namesakes, and Minton and Ayrton in particular, it would be useful to consider if that influence was altogether beneficial.

Only one of the group was actually French and he, Christian Bérard (1902–49), was possibly the weakest as a painter. Nevertheless, he had an enormous reputation as a stage designer, and formed a social link between the Parisian and London artistic circles – for example, on a visit in 1948, just before his death, Lucian Freud drew his portrait.[3] The most important group members, Eugene Berman, his brother Leonide (1896–1976) and Pavel Tchelitchew (1898–1957) were all Russians. They had come as exiles to Paris when Cubism was still the dominant 'ism' amongst the avant-garde – that, and its rival, Surrealism.

After the Impressionists' sensuous pursuit of the reflective surfaces of things, the Fauves' wallow in decorative colour, and the Expressionists' public breast-beating, the Cubists stood for the importance of structure and analytic intelligence in art. It was an anti-literary movement, a vigorous spring-clean of painting's cupboards which threw out humanistic subject matter, overt sensuality, chiaroscuro, and, for a time, all but the drabbest colours. By the time of its collage researches it had also suppressed painterly brushwork in favour of using ready-made textures and patterns such as newspapers, linoleum and doilies. Some major artists, such as Matisse, Rouault and Chagall, could virtually ignore it, but most European artists were affected by it in some way, even if they misunderstoood its basic premises. Nash and Piper, as we have seen, experimented with it for brief periods and the younger Neo-Romantics in England took over some of its superficial features such as faceted planes, simplified outlines and multiple viewpoints taken round a single object.

On the other hand, the Surrealists were anti-intellectual and not interested in the analysis of form. In his best period de Chirico had wanted to convey 'the whole enigma of sudden revelation', and knew that Cubism's technical researches were

* Fourteen of these Minton-Ayrton trifles were exhibited in the Christopher Hull Gallery, London, in spring 1984.

no help in this. The only unexplored area, he and the other Surrealists believed, was below the level of consciousness, into madness and dream. They aimed to put man back at the centre of art rather than the act of painting. Being ignorant of all things English they were not to know that Blake, Fuseli and Richard Dadd had already lowered buckets into the murky depths of the id and hauled up marvels and monstrosities. Only Picasso could manage to march under the banners of both Cubism *and* Surrealism.

It was into this Spanish-German-French hubbub that the three Russians came in the 1920s. They took no sides but noted that Cubism's discovery of multiple viewpoints was usable, and that de Chirico's use of side-lighting and long perspectives to heighten a picture's mood could also be appropriated. Ironically, in their resistance to Picasso's intellectual Cubism they turned back for inspiration to works by him which he now despised – the elegaic Blue and Rose periods (*c.* 1901–7). They admired these in the collection of Gertrude Stein and liked the way Picasso had played up their pathos by making one colour, such as blue, dominate the whole canvas, and they also noted his *fin de siècle* cast of prostitutes, harlequins, dancers, beggars and sad clowns. The sentimentality of these works appealed to them deeply.

When Minton and Ayrton met Berman he had been established in Paris for nineteen years, though he travelled often to Venice, Ischia, Padua and around France. Unlike de Chirico he used these real places in his canvases, but much transformed into 'props for a romantic theatre, controlling them quietly and with great intelligence: a magnificent theatre in which colour is everything'.[4] The early works were often of moonlit squares dominated by blue, the most emotive of all the colours. Later he turned his attention to figures, moving them indoors to sleep on tumbled beds in dusky rooms – a subject Tchelitchew was also exploring. After visiting Italy Berman ventured out into the sunlight again, armed with a brighter palette to paint the bridges of Paris, Roman courtyards, Parisian parks, the statues at Versailles or the twisted rocks near Avignon. He was perhaps the most painterly of the exiles though his post-war reputation seems to rest now more on his opulent settings for the New York Metropolitan Opera House. For two young romantic English artists in search of a Parisian master who was neither a dogmatic abstractionist, nor a wilfully daft Surrealist, he seems to have been an ideal choice.

The self-appointed star of the Parisian Neo-Romantics was undoubtedly Pavel Tchelitchew, a Muscovite who began as a Constructivist in Kiev; fled the post-revolutionary philistinism to Berlin, arriving in 1921, to make a new reputation as a stage designer; and then settled in Paris in 1923 to become a protégé of Diaghilev and Gertrude Stein. From there he was launched into the company of the international Homintern and its mixed population of aristocrats, rich playboys and people with real artistic talents. Gertrude Stein, whom he called 'Sitting Bull', soon tired of this shrill charmer and poseur and passed him on to Edith Sitwell who became his lifelong champion, in spite of the torment he gave her. In return for her boosting of his reputation in London he painted six portraits of her in all and made one sculpture. She wrote of him after his death as 'that tragic haunted and noble artist – one of the most generous human beings I have ever known'.[5]

He had written to her, 'There is sometimes such hell in my soul that it is frightful to touch it, and you know that there isn't a single person who can understand and console me more than you.'[6] They came as near to love as their differently warped egos and sexualities would allow, but on at least one occasion came near to blows. Tchelitchew lost his always elusive temper whilst painting Edith and chased her round the room hurling furniture* and shouting, 'Yes, yes I choos keel you, you know! I choos keel you.' To this she replied, as an aristocrat would, 'Very well old boy. If you must, you must! But kindly spare my amber' (one of her barbaric chunks of jewellery). Fortunately Cecil Beaton, who also loved Tchelitchew, arrived for tea and saved bloodshed.[7]

The Sitwells' advocacy of Tchelitchew's work in London paid off so that several of their society friends acquired works, and Kenneth Clark commissioned a portrait of his son. At the request of Cecil Beaton the Russian also painted Beaton's great love, Peter Watson, who was one of the most influential of the English Neo-Romantic artists' patrons. This portrait showed Watson in a suit of armour and drew the waspish comment from Christian Bérard: 'The English Joan of Arc done by the Russian Botticelli.'[8] Tchelitchew had several London exhibitions in the 1930s and in one in 1938, at Tooth's Gallery, created a sensation with *Phenomena*, a large picture of a crowd of wildly deformed figures. Ayrton and Minton would certainly have known both his pictures and ballet designs in London, and indeed Ayrton seems to have met him there several years before.[9] They were probably hoping to meet him in Paris too but much of that year he spent in Connecticut doing 'metamorphic' pictures of autumn leaves, which on closer inspection turn out to be children in russet cloaks. Nevertheless, he did find time to return to Paris to design sets and costumes for Giraudoux's play *Ondine* which the two Englishmen saw and were so inspired by that they decided to collaborate as stage designers themselves. When the war came Tchelitchew shuttled back to America where he continued to enhance his reputation as a social figure and stage designer, and eventually took American citizenship.

Tchelitchew's work went through several phases. In the early Parisian ones he produced 'laconic compositions' where forms were ambiguously shared between two figures. Ayrton returned to this idea in his later sculpture, and, I believe, made a better job of it. Following on from a study of Picasso's pre-Cubist period he tried overall colour schemes, especially blue – as one critic points out, Tchelitchew 'was one of the first artists to cannibalize the past of Modernism.'[10] Next on the advice of Juan Gris, he varied surface textures by adding sand and coffee-grounds to his pigments. In *The Bullfight* he painted the same figure in three different perspectives and distorted it in the way a close-up camera might do. Ambiguity and double imagery characterise much of his output, a trait he explains first by a childhood habit of playing with picture bricks, and then with some arcane mumbo-jumbo about mathematics.[11] So, children merge with foliage, feet and hands with tree trunks, recumbent figures with landscapes, a pile of studio clutter becomes a doleful

* In Kenneth Clark's version of the story Tchelitchew was wielding an axe! (*The Other Half*, London, 1977, p. 63).

clown, and the interiors of heads and bodies glow through their bones and flesh until one no longer knows which is inside or out. Minton, and more particularly Ayrton, were to try their own versions of several of these theatrical sleights-of-hand in their own works once they were back in England.

Before leaving France Ayrton and Minton were joined by another art school friend, Michael Middleton, for a tour down to Berman's favourite painting area of Les Baux de Provence, where they became ballet enthusiasts. Diaghilev's conductor, Pierre Monteux, ran a music and ballet summer school there and what they saw of it inspired Ayrton and Minton to design settings for an imaginary production of Purcell's *Dido and Aeneas*, each adding to the design on the drawing board as the fit took him. The results, as one might expect, are wildly romantic, being influenced by both Bérard and Tchelitchew.*

Scampering back to London as the war broke out these young men had packed in their mental luggage the tilted perspectives and dramatic lighting of de Chirico, the nostalgic and sweet harmonies of Picasso's Blue and Pink periods, and the stagey tableaux of the Parisian Neo-Romantics. These were not, perhaps, the most useful supplies with which to sit out the coming *blitzkreig*.

The kind of art they had come in contact with in France undoubtedly had a strong and, I believe, largely detrimental effect on both painters – until they began to learn a new tougher-minded kind of Romanticism from Nash, Piper and Sutherland, and the experience of war forced them into making art which was not wholly derived from other artists. The older English Neo-Romantics, by comparison with the Russian-Parisians, were much closer to observable natural phenomena for their starting points, and the ambiguity of their tree roots or anthropomorphised rocks was much less obvious and striven for than Tchelitchew's children in leaves, or knuckles in tree trunks. The Russians, and Tchelitchew in particular, had made an art that was, at its worst, gimmicky, morbid, camp and stagey in the worst sense of being tinsel-thin. It was also very easy for impressionable young artists to take over its surface characteristics. Ayrton produced some particularly sentimental and flimsy works under this influence, as we shall see. Minton too, once back in London, began to produce poignant drawings of moonlit streets; often those mean dockland terraces now bombed into ruins, with here and there drooping youths and thin maidens posing amongst the rubble. Sometimes he adopts an aerial viewpoint so that we can look down into a ruined house. Many of these works are in blue ink, or ink combined with wash or gouache as in *Lovers/Bombed Buildings* (1941), or in very dark oil as in *London Street* (1941). The debts to Berman and de Chirico are obvious and the theatrical lighting and overly-dramatic viewpoints seem to come from Minton's enthusiasm for the stage, rather than from observation. These can hardly be classed as war pictures, even though bombed buildings may have been their starting point: a comparison with Sutherland's or Piper's works in the same docklands makes this clear. The Keatsian melancholy in which 'but to think is to be full of sorrow/And leaden-eyed despairs' springs from something

* These designs were shown at the Christopher Hull Gallery, London in 1984.

London Street (1941), oil on canvas

deep in Minton's character rather than from a response to the dilemma of homeless Cockneys.

In 1942 Minton and Ayrton had a joint show of their drawings and stage designs at the Leicester Gallery, and one wonders if Osbert Sitwell, who, like his sister, was Tchelitchew's ardent admirer (he ranked him with El Greco), had them in mind when he wrote of the Russian tossing aside each new discovery as he had finished with it:

> It is of that moment that the jackal painters and decorators of the Art World pounce on his refuse and produce it as their own . . . Thus, there are often exhibitions, derived solely from the example of this painter, in progress at galleries in fashionable streets, just as there are to be seen in the theatres several ballets similarly founded, without acknowledgement, on his work.[12]

By 1956 Ayrton had renounced all the French influences he had picked up, and by then he had Tchelitchew's measure:

> An enormously talented draughtsman who at his best, in his early work, was capable of realising volumes and relating forms with a skill which would have borne the burden of profound thought, he became the victim of his own lively

but shallow gift for pictorial invention and subsided into 'veritable mysticism and strange sciences' with results which might be compared to the theology of a cardinal who has embraced spiritualism. The falsification of his later drawings is the result of the triviality of his thinking. His skill remains extraordinary.[13]

Oddly, by that date most of this criticism could be applied to Minton too – except the bit about mysticism and strange sciences which attaches more aptly to Ayrton himself as he began to identify with Daedalus, the first man to fly.

Soon after their return from France Ayrton was called into the Royal Air Force, though he was eventually invalided out. Minton first registered as a conscientious objector, but then changed his mind and served in the Pioneer Corps until he was discharged for homosexuality in 1943. He was stationed for part of this time at Harlech in North Wales which led him to look at landscape more closely (there being little else to look at), and also to an admiration for Sutherland's Pembroke sketches. During the time they were both in uniform the two friends spent their 48-hour leaves looking at the few works on show by their English contemporaries, and on making more theatrical designs for purely hypothetical productions. Eventually, on the recommendation of Hugh Walpole, they were invited to design the costumes and sets for John Gielgud's 1942 production of *Macbeth* which opened in Manchester and then transferred to the Piccadilly Theatre in London shortly before Ayrton's twenty-first birthday. Walpole also financed their display at the Leicester Galleries, and later one of the designs was reproduced in *Horizon*. Ayrton did a portrait of Gielgud dressed for his role as Macbeth. We might take the set design for Act III Scene 9, Dunsinane, as typical with its impossibly ruined walls, and view across an arid plain to a wild dark Piper sky. It is a kind of Berman courtyard or de Chirico piazza bombed by the Luftwaffe.[14] In the other sets bare trees (often with rags in the branches), dwindling perspectives, turbulent skies and great swags of cloth sometimes supported by Dali crutches must have helped push an already violent play over into melodrama, or to have cowed the actors completely.

The problem of earning a living was not a pressing one for Minton since he always had a generous allowance from his grandmother, but he began to teach illustration at Camberwell School of Art, one of the few colleges still open during the war years. Ayrton soon joined him there, having meanwhile begun to live with a woman friend, and having grown a beard to make him look older than his students. Minton, who might have expected to share lodgings with his friend, now had to look around since, temperamentally, he was of a gregarious nature. In 1943 he moved in with Robert Colquhoun and Robert MacBryde at 77 Bedford Gardens, London SW19. These two Scots had become protégés of Peter Watson when they arrived in London and it was possibly Watson who introduced Minton to them. They had also picked up the artistic community's enthusiasms for Samuel Palmer, and Minton, in his turn, became re-enamoured of his works. This was not his first encounter with Palmer of course, since his tutors at St. John's Wood College of Art, Patrick Millard and Anthony Gross, were just as excited about him as the Sutherland group had been at Goldsmiths' College a little earlier. The 'Two Roberts' quickly passed through

Surrey Landscape (1944), pen, ink, wash on paper

their Palmer phase but Minton now seemed to find Palmer's rural subject matter, richly detailed and textured drawings, and methods of building his compositions well worth lingering over. Rothenstein pays him this compliment:

> For Minton the example of Palmer was particularly inspiring. Without it one of his finest works, *Surrey Landscape* (in indian ink and wash, of 1944 . . .) would hardly be imaginable. It is remote from a slavish imitation: more precise, muscular and altogether crisper than a Palmer, yet it is imbued with much of Palmer's spirit. It could hang without discredit in a collection of Palmer's; indeed in my opinion it is superior to most of his work except that of the sublime 'Visionary Years' at Shoreham.[15]

Ayrton in his 1946 book *English Drawings* reproduces the pen and wash drawing *The Orchard* (1945) with its overall densely worked detail and wide variety of marks for grass, leaves, earth, tree trunks, sky and apples and makes the single observation: 'Minton is English and Palmer shines through him, but his work is personal none the less.'[16] Other works in ink and wash showing the same stylistic debt are *Road to the Sea* (1943), *English Landscape* (1944?), *Recollection of Wales* (1944), *Harvest Moon* (1944), *Summer Landscape* (1945) and *Landscape with Harvester Resting* (1945?). These works with their closely interlocking areas of rich texture obviously

relate more to Palmer's early drawings than to his engravings or to the later paintings which depend so much for their effects on colour. I refer to such Palmer works as *Early Morning* (1825) and *The Valley Thick with Corn* (1825)*, both of which were reproduced in *Horizon*.[17] Yet, peering into the lush foliage of Minton's *English Landscape* and *Surrey Landscape*, one realises they are inhabited, not by idealised Kentish yeomen but by twentieth-century male nudes. Here is a frank paganism which is much nearer to Edward Calvert in his small works such as *The Primitive City* (1822), or *The Cider Press* (1828) than to Palmer. There is also a gusty energy blowing through Minton's landscapes and agitating his line which is totally absent from Palmer's hushed valleys. If there is a spiritual dimension beyond the sensuality of these fine works it comes from goat-footed Pan rather than the pale Galilean.†

It is inevitable that Minton learned more than a bohemian life style from his new flat-mates. They were three and four years older than he was and had not been to any of the in-bred London art colleges but to Glasgow School of Art. This, and their European scholarship travels, must have given them a certain novelty and even prestige: their address certainly became the social focus for other young artists such as Ayrton, Craxton, Vaughan, Prunella Clough, Freud, Bacon, Ruskin Spear, Rodrigo Moynihan and the young Scot, Hamilton Finlay. Many of the Fitzrovian writers also felt its pull after pub closing hours.

The two Scots had been early admirers of Wyndham Lewis's work and after he returned from his miserable wartime exile in Canada he became their neighbour in Notting Hill. Ayrton too became his friend and admirer. From him they added to their Glasgow inheritance of solid drawing and French-derived colour a liking for strongly faceted forms and decisive outlines. A refugee Jewish-Polish artist, Jankel Adler, also came to live in the same terrace as Minton, Colquhoun and Mac-Bryde and showed them further colouristic possibilities, and helped to change Lewis's angularities into a more decorative, sinuous division of forms and picture surface. Adler's influence on Minton, either directly or second-hand through the Two Roberts, can be observed in the schematised head and clothing of the figures in *Children of the Gorbals* (1945), *Rotherhithe from Wapping* (1946), *Street Scene in an Industrial City* (1946) and *Warehouses* (1947).‡ It is still vestigially there in the colour harmonies and pattern-making of his London Transport poster of *London's River* (1951). Minton's *Withered Plants and Landscape* (1947) has overtones of Adler, and also takes its theme of tomato plants from Picasso and Colquhoun, both of whom had used this motif before – but the mood of drooping disconsolateness is all Minton's own. Essentially though, these paintings are coloured drawings, still conceived in lines – though simpler lines than his *Surrey Landscape*.

Like the rest of his generation Minton had a great admiration for Sutherland. He tried an *Entrance to a Lane*, sought out the same moonlit devastation in the East

* See page 17.
† He also made a clever imitation of Vaughan's interpretation of the Palmer manner in *The Path Round the Copse* (1944–5?).
‡ These last two I know only from their reproductions in *Penguin New Writing*, No. 28, 1946 and No. 31, 1947 respectively.

Landscape with Harvester Resting (early 1940s), pen, ink, body colour

End, and his *Blast Furnace* (*c.* 1942) could almost be passed off as a Sutherland with the leaping flames and heavy machinery, except that the male figure is too realistic and effortlessly drawn. Minton also acquired a taste for black shadows, spiky flotsam and battered roots, but used them in a more obviously decorative way than Sutherland. He was not on the look-out for the sinister in Nature, as Sutherland and Nash had been; his was a less tough, more elegaic vision which sought, he said, to convey 'the touching and melancholy impermanence of all physical beauty'.[18] Again we hear that Keatsian echo.

In addition to those artists already mentioned as sources of inspiration and ideas to Minton he also professed enthusiam for Bewick, Blake, Constable, Turner, and amongst his contemporaries Edward Bawden, Vaughan, and above all Picasso. This makes Minton sound no more than a facile pasticheur passing from one borrowed style to the next. There is a nugget of truth in this, but he managed to assimilate each new discovery into his own sweet-sad vision; softening the roughness of Sutherland and Picasso, and diluting the spiritual fervour of Palmer and Blake; filtering them through his formidable charm so that all his works, from whatever

period, are recognisably his own. Michael Middleton puts it well: 'At a deeper level, I suppose it might be argued that the decorative nature of so much of his work – he was incapable of making an ugly mark on paper or canvas – betrays a certain desire to please that inhibited in him the abandon of blind faith.'[19]

Minton knew, of course, that he was a victim of his own adroitness, and that he needed to borrow ideas and motifs from other artists because he could not generate his own pictorial obsessions. In his occasional farcical writings he could get his own back a little by pulling their legs: 'The only one of our lot who ever got by was Gerda Switzerland with her series Thorn Feet, and none of the rest of us seemed to make it.'[20] And elsewhere, when describing the misery and frustrations of making posters for Yahoo film moguls at Ealing: 'I put in a black sky for drama and for Piper.'[21] John Craxton remembers him rushing round with mock enthusiasm during the Palmer fashion giving the hot tip: 'Have you heard? Moons are in! Half-moons are really selling this year!'[22]

Minton was an enthusiastic teacher and from 1943 passed on his fluent draughtsmanship to the illustration students at Camberwell School of Art. The painting

Withered Plants and Landscape (1947), pen, ink, gouache

tutors at Camberwell, William Coldstream, Claude Rogers and Lawrence Gowing, were advocates of what Coldstream called 'straight painting', that is painstakingly measuring the model, still-life or landscape in front of the artist, then transferring these measurements on to the canvas and painting in the subject matter between them as objectively as possible in thin, subdued colours. This plodding low-key reaction to nature was as far removed from the Neo-Romantics' subjectivity as it was possible to be. However, Victor Pasmore, one of the original founders of the Euston Road School from which this style of realism takes its name, was by this time breaking away to paint pearly Whistlerian views of the Thames, and would soon make an even more decisive change of direction towards total abstraction. Neither Minton or Ayrton seems to have been affected by their contact with these older realist painters.

In 1946 Minton left Camberwell to teach drawing and illustration at the Central School of Arts and Crafts, and after two years there he moved again to teach painting at the Royal College of Art. This change to teaching painting made him reconsider his own priorities and led to a shift away from his graphic work, in which he was by now an acknowledged master, towards easel work which suited him less well. The kind of linear style he passed on to all his students was far removed from that tentative holding back from the decisive contour which Nash had encountered in Tonk's classes at the Slade. The pen, which allows no second chances, was Minton's

Summer Landscape (1945), pen and ink

favourite tool, rather than a smudgy rub-out-and-try-again pencil. He was also a master of all the reprographic techniques and publishers could not get enough of his effortless-looking works in black and white or colour. These flowed from his studio into books, book jackets and the pages of *Radio Times, Lilliput, Picture Post, London Magazine, The Listener, Vogue, Opera, Orpheus, Penguin New Writing*, and innumerable technical journals where a clear expository drawing was needed. Minton's style became the fashionable norm of the late 1940s and early 1950s, especially as it was spread further by his imitators and ex-students who adopted his mannerisms. By then he was a well-known figure collecting followers and hangers-on wherever he went. As Maclaren-Ross observed, creative people like Minton need 'to be armoured against the supporters who at successful periods immediately accrete like barnacles on the bottom of a ship, unimportant in themselves but capable of causing erosion if from time to time not scraped off. Minton was incapable of scraping anybody off.'[23]

In 1946 Minton left the house of Colquhoun and MacBryde to share a flat with Keith Vaughan at 37 Hamilton Terrace, Maida Vale. Being an artistic chameleon he now tried painting more simplified blockish landscapes in subdued colours (*Road to Valencia* 1949) and more nude figures in the Vaughan manner, just as earlier he had tried in *The Path Round the Copse* (no date) Vaughan's wartime 'haunted house' style. These restrictions were too severe for him to endure for long, however, and his exuberant line and decorative colour harmonies soon reappeared in a series of portraits of friends. Vaughan, whilst being Minton's equal as an artistic force, was more introverted as a character and soon felt uneasy about being overshadowed on all social occasions by his flat-mate. Vaughan records in his *Journal* for Christmas Day 1948 :*

> I thought last night – for my Christmas has been discoloured by such thoughts – that Johnny's use of life might be compared to a Thibetan's use of a prayer-wheel. A circuit of activity is revolved with monotonous persistence in the simple belief that disaster can thereby be avoided and some lasting gain can be tasted, but the revolutions are so quick that nothing can be grasped or savoured.[24]

This hectic life style attracted attention so that soon Minton's gaunt photogenic face began to appear in the newspapers and gossip columns of glossy magazines, where his taste for taxis, night life and jive was reported with glee – though in those days his homosexuality could only be conveyed by innuendo. He became the Hockney of his day, the media's favourite artist. In 1952 Minton moved out of the address he shared with Vaughan into his own house in Allen Street in Kensington.

By now he had inherited enough money to do as he liked but whilst this swelled the ranks of his followers and increased the tempo of his social life it did nothing to increase his self-esteem as a painter. He was becoming tired of his own facility and the ease with which he turned out 'yet another Johnny Minton' on demand

* Minton's birthday was Christmas Day.

Dark Wood, Evening (c1945), pen, ink, wash on paper

and sought increasingly exotic stimuli to test himself against. For example, in 1947 as soon as wartime travel restrictions were lifted he left for Corsica with Alan Ross, then in 1948 to Spain, 1950 to the West Indies, 1952 to Morocco, and again to Spain in 1954 with Rodrigo Moynihan. He returned from each trip with a refreshed palette and a series of pretty drawings. In Jamaica, for example, he found, 'the colour of Jamaican landscape is that of coloured inks, of over-ripe fruit, acid lemon-yellows, magentas, viridians, sharp like a discord' – just those colours Sutherland had discovered nearer home in Pembroke. Minton continues his description of what else he was trying to convey: 'The vegetation, intricate, speckled and enormous seems to grow before the eyes, bursting with sap, throttling itself in coils towards the sun.'[25] Sutherland had seen a menacing force behind the bleached roots and splintered rocks of Pembroke, and now Minton began to pick up hints of it in the rank fecundity of the tropics. However, Minton's dextrous line and compulsion to make rich patterned surfaces did not allow the menace to show through.

These holiday views were usually shown at the Lefevre Gallery and reproduced in *Penguin New Writing*, or more glamorous magazines such as *Vogue* where, for example, the editor used Minton's Caribbean drawings in November 1951 to illustrate an article on holidays in that area. By now the line-work was as fluent as could be imagined and the colours often startlingly decorative, but the works had become picturesque, not in the original sense of half-way between the Beautiful

and the Sublime, but in the modern package-tour sense, meaning worthy of a snap-shot. They are now obvious views of obviously attractive places and people. Could one imagine a fashion magazine using Sutherland's Pembroke water-colours or Piper's Snowdonia drawings to advertise holidays in Wales? Or Nash's Dymchurch vistas to sell beach cottages?

Minton lacked what Wyndham Lewis called the prize-fighter quality in a pain-ter.[26] He was not self-assertive enough and did not push his superb talents hard or far enough. He confessed to sitting before his easel not knowing what to paint. Somehow he had lapsed from being a painter of enormous potential to being a sophisticated illustrator of other people's ideas.

As an example of how well he could tackle a set commission we may consider his illustrations for *Time Was Away*, commissioned by John Lehmann and written by Alan Ross.[27] It describes a journey the writer and artist made through Corsica in 1947 – a journey made 200 years earlier by James Boswell and 100 years earlier by Edward Lear. Ross describes Corsica as a corrupt, defeated place stinking of poverty, disease, ordure and decay. Again and again, however, Ross's account of some fly-blown village is contradicted by Minton's drawing of it looking like a set design for an Italian operetta. Here the nimble line, control of black and white areas, and the enormous variety of mark made by pen and brush are all seen in full flow.

Propriano: Timber and Lighthouse illustration to *Time Was Away* (published 1948)

Echoes of Palmer might be detected in the rhythmic overall patterning and texture, of Sutherland in the fondness for eroded rocks and trees at the front of the picture, of Berman in the city vistas and deep perspective, and there is even a Tchelitchew metamorphic landscape where the rocky outcrops of Les Calenches de Piana turn into hooded figures muttering together beneath a spinning sun. Despite this seeming eclecticism the style is already, by 1947, firmly established as Minton's own, and though he was to apply it to many new commissions to the end of his life it would never develop much further than this.

Time Was Away is a splendidly produced book considering the austere times in which it was published, yet looking through it again one begins to find the illustrations blending together: here is the same path winding into the same three-tiered picture space; the same litter of boats, rocks, cacti and bric-à-brac cluttering the front of the stage; the recurring trick of dipping a branch in from the top to frame a vista; and, on a closer look, certain calligraphic tricks for rendering foliage or weathered surfaces begin to impinge. The portraits of local men and boys, on the other hand, are terse fresh statements in pure unshaded line, each feature effortlessly right.

It is difficult to assemble a body of serious criticism on Minton's *œuvre*, but no problem at all to collect dozens of anecdotes on what Michael Middleton called 'the novelettish tenor of his life'. His jokes, binges, gangling body and 'El Greco' face, his wild swings from elation to depression, his need for recuperative deep sleep, are all recalled with affection, tinged with pity, by those who knew him. John Rothenstein remembers him dancing by himself to the juke-box music in Muriel's Soho club, 'the wildness of the gestures of his long arms contrasting in bizarre fashion with the near melancholy of his expression'.[28] Behind the twitchy restlessness and manic gaiety his true friends began to detect a profound despondency, even a death-wish. This depressive side of his character is already peeping through Ayrton's 1941 portrait of him, again in Robert Buhler's of 1949, more nakedly still in Lucien Freud's merciless work of 1952, in John Deakin's undated photographs, and most poignantly of all in his self-portrait of 1953 where the bottom lip seems on the verge of quivering and the big eyes to fill with tears. Rodrigo Moynihan's famous picture of *The Teaching Staff of the Painting School, Royal College of Art* (1949–50) brings out the pathos of Minton's growing isolation. Most of the staff are in suits – the artist had become institutionalised by this time – but Minton sits alone to the left in his existentialist black sweater and coat, his sad face the focus of the whole huge canvas. By this time in the early 1950s those Soho and Fitzrovia dives – the Wheatsheaf, the French, Muriel's, the Gargoyle and so on – were beginning to lose their charm, even for Minton. Maclaren-Ross described their invasion by 'Slithey Toves' come to gape at the ageing inhabitants, and the provincial university students looking for the spoor of Dylan. Minton's own students were even deserting the pubs altogether to meet in coffee-bars, or staying at home to watch television.

Minton sought distraction from whatever it was that gnawed him inwardly in two ways: rough sex and hard work. In the end neither offered solace or answers.

Keith Vaughan, who had by now moved away to his own flat, was riven by some of the same doubts, but more intellectually equipped than Minton to analyse them. He quotes T. E. Lawrence on his preference for rough companions: 'I always took my pleasures downwards because there is certainty in degradation.' Vaughan comments perceptively on what is essentially the dilemma of the Romantic artist who finds his inner resources dwindling and his isolation increasing no matter how much he seeks company:

> Really it amounts to an attempt to escape the responsibilities of that position to which by nature and education they are inheritors. Not artists enough to find themselves completely in their art, they still have to pay the price of the artist, loneliness and isolation. They envy the seeming completeness of the simple, the naturalness of simple tastes, ideas, actions. But it is their particular perceptions as artists that reveal, what to others remains totally unremarkable, the rare beauty of the commonplace and simple. And it is precisely the possession of those perceptions that bars them from entering the ranks of the simple.[29]

Only when we abandon all those civilised qualities which make us the different people we are, says Vaughan, when we are reduced to the minima of hunger, danger

Street and Railway Bridge (1946), oil on canvas

or sex, do we find an illusory unity with our fellows – remove the conditions and the bond vanishes. Minton was perhaps on the trail of this illusion.

For all his reckless self-destructive bohemianism, and the newspapers' determination to portray him as a representative of the Beat Generation, Minton still seemed to need some kind of formal recognition from those who represented the conservative tradition in English art. Whilst his friends were seeking approval from the ICA, or more adventurous commercial galleries, Minton sought membership of the London Group in 1949 and in the same year exhibited for the first time at the Royal Academy, then going through one of its most reactionary periods since its foundation.

In February 1949 he had shown a vast (60 inches × 132 inches) painting called *The Harbour* at the Lefevre Gallery, and in spite of its low price of £125 nobody bought it. Then in the Summer Exhibition of the Royal Academy Minton showed it again, now priced at £250. The RA President, Sir Alfred Munnings, implacable opponent of anything in painting later than the Impressionists, attacked this work in his banquet speech which was broadcast on the radio. He also pointed it out to the Press with the comment, 'Just look at that awful thing – just juggling about copying others. It wouldn't even make a good poster.' The painting was based on sketches made during the trip to Corsica, and apart from a few hints of watered-down Cubism it was a bright eye-catching work which undoubtedly *would* have made a good poster. Munnings told Minton, 'You need to get out in the country my boy,' which apart from being a curious echo of Sir William Blake Richmond's advice to Paul Nash: 'My boy, you should go in for Nature,' was shrewd advice on how to refresh his art and unclutter his life. However, Munnings' attack was seen as patronising philistinism and the more progressive painters rallied to Minton's defence in just the way they had to Wyndham Lewis's when his much greater and more innovative portrait of T. S. Eliot had been rejected by the Academy in 1938. Minton's pleasant holiday souvenir hardly merited this support and he rather betrayed his radical supporters' confidence by agreeing with Munnings that the finest picture on show was Annigoni's self-portrait.

Minton continued to submit to the Academy. Some of his portraits, including his self-portraits, were influenced by his friendship with Lucien Freud, though he lacked that painter's ruthless penetration. He also began to attempt huge narrative works of the kind that Reynolds or Benjamin West might have attempted when the Academy began. Interestingly, one of these, *The Death of Nelson* (1952), he adapted from the Victorian history painter Daniel Maclise (1806–70). Maclise had made an oil version of this in 1862 and gone on to complete a vast fresco of it for the Royal Gallery in the Houses of Parliament in 1865. In its widely reproduced engraved version it appears as a frieze-like composition, full of turbulent narrative detail which in spite of the surface realism plays up the drama and pathos for all it is worth. Minton's version simplifies the details and severely curtails the composition, tilts up the deck and empties it of clutter, darkens the whole scene, and makes the group around Nelson the sole dramatic focus. In its way this is a very impressive canvas, but close up one can see that every hair is drawn in, every figure has a

Male Life-Study (undated), pen and ink

hard definite edge, and every feature has a line round it. It is essentially an enormous book illustration conceived in line rather than paint. Less impressive is *Coriolanus* (1955) which looks like a play-bill awaiting its lettering, and *The Gamblers* (1954), a scene at the foot of the Cross. By this time Minton has come to rely on short-cuts and tricks: ways of painting clothing to suggest folds; filling empty spaces with meaningless abstract textures; simplifying the drawing of bodies so that arms, for example, become two sausage shapes which touch at the elbow. It was all a sad falling away.

One of his last and largest attempts to move away from the small-scale decorative works he did so supremely well was called *The Survivors* (1956), which showed

six men clinging to a life-raft.* This was a bold venture at one of the archetypal Romantic themes where survivors clinging to upturned boats or spars take on, Eitner tells us, the symbolic role of distressed mankind isolated in a hostile universe. Turner used the motif several times, but the most famous version is Géricault's *Raft of the Medusa* (1819). The gossip columnists reported with glee how Minton had to work through the night to get it ready for display because his days were so full of social events and teaching at the Royal College. John Berger, reviewing for the *New Statesman*, thought the haste showed:

> His two large narrative pictures of *Coriolanus* and *The Survivors* of a shipwreck are extremely well composed, but again remain skeletons. Oh, one knows what he means and there are excellent things in them – the sailor's drenched shirt and the wet light in the sky – but they could be so much more, the figures could be as complex as the waves of the sea – then they would move us. Géricault made hundreds of studies for *The Raft* – from Michelangelo, from models, from the sea, from the accounts of the survivors. Minton, I am sure knows all this, but he is too honest an artist to deceive by the surreptitious lowering of our standards.[30]

Minton's sixth and last exhibition at the Lefevre Gallery in 1956 flopped and its critical reception, of which Berger's article is but a part, hurt him badly. He resigned from the Royal College; began, but never finished, *The Death of James Dean* (an actor who died young in a car crash and with whom Minton and many other homosexuals seemed to identify); tried stage design for the Royal Court Theatre but failed to charm the critics and so was forced, in between drinking bouts, to take stock of his life and work.

Minton's younger Neo-Romantic friends were scattered or interested in other things by 1956. Ayrton was married, lived out of London, and was turning his attentions to sculpture. Vaughan had found his obsessive theme of the male nude and also seemed interested in De Staël and Abstract Expressionism, neither of which meant much to Minton. Craxton was in Greece, Sutherland settled at Menton, Prunella Clough was in London but steadily moving towards abstraction. Bacon was now the rising star with his sadistic dismemberings of the human body, and Freud was about to abandon his early meticulous style of inquisition for a more brutal attack on his sitters. Minton, who always said that art was about the creation of beauty, could not follow these last two either. Only Colquhoun and MacBryde seemed equally at a loss and heading downwards.

Young students had always been attracted to Minton, but now he seemed to be losing touch, to seem to them a figure forever fixed in the forties. Youngsters from his own college such as Bratby, Smith, Greaves and Middleditch were asserting in The Young Contemporaries show of 1952, and on Britain's behalf at the 1956 Venice Biennale, that babies in nappies, drowned hens, chip fryers, littered breakfast

* Keith Vaughan had done two paintings of survivors on a raft in 1948, subtitling them 'Variations on a theme of Géricault'.

Sunflower (1948), ink, watercolour, wax crayon

tables and dustbins were valid subjects for painters. John Berger, the newly influential Marxist critic, welcomed this so-called 'Kitchen Sink' School:

> Their way of looking implies a fresh intention; an intention to discover and express the reality, the sharper meaning, given to such unremarkable subjects by the lives and habits of the people they concern.[31]

These charmless pictures in muddy colours represented not only the next short-lived fashion to replace Neo-Romanticism, but a wider attack on the *belle peinture* tradition in art which Minton so respected. It was also an attempt to proletarianise art and again, though Minton had been active on the fringes of the AIA and had cruised Poplar, Rotherhithe and Wapping for both adventure and subject matter, he could not follow this lead. His pictures of slums and slum dwellers had always enhanced reality, loaded every rift with ore, rather than carried banners for a cause. 'All art forms create and fight for order out of chaos,' he told students, 'and in this lies their supreme social value.'[32] His puzzled, ironic review of the Kitchen Sinkers' work showed how little he sympathised with their intentions. A sad youngish man he might be, but even the popular Press could not label him an angry one as they seemed to do with every novelist, poet and playwright in the mid-1950s.

The news from abroad was not reassuring either. The School of Paris was no longer recognisable in its new brutalism or its adherence to international abstraction. Picasso and Braque were still there, but Matisse died in 1954 and the newcomers, Estève, Bazaine, Bissière, Lanskoy and Poliakoff, were all abstract painters. Hartung made bundles of interchangeable brushstrokes and Mathieu scribbled. Fautrier, Riopelle and the German Wols were more interested in paint surface than in having a subject to express. Minton had no love of the abstract and had urged students in 1952 towards an 'urban romanticism' as a way of avoiding it and retaining 'the necessity of the thing itself'. He continued to push against the tide of the times:

> Abstract painting at this point must lead to picture making – and by its own logic, back to the blank canvas, so if abstract art presents you with a blank canvas, surely it is up to you to put something on it: but with the knowledge that the greatest painting has always been made from a real love of the object.[33]

There *was* a major new figurative artist emerging in Paris who was also interested in the object, but not in the same way as Minton. 'Mud, rubbish and dirt are man's companions all his life; shouldn't they be precious to him, and isn't one doing man a service to remind him of their beauty?' Dubuffet asked.[34] In a parody of Romanticism's love of the unspoiled primitive Dubuffet imitated child art, graffiti, cave paintings and madmen's doodles and exhibited lumps of clinker as the new *Art Brut*. Even the more orthodox figurative painters in Paris were a joyless impoverished lot, if the highly priced Bernard Buffet was an example.

Kent Garden (1948), pencil, watercolour, ink

In the same year, 1956, that the Kitchen Sinkers represented British painting in Venice and the critics dismissed Minton's exhibiton at the Lefevre, the Tate Gallery showed 'Modern Art in the USA'. On the one hand these Americans offered a raw gestural art which did away completely with traditional drawing and went straight to dribbling, splashing or throwing paint on to the canvas; and on the other it gave, in Rothko, a kind of mysticism based on floating rectangles of pure colour. By the mid-1950s these two options had also been enlarged to include Mark Toby's 'white writing', Neo-Dadaism, post-painterly abstraction, colour-field staining, structuralism and all manner of other ways of working on an enormous scale without much reference to the external world. It was not a good time to be a gifted linear draughtsman at the fag-end of the English Romantic landscape tradition.

Our own muted reply to the American invasion was a Whitechapel Art Gallery exhibition in the same year called 'This is Tomorrow'. This featured Richard Hamilton's collage *Just what is it that makes today's homes so different, so appealing?* which shows a room constructed from snipped-up advertisements for consumer goods upon which Ruskin glowers from his frame on the wall. After that we had, in no very clear order, Op Art, Kinetic Art, Conceptual Art, Minimalism, Post-Minimalism, Land Art, Body Art, Process Art, Assemblage, Neo-Dada, Super-Realism, Language Art, Neo-Expressionism, Bad Painting, and eventually, in an attempt to start again free from the 'Modernism' which began in Paris before World War I, we arrived at 'Post-Modernism'. All these and several others seemed to flash across the gallery walls with the speed of a slide-show of holiday snaps – though Minton did not stay to see the later ones. All were a very long way from that previously unbroken tradition of landscape painting that began before Palmer but came down through him, Constable and Turner to Nash, Sutherland, Piper and Minton himself. Only on the wall of the Royal Academy Summer Exhibition did the search for the *genius loci* continue. There heightened realism, pastoralism, lyricism and anthropomorphically conceived landscapes continued to splutter on in a popularised form. In a way Minton, in turning to the Royal Academy for recognition and refuge, was guided by a right instinct: at heart he was a conservative and a traditionalist.

As Minton became more despairing his work rate slowed. T. S. Eliot wrote, 'The more perfect the artist, the more completely separate in him will be the man who suffers and the mind which creates.' Curiously, for a Romantic, this was true of Minton who in his elegantly crafted drawings continued to express a hedonistic love of people and things, resisting any impulse to make them more confessional or cathartic. As a character he seems to have been a textbook case of the manic-depressive creator described by Anthony Storr – seeking approval by his extravagant generosity; turning his aggression against himself rather than outwardly on others; seeking public acclaim and over-producing in order to get it frequently; and manically over-active in order to ward off the depressions which lurked just beneath the frenetic clowning of his public life.[35]

Finding no future for his kind of art, and suffering from the loss of his current lover to the barmaid of one of the Soho clubs, he drank heavily for several days

Prunella Clough, *Manhole III* (1953), oil on canvas

John Craxton, *Reaper with Mushroom* (c.1944), conté crayon on blue paper

John Craxton, *Tree Root in Welsh Estuary* (c.1943), oil on panel

and was then found dead on 22 January 1957 at his last home in Apollo Place, Chelsea. The coroner's verdict was suicide from an overdose of barbiturates. Alan Ross, his companion in Corsica, thought 'he was haunted by the fact that everything had been done before and there was nothing left to do, at least by him.'[36]

Minton was careless with his works and many are now widely scattered, making judgement difficult, but on the basis of those available one must conclude he was an artist of dazzling proficiency in the handling of line and wash, but his skill was largely expended on lightweight subject matter. He was like a brilliant linguist who had nothing interesting to say. Given a clear commission and deadline to produce a poster for London Transport, or a book on steel manufacturing processes, or a book jacket, or illustrations for *Treasure Island*, then Minton could do the job as well as anyone in the land. He was, for example, an inspired choice by John Lehmann to decorate Elizabeth David's *A Book of Mediterranean Food* – a reminder in the darkest days of austerity and rationing that 'peace and happiness begin,

Vignette from Elizabeth David's *A Book of Mediterranean Food* (first published 1950), pen and ink

geographically, where garlic is used in cooking'.[37] It was a message that Minton's and Connolly's generation were only too happy to believe – though the next one seemed to prefer hamburgers.

To call Minton an illustrator rather than a major painter (where are the major paintings?) is not to denigrate his achievement, but it is not how he would like to be remembered. Had he been encouraged after those early collaborations with Ayrton he could have been an outstanding designer for ballet and theatre, but this was not to be and he wasted his ingenuity on Chelsea Arts Balls and the décor for college dances. He will continue to do his melancholy solo dance across the pages of raffish memoirs from the 1940s and 1950s, but as an artist, gifted though he was, I doubt he will command more than a footnote when the full story of British art in the twentieth century comes to be written.

The final tribute should be Keith Vaughan's written on his return from Minton's funeral:

Johnny will, I suppose, become a sort of legend now. After the rather dreary and desperate last three years of his life are forgotten, one will remember the scintillating creature one knew before. He was a profligate with everything – with his affections, his money, his talents, and with all his warmth and charm essentially destructive. He turned everything into a joke and a subject for laughter. People never stopped laughing in his presence. 'What does it all *mean?*' he would repeat year after year, without really wanting to know the answer. But there comes a point in life when that question has to be answered or else one cannot go on. His influence was considerable on all who knew him, particularly the young, and not always I fear for their benefit. No one else could shine in his presence – his light was too strong – you were devoured and robbed of your identity – and he managed to persuade you that this did not really matter.[38]

REFERENCES

1. These details are from Hetty Einzig's, 'John Minton', unpublished MA thesis, Courtauld Institute, London University, 1979, and a conversation with Alan Ross.
2. Soby, James Thrall, *After Picasso* (Hartford and New York, 1935).
3. Gowing Lawrence, *Lucian Freud* (London, 1984 edition), Illus. 53.
4. Soby, James Thrall, op. cit., p. 33.
5. Sitwell, Edith, *Taken Care Of* (London, 1966), p. 137.
6. Pearson, John, *Façades: Edith, Osbert and Sacheverell Sitwell* (London, 1980), p. 274.
7. Sitwell, Edith, op. cit., p. 139.
8. Rose, Sir Francis, *Saying Life* (London, 1961), p. 150.
9. Cannon-Brookes, P., *Michael Ayrton* (Birmingham, 1978), p. 7.
10. Lucie-Smith, Edward, *Art of the 1930s: The Age of Anxiety* (London, 1985), p. 161.
11. Roditi, Edouard, *Dialogues on Art* (Santa Barbara, 1980), pp. 105–31.
12. Sitwell, Osbert, 'The Art of Pavel Tchelitchew' in *Sing High! Sing Low!* (London, 1944), p. 115.
13. Ayrton, Michael, 'The Act of Drawing' in *Golden Sections* (London, 1957), p. 73.
14. Cf. Cannon-Brookes, P., op. cit., p. 12.
15. Rothenstein, John, Introduction to catalogue, 'John Minton 1917–1957: Paintings, Drawings, Illustrations and Stage Designs', Reading Museum and Art Gallery, November 1974, p. 2.
16. Ayrton, Michael, *British Drawings* (London, 1946), p. 47.
17. *Horizon*, Vol. IV, No. 23, November 1941, as illustrations to Geoffrey Grigson's 'Samuel Palmer: The Politics of an Artist'.

18. Letter from Minton quoted by Michael Middleton in catalogue to Arts Council exhibition of Minton's work, 1958, p. 4.
19. Middleton, Michael, ibid., p. 8.
20. In *John Minton: A Commemorative Exhibition*, introduced by Rigby Graham (Cog Press, Aylestone, 1967), p. 14.
21. Ibid., p. 31.
22. Hastings, Gerard, 'Neo-Romanticism: its Roots and its Development', unpublished MA thesis, Aberystwyth, 1984, Chapter VII, footnote 20.
23. Maclaren-Ross, Julian, *Memoirs of the Forties* (London, 1984), p. 187.
24. Vaughan, Keith, *Journal and Drawings 1939–1965* (London, 1966), p. 114.
25. *John Minton: A Commemorative Exhibition*, p. 23.
26. Lewis, Wyndham, in *Wyndham Lewis on Art*, ed. W. Michel and C. J. Fox (London, 1969), p. 412.
27. Ross, Alan, *Time Was Away* (London, 1948), illustrations by Minton, typography and spine design by Keith Vaughan.
28. Rothenstein, John, op. cit., p. 3.
29. Vaughan Keith, op. cit., p. 56.
30. Berger, John, *New Statesman and Nation*, 17 March 1956.
31. Lucie-Smith, Edward, *Cultural Calendar of the Twentieth Century* (London, 1979), p. 122.
32. Swenson, Ingrid, 'John Minton 1917–1957: A Study of the Artist's *Oeuvre* in the Context of English Neo-Romanticism and Realism', unpublished MA thesis, University of Sussex, 1984, p. 49.
33. Ibid., p. 48.
34. Catalogue, 'Aftermath France 1945–1954', Barbican Art Gallery, London, March–June 1982, p. 5.
35. Storr, Anthony, *The Dynamics of Creation* (London, 1972), Chapter 7.
36. Ross, Alan, 'Lost Heroes', *Sunday Times Magazine*, 29 January 1967.
37. David, Elizabeth, *A Book of Mediterranean Food* (London, 1950), Introduction, p. 1.
38. Vaughan, Keith, op. cit., p. 144.

MICHAEL AYRTON

RESEARCHING the career of Michael Ayton is a humbling task. All the written and living sources proclaim his brilliance as a wit, controversialist, critic, broadcaster, film-maker and artist – though running through several accounts is a scarcely concealed envy of his talents and resentment of his dogmatism and self-promotion. In 1975 he died of a heart attack at the age of fifty-four, but left behind a prodigious amount of work to sift through. Not only did he have over fifty exhibitions of his drawings, paintings, etchings and sculptures; but he made films on Leonardo's drawings, Greek sculpture, and the Daedalus legend; wrote thirteen books covering such topics as Giovanni Pisano's sculpture, Berlioz' music, a satire on the life of Picasso, and a skit on bureaucrats and critics (*Tittivulus* 1953); and published two volumes of collected essays on art, literature and music. In between times he illustrated thirty books and designed for ballet, drama and the most sumptuous production ever seen at Covent Garden. He became the youngest guest on *The Brains Trust*, a radio programme which dared to make stars of intellectuals and which had built up a Sunday afternoon audience of ten to twelve millions by 1943. Then he switched to television and back and forth to journalism, succeeding John Piper as art critic for The *Spectator* in 1944. One day soon there must appear a worthy biography of this compulsive communicator and polymath. For our purposes, however, we can confine ourselves to a consideration of the work he did up to his second retrospective exhibition in 1955, and equally to his art criticism which did so much to establish the identity and confidence of the younger Neo-Romantics around the mid-forties. It must be admitted that his final reputation, whatever that may turn out to be after its present slump, will not rest on these early works, but on his later sculpture and associated graphics. That is also how he would wish to be remembered.

Ayrton's insatiable gusto for tackling new problems and finding new channels for his teeming ideas was never damped down by an academic training. He was ill during much of his childhood and then had to leave his last school, aged fourteen, under some kind of cloud, perhaps to do with a precocious interest in sex. However, it would hardly be possible to devise a more stimulating intellectual background for a child to grow up in than his family home. His maternal grandfather was for-

merly Professor of Physics at Tokyo University and this man's second wife, another scientist, was the first woman to be elected to the Society of Electrical Engineers. Ayrton's mother, Barbara Ayrton-Gould, was a politician, Member of Parliament for North Hendon, and eventually, in 1939–40, the Chairperson of the Labour Party. His father, the poet, essayist and critic Gerald Gould, was close to his son but died when Michael was fifteen.* Ayrton was accustomed to meeting famous and talented people from an early age and continued to seek them out, unashamedly, all his life. Soon after his father's death he adopted his mother's surname because beginning with an 'A' it would get him to the top of catalogue lists in mixed exhibitions.

By his mid-teens Ayrton was already a confident traveller having gone to Paris and Flanders and then on to Spain where he lied about his age and suddenly found himself in Barcelona whilst Franco's forces were bombarding it. He thus became the only one of our Neo-Romantic group to take even a minor part in that rehearsal for World War II. Once rescued from there by his mother he was sent to Vienna for a year to stay with his militantly Socialist aunt, Amelia Levetus. Whilst there he took the opportunity to study the German masters, particularly Dürer, in the Albertina. Next he returned to London for brief study periods at Heatherley's Art School and St. John's Wood Art College before going to Paris in autumn 1938 with John Minton. As we described in the previous chapter the two youngsters studied there under Berman and de Chirico, and whoever else they could persuade to talk to them, before the war sent them back to London. Ayrton's emaciated, pinky-blue Picasso and Tchelitchew clowns, jugglers, gods and goddesses of this period were blatantly derivative, as we can see by glancing at *The Bull Ring* (1939), *The Vase of Flowers* (1940), *Jupiter and Antiope* (1940), *The Maskmaker* (1940), *Strolling Players* (1940), *The Juggler in Sequins* (1940), *Fête Champêtre* (1940–41) and the woe-begon *Orpheus* (1941). These are remarkably escapist and sentimental works considering their creator's political commitment and the war raging around him. They are laboriously drawn too, showing that his later achievements and fluent line were built up by dogged application and the intelligent deployment of his resources, rather than by the flowering of great gifts. Only their literary subject matter and the strong undertones of sexuality prefigure aspects of his later works.

Briefly, Ayrton served in the Royal Air Force before being invalided out with a deep throat abscess which frequently made him delirious until it was cured. The RAF was, symbolically, the right service to enter for an artist whose last twenty years were spent exploring the theme of men with wings. It was probably the favourable critical reception to his, and Minton's, *Macbeth* designs which then secured him his first job – that and the fact that most established artists were away at the war. He was asked to join Minton at Camberwell School of Art to teach life-drawing and theatrical design. He was still only twenty-one but he relied on his mature beard, his Viennese studies and his 'gift of the gab' to impress the students when demonstrating.

* Gould reviewed for the same paper as Paul Nash, *The Week-end Review*, and was satirised by Wyndham Lewis as the character Geoffrey Bell in *The Roaring Queen* (1936).

Orpheus (1941), oil on canvas

The war had little impact on Ayrton's art – even his *War Fortification* (1940) looks like a random collection of stage props. However, in June 1942 two of Ayrton's gouaches were purchased by the WAAC at 15 guineas for the pair. *Chainmaker Drying Off* and *Chainmakers Taking a Link Out of a Furnace* show a great increase in competence, a close study of Sutherland's war pictures, and Ayrton's lifelong liking for lurid lighting and nude or semi-nude figures shown under physical stress.* These works are obviously tied closely to the observation of real events, but other pictures of this period are equally obviously from a deeper level of imagination. He was at this time interested in the occult and may have met, on his Fitzrovian

* The Imperial War Museum has recently acquired a third in this series, *Chainmakers Shaping a Link.*

Temptation of St Anthony (1942–3), oil on wood

travels, the Great Beast himself, Aleister Crowley, who was by this time past his best as a seducer, poet, mathematician, mountaineer and wizard and reduced to a pitiful drunk. He had also been defeated in battles across the ether by the white witch Barnett Stross, MP for Stoke-on-Trent, and inevitably a friend of the Ayrton family. It is impossible at this distance to know how deeply Ayrton took this interest, but there is evidently some quite extreme spiritual crisis being worked through in various studies for *The Temptation of St. Anthony*. In the final version of 1943 he makes roots coil, rocks undulate, moonlight flicker and the agonized saint howl before a man with a flaming hand, a vulture, a hydrocephalic child and a naked woman. This is a startling subject for a twentieth-century artist to undertake. It is also emphatically not a French subject and already shows Ayrton's determination to look to other sources besides the School of Paris – here he had Bosch and Bruegel in mind, and above all Grünewald.* Normally Ayrton did not paint directly from the model but in this case he increased his identification with the saint's agonies by first outlining his own muscles, and then copying his own figure from a mirror.

* There had been a long discussion by Robert Melville, with reproductions, of Bosch's *Temptation* in *Horizon*, No. 10, October 1940, which might have inspired Ayrton to tackle this subject.

Skull Vision (1943), oil on panel

Next Ayrton turned to the subject Sutherland had turned down in favour of his *Crucifixion: a Gethsemane* (1944). He made a similarly fraught and dramatically lit picture to his St. Anthony, this time throwing a monster-log across the foreground and a swirl of moonlight on the naked Christ who crouches on a Sutherland rock, high up in the composition. 'A sense of pain provoked my painting of Gethsemane in Wiltshire,' said Ayrton, though he does not tell us what moved him on from the posed melancholy of his earlier jugglers to the spiritual torments of Anthony and Christ. A further picture in this series, *Skull Vision* (1943), universalises this feeling of terror. There are none of Nash's or Tchelitchew's equivocal forms here, no hints of bogies in the bushes, but a direct and terrible vision of a fanged skull which had devoured the landscape and now towers into the clouds like a Gothic ruin.*

A calmer, but still eerie, vision of the same year as the skull is *The Sleeper in Flight* in which a giant male nude drifts into the moonlit sky, far above the land.

* This work may have been inspired by Liszt's *Totentanz*, a work for piano and orchestra much admired by Ayrton, Constant Lambert and Cecil Gray (Cecil Shead, *Constant Lambert*, London, 1973, p. 138). Edward Burra used the same motif in *Skull in Landscape* (1946) but made it a more direct comment on the times by putting a tin helmet on the skull.

Tchelitchew had been fond of figures liberated into space like this. By 1944 the sleeper has landed and now sprawls on his back in *Earthbound*, stretched across a wheatfield with retreating stooks. Two last, inferior, products of this disturbed period are the drawings *Convulsive Landscape* and *Tree Forms*, both of 1944, where he has borrowed Sutherland's roots and Tchelitchew's ambiguous landscapes to suggest two grappling nude bodies. In these works he is well down the branch line which leads from Romanticism to the worst banalities of Salvador Dali.

These dark and turbulent works of 1939–44 set Ayrton somewhat apart from the other Neo-Romantics who were still taking natural phenomena as their starting point rather than creating wholly imaginary melodramas such as these. They seem nearer to German sources in their eroticism and emotionalism and, further back, to Dürer's kind of linearity rather than to any English ancestry. Ayrton always felt the need to tune up the dramatic aspects of his already sensational subject matter by use of lighting effects or unusual viewpoints and seemed constrained by none of that good taste which held back his friend Minton.

Ayrton had not yet fallen under the spell of Palmer but there was an older contemporary of Palmer's who seemed to have had many of the same obsessions as Ayrton at this stage of his career, and later too. This was Henry Fuseli (1741–1825), the Swiss-born painter who settled in London and became a friend of Blake's ('Blake is damned good to steal from,' he said). He was a failed preacher, poet (in German), polyglot, irascible socialite, brilliant lecturer, the object of Mary Wollstonecraft's desires and Goethe's admiration, and an avid reader steeped in Milton and

Earthbound (1944), oil on board

Shakespeare. 'His look is lightning, his word a thunderstorm; his jest is death, his revenge hell,' his friend Lavatar said of the young Fuseli in 1773, but by the time Benjamin Robert Haydon visited him in old age he had become 'a little white-headed, lion-faced man in an old flannel dressing gown tied round his waist with a piece of rope and upon his head the bottom of Mrs. Fuseli's work basket.'[1] By then his wild nightmares and hellish visions had scandalised Reynolds and earned him the nickname 'Principal Hobgoblin Painter to the Devil'. Palmer admired him, and so did Blake who thought: 'This country must advance two centuries in civiliza-tion before it can appreciate him.'[2] Perhaps by the 1940s the time was ripe. Piper mentioned him favourably in his *British Romantic Artists*, wrote at greater length in *Signature*, and yet again in an Introduction to Paul Ganz's *The Drawings of Henry Fuseli*, the first book in English on the artist since 1831.[3] Geoffrey Grigson thought Fuseli's intelligence, energy, and fearlessness of the artistic establishment made him the Wyndham Lewis of his day; and Ayrton himself, whilst conceding Fuseli's inclination to push emotions too far and his liking for the morbid and supernatural, thought him a major painter of genuine power. He provided a link between the visionary Romantic art of Blake and the fleshly vitality of Rowlandson, and 'saw his contemporaries clearly if theatrically, which may also be said of El Greco'.[4] Fuseli told Haydon that 'the subject of a picture should astonish, surprise, or move; if it did neither it was not fit', and obviously the young Ayrton shared this view and found many qualities in Fuseli with which he could feel kinship.

What he shared, it seems to me, both then and later, were Fuseli's very literary, illustrative approach to picture-making, his rather obsessive but cold eroticism, and his mannerist distortions of the human figure. Both artists were at their best in their drawings, rather than in their overworked and unsubtly coloured paintings. An acquaintance of Fuseli's, called Joseph Farington, noted in his diary that the painter regretted his lack of early training and that 'his powers of execution cannot keep pace with his conceptions, which are generally, if not always, of a nature that particularly require vigorous practice to express them properly.'[5] Much the same things could be said of Ayrton until about the mid-1950s, but being an acute critic he was the first to bring such charges against himself when he came to survey his own retrospective exhibition.

Around 1942 Ayrton began a relationship with Joan Walsh. They moved into a house and studio in All Souls Place behind Broadcasting House and the BBC soon found employment for Ayrton's ability to make ideas exciting. With this domestic content his obsession with disturbing phantasms seems to have slowly weakened and he turned his attention both to the real people about him and to the English landscape. *Joan in the Fields* (1943) suddenly comes outdoors into the full sunlight of Great Missenden. There are deliberate echoes here of Gainsborough's early work *Mr and Mrs Andrews* (1749), and perhaps unconscious ones of Nash in his treatment of the distant hills. A modern Adam and Eve lie uncomfortably on the stubble. Joan's head is finely drawn, but the colour has reverted to his Parisian prettiness, and the kitten in her lap is pure Disney.

In 1945 and 1946 Ayrton spent the summer holidays in Pembrokeshire where,

Joan in the Fields (1943), oil on board

like Craxton, Freud and Vaughan, he met Graham Sutherland whose work he had already studied and learned from. By now Sutherland was beginning to work on his thorn-inspired heads and Ayrton, ever ready to absorb new influences, also began to use skewer-like forms. His *Entrance to a Wood* (1945) and the drawings for it show the path through to sunlight blocked by barbed creepers and branches sharp as bayonets. Other works of this period with the same spikyness are *Pine-trees in a Gale* (1945), *Honeysuckle Picker* (1945) and *Susannah and the Elders* (1945) where the characters are represented by three trees, one of them with breasts.* By now he had caught the Nash habit of regarding trees as people: he identified, he said, 'with the genial good will of trees sunbathing, the terror of bare windblown trees, the lonely grief of isolated trees under rain'.[6] Now, he claimed, 'To paint the essentials of a tree one must come to understand what it is to be tree, one must become the tree one is painting' – as if Method Acting could be adapted to easel painting.

A calmer, more consciously Palmeresque vision of the English countryside is the 1945 pen and wash drawing *Apple Trees by Moonlight* which is richly textured and

* Nash had made a similar surreal pun in *Striptease Object* (1937), an upright log on a beach.

Entrance to a wood (1945), oil on canvas

carefully composed, though even here there is a writhing, clenched energy in the
knuckled branches that Palmer would have subdued. At about the time he did this
drawing Ayrton must have been drafting his book *British Drawings* in which he
states, 'It is Palmer, more than any other individual draughtsman, who influences
the landscape drawing of the younger generation today'.[7] In Ayrton, however, there
are a demonic restlessness and a spiritual unease which prevent him from achieving
Palmer's calm visions of England before the Fall. For example, Palmer would never
have attempted such a subject as *Winter Stream* (1945) with its dash and splash
of a stream in flood, its bare trees, and the rearing log in the centre of the composi-
tion. In spite of the hints of Nash in the distant hills and the jumpy colour this
is a picture full of rhythmic curves and implied movement, a characteristic of all
Ayrton's work.

In 1945 *Poems of Death* was published, an anthology chosen by Phoebe Pool
who justified its seemingly gloomy theme by saying that, after all, 'the subject had
been forced on our attention for the last five years'.[8] Ayrton was an inspired choice
as illustrator since he could indulge his love of the Grand Guignol and fill pages
with corpses, skeletons, hooded figures, ravens picking bones, funeral urns, engulf-
ing waves and moonlit gallows. He could also legitimately recycle his *Skull Vision*

Study for Apple Trees by Moonlight (1945), black ink and wash

and invent Sutherland-like humanoid plant forms. The sheer theatrical gusto of these lithographs makes Nash's *Urne Buriall* illustrations look rather anaemic.

Ayrton obviously enjoyed the challenge of working from literary texts and the opportunities this offered him to try other graphic techniques such as lithography, monotype, line-blocks and engraving. His choice of works reflects his love of the eccentric character, the extravagantly costumed setting and the macabre event. Subjects in which characters could be shown under the extreme pressures of lust, awe, terror or pain drew his attention particularly. It is not surprising, therefore, to find him illustrating *Macbeth* (Fuseli's favourite play), *The Duchess of Malfi*, *The Picture of Dorian Gray*, *English Myths and Legends*, *Ghosts and Witches*, *The Golden Ass* of Apuleius, the poetry of Archilochus, Poe's *Tales of Mystery and Imagination*, *The Epic of Gilgamesh*, *The Oresteia*, *Gilles de Rais* by Cecil Gray, and a very erotic edition of Verlaine's *Femmes/Hombres*.[9] He also tackled Keats, and seemed fond of the Elizabethan writers, particularly Thomas Nashe; later, after his complete immersion in the classical world, he illustrated Aeschylus, Euripides, and Plato's account of the death of Socrates. The only contemporary artist-illustrator-writer with a similarly Gothic love of the absurd and melodramatic was Mervyn Peake, author of *The Gormenghast Trilogy* – a man whom Ayrton several times praised in his reviews.

Ayrton's bookishness naturally brought down upon his head the charge of being 'literary' – an accusation all the Neo-Romantics from Nash onwards had to face. Ayrton answered for them all in 1946:

> In the years between the wars, the shrill cries of 'illustration' and 'literary' were heard as terms of abuse from the 'Significant Form' contingent, and this curious misunderstanding of the many differences of pictorial purpose still survives, if only in a whisper, in the face of the increasing power of contemporary British painting, most of which is – if the word must be used – 'Romantic'. The real point is that a picture is either good, bad or mediocre, whether it is inspired by the Bible, a bowl of apples or Bradshaw's railway timetable. If a picture is sufficiently well painted, deeply enough felt and conceived in essentially visual terms, it is not of great consequence whether it illustrates an episode from Shakespeare or is a portrait of the Bishop (Elect) of Vermont.[10]

In fairness he has to add,

> It is however, as possible to overstate a case in paint as it is in prose, and this the English Romantics did in their plunge from Burke's 'sublime' in the hands of Ward and Fuseli to Millais's 'Bubbles'.

Ayrton moved easily through the worlds of art, literature, politics and broadcasting, but he also confronted musicians with a wide-ranging knowledge of their specialisms. He was a friend of William Walton, Cecil Gray and Alan Rawsthorn, but closest of all to Constant Lambert (1905–51). Lambert had a painter father

and a sculptor brother so they overlapped interests enough for Lambert to live with Ayrton – in the house behind the BBC – from 1944 to 1947, when Lambert left to get married. At this time he was known for *The Rio Grande* (1928), a jazzy setting of Sacheverell Sitwell's poem, and for his contributions to the 1942 readings of *Façade*, for which, it will be remembered, Piper provided the front cloth. As an author he had raised many hackles with *Music Ho!* (London, 1934), his book subtitled *A Study of Music in Decline.* He and Ayrton had in common a love of cats, public houses, the Elizabethan pamphleteer Thomas Nashe and other arcane byways of knowledge. Lambert for example, could offer expertise on bats, numerology, early aeronautics, Jacobean tragedy, French seaports and London docklands. They enjoyed an anarchic sense of humour which led them, both bulky men, to climb into the luggage racks of a darkened railway compartment to complete a graffiti mural of cats and fishes as the train bore them towards the Potteries.* They both loved ballet and it was to visit the Sadler's Wells company, then touring the provinces because its London home was closed, that they were making this wartime journey: Lambert to play the piano for them to dance to since they had no orchestra, and Ayrton to discuss making stage designs for them. He also turned their miserable stay in the blacked-out Midlands to good use with two paintings; the first, *The White Country* (1945), shows another of his nude giants standing before a moonlit and crockery-littered crater and a distant town: the second, *The Tip, Hanley* (1946), shows just the crater where, he wrote, 'a million broken cups and saucers make for rats a porcelain Chicago.' Perhaps his memories of de Chirico's moonlit perspectives had enabled him to see the possibilities in this unpromising hole in the ground.

When the war ended Lambert adapted Purcell's *Fairy Queen* for production at Covent Garden, its first performance since the seventeenth century. It was in three acts and six scenes and designed to run for three hours and to blend music, dance and the visual arts in the true Diaghilev tradition. Frederick Ashton provided the choreography, Fonteyn and Soames danced, and the Covent Garden opera company sang under Lambert's baton. Ayrton provided the costumes and scenery after a typically thorough but high-speed ransack of Italian Renaissance sources and the masque designs of Inigo Jones. The costumes are extravagantly flouncy fantasies, but the backdrops, insofar as one can judge from the reproductions in the souvenir book (designed, of course, by Ayrton), are *tours de force* in false perspectives, swags, wild streaming skies, eroded grottoes, classical ruins, tentacular roots and branches – in short the whole Neo-Romantic bag of tricks all held together by his characteristically swooping and undulating rhythms.[11] They are very ambitious indeed for a mere twenty-five-year-old working within the limits of post-war material shortages, union demarcations, an audience used to the cinema's extravagant special effects, and a pressing time schedule. Christian Bérard thought Ayrton's contribution 'a work of authentic splendour and grandeur', but other critics gave the masque a rather mixed reception so that it was only revived once more, for the 1951 Festival

* Ayrton recalls this and other bizarre episodes in his valedictory essay on Lambert, 'Sketch for a Portrait', *Golden Sections* (London, 1952), pp. 123–35. A more harrowing account of the self-destructive Lambert family is given in Andrew Motion's *The Lamberts: George, Constant and Kit* (London, 1986).

Self Portrait (1947), pen, ink and wash

of Britain Year, and then disappeared. This work, together with the earlier *Macbeth* with Minton, the ballet *The Spider's Web* (1944), and the 1944 ballet production *Le Festin de l'Araignée* for Sadler's Wells, showed how easily the young Ayrton could have opened up yet another career for himself, and one very suited to his style and outlook. If the adjective 'theatrical' was constantly applied to Piper's work, then with how much more justice could it be attached to almost everything Ayrton produced! Nevertheless, after Lambert's death from drink in 1951 he seemed no longer interested in working for the stage itself and confined his sense of drama within the picture frame, or later to the sculptor's plinth.

In an attempt to get back to a tougher reality Ayrton changed direction yet again. The dockland areas of London seemed to exert some kind of pull on the capital's intelligentsia: Cyril Connolly, for example, had toured them as if they were a foreign, picturesquely squalid country, only to be accused of being a foreigner himself because of the plummy way he drawled. The Homintern had toured the East End for pick-ups, and Minton had made some rather sentimentalised pictures of the wharfs and waifs. Sutherland had painted the devastated housing but stayed away from the river-fronts. Ayrton now went there with a straightforward realist intention and painted *The Quay Isle of Dogs* (1947) and the much better *Thames Foreshore* (1947), both showing the debris left by the tide and the complex skyline of cranes. In the latter he also enjoys the swooping curves made by seagulls' wings in contrast to the flat horizon and the sharply diminishing lines of the wharf. Perhaps in emulation of Jankel Adler, or Robert Colquhoun, or his earlier hero Tchelitchew, he also mixed other matter in with the paint to add interest to the surface, but it was done in a straightforward imitative way rather than for decorative purposes. These were painted in 1947 when the whole country was paralysed by snow and ice. There are several of these Euston-Road-style pictures, though one can tell they are painted in the studio rather than in front of the motif, but they are all free of that sentimentality which had marred Minton's attempts to draw London's rougher areas. In the same year he painted *Haytor Quarry*, a study of the energy in rocks, and slightly earlier two coastal scenes, *Hooper Point* (1946) and *Headland, Storm Blowing Up* where the sea, sky, rocks and land boil and heave and convulse like an even madder vision than Soutine's.

A neglected little gem of 1946 was the book *Clausentium* (Jonathan Cape, London), a joint work with John Arlott who wrote sonnets about a house they had both discovered near Southampton. The site had been continuously occupied for 2,000 years but now the buildings lay shattered by bombs and vandals, as open to the caress of moonlight as either the Romantic poet or the Romantic artist could wish. Ayrton made this vulnerable ruin as much his own as Piper had made Hafod in Wales, a house which suffered a similar fate in being vandalised, burnt and eventually blown up. Ayrton's ink drawings on grey paper with touches of white are examples of Neo-Romantic graphics at their most appealing. The blood and thunder excesses of *Poems of Death* are now under firmer control, the images tied tightly to close observation, and for once Ayrton does not impose those unnaturally sinuous rhythms through and across all his forms.

Ayrton was never the leader of the Neo-Romantic movement – Sutherland perhaps aspired to that position – but there is a good case for calling him the brains and chief propagandist. Not only did he spread Neo-Romantic ideas on radio and television, in *The Studio* and *Orion*, and his little book *English Drawings* (which he later said covered 2,000 years in 14,000 words of 'chauvinistic heartiness'), but also by his weekly art reviewing for the *Spectator* from 1944 to 1946. These reviews are as truculent and opinionated as anything he wrote but they reveal very clearly both his passion and his blind spots. He could be generous in his praise of Minton, Colquhoun, Frances Hodgkins, Matthew Smith, Ivon Hitchins, William Scott or

Leslie Hurry, but he could also be savage and dismissive both of his contemporaries and of his elders and betters. The youngest, Craxton, was called empty and derivative though, 'if he would be in less of a hurry, and consider his reputation less, immediately he would have nothing to worry about.' Lucian Freud, he thought, could not draw the figure, and MacBryde showed 'a certain derivative formal monotony', whilst Lowry's 'ill-drawn automata' revolted him. Ben Nicholson's work, now coming into the open again after the artist's wartime withdrawal in St. Ives, provoked this comment:

A good Ben Nicholson is, unto itself, a true and perfect creation. No one else can do it. No one else, and it might as well be said once and for all, is in Nicholson's class at what Nicholson does best; neither Mondrian, Kandinsky, Arp, nor any of them. It is perfect and final; it is an expression of impeccable taste, exquisite balance, subtle design and elegant conception. The only reason why it is not great art is because it lacks humanity.[12]

In turn he could be rude about the work of Bacon (whose paintings he never liked), and occasionally about his hero Sutherland; Henry Moore, who was later to teach him sculpture, received this verbal cuff round the ear:

Henry Moore is a gifted sculptor, for the moment highly overrated. He produces an endless series of sculptor's drawings, window-dressed with washes of colour which seem to supply an inexhaustible market. He draws only three figures. The first stands up, the second holds the baby and the third is the first lying down. It is a simple, elegant formula, utterly without real humanity. His sculpture is more interesting, and the small bronze studies for his Northampton Madonna will make pleasant ornaments.[13]

Ayrton, who did no official work as a war artist, dismissed what the Official War Artists produced as 'ten per cent art, fifty per cent competent journalism, and forty per cent junk',[14] which is probably a fair, if brutal, estimate.

He had two main messages. First, that art should relate directly to humanity and human concerns. Second, his was a crusade to inoculate his fellow English painters against the 'French flu', as Koestler called it, and to get them to be true to their own traditions and qualities. The French might have 'succulence of surface, classical elegance, and the sensual enjoyment of paint for its own sake', but we had a different and equally valid tradition which stressed qualities of line, social satire and a 'mystical and poetic realism'. That tradition was now flourishing again, he claimed, in the hands of Spencer, Lewis, Nash, Burra and Sutherland. French art had collapsed exhausted after its century-long run of success so that 'Robert Colquhoun, William Scott and a number of others in their late twenties and early thirties are faced with no serious competition from any of their continental contemporaries.' Forget all about Fry's Francophilia and Significant Form nonsense, rally behind Sutherland and Nash (he had little time for Piper) and Britain can

be the cultural centre of the world: 'I believe England is just about to emerge from a century of pictorial mediocrity into a period of great painting, and that this fact should be shouted from the rooftops.'[15] The wartime isolation had unified us, given us strength, put us in touch with our own native traditions and we had every reason to go forward optimistically: this was the repeated burden of Ayrton's writing on art.

Ayrton admitted to a great admiration for Dégas's intelligence and thought 'Rouault is incomparably the greatest living artist', but otherwise exhibitions containing French painters usually got a very bad press from him. Braque was dismissed for his 'slap and daub', and Ayrton must have been one of the few reviewers in Britain to damn the first post-war exhibition of Picasso and Matisse at the V & A Museum. Once Ayrton had shaken off his pre-war admiration for the Blue and Rose periods Picasso never failed to bring out the strongest vituperation from him. Here is his reaction to those same wartime works Kenneth Clark had also been scornful of:

> His pictures are now uniformly dung-coloured except for an occasional display of vulgarity in the primaries, and his deplorable handling of the medium of paint reduces this to further nullity. Picasso has in fact ceased to practise oil-painting as a craft, and any other medium would have done as well for these pictures, particularly that of glossy expensive reproduction. He is now engaged upon the intellectual activity of flogging his own clichés to death with one dirty brush.[16]

Ayrton loved the role of the little boy who tells us the Emperor has no clothes.

In spite of his ubiquitous presence in the London art, theatre, literary, broadcasting and social worlds Ayrton remained a rather isolated figure as a painter. His sharp dogmatic judgements and his erudition made many wary of him, but his own paintings left him vulnerable to critical counter-attack. He was not admired by the traditionalists at the Royal Academy, nor by the progressives at the Institute of Contemporary Arts. He remains unclaimed by either faction to this day.

The first full year of peace, 1946, was the time of Ayrton's first major change of direction. So far he had been a clever young man in a hurry, picking up a second-hand style here and there, and veering wildly in subject matter between the sentimental, the ghoulish and social realist. Now, he decided, if he was to be a real painter he must concentrate on it, drop reviewing and all the other distractions and visit the true cradle of humanist painting, Italy. In this he was defying the fashion of the time which favoured the 'primitive' rather than Renaissance sophistication. Being Ayrton he went direct to the top and sought an audience with Bernard Berenson. In 1947 he went to Italy (with Lambert) and again in 1948, 1949 and 1950 and frequently after that until Greece replaced it in his affections. There he studied Piero della Francesca, Uccello, Masaccio and other masters of the early Renaissance, before returning to assimilate their lessons in his London studio. By now he admired painters who ordered their forms 'by a deliberate adherence to systematic disciplines'. He began to construct large compositions, lighter in tone with the southern sun in them, monumental and sculptural in their pretensions,

but self-consciously schematic in their compositions. Often he used grids based on the Golden Section formula, or as he put it himself, 'In 1950 I chose the bridle of geometry as my harness.' Like Nash and Piper and Sutherland before him he was seeking a discipline. There are still traces of Sutherland's spiculate forms in his vine pictures (*Olives and Vines* (1947), *Vines Before Easter* (1949), *The Passion of the Vine* (1949), *Good Friday* (1949)), but from now on he is essentially lost to English landscape painting. He now deliberately cut away from those earlier English traditions which had inspired him during the war, and which he had advised others to follow to seek their artistic destinies.

In 1949 Ayrton, still only twenty-eight, was offered a full retrospective exhibition at Wakefield City Art Gallery. The catalogue had an introduction by the Director of the National Gallery, Philip Hendy, and a fulsome appreciation by Wyndham Lewis ('He is a great classical artist in the making. Unlike so many of his contemporaries, he is totally emancipated from the Parisian plastic *cuisine* and pictorial dressmaking. This is to be especially noted.'). Ayrton, however, had a clearer view of his own worth and proved to be his own most perceptive critic:

> I am not really gifted with 'painterliness' in the French sense, a shortcoming the critics have not been slow to point out. Paint texture and handling of the material interests me no more than it interested Hugo van de Goes or Antonello da Messina and indeed the overriding influence upon my recent work of artists who were primarily concerned with fresco (wherein the presentation of the image was the first concern and the surface of the artifact was, apart from the achievement of a smooth and proper finish of relatively small concern), has inevitably reduced my interest in 'handling' to a minimum. A critic has accused me of applying paint like a skilful housepainter and I take no exception to this since I am concerned with rendering images as simply and austerely as I am able and not in producing delectable or succulent pictorial dishes.[17]

He claims, and in this there are echoes of his new friend Wyndham Lewis, that there needs to be a more astringent form of painting where sculptural form is achieved by linear means to counteract:

> the current and general desire of painters to express an original opinion about the critical situation in which the artist finds himself today, and which painters often tend to express by loading their canvas with the bloated flesh of emotionalism, the succulent fat of 'paint quality,' the alluring vestment of rugose and romantic obscurity or the glittering draperies of undisciplined light.[18]

And then, disarmingly, he adds that of course he has succumbed to all these mannerisms himself, but from now on he is determined to eschew the flesh and go for the less perishable bones with severe classical restraint. This is also a clear signal to the public that he will not conform to their silly romantic stereotype of the artist as 'a semi-sacred idiot' with no intellect. The artist who does conform

to this betrays his own mind and helps the public rob itself of any art which is more than just sensory stimulation. 'When this occurs drawing becomes flaccid and diffuse and is overlaid with the mucus of soft sensation.'[19]

This account so far may make Ayrton seem a dry stick, a calculating, puritanical logician in paint, but this is immediately contradicted by his work, the drawings especially – these are always more fluent than the paintings, which tend to go dead from over-finishing. He is by far the most erotically conscious of our group, even in those works he claims are bridled by geometry. In *Roman Window* he reversed the traditional Romantic motif of looking out of a magic casement on to the foam of perilous seas in faery lands forlorn, and instead peers in through somebody else's window to see what Roman ghetto dwellers get up to. In *Trio* and *The Sisters*, both of 1951, we get peeping Tom glimpses of sexual dramas just before the bedroom curtains swish across. *The Captive Seven* (1950) for all its static geometry is crackling with jealousies and tensions between the sexes. This frank curiosity about bodily appetites runs through his later explorations of the Demeter and Pasiphae legends and the other Greek stories, and culminates in his inventive explorations of the homosexual and heterosexual loves of Verlaine – so reminiscent of Picasso's last erotic etchings, though Ayrton might have shrugged off the compliment.

At the basic of all Ayrton's work, even the paintings and sculpture, is the single, flexible line, the same 'wiry line of rectitude' Blake sought to pin down his visions. 'In the act of drawing one discovers what one is doing,' wrote Ayrton, and also of course what one is thinking, 'but I do not mean, when I describe drawing as a process of thought, to imply a chilly cerebration divorced from feeling. I do not see thought itself in that light, for the mind has hot and cold winds, no less than the body.' Look, says Ayrton, at that archetypal classicist Ingres when he draws a nude; it looks as if he has drawn it with the tip of his tongue, 'the long smooth caress with which he achieves the contour of a thigh is a sexual gesture but the controlling mind directs the hot impulse with the elegance and skill of an experienced lover.'[20] Here Ayrton is pushing into areas rarely explored by English artists, and certainly never considered even as possibilities by Nash, Piper or Sutherland. Only Lucian Freud's work generates a stronger erotic charge. Ayrton's insatiable curiosity about the human body, which seems to have got him sent out of school at fourteen, persisted all his life and overrode the genteel taboos which seem to have restrained Keith Vaughan and John Minton in their public works.

In 1950 Ayrton married Elizabeth Balchin, the divorced wife of a novelist, and acquired three stepdaughters. A year later they all moved out of London, away from the distractions of the capital, into Bradfields, a large rural property in Essex, near Toppesfield. Here he briefly returned to landscape painting with *Winter* (1950), *Figures in Snow* (1952) and the later *Snowbird* (1955), pleasingly atmospheric works with all his past influences marinated down into a style all his own. Curiously, both the first and last of these are seen from a window, looking out – perhaps an indication that Ayrton is already suffering from the arthritis which would later give him so much pain. Dégas also had a low opinion of painting outdoors: 'Nature gives you rheumatism,' he said. Another rural theme taken up in Essex was a series

The Shepherds (1951), oil on canvas

of shepherd drawings and oils where the initial stimulus may have been an antique sculpture in the Uffizi, but the final figures are convincing working men, shirts open to the waist or wearing woolly mufflers as they carry lambs in their arms or slung across their shoulders. There is no religious top-dressing here, of the kind he had tried to impose on the Vine series; no hint that this might also be The Good Shepherd; nor any of the fake Arcadianism which characterised Craxton's early shepherds.

In 1953 Ayrton further exploited his new sensual contact with the soil in a series of 'succulent' (to use his favourite word), if rather academic, still-lifes of vegetables, hams and napery. There is no stage-lighting here, just a frank Impressionistic attempt to render the surface of things in daylight. By now he had abandoned that restraint he had so masochistically embraced in the Wakefield catalogue and frankly set out to make 'paintings which enter the mouth or the eye's mouth and penetrate the senses, between the teeth'.[21] He is trying now to beat the French at their own game. But even these works were not palpable enough; he now wanted to cup his hands round curves, stroke planes, caress hollows and finger crevices as he had seen a blind girl do with a Manzu sculpture. It was the same urge which led Sutherland to model his Standing Forms. Bradfields provided enough space to sculpt; his researches into the early Renaissance sculptor Pisaro provided him with

theory and motivation; and talks with Moore and Giacometti gave him the practical know-how to begin. To model (he was never a carver) seemed now to be the logical extension of his drawings which were thrusting shoulders and breasts and skulls out of the paper demanding to be released into three dimensions.

These sculptures are not part of our theme here but they are surely the works upon which Ayrton's reputation will eventually rest. He believed that too, for in an introduction to his work in 1975 he wrote, 'There is nothing much about me that need concern anybody before May 1956.' His career before then he dismissed as 'I did anything that came up around the arts with a youthful, but I suppose convincing, air of authority and so earned a living.' But on that date in 1956 he stood for the first time on the Acropolis at Cumae* and 'suddenly north of Naples there was a day and a place that took me by the throat, by the mind, by the guts, and changed what I was doing and what I was to do for eighteen years thereafter, and maybe more.'[22] Now he could repudiate his whole Neo-Romantic campaign as youthful folly: 'I became prematurely well known as a poetic sort of English Romantic landscape painter and very foolishly got a temporary job as an art critic.'

Ayrton had now become inhabited by the spirit of Daedalus, the archetypal artist-craftsman-engineer, maker of the Cretan maze, inventor of the saw, goldsmith and manufacturer of the first wings for man. He was convinced he was in possession of a myth that could be made to explain everything, and so began his retreat from contemporary subject matter and withdrawal deep into the labyrinth of the second millennium BC. In taking the myths of classical Greece he did not, however, adopt a Praxiteles style: he rethought and refelt them with all the violence, sensuality and self-knowledge of a post-Freudian man. In his novels, *The Testament of Daedalus* (London, 1962) and *The Maze Maker* (London, 1967), and in his drawings and sculpture he explores the minds and timelessly naked bodies of his protagonists (Icarus, Daedalus, Pasiphae, Demeter and above all the bull-headed but man-genitalled Minotaur struggling to articulate his frustrations at the centre of the Maze) with a complexity which is completely modern.†

The onward sweep of Ayrton's career has carried us past three important events: the 1955 retrospective exhibition which really marked the end of his career as a serious painter, his friendship with Wyndham Lewis, and his repeated attacks on Picasso. Each reveals something characteristic about Ayrton and his times.

For the Whitechapel Gallery retrospective the thirty-four-year-old Ayrton displayed 175 items produced over the previous decade in the fields of oils, drawings, collages, sculptures, stage designs and illustrations. As usual he provided a lucid self-analysis in the catalogue, defining himself as 'a natural romantic moving with determination towards a classic art', and seeing his besetting temptations as melodrama, the grandiose, overly romantic expressiveness, and overstatement, all

* Keith Vaughan had preceded him to this holy place in 1950 – cf. his *Figure Group at Cumae* (1953), though as usual with Vaughan there are no topographical references to be discerned.
† Few modern artists have looked to classical Greece for inspiration, though Picasso explored the Minotaur myth with much less erudition than Ayrton, and Bacon claims to be inspired by the cry of Aeschylus' Furies, 'The reek of human blood: it's laughter to my heart.'

of which needed curbing if he was to portray human relationships with that tense, 'enigmatic' quality he was after. It is the same impulse Nash and Piper had felt and Vaughan and Clough were to feel later, as if Romanticism had built into it a need to rebel, even against itself; to seek a purgative after excess. As Barzun noted, 'Romantic diversity ends by making men desire classical order, just as in the beginning Romanticism showed that the only possible life lay outside the classical trammels.'[23] Ayrton's feelings were too strong for him ever to achieve a truly classical detachment and his impulse to swing his lines from the wrist meant he was forever bursting out of the geometrical bonds he had strapped his works into. In spite of his professed admiration for the more austere fifteenth-century Italian masters he was temperamentally nearer to the sixteenth-century Mannerists in the way he enjoyed twisting and elongating his nudes, or making them undertake athletic struggles to defy gravity under a spotlight as harsh as that in a circus ring.

The reviewers grasped Ayrton's lucid self-analysis in his catalogue and turned it back on him with glee. He was called a garish colourist, a crude handler of paint, guilty of an 'indolent kind of decorative drawing', and his narrative subject matter was described as reminiscent of the Victorians at their worst. John Berger found 'a formal plastic failure' in nearly everything he did. The *Listener*'s anonymous critic dismissed everything as pretentious and deeply conventional: 'The drawing and design pay tribute to the great humanist tradition in Italian painting while really cheapening it. This, in short, is an achievement not dissimilar to Annigoni's.'[24] Even his own former paper, the *Spectator*, gave him the thumbs down:

> Ayrton's particular habits of distortion are at the heart of the matter. They do not intensify the flesh and nerve of his people, explain their feelings, dramatize their relationships one with another, so much as change them into actors giving a characteristic performance of themselves. . . . In Ayrton's painting life wears a mask and becomes a melodrama; his best work, indeed, has been done in direct contact with the stage. And it is perhaps his draughtsmanship which throws the mask over things, for it seems controlled by certain mannerisms and arabesques which drive out reality and limit the freedom of his hand . . . It is difficult to understand how such a searching intelligence and such insensitivity can co-exist.[25]

Ayrton was now on the receiving end of the same kind of forthright views he was more used to expressing, and his versatility in so many media, but particularly in words, was seen as a handicap rather than a gift. Matisse's advice in the Preface to his book *Jazz* was: 'Whoever wishes to devote himself to painting should begin by cutting out his tongue,' and perhaps the reviewers would have been more forgiving if Ayrton had.

Not all the critics were so vicious. Two years later Wyndham Lewis stated boldly in an introduction to Ayrton's book *Golden Sections*: 'Mr Ayrton is one of the best artists in England. He is sufficiently mature to generalize, is an excellent writer and one of the wittiest of men.' This admiration was mutual for in his book on *British*

Drawings Ayrton had reproduced a Lewis drawing *Seated Woman* and called him 'perhaps the greatest living portrait draughtsman'. At this time Lewis was generally regarded as a spent force after an undulating career which had produced Vorticism before the First World War, his best books in the 1920s, some interesting pictures in the 1930s, and a fallow period in the 1940s when he had been in penurious exile. Lewis took a pride in making enemies and had in his time alienated Fry, the Sitwells, the whole Bloomsbury group ('a supercilious cohesive clique'), Kenneth Clark and Herbert Read ('Mister Abreast of the Times'). He had also gone against the intellectual tide of his times by befriending Oswald Mosley, supporting Franco, and writing in praise of Hitler and Mussolini during the 'Pink' 1930s. In this he had been joined by several of his peers, including Eliot, Yeats, Lawrence and Pound – though only he and Pound suffered prolonged anathematisation for it.

By the time Ayrton met him, Lewis's eyesight had begun to deteriorate and he was living in dire poverty quite near to the two painters Colquhoun and MacBryde in Notting Hill. Surprised at this sudden attention from a fashionable young man-about-society, Lewis invited Ayrton to tea in his flat. 'I had expected', confessed Ayrton later, 'to see Mr Lewis in a black sombrero, casually grinding some volume of Herbert Read's philosophical speculations into the bare floorboards with an iron-shod heel' Lewis, in spite of the formidable mind lodged in his equally formidable head, 'wedge-shaped, blade-nosed, with a forehead like a sledgehammer', turned out to be positively genial and they began a friendship which lasted until the older man's death.

The list of things Lewis was against was a lengthy one and included homosexuals, people who wrote about painting, Jews, Romanticism, humanism, Impressionism, relativism, subjectivity, most Italian Renaissance painters, the Freudian emphasis on the unconscious, Surrealism, and any attempts in art to express fantasy, sensuality or spirituality. All these he thought led to 'sloppiness'. T. G. Rosenthal asks the obvious question: 'What could be more disparate than the fierce iconoclasm, revolutionary fervour, right wing political stance and passionately personal polemic of Lewis and the solidly mainstream, almost antiquarian, intellectually elegant and erudite man of the left, Ayrton?'[26] However, by the time they first met Lewis had retracted his pro-Fascist views and begun to adopt a more conservative view of art. In *The Demon of Progress in the Arts*,[27] which is a garrulous piece of misanthropy, he attacks 'extremism' in the arts, opposes all non-figurative art and even denounces his own early Vorticist works. Earlier, in America, he had offended his reluctant hosts by belittling abstract art and vainly prophesying, 'Braque's bric-à-brac is fast becoming junk. . . . Brancusi's egg has gone to join the Dodo's.'[28] Basically these were Ayrton's views too. They both believed the line was the basis of art, Lewis having written a pamphlet on 'The Role of Line in Art' in which he deplored the 'enfeeblement of the appetite for the linear in the present century', blaming the French Impressionists for this lack of precision and demanding a return to the harder traditions of Dürer, Goya, Mantegna and Rowlandson.

Of course, Ayrton and Lewis were the most famous artist-writers England had produced this century, apart perhaps from Fry who was no match for either of

Wyndham Lewis (1953), oil on canvas

them as a painter. Lewis explained how the two arts were complementary for him. His first short story came to him whilst he was painting a beggar, 'as the crystallization *of what I had to keep out of my consciousness while painting.* Otherwise the painting would have been a bad painting. . . . As I squeezed out *everything* that smacked of literature from my vision of the beggar, it collected at the back of my mind. It imposed itself upon me as a complementary creation. . . . There has been no mixing of the genres. The waste product of every painting, when it is a painter's painting, makes the most highly selective and ideal material for the pure writer.'[29] Certainly nobody calls Lewis a 'literary' painter, whereas Ayrton, on the other hand, seemed not to make this clear distinction in his mind. Sometimes one suspects the story came first, then his sculptures or graphics retell it or illustrate episodes in it, and his novels fill in those aspects of his character's behaviour he cannot narrate in bronze or line.

Ayrton, eclectic as ever, tried his hand at Lewis's hard-edged crystalline forms, notably in his portraits of *Norman Douglas* (1948) and *William Walton* (1948). Lewis thought the latter so splendid it ought to be in the National Portrait Gallery, and indeed that is where it came to rest. These are interesting attempts by Ayrton to

work in facets rather than his more characteristic ellipses, arabesques and curves, but he cannot sustain the effort over the whole canvas – as we can see in Walton's jacket which falls into decorative eddies which fail to describe the forms beneath. He also painted Lewis's portrait in 1953 and in this he did succeed in getting a Vorticist edge and crispness to his forms. Ayrton thought this his best painting, and he is probably right, though it is his least typical:

> It is Lewis in the dark armchair in which I first saw him, slumped across the canvas from left to right, with the armour-plated ashtray at his elbow and the green bladed eye-shade at his brow.[30]

Ayrton also designed the covers and nine monotypes for Lewis's trilogy *The Human Age* because by now Lewis was blind and Ayrton had assumed the honour and responsibility of becoming his eyes. Lewis went down raging against the dying of the light, but just before he finally succumbed a Tate Gallery retrospective exhibition was held for him. Ayrton wrote a powerful and admiring review of his work, placing Lewis's portrait of Ezra Pound amongst the ten best portraits of the century (Ayrton was fond of ranking things). On the day after Lewis's death in March 1957 Ayrton and his wife called on Mrs Lewis only to find the building being demolished and the long-locked studio smashed open. He managed to snatch a basketful of treasures before the walls came tumbling down, finding amongst the rubble a torn head of Ezra Pound which, in due time, Ayrton drew the missing part for. 'It was my last act as a sort of substitute for the eyes of Wyndham Lewis.'[31]

It had been a strange but rewarding friendship between two of the most articulate artists England has produced, the professed Classicist and the confessed Romantic. Not all the favours were on Ayrton's side since Lewis, before he became blind in 1951, was the strongest advocate of the Neo-Romantic painters after Ayrton himself. He praised them whenever they exhibited, though one feels the younger Lewis in his critical prime would hardly have called them 'the finest group of painters and sculptors England has ever known', nor hailed Ayrton as 'one of the two or three young artists destined to shape the future of British art'.

Lewis was little known beyond the shores of England, but served well as a father-figure and Old Master in those bleak post-war years before France recovered enough to reassert its old charm. But even when France was cut off totally during the war years the School of Paris continued to exert an influence through reproductions in pre-war books and magazines and smuggled prints. Cézanne's work was still being discussed and assimilated long after Fry's advocacy of him; the Surrealists' discoveries still being timidly tried out (though not their politics); and Cubism's later decorative period could still be plundered for its angular planes and simplified chipped forms. Above all Paris meant Picasso, who overtopped his contemporaries as the Eiffel Tower does the trees round its feet. His name has occurred frequently in our story so far and will do so to the end because none of the Neo-Romantics escaped his influence. All accepted that influence gladly, except Michael Ayrton who resented it with an almost paranoid intensity.

In 1944 when Picasso was isolated in Paris Ayrton made a broadcast and wrote an article for *Penguin New Writing* entitled 'The Master of Pastiche', subtitled with Picasso's saying, 'There ought to be a dictator of painting', which enabled Ayrton to make some unwarranted parallels between Picasso's position in art and Hitler's in politics.* Ayrton did not take a crudely anti-modernist viewpoint – in fact he thought Picasso's work absurdly simple. All the Spaniard did was engulf an existing style from almost anywhere in art history, discard some bits, exaggerate others, knock it around to depict his few motifs (still-life, guitar, female nude) and then pass on to devour the next dead artist's work. Mere artistic vampirism, declared Ayrton, the work of a pasticheur who never goes all the way back to nature for his observations, but to art itself. Of course all artists *begin* by imitating others (Ayrton was just through a period of imitating Picasso's Blue Period, though he does not admit it), but then they combine this with the close observation of reality until they evolve their own personal style. Picasso's so-called originality is only based on necrophily and ingenuity, not real change. The *Guernica* of 1937 did seem the result of real feeling for once, concedes Ayrton, but even there surely a wounded bull is a rather banal symbol for Spain's agony? The idolatry with which most painters regard his works is not based on their merit but on the widespread commercial reproduction of them which hides the lack of paint quality and shoddy craftsmanship of the originals. Finally, 'the crux and centre of Picasso's art is, in my view, hysteria and in this he so echoes the prevailing evil of the age that he seems to be its prophet. Added to this is the element of speed, which Picasso brought to such jet-propelled perfection that he can hit the target of taste with repeated but varied hammer-blows.'[32]†

Ayrton was twenty-three when he wrote this and his presumption infuriated his fellow artists. Nash and Piper were both sincere and devoted admirers of Picasso's work, and 'Mr Graham Sutherland smote me hip and thigh,' Ayrton recalled, for suggesting that he drew on English sources alone and had no need of Picasso. Sutherland declared publicly that Picasso was 'a major influence' on him. Craxton was so alienated by Ayton's arrogance that he never spoke to him again. The group were happy to enjoy Ayrton's vigorous promotion of their reputations as the new hopes of English art, and to go along with his rewriting of our art history so they seemed the natural heirs to a strong national Romantic tradition – but to claim they could wean themselves away from the influence of the greatest of Continental modernists seemed to them outrageous.

Ayrton returned to the attack in 1956,[33] and by this time Picasso, Matisse and

* In the original context, 'A Conversation with Picasso' in Myfanwy Piper's *The Painter's Object* (1937), this was a call by Picasso to purge the sham followers of art. The painter-dictator would begin 'to suppress all those who have betrayed us, to suppress the tricksters, to suppress the means of betrayal, to suppress mannerisms, to suppress charm, to suppress history . . .'

† Lewis had made similar charges against Picasso (*Kenyon Review* 1940) whilst in New York. Cézanne would have loathed Cubism; the Blue Period made Burne-Jones look 'well-nigh *tough*'; the *Guernica* was a fiasco, only a poster which bore no relation to the event which provoked it; the *Minotauromachy* was a 'confused, feeble, profusely decorated, romantic carpet', and so on. Ayrton must have known this essay at least by the time of his second attack on Picasso.

Braque had all had major post-war exhibitions in London (all badly reviewed by Ayrton), and fickle fashion had moved the spotlight on to newer masters such as Giacometti, de Stäel, de Kooning and the American Abstract Expressionists. Picasso was now elevated to the status of Old Master, prematurely enjoying his own posterity. Picasso's reputation, claims Ayrton, has not been helped by those adulatory critics who mystify his work by presenting it as the product of a trance-like frenzy which must, therefore, remain for ever subjective and hermetic in its symbolism. Ayrton always resented any suggestion that artists were all feeling and no brains – utter nonsense, he declared. Take the *Minotauromachy* etching which has a transparent, easily verbalised meaning as opposed, say, to Jackson Pollock's Action Paintings which deliberately avoid having any meaning whatsoever. What both share is gesture – and Picasso's is admittedly marvellous in its muscular sweep and potency. It is this potency which Jackson, Riopelle, Mathieu and the other *Tachists*, Action Painters, Abstract Expressionists or whatever are seeking to imitate in their speed of attack and urgent gestures.* The difference is that Picasso's violence is used to fashion a communicating, understandable image, whereas the others leave the spectator to impose his own meaning on their haphazard maelstroms of dribbles and splashes, and this 'working on himself' is essentially a masturbatory activity on the part of the spectator, Ayrton claimed.

If these Americans represent the future of painting, and for a time just after 1956 they did, then Ayrton would obviously settle for Picasso as the lesser of two evils: at least he was still a figurative painter, and rather a 'literary' one at that. But, for all the Spaniard's vigour and immediacy, there was no reflection, no intellect, no profundity gradually unfolding: 'You are either raped or you lift an eyebrow.' There are enormous graphic skills on display, dazzling as the virtuosity of Liszt's piano playing, but at the heart there is a void. Picasso devours a past master's *oeuvre*, say Cranach's or Grünewald's, because it has already 'partially solved the visual problem and was therefore in its (to Picasso) predigested condition capable of carrying the force of his blow without losing all contact with reality'.

It is unlikely Picasso ever heard of either Lewis's attack or Ayrton's various attempts at iconoclasm. In fact Picasso complained to Ben Nicholson that every time he asked about modern English art people offered him the name of Duncan Grant! He must have been asking Roger Fry or Clive Bell, both of whom visited him. Nor is it likely he knew or cared about John Berger's further attack on his reputation in *The Success and Failure of Picasso* (London, 1965). For the third time Ayrton took up his pen, on this occasion with some irritation, to say that he should have written the book himself since many of the ideas were his.[35] By this time Ayrton was more obsessed by the Minotaur myth than ever Picasso had been and so could correct Berger on this, and also chide him for his Marxist solemnity and inability to see the humour in Picasso's work. He made the first comparison of Picasso to Midas whose gifts brought golden benefits, but also left him isolated. This com-

* Harold Rosenberg, the publicist for Abstract Expressionism, claimed: 'The big moment came when it was decided to paint . . . just to PAINT. The gesture on the canvas was a gesture of liberation, from Value – political, aesthetic, moral.'[34]

parison he later developed at length in a funny but cruel novel *The Midas Consequence* whose central figure, a monster-genius called Capisco, is obviously a portrait of Picasso.[36] It was the last substantial writing Ayrton did.

Even while one reads these brief summaries of Ayrton's fulminations against Picasso it becomes obvious that many of the charges he brings against the older man could equally well be levelled against himself. He, too, ransacked the past gleaning what he could from Dürer, Palmer, Gainsborough, Fuseli, Grünewald, Piero della Francesca, Masaccio, Uccello, Seurat, Dégas, and from his own contemporaries Berman, Tchelitchew, de Chirico, Sutherland, Nash, Lewis, and of course, as he reluctantly admitted, Picasso himself. Both men shifted restlessly from style to style and medium to medium. Ayrton too was a better draughtsman than painter and relied on a gestural, rhythmic attack on form, though this was smoother and nowhere near as biting and unpredictable as Picasso's. He too had a strong erotic preoccupation mixed with tinges of cruelty and hysteria, and his charge that Picasso's works lacked profundity could be turned against many of his own. There comparisons should end because in terms of importance, genius and productivity we are no longer comparing like with like. Ayrton is, simply, not a major painter. Though Ayrton's attacks are witty and thought-provoking they seem more and more like the struggles of an adolescent son trying to wriggle out from under the domination of his simultaneously loved and hated father. Mixed in with this is a chauvinistic resentment that the English school, which he did so much to define and promote and of which he is a member, did not fulfil the future he predicted for it. Instead of assuming the leadership of Western culture it reverted to its old pre-war obsequiousness before the School of Paris, whose headmaster was Picasso, or it found new and equally clay-footed heroes amongst the American Abstract Expressionists. Ayrton admits, finally, 'the case is not primarily against Picasso, but against his times, and cogent arguments cannot easily be aimed at an age, especially the one to which one belongs oneself.'[37]

In several important ways Ayrton did not belong to the age in which he lived. He felt closer to the art practices and priorities of nineteenth-century England, or Renaissance Italy and Germany, or to the mythical era of Theseus. As a critic he was essentially reactionary, offering brilliant insights into many past masters, but much less receptive to the art of his own day. This art was moving steadily away from the literary, figurative, nationalist, humanist tradition to which he pledged allegiance. For Ayrton, Man was the central subject of all art and he resisted any new fad which shifted or blurred that focus. In his own work he never compromised that position which left him high, dry and old-fangled-looking as the newer movements swept in and surged up the gallery walls.

REFERENCES

1. Piper, John, 'British Romantic Artists', in *Aspects of British Art* (London, 1947), p. 186.
2. Piper, John, 'Henry Fuseli R.A. 1741–1825', in *Signature*, No. 10, 1938, p. 11.
3. Ganz, Paul, *The Drawings of Henry Fuseli* (London, 1949) with Introduction by John Piper.
4. Ayrton, Michael, *British Drawings* (London, 1946), p. 30.
5. Todd, Ruthven, *Tracks in the Snow* (London, 1946), p. 86.
6. Feaver, William, 'Wartime Romances', the *Sunday Times*, 20 May 1973.
7. Ayrton, Michael, op. cit., p. 34.
8. Pool, Phoebe (Ed.), *Poems of Death* (London, 1945), Introduction.
9. Verlaine, Paul, *Femmes/Hombres*, ed. W. Packard and J. D. Mitchell (Chicago, 1977).
10. Ayrton, Michael, *Spectator*, 5 March 1946.
11. Purcell's *The Fairy Queen* as presented at the Sadler's Wells and Covent Garden Opera. Preface by Prof. E. J. Dent, articles by Constant Lambert and Michael Ayrton. Published by John Lehmann, 1948.
12. Ayrton, Michael, *Spectator*, 12 October 1945.
13. Ayrton, Michael, *Spectator*, 13 April 1945.
14. Ayrton, Michael, *Spectator*, 2 November 1945.
15. Ayrton, Michael, *Spectator*, 19 April 1946.
16. Ayrton, Michael, *Spectator*, 14 December 1945.
17. Ayrton, Michael, Catalogue statement, Wakefield Art Gallery exhibition, June 1949.
18. Ibid.
19. Ayrton, Michael, *Golden Sections* (London, 1957), p. 75.
20. Ibid., p. 67.
21. Ibid., p. 166.
22. Programme notes for BBC Schools Radio programme first broadcast 13 May 1975.
23. Barzun, Jacques, *Classic Romantic and Modern* (Toronto, 1961 edition), Introduction, p. xxii.
24. *The Listener*, 29 September 1955.
25. Taylor, Basil, *Spectator*, 30 September 1955.
26. Rosenthal, T. G., Introduction to the Michael Ayrton and Wyndham Lewis exhibition at the National Book League, 1971.
27. Lewis, Wyndham, *The Demon of Progress in the Arts*, (London, 1954).
28. Meyer, Jeffrey, *The Enemy: A Biography of Wyndham Lewis* (London, 1980), p. 254.
29. *Wyndham Lewis on Art: Collected Writings 1913–1956*, ed. W. Michel and C. J. Fox (London, 1969), p. 295.
30. Ayrton, Michael, *Golden Sections*, p. 155.

31. Ayrton, Michael, 'The Enemy as Friend', in *The Rudiments of Paradise* (London, 1971), p. 267.
32. Ayrton, Michael, 'The Master of Pastiche', in *The Rudiments of Paradise*, p. 266.
33. Ayrton, Michael, 'A Reply to Myself', in *The Rudiments of Paradise*, pp. 228–39.
34. Rosenberg, Harold, *The Tradition of the New* (New York, 1959), p. 30.
35. Ayrton, Michael, 'The Midas Minotaur', in *The Rudiments of Paradise*, pp. 240–8.
36. Ayrton, Michael, *The Midas Consequence* (London, 1974).
37. Ayrton, Michael, 'A Reply to Myself', in *The Rudiments of Paradise*, p. 229.

ROBERT COLQUHOUN

THE main Neo-Romantic artists came from comfortably off middle-class back-grounds. These may have been a shade stuffy and conservative in their views on art, but at least books, music, architecture and painting were discussed within the family. Nash, Piper, Sutherland and Minton each had a father trained in law. Ayrton's father was a poet and his mother a politician, but the whole family had connections with the leading figures in England's intellectual life. Craxton's father was Professor of Pianoforte at the Royal College of Music; Vaughan's father was a civil engineer; and Prunella Clough's was both a Civil Servant and a writer. All these artists were born and bred in the southern counties within easy reach of the capital, and continued to live in or near London most of their adult lives – with the exceptions of Sutherland and Craxton who eventually moved abroad. Their education was in preparatory schools and private secondary schools, and when they left few of them received any implacable opposition to their choice of a career in the arts. They were highly articulate and literate and several had second-ary careers as writers, reviewers or teachers. They disseminated their enthusiasms and practices in art through periods of lecturing and demonstrating in such London art schools as the Slade, Royal College, Camberwell, Central School of Arts and Crafts, and Chelsea. Once established as artists with their figurative, accessible style in which modernism mingled with tradition, they attracted the patronage of Government-funded bodies such as the WAAC, the British Council and the Arts Council. Their private patrons were well-heeled London society people, often with an Oxbridge education and literary pretensions. The Neo-Romantics may not have been quite top-drawer (which artist ever was?) but they had sufficient social aplomb to move without self-consciousness through the drawing-rooms of the Bloomsburys, the Sitwells, the Clarks, Sir Colin Anderson, John Lehmann, Stephen Spender and the other mandarins of the time.

It could be argued, perhaps, that this social environment and the unspoken assumptions about what art was for and what artists did that the Neo-Romantics absorbed from it, put clear limitations on both their styles of painting and their range of subject-matter. Given this background, one would not expect their works to have a radical political message, or to have any concern with the struggles of

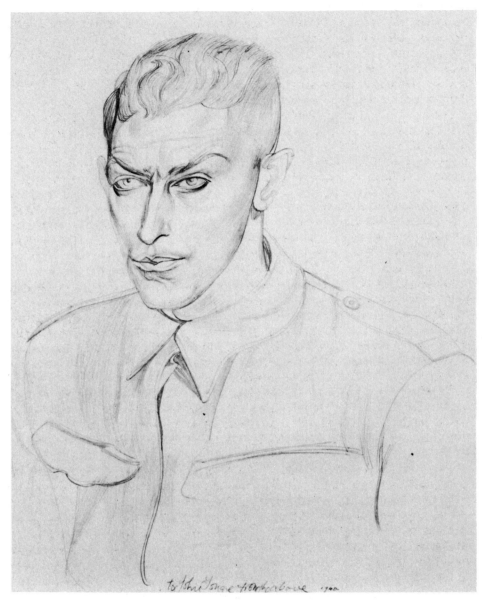

Self Portrait with Army Hair Cut (1940), pencil

the proletariat, in the ways the AIA artists and the Euston Roaders did. Stylistically, they were looking as much backwards, towards our English tradition, as they were sideways to Parisian modernism and the resulting hybrid was far from insurrectionary. Nor could they bring themselves to admire and use the brash products of mass commercialism or popular culture in the way the later Pop artists did. We must now see if these generalisations are overturned by two artists who joined the Neo-Romantic movement from a totally different class and cultural background.

The two Scots, Robert Colquhoun and Robert MacBryde, always known as The Two Roberts, stand out sharply from the eloquent and literate bourgeoisie we have just described. They left behind no writings that I can trace and no BBC interviews or television films on their works. They did no teaching, and friends cannot remember either of them reading or talking much about Art, even with fellow practitioners. George Barker, who travelled around Italy with them, reported that Colquhoun popped into a museum there no more than once a fortnight.[1] Yet, in spite of their provincial origins and training, they produced work as international in flavour as any of their friends, and, what is more, it was based on a sounder academic training in their craft than that of most of the other Neo-Romantics who had been, as students, a mixed bunch of late-starters, auto-didacts and non-finishers.

Robert Colquhoun was born in 1914, the eldest child of an engineering fitter and his wife. The place was Kilmarnock, and after local primary school he went to Kilmarnock Academy secondary school where his precocious talent for drawing was encouraged. By 1929 the Depression was hitting Ayrshire severely and Robert was under pressure to leave as soon as legally possible to follow his father into an engineering apprenticeship. Mr James Lyle, his art teacher, rallied local worthies to help pay the boy's fees at the Academy, and so he was able to stay on until 1932 when he won a scholarship to Glasgow School of Art. It was in this magnificent building, designed by Charles Rennie Mackintosh, that he first met Robert Mac-Bryde. By the second term they were sharing lodgings and never parted company again, in spite of frequent and violent tiffs, until Colquhoun's death thirty years later.

MacBryde was born one year after Colquhoun and twenty miles away at Maypole, also in Ayrshire. His father was a leather worker and no local patrons came to rescue him from five years' slog in a factory before he had accumulated enough money to go to Glasgow School of Art. Both men stayed there five years, winning prizes for their drawings and enjoying the tuition of Ian Fleming, who painted their double portrait (which is still in the possession of the School of Art), and of Hugh Crawford. In their vacations they made brief trips to Paris. Scottish painters have always maintained strong links with French painting, being less literary and more concerned with the demands of the medium and colour than their English neighbours. The Two Roberts were to continue this formal bias.

The slide collection of Colquhoun's works in the Dick Institute in Kilmarnock covers his career until he moved to London. The numerous life-class drawings in this collection show he received a very thorough grounding in anatomy, and their heavy modelling by light and shade must reflect the accepted school style, so dif-

ferent from the Slade's method of drawing. When he, and MacBryde, began to slice
up, flatten and rebuild the figure later in their careers they were doing it from a
position of knowledge. What these apprentice graphics do not show is any straying
from the subject in front of the artist's eyes, no flights of fancy or dabbling in any
style other than the realistic. Then, amongst these skilled but rather dour portraits,
pets, landscapes and nudes come sixteen undated drawings of ballet subjects, and
for the first time Colquhoun's spirits and lines soar. His study of a male dancer's
legs are still very solidly modelled and his Harlequin is built more like a prop forward
than a Pink Period consumptive, but then in a wonderful imaginative release a
series of figures from *Daphnis and Chloë* and *L'Après-midi d'un Faun* ripple and flow
across the page. These must date from his scholarship visits to Paris, or, less likely,
from his wartime years in London. These early works show us a strong natural
talent undergoing an orthodox academic training, but there is no clear indication
here, apart from the confident line, of the way that talent might develop.

Apart from its School of Art Glasgow was, at this period just before the Second
World War, in the doldrums as an art centre. The Frenchified 'Glasgow Boys' who

Page from a sketch book '*L'apres midi d'un Faun*' (c1938–9), pencil

were famous at the turn of the century were now dead and three of the 'Scottish colourists' had also recently died: Samuel John Peploe (1871–1935), Leslie Hunter (1879–1931) and Francis Campbell Cadell (1883–1937). The fourth of these Scottish Fauves, John Duncan Fergusson (1874–1961), was about to return to Glasgow from France to help revive artistic life, but too late for Colquhoun and MacBryde. Commercial outlets for young artists were few and they had either to make their names in the conservative galleries of Edinburgh, or, if more ambitious or modern in outlook, to move to London. However, there were good travelling exhibitions passing through the public galleries where the two young men saw Post-Impressionist works and the occasional Picasso. There were also solid city collections and in the Glasgow Art Gallery they admired Wyndham Lewis's rich red, blue and brown portrait *Froanna, Portrait of the Artist's Wife* (1937), an unusually benign work for him. Lewis's influence began early for them, and was to grow stronger when they moved to London and found he was a neighbour in Notting Hill.

First, however, Colquhoun won a travelling scholarship worth £120. By now even the college authorities saw The Two Roberts as inseparable and raised enough money to send them both off to tour Rome, Venice, Florence, Paris, Aix, Avignon and Orange during 1938–9. There is no written record of their adventures, though Colquhoun's topographical drawings of French and Italian buildings confirm the School's confidence in him as a young man full of promise.

They returned to Ayrshire one week before war began. At first it looked as if Colquhoun might train as an art teacher in Glasgow, but he was called up into the Royal Medical Corps as an ambulance driver. MacBryde, who was consumptive, was rejected for service as Grade Four. Colquhoun served first in Dalkeith, and then in Leeds where MacBryde followed, bringing him extra food and canvassing for his friend's release with flurries of letters to the Minister of Information pleading: 'The sickness of soul this lad has experienced begins to manifest itself in his body and anything that can be done for this lad must be done quickly.'[2] Emptying latrines and scrubbing floors was a waste of precious talent, MacBryde pointed out, but the Ministry was unmoved. It was not a good time to be an unemployed artist and MacBryde wrote long rambling letters to the WAAC begging to be used:

For a little food, a battle dress to keep the wind out, and private's pay I would work night and day to make useful historical and artistic records of this thing which threatens to change the face of the world. (14 October 1940)[3]

And on Colquhoun's behalf:

Frankly, this lad is so far down, in spirit that I had to write to his Captain to ask him to do what he could for him in the camp to cheer him up. This mental sickness is brought about by the fact that he has suddenly been torn from the work which is his life and thrown amongst these new forms without the opportunity of recording them. (30 October 1940)

The Captain's reply, if any, is not recorded. In desperation he rustled up references from their old Principal in Glasgow and from Muirhead Bone, a veteran war artist who had served in both wars and was a member of WAAC, and pointed out:

> I am not pleading for 'artistic boys who are pale and interesting' but for young men who must contribute to a real culture after the storm has passed and *while the storm is raging*. (30 October 1940)

The WAAC Secretary, E. M. O'Rourke Dickey, replied to MacBryde's pleas that neither of them could be given a definite commission, but MacBryde would be granted facilities to make pictures of Edinburgh after air-raids. His gouache, *Bombed 1941*, seems to be the only outcome of this grudging offer.

In 1941 Colquhoun collapsed, overstraining his heart whilst heaving mail-bags, and was discharged. They both moved immediately to London and were taken into the care of Peter Watson, a vital patron and co-ordinator of all the Neo-Romantics. Watson wrote to his friend Kenneth Clark recommending Colquhoun to his attention: 'Obviously very influenced at present by Wyndham Lewis, his competence at draughtsmanship seems to me to be self evident' (February 1941). However, it was not until November 1944 that Colquhoun received the summons to do something for the WAAC, and this was to depict women weaving cloth for the army's uniforms. Meanwhile, in the years between 1941 and 1944 he tried out a selection of the styles current amongst the young artists in his circle, before coming round again to Wyndham Lewis, and finding a new source of ideas in Jankel Adler.

Ironically, as soon as The Two Roberts had severed their ties with Glasgow (and they never went back) the city took an upward turn as an art centre. J. D. Fergusson was now back from France to preach the gospel of Cézannism and to revive Scotland's national school of painting. He was joined by two Polish refugee painters, Jankel Adler (1895–1949) and Josef Herman (b. 1911), both at this time disoriented and hurt by their recent experiences in Hitler's Europe, but both highly talented men. Glasgow's discussion and exhibiting facilities were suddenly increased by the founding of The New Art Club and The Centre in 1941, and the New Scottish Group in 1942. Adler moved to London in 1942 and Herman followed a year later, both then coming into close contact with the talented young artists gathering round the Two Roberts in Notting Hill.

Word had gone ahead of The Roberts on the grapevine so that when they arrived in London they were invited to stay in Peter Watson's flat until they found a home. This they soon made at 77 Bedford Gardens between Kensington High Street and Notting Hill Gate. Watson, of course, introduced them to his other protégés, Minton, Freud, Craxton, and Vaughan. Minton soon moved in with them and Adler acquired a studio at the same address so this quickly became the vortex which drew in the young painters and literary people of London's Bohemia. In spite of the increasing tempo of their social life, and the fact that Colquhoun drove a Civil Defence Corps ambulance on alternate days until 1944, both Scots began to work steadily at their art.

Robert MacBryde, *Bombed* (1941), gouache on paper

They had arrived from Glasgow as rather gauche, if boisterous young men, abstemious and near-teetotallers. Soon, however, in the high-spirited gang which developed round them they began to drink more and more on the Fitzrovia circuit of The Wheatsheaf, The Black Horse, The French, Muriel's, and so on. There they adopted a belligerent stance which got them into scrapes. Theirs seems to have been a very similar attitude to Dylan Thomas's who also appeared to need to prove something about his manliness by showing how much he could drink and how rude he could be to strangers, especially those in uniform. One might speculate that these creative people were feeling some unease about their lack of a direct productive role in the war, and they were taking up the fight directly with those who resented pacifists, the unfit and conscientious objectors. Orwell, too old and sick after his Spanish neck wound to fight, felt guilty about creating books when events were so dire in Europe. He recorded in his diary for 6 June 1940 'Everything is disintegrating. It makes me writhe to be writing book reviews, etc. at such a time, and even angers me that such time wasting should be permitted.' As we have seen, The Two Roberts' pleas to be made use of by the WAAC fell mostly on deaf ears and when this happened they turned back to painting still-lifes, figures and

landscapes and made no pretence that these had anything to do with the war or could contribute in any way to winning it. Similarly Ayrton, once out of the RAF, felt free to work out his tormented religious visions; Craxton to depict fictitious shepherds in imaginary landscapes; Minton to draw his lushly vegetated idylls; and Vaughan to explore the male nude in pale sunlit woods. Churchill had told the nation, 'The front line runs through the factories,' but it did not run through these canvases because the artists turned their backs on the war, closed their ears to the nightly bombs, and pursued the visions in their heads. A painter's vocation is to paint as he feels he must; nevertheless, there must have been a few twinges of guilt felt in the studios of St. Ives, Hampstead, Kensington and Notting Hill where the painters continued to do the thing they loved most whilst others gave up *their* careers and risked their very lives to enable them to do so.

As well as being non-combatants the Two Roberts were vulnerable to taunts about their relationship. Josef Herman, who, as we mentioned previously, had now moved to London for his first London exhibition and who became involved in their circle before moving on to Wales, remembers one incident in a Fulham pub. Colquhoun was taunted about his homosexuality by a drunk.

> MacBryde was ready to punch him in the face but Colquhoun stopped him and turned to the drunk: 'I am as nature made me' – (pause while Colquhoun looked the drunk in the eyes) – 'and so, unfortunately, are you. Now shove off!!!' His voice had so much authority that the fellow disappeared as though through the floor.[4]

Apart from Keith Vaughan, who was away from London for most of the war, The Two Roberts were the oldest of the second generation of Neo-Romantics. Their obvious talent, together with their recent knowledge of Italian and French art, must have given them a certain prestige within the group. Being of provincial, working-class origins would be no handicap either since their fellows, if they were political at all, had left-wing sympathies. In spite of their roisterings round the capital they quickly produced enough work to impress Sir Colin Anderson, then a near-neighbour, so that he began to collect Colquhoun's work as he had done Sutherland's. They were also taken on by the Lefevre Gallery, virtually the Neo-Romantics' home-ground, where they were enthusiastically supported by one of the directors, Duncan MacDonald. Both painters were included in the 1942 exhibition of 'Six Scottish Painters', and Colquhoun had his first one-man show there in 1943 and a second in 1944. In 1943 they were both established enough to exhibit works alongside Sutherland, Piper and Ayrton in 'Notable British Artists'. For this Colquhoun produced a portrait of Minton and MacBryde a nationalistic oil, *The Red Kilt*. John Piper gave them both enthusiastic reviews in his *Spectator* column.

Before we consider their work in any detail, it is necessary to point out that though The Two Roberts formed one indissoluble pair, they were not interchangeable, either as men or as artists.

Acquaintances describe Colquhoun as tall and darkly handsome, but also as shy,

passive, sombre, inarticulate and given to long morose silences or to the pointless reading of any printed matter to hand. Prunella Clough, on the other hand, thought him fun to be with and, along with many other artists, admired his technical virtuosity and strange colour sense. The poet George Barker who was his close friend, without claiming Colquhoun was an intellectual, thought he had 'a natural beautiful intelligence'. However, in the funeral eulogy he composed for his friend Barker acknowledged this intelligence had its darker side:

Tenderest of men in the morning before the ravening ghouls
Swept out of his holyrood conscience like lost souls,
In the evening we heard him howling in their chains.[5]

MacBryde was the livelier, more extrovert of the two. 'He had a round head with the prominent bushy eyebrows and the mobile rubber features of the clown, or perhaps of some sophisticated, disillusioned, rather tired French cabaret artist.'[6] He was small, fair, deft, and took care of their domestic arrangements and clothing. MacBryde was once seen pressing Colquhoun's trousers with a heated spoon. There was a certain vanity about his own and his friend's good looks in those early days of relative prosperity, and on one occasion he stamped on Colquhoun's new spectacles because he thought them disfiguring. If in any couple there is always a loved and a lover, then MacBryde was the lover, furiously jealous, especially when Colquhoun talked to women, yet capable of sacrificing his considerable gifts to serve 'the great master'. The consensus seems to be that his was the lesser talent of the two.

MacBryde's early works are difficult to trace, but Colquhoun's search for a personal style is well documented. This shows a restless trying on of various styles and subjects for size and fit, until around 1946–7 when the characteristic vision we now recognise as Colquhoun's own emerged. By that time he had assimilated, or rejected, most of what Neo-Romanticism had to offer him. Two small paintings of 1941 show him trying out the current enthusiasms of his new friends and putting aside his own early preference for Lewis to do so. *Marrowfield Worcestershire* takes the Palmer-Piper-Sutherland subject of a dilapidated cottage amidst lush vegetation. There is something of Palmer's and Piper's variety of textural marks in this, and a breaking up of the picture into clear areas of pattern, but the energetic swirl of line round them is Colquhoun's own. *Church Lench* is not so restless in mood and is drier in texture, more Nash-like, but it is even more concerned to show interlocking, textured shapes. There is a coarseness and attack about the brushwork that none of his friends were employing at this stage.

London as a subject never seemed to have any appeal to Colquhoun in all the years he lived there, but, like Moore, he was intrigued by people settling down for the night in the wartime tube stations and air raid shelters. Keith Vaughan's soldiers in their bunks also come to mind when one sees *Composition with Figures* (*Air Raid Shelter*) (1941). These figures, whilst nothing like portraits, are more particularised than Moore attempted. The paint has been scratched through to the board and otherwise abused to give it surface variety, but the composition is oddly

Marrowfield, Worcestershire (1941), oil on canvas

Composition with Figures (Air Raid Shelter) (1941), oil on board

fragmentary, like two or three studies tacked together.

In 1942 Colquhoun painted four interestingly varied works though it is now impossible to reconstruct the order in which he completed them. *The Loch Gates* shows figures in a landscape with Sutherland-derived foliage to right and left, and the strong shapes of the beams of the loch gates over them in the top centre. There are more bits of Sutherland flotsam and rockery and another high horizon in *The Encounter*. This is a steeply tilted upright landscape setting for a tense meeting between a solidly built young woman in the foreground, and an unsmiling man who approaches bearing a stick or leash in his hand. The psychological tension between two people was to occupy him more and more over the coming years, though the protagonists are never again as firmly modelled as this young woman is. He returns to the horizontal canvas for *Tomato Plants*, bringing them virtually up to the top of the canvas in the Sutherland manner. Minton tackled exactly the same subject using very much this format in 1947, but he brings every-thing into much sharper focus than Colquhoun, smoothing out the painting and putting a distinct line around every form. Minton changes the subject from a painting into a decoration, though a masterly one it must be admitted. Finally in 1942, there is Colquhoun's *The Barren Land*, a very strange work, owing much, I believe, to Nash's surreal studies of seaweed and flotsam, and to Sutherland's too, though the ambiguity of the spatial relationships is something neither would have bothered to try. Most artists learn to find themselves by first working in the styles of other artists they admire, but so adept had Colquhoun been at this during his first years in London that the following quatrain circulated amongst his acquaintances:

> Said Colquhoun to MacBryde
> Here's a trick we've not tried
> Said MacBryde to Colquhoun
> Then let's try it soon.

It is solely on the basis of these few early works that Colquhoun is classified with the Neo-Romantics – though socially he remained close to many of them until his death. He was never deeply converted to the Palmer manner, lacking any religious convictions, and perhaps finding the fecund dells of Kent little to his taste after the breezy spaces of Ayrshire. Sutherland he undoubtedly admired and learned from in terms of unusual colour combinations and the dramatic possibilities of an unex-pected angle of view. Minton too must have passed on some of the London group's enthusiasms during the period he shared a flat with The Two Roberts. Colquhoun was, however, the more powerful artistic personality of the two and soon the influ-ence flowed the other way towards Minton.

In 1943 Colquhoun painted a portrait, *David Haughton in a Landscape*, in which the sitter has a sharp Wyndham Lewis face and metallic jacket and behind him there is a menacing Sutherland hedge. *Thea Neu* is also a very successful adaptation of the Lewis manner. Both pictures were indications that he was moving away

The Encounter (1942), oil on canvas

from poetic landscapes and becoming more interested in figures. Around this time he, and MacBryde of course, went to stay in Cornwall with the Scottish poet Sidney Grahem. There Colquhoun drew many studies of goats which he used later, in 1947, as the basis of a series of paintings. These refreshing stays in the country became a recurring necessity in his career – so he was in Wivenhoe in 1945, Ireland in 1946, Lewes in 1947 and Dunmow for several years after 1950. The metropolis seemed to corrupt him and there his art lost its contact with the earth and became etiolated, over-elaborate and derivative. Once in the country amongst goats, pigs, chickens and horses his art grew robust and put on weight.

The portraits of David Haughton and Thea Neu hinted that Colquhoun was looking for something a little more severe and less decorative than Minton's kind of Neo-Romanticism offered. It was that same puritan urge to restrain excess that we have already noted in Nash and Piper. Braque said, 'I love the rule that curbs emotion,' and it was to Braque's style of Cubism that Colquhoun turned now. However, he seemed to have taken this largely pre-digested or second-hand from Jankel Adler, now living in their ground-floor studio, and to have grafted it upon those lessons he had taken from the work of Wyndham Lewis, the professed enemy of Romanticism. This can be seen in the way his forms became decisively outlined, the curves reduced to angles, rotundities to planes and smooth transitions to edges. These formal devices, widely adapted by European artists, meant that when his works were exhibited in Paris immediately after the war the French welcomed him as almost one of their own, whilst they found very little to admire in his fellow exhibitors' home-grown, rather literary productions.

The friendship between the two Scots and Adler flourished. He was already a middle-aged man with a European reputation, and progressive enough in style to have been chosen for inclusion in Hitler's exhibition of Decadent Art. This past and his continuing enthusiasm for all aspects of painting must have made him an attractive figure for the younger painters now cut off from the Continent. Perhaps too the young Scots felt an affinity with him because he also was exiled, heavily accented, and adrift in the snobby intellectual world of London. For whatever reason, they were both more affected by Adler than any other artists of their generation, and since that influence took them steadily away from their connections to the Neo-Romantic way of seeing and painting we must examine what Adler had to offer.

Adler was born in Lodz in Russian Poland in 1895, the seventh of the twelve children of a Jewish miller. After periods as an apprentice engraver and a soldier in the Russian Army he travelled to Düsseldorf in 1920. There he progressed rapidly as an artist, had his portrait painted by Otto Dix, and occupied the next studio to Paul Klee in the Düsseldorf Academy. When he arrived in England he tried to establish Klee's reputation here, writing a poetic tribute to his friend in *Horizon.**

* Adler dictated his views to the poet Sidney Grahem who then turned them from Polish-English into polished English.

> Klee had the courage to walk the windswept platform of the twentieth century and not to continue in the shades of Renaissance standards. He did not try to make a new shadow. He made a survey of the place for others who will come.[7]

In Germany he soon built up a reputation as a modernist painter and teacher, and he settled down with a German wife. His intention was to establish for himself, and other Jewish painters, an international style of art based on Jewish calligraphy and Hassidic craftsmanship in fabrics, candelabra, gravestones and so on, since there was no figurative tradition to draw upon in the Jewish past. This rich tradition he intended to blend with the new language of the twentieth century: Cubism and its analysis of space. Josef Herman says Adler set out to personalise the Cubists' analytic discoveries, to use them, as Klee did, for poetic ends and make Cubism express 'more durable inner experiences'. To this end figures were to be elevated to the hieratic and universal. The nostalgic sweetness of Chagall was to be eschewed, and colours were to be unrealistic and rich as oriental carpets. This idealistic and ambitious programme was under way when the growing anti-Semitism in Germany forced him to flee to Paris in 1934, leaving behind his wife. In Paris he came under the spell of Picasso. His essay on Klee also contains the acknowledgement of his own, and others', debt to that rich source:

> Picasso the great innovator of the twentieth century has knocked on the door of every painter's studio in the world. The richness of his form gives a totality from which to build the scaffolding of new painting.

After more travels in Eastern Europe Adler returned to Poland from 1935 to 1937, and then with the coming of war volunteered for the Polish Army; fleeing after its dispersal he was eventually evacuated to Glasgow in 1940. There, as we have recounted, he met Herman again and played his part in the revival of artistic life in that city. Both were welcomed as established older men by the young London painters when they moved south. They brought with them the glamour of Europe and stories of German and Belgian Expressionism (Herman knew Permeke), and the School of Paris. The Two Roberts had met no one up to now who could compete with the tumultuous conversation of Adler in which 'art linked with philosophy, philosophy linked with folklore; a Hassidic tale or a quotation from the Jewish book of mysticism, the Zohar, led to present-day trends in science, literature, the theatre and cinema.[8]

During the last years of his life Adler was researching ways of making singing, unreal, colour harmonies bound together by decorative outlines. Herman says he achieved these luminous colours by using his own 'fat' gesso primer mixed with a touch of burnt umber and linseed oil, which remained flexible, and dried slowly, as the colours were built up in thin layers. The Two Roberts were not painstaking craftsmen of this kind and tried to imitate Adler's colours by direct painting, using thick paint from the tube rather than laying it down glaze on glaze. They were after his effects but were too impatient to follow his means and so the results looked

Thea Neu (1943), oil on canvas

Flowers in a Vase (c1942), oil on canvas

cruder. Jewish themes continued to occupy Adler (Purim players, rabbis, etc.) in London, but the figures became flattened and bound down by strong rhythmic outlines and the forms were often cut across by seemingly arbitrary colour divisions derived from late Cubism. This does not mean they were reduced to emblems or lacked emotional force: one of his finest oils is *The Two Orphans* (1943), a deeply poignant work he painted for Herman after learning they had both lost their entire families in Poland at the hands of the Nazis.

Adler's ability to use his colours for emotional and decorative rather than descriptive ends; his simplification and flattening of forms; his use of line and the division of the picture surface into differently textured areas which cut through and across forms; his concern with his fellow human beings rather than landscape; and his subjects taken from folklore and imagination, rather than from models, must have all impressed the Two Roberts as worth learning from. From now on all these features appear increasingly in their works until it is difficult to believe that those early 1940–43 works of Colquhoun's could be from the same artist. They had already been drawn to the severe, edgy works of Wyndham Lewis, as we have seen, but Lewis had little interest in paint texture, or painterly 'effects', or in still-life subjects (MacBryde's speciality), and very little compassion for his fellow men and women. These two sources set the Scots apart from their friends who were still working out the implications of Sutherland's example at this period. Ayrton eventually conceived an admiration for Lewis, but when Adler exhibited at the Lefevre in 1946 Ayrton could make nothing of this un-English exotic and, with customary chauvinism, condemned him.

> Jankel Adler is a chef in paint. His dishes are so richly and admirably cooked that I cannot eat them. His ingenuity of surface seems to me to be put to no very real purpose, and he is therefore a good decorative painter without being a very interesting artist. This is first-rate professionalism in the French sense and makes me long for the amateurishness of Blake . . . In most of his other oils the human head is treated with a mask-like blankness which makes *homo sapiens* no more than a prop on which to hang patterns.[9]

There are elements of truth in this attack insofar as Adler was still disoriented by his loss and exile, and still digesting his recent sampling of the School of Paris, and Picasso in particular. He had not yet regained the magnificent assurance of those works he had created in Germany. Nevertheless, Ayrton and the other reviewers were remiss in not seeing that here was a significant master in their midst. By 1949 it was too late: Adler died of a heart attack at the age of fifty-four.*

Adler was responsible for weaning Colquhoun and MacBryde away from the English landscape tradition (it had never been *their* tradition, anyway) and on to a richer eclecticism, a less parochial style, and more humanistic subject matter. As he explored his Jewish tradition, so he urged them to explore their Celtic heritage.

* Our neglect continues. In 1986 a major Adler exhibition was organised in Lodz, Düsseldorf and Tel-Aviv, but it did not come to Britain.

Soon Colquhoun began to paint Irish and Scottish peasant women, haggard, shawled and black-skirted. These remote static figures were meant, like Adler's, to represent something archetypal, enduring through time, but they are also expressed in an unmistakably twentieth-century idiom derived from Picasso and Braque. This, I think, is as far as the Celtic aspect of Colquhoun's works went. There is no evidence in the works that he researched Celtic art's richly intricate pattern-making, or that he was aware of the fantastical elements in its legends. That he took a belligerent pride in being a Scot many people testified to, but this did not transfer to the canvas in any ways I can detect.

Before Colquhoun could settle down to a serious working-through of the lessons he was learning from Adler his long-delayed commission from the WAAC arrived in November 1944. This was to depict the weaving of army cloth for a fee of 25 guineas and the usual terms, that is, third-class travelling expenses, maintenance allowance of up to £1 per day for each 24 hours away from home, and a day allowance of 6s. 8d. for an absence of more than 10 hours. Colquhoun hoped to be sent to the Hebrides for this work, but ended in Peebles. The crayon and wash studies for this commission are now in the Imperial War Museum and show women working on looms and dye vats and other weaving machinery. However, they are far from being documentary works since the colour schemes are heightened by decorative reds and yellows and the factory clutter eliminated in favour of strong flat shapes. The women are depersonalised and derive their puppet-like appearances from Lewis and Adler.

At last Colquhoun could work out his own mature style, and between 1944 and the end of 1946 came a series of graphics and oil paintings which still form the basis of his reputation. The ink or pencil drawings are scratchy, very delicate, studies of people and animals whilst the paintings are strong and monumental. Typical works of this period are *The Whistle Seller* (1946) based on a one-legged beggar and his cat Colquhoun had seen in Oxford Street, but worked up into a pattern of subdued greens and pinks, rectangles and curves; *Woman with a Birdcage* (1946), the heavily stylised figure contrasting with the fragile cage; *Woman with Leaping Cat* (1946); *Seated Woman and Cat* (1946); and *Actors* (1947). Adler had been fond of painting cats and had perhaps passed on this motif and the gaunt, unsentimental way of seeing them, but the recurring cages, windowless rooms and the chilly lack of communication between his pairs of figures reflect some deeper concern all Colquhoun's own. These are all unusual works with no precedents in British painting. If we take *The Fortune Teller* (1946), now in the Tate Gallery, as a representative work from this rich year we can see that for all the gesturing hands and the nearness of the two bodies there is no thread of intimacy between the women, whose gazes fail to meet. They are distanced from us by their lack of characterisation, by the mysterious nature of their activity and their weightless, stiff postures. A clear line runs between them separating the picture into a yellow and a green half, in neither of which is spatial recession implied. Further quite arbitrary-seeming divisions into non-descriptive colours and textures occur within the figures, each staying flat and unexpressive of the torso or arm beneath. The clothing and extraordinary hats are

undatable as is the elementary, Cubist, furniture which cuts across the front of the canvas to distance the figures still further from us. Colquhoun explained his purely formal preoccupations in the only interview he gave:

> Each painting is a kind of discovery, a discovery of new forms, colour relation, or balance in composition. With every painting completed, the artist may change his viewpoint to suit the discoveries made, making his vision many-sided. Figures and objects in modern paintings may appear distorted. There will be those who seek a factual resemblance, or a mirror-like reflection. The special forms, evolved from the relation of colour masses, line and composition, to express the painter's reaction to objects, will be the reason for a painting's existence.[10]

The word 'people' does not occur here, though it is obvious that Colquhoun needed to keep some human content in his work rather than go totally abstract in his pursuit of 'the relation of colour masses, line and composition'.

At the end of 1946 he spent eight weeks in Ireland and returned to paint 'Irish family groups . . . welded together into a kind of composite totem pole, with heads facing outwards into space', as Bryan Robertson described them.[11] The figures were now clumped together, though still not intimate, and even more drastically simplified, as in *The Dubliners* (1946). The next stage was to simplify the colours and the surface divisions rather than to elaborate them as he had done in the works of 1946.

Suddenly The Two Roberts were in demand. Richard Shone accounts for this rise in their fortunes as follows:

> On its first appearance in the mid-forties, Colquhoun and MacBryde's painting was what people had been waiting for. Its emphatic imagery, direct emotional appeal and legible modernity all contributed to its public success. Between the dubious hysterics of Minton and Ayrton's romanticism, Sutherland's unpeopled landscapes and the pacifism of Euston Road and its followers, Colquhoun, in particular, struck a blow for a Celticism which was undecorative and unliterary, a lyrical humanism which was unassailably compassionate.[12]

Wyndham Lewis felt Colquhoun to be, at this period, the best of the younger generation and remarked of his women, peasants and beggars that it was 'very unusual to find *la condition humaine* attacked, as a subject, by artists in any field in England today'.[13] It seems to me, however, that Shone's and Lewis's admiration for Colquhoun's compassion is overdone. Compare Colquhoun's beggars with George Grosz's maimed derelicts, or Kathe Kollwitz's grieving women, and they look merely posed in their melancholy. Even Adler, with all his painterly preoccupations, had managed in his best works to combine a rich surface patterning with a palpable tenderness for his Jewish maidens, rabbis and soldiers. Herman too, now living in Ystradgynlais and painting miners, told us something about the dignity of human beings living in tough circumstances. Even Lewis must have begun to feel some unease about

the shift in Colquhoun's interest from his protagonists to the formal organisation of his picture surface, which left the people more and more ethereal:

> None of his female figures are troubled with bloodstreams any more than phantoms. There is a grave dug behind all his canvases of a certain kind: his elderly women, covered with such summary garments as their poverty and the austerity of his mind allows, are posed above it, already they have the waxen pallor of a corpse.[14]

Still, in 1947 The Two Roberts were riding high with successful exhibitions, the encouragement of Adler and the advocacy of Lewis, and the admiration of their young fellow artists who flocked to Bedford Gardens.

Then, suddenly, the landlord threw them out for having too many 'drunken orgies'[15] and things began to go downhill for them, slowly at first, and then with increasing acceleration.* They continued to gain and keep friends such as George Barker. Sidney Grahem and Ian Hamilton Finlay as well as writers Anthony Cronin and Fred Urquhart – several of these were, like themselves, Scots trying to make an impression on the English artistic establishment. Others they irrevocably offended were John Rothenstein, the Director of the Tate, poet and fellow Scot Ruthven Todd, the writer Maclaren-Ross, and Dylan Thomas whom they abused as a phoney because he did not sound as they thought a Welshman should. In spite of their reluctance to revisit their homeland, or to keep in touch with those early supporters of Colquhoun's who had made his career possible,† they remained exaggeratedly Scottish, thickening their accents, dancing reels, singing Scottish ballads, reciting Burns, and painting Hebridean women and men in kilts. Like Minton they began to be known more for their escapades than for their works. Behind all their violent behaviour lurked the demon drink, and much of their time in Fitzrovia seems to have been spent looking for people to charm or bully into buying their whisky. On the other hand, there was no meanness about them: in their later years of desperate poverty they seem to have been generous and spendthrift with the little they had, and the couple of hundred pounds they received from Minton's will was soon scattered.

As we have already suggested, they did escape from the snares of Fitzrovia for brief periods, one of these being to Lewes in Suffolk during 1947–8 where two elderly and aristocratic ladies, Mrs Frances Byng Stamper and Miss Caroline Byng Lucas ('Bay' and 'Mouie'), lent them a studio. The two ladies were determined to make their Miller's House an artistic haven and pulled enough strings to have Kenneth Clark launch the whole venture, and the Bloomsbury painters take part in its programme. They commissioned Colquhoun to embellish an anthology, *Poems of Sleep and Dream*, with sixteen lithographs[16] to be published by Frederick Muller, a firm

* Maclaren-Ross declares they abandoned the studio because vandals broke in and destroyed their works (*London Magazine*, January 1965, p. 20).
† The only time Colquhoun's body crossed the border after 1946 is said to have been for his burial in 1962.

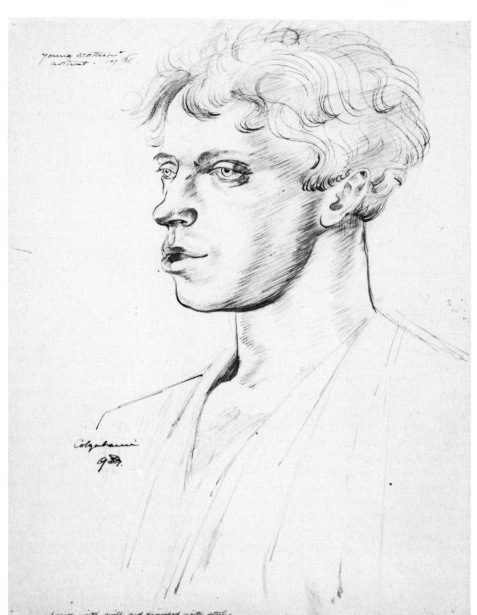

Portrait of Robert MacBryde (1938), pen and ink on paper

Illustration for *Poems of Sleep and Dream* (published 1947), lithograph

which had already published Ayrton's illustrations for *Poems of Death* (1945) and John Craxton's *The Poet's Eye* (1944). Of these it seems to me that Craxton's are the best works, in spite of his being the youngest of the three artists. Colquhoun's are strange images, but several seem to be rather cursorily done and all are in an unattractive combination of black, salmon pink, dull lavender and gamboge. They seem to have little to do with the text and are inserted in such an arbitrary way that they fail to decorate or integrate with it visually either. Colquhoun was evidently not at home with literary themes and it was his last book-work.

Kenneth Clark had been impressed by the long-delayed drawings of weaving for the WAAC and now suggested to Léonide Massine that Colquhoun and MacBryde would be the ideal designers for his new ballet on a Scottish theme. This was *Donald of the Burthens*, which included bagpipes, but at least avoided the cliché of everybody being dressed in tartan. This was eventually produced at Covent Garden in 1951 to lukewarm reviews of the ballet, but favourable comments on the stage and costume design. Later, in 1953, Colquhoun did more design work for the Stratford production of *King Lear* with Michael Redgrave in the lead and George Devine as producer. This seems to have impressed observers more than the ballet designs did.

However, towards the end of 1947 the first warning notes began to sound. Colquhoun's exhibition at the Lefevre that year was favourably received by his friend Wyndham Lewis, but with the warning that he needed to go back to Nature if his images were not to become thinner and more conventionalised, 'not to put it [Nature] into his pictures, or to make them more naturalistic, but in order to enrich,

with memories of carefully studied form, the pictorial intelligence within, which is responsible for the pictures we do "out of our head".[17] Patrick Heron in the *New Statesman and Nation* gave the same advice. He found Colquhoun's works falsely complex, static and flat, for which he, and several other critics, blamed the influence of Adler. The general charge seemed to be that the older artist had turned Colquhoun from the close observation of his fellows and his landscape, and encouraged him to make art from art. Colquhoun was starting to repeat himself, warned Heron, and he remained totally unimpressed by MacBryde's work even when the Museum of Modern Art in New York purchased his *Woman in Red Hat* in 1948.

Heron had to be listened to. He was an important painter-critic at this time, having emerged from wartime St. Ives to reaffirm those formal values upheld there by Nicholson and Hepworth, and to re-establish the power of Parisian painting, particularly that of Picasso, Léger, Matisse, Rouault and, above all, Braque. Later he would be one of the chief advocates of Abstract Expressionism. The *New Statesman and Nation* gave him a platform for his views between 1947 and 1950. His obsessions with 'pictorial space' and the 'structural' use of non-realistic colour meant he was out of sympathy with the more literary and linear Neo-Romantics though one might have expected Colquhoun and MacBryde to be more to his taste than Ayrton or Minton, who were basically illustrators. But no, Heron said, both painters had taken Cubism second-hand from Adler and all three had misunderstood it, thinking it only a device for dividing a surface into patches. Heron explained further:

The very conscious attention to texture which MacBryde and Colquhoun bestow on such patches cannot, of itself, invigorate them. If a painted shape is flat in conception and drawing, an additional devotion to its exact quality *as a painted surface* does nothing to redeem it. Both these painters construct a woman or a still life out of flat, sometimes flapping, shapes which resemble the pieces of a jigsaw puzzle in that their edges are unpredictable: these facets or pieces tend not to be rectilinear, as in a cubist painting. The cubist facets had a plastic derivation: they were 'planes' and so they invariably evoked a solid form. The edges of cubist planes were always taut, consisting of straight lines and rigid arcs. Not so the flat pieces in a MacBryde or Colquhoun, which are both more, and less naturalistic than cubism.[18]

Colquhoun would have done well to ponder this, even if ultimately he disagreed with Heron.

Meanwhile The Two Roberts' friend, George Barker, suggested they all three collaborate on a book about Italy, which John Lehmann would publish as he had done the Ross-Minton one on Corsica. Accordingly they toured Italy together in 1949, taking in the puppet plays at Modena and the Palio horse-race round the streets of Siena. Although the book project came to nothing Colquhoun returned to the man-with-horse theme, masked figures and puppet creatures for several years afterwards. When Colquhoun exhibited these works at the Lefevre in 1951 the critics turned their backs on him as cruelly as they were to do on Ayrton in 1955

and Minton in 1956. There seemed to be no development, complained Wyndham Lewis, no sense of joy in these festive subjects. Nor was there any sense of place in spite of titles like *Siena Palio* or *Puppet Show Modena*, said other reviewers. He had gone stale, the figures were mere husks, and he could not even draw a believable donkey saddle. David Sylvester said his staleness 'may have been due to his having been cooped up for a decade in two little islands and submitting meanwhile to the stultifying influence of a cosmopolitan pictorial chef like Jankel Adler'.[19] Adler was dead by this time and could be hurt no more by such jibes, but Colquhoun could. Like Minton his moment in the limelight was over and the Lefevre Gallery, which had given him one-man shows in 1943, 1944, 1947 and this in 1951, no longer wished to exhibit his works now that his chief advocate there, Duncan Macdonald, was dead. Europe was open again, the Salvador Dali circus was in town, and the British reviewers, gallery owners and patrons were sinking back into their genuflexions before any canvas that came from Paris.

Earlier, in 1950, The Two Roberts had been offered the use of a cottage at Tilty Mill, near Dunmow, Essex. This belonged to Ruthven Todd, Blake and Fuseli expert, Fitzrovia bar-fly, poet and also good friend to most of the younger Neo-Romantic group – he had, for example, invited Craxton and Freud to stay there on earlier occasions. At this time he was working in America and the poet George Barker had taken over temporarily; he had in turn invited the poet W. S. Grahem, and Colquhoun and MacBryde. Accounts of life there vary according to who is telling the tale. Rothenstein records an idyllic memory from Barker's son who was then eight years old and appreciated having imaginative yet anarchic Scots around, even if they did fight all night in their bedroom.[20] Todd, on the other hand, reacted with horror when he found the two drunken 'spongers' had smashed all the windows and demolished or sold most of his possessions.[21] Anthony Cronin also claims that MacBryde in a rage attempted to burn the cottage down with both Colquhoun and his paintings still in it. Cronin also tells of being host to the pair himself in his house in Wembley. They evidently made lively guests as Colquhoun chased MacBryde through the front gardens of his street brandishing a carving knife. Both men were naked at the time and it was in the middle of a thunderstorm.[22]

In spite of these alarums and excursions Colquhoun did get some solid work done in Essex, being inspired by the goats, pigs, dogs, cats and particularly horses which were all around him. Perhaps he was trying to heed the reviewers' warnings that he needed to top up his reservoir of natural forms. These are spare, unsentimental drawings of a subject usually shunned since Landseer had turned all his animals into little furry ladies and gentlemen. Pigs and horses seemed to bring out the best in Colquhoun. It would have been interesting to know how he would have responded to the tigers burning bright in London Zoo after all the domestic cats he was so fond of; or how he would have coped with the near-wild Arab horses Delacroix and Géricault drew, rather than the heavy dobbins of Dunmow.

By 1954 tensions were running high at Tilty Mill and the two painters returned to London. By now drink had even destroyed their working habits and they began to neglect their physical welfare as funds and friends dwindled. They were totally

out of fashion, owing allegiance neither to Kitchen Sink realism nor St. Ives abstraction, and the next flurry of chic styles would offer them nothing either. Neither was reliable enough to be employed as a teacher, and neither had commercial talents they could turn to. They were destitute and reduced to picking up and cadging what food and drink they could round Soho and Fitzrovia.

It was an act of considerable courage and faith for Bryan Robertson to step in at this low point in their lives with an offer to Colquhoun of a retrospective exhibition at the Whitechapel, to open in April 1958. At different times he made the same offer to Ayrton, Vaughan, Craxton and Clough. Now he predicted a come-back for Colquhoun:

> If his initial and basic lyrical impulse is entirely synthesized with the formal side of his work, a new phase seems likely which may well transcend everything that has preceded it. In several large new canvases there is every sign that such a synthesis is beginning to take place.[23]

Colquhoun had painted eleven big canvases in the two months before the exhibition opened, including the unlovely monochrome *Bitch and Pups*, and the brooding *Women in Ireland*, dark and grim against a deep blue sky. Some of these works showed his haste in the empty passages and dull paint surface, but for the most part they were seen as hopeful signs that he was back on course. The sources of his early inspirations from Palmer, Sutherland, Lewis, Picasso and Adler were enumerated by all the reviewers but, it was generally agreed, Colquhoun had by now successfully assimilated them all and was in possession of his own subject matter and his own strange colour sense. After the first Neo-Romantic landscapes, first without then with figures, then the plant drawings, he had slowly narrowed his most typical subject range to three-quarter length figures, usually female, and usually in pairs. They were simple in their outlines and austere in their settings but given a surface complexity by lines which divided the figures as if seen in a shattered mirror – 'playing cards without court dress', thought one reviewer, and 'curiously stiff as if he drew them with an axe-head', said another. In some of his latest the patchwork effects he had always favoured were broken up even more, so that faces resembled cracked plates, their features lost in this needless over-elaboration.

It was possible now, with all his works gathered in one room, to see that he had always to balance a concern for outcasts or lonely women with his formal obsessions which led him to distort, simplify, rebuild and over-complicate their figures. On the whole, with the exception of some of the 1946 masterpieces, I believe art won over heart, and that the humanity of his images bled away under the weight of stylisation he imposed upon them. There are no accidents in Colquhoun's work, happy or otherwise, only a steady decrease in sensuousness. It is a very long way from the plump young woman of *Encounter* (1942) in warm russets and reds, going to meet her man on the beach, to the hawk-faced *Woman Ironing* painted two months before the retrospective exhibition opened. Now she is trapped between bare walls and a table top and her body has become as sharp-edged and crystalline as

her sheet-metal clothing. She has become a strange form of totem, or still-life. A comparison with Dégas's pictures of women ironers will show how far Colquhoun's is removed from flesh and blood women.

As a colourist Colquhoun was admired by many of his fellow artists, at least until he began the austere last oils. The characteristic works of the second half of the forties were described by reviewers as 'plangent', 'sardonic', 'uningratiating', 'withholding sweetness' and so on, but it was generally agreed he was a painter 'with the colour sense of an old master'. The early intensities of browns and yellows gradually chilled as he matured, but this was in part compensated for by an increase in textural richness and a tautness of design. On balance most of the serious reviewers welcomed Colquhoun back at the Whitechapel retrospective exhibition as if he was Lazarus newly risen, and seemed to think he was still as promising at forty-four as he had been at twenty-four.

There were enough sales amongst the ninety-five oils, one hundred drawings and fifty-six monotypes to give the two friends a holiday in Spain. They returned to do more work and to mount their final two-man show at the Kaplan Gallery in 1959. In 1962, after another depressing period of shifting between seedy bed-sitters, they were offered another studio, this time over the Museum Street Gallery owned by David Archer. One of the well-intentioned conditions of this offer was that Colquhoun should work towards another exhibition of monotype prints. After the Whitechapel exhibition he seems to have virtually ceased oil paintings: instead he turned to monotypes, a technique he had first tried in 1946. It is a simple technique tried by Blake, but brought to perfection by Dégas.*

A monotype is made by spreading printer's ink or thinned oil paint over a sheet of glass or marble with a roller, then this sticky film is worked into with fingers, brushes, sticks or any improvised tool. A sheet of paper is then placed over the drawing, pressed down, and peeled off to give one reversed, unique print – though in practice the artist often cheats by fiddling with the print. Colquhoun became the modern master of this technique which is neither painting nor drawing and relies for its texture on accident. It seemed to release him from his late colour problems and the over-elaboration that had stifled some of his oils. He also made some delicate offset drawings by using carbon papers, another device which introduces accidental effects. By 1962, however, there were no more oils, drawings or monotypes to come. On the night of 20 September he was working late on a monotype of a man dying in outer space when he had a heart attack. He died in the arms of Robert MacBryde.

The Times gave him a generous obituary, saying his work was 'intense and somewhat strained in manner, it was in intention both humanist and tragic, with strong elements of romantic lyricism', which seemed to cover everything.[24] More widely the verdict seems to have been that his was a major talent wilfully thrown away by a disorganised and self-destructive fool. This underestimates the rigidity of the

* The Lefevre Gallery had a show of Dégas monotypes in April 1958 which Colquhoun may have seen.

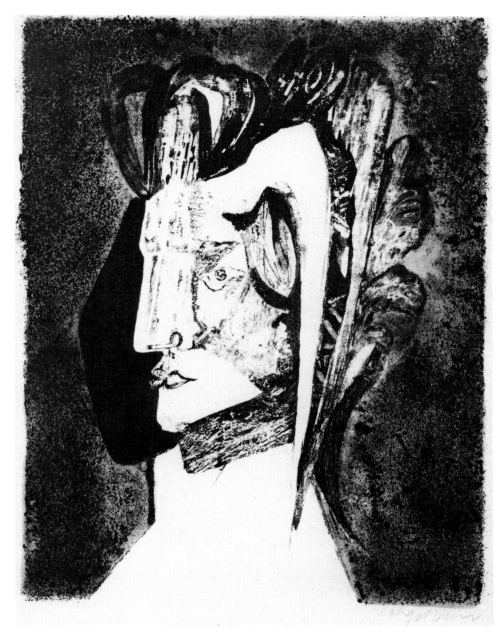

Head (undated), monotype

London art world and its ruthless discarding of yesterday's fashion. Maclaren-Ross makes this point with some venom:

> The obituary writers who so simply stated that Colquhoun had not developed much as a painter during his last years were not apparently aware that for some of them he was virtually homeless, or else did not realize that it's difficult to develop or even paint at all without a studio to do it in. The rich dilettantes and art-fanciers who claimed to admire his work so greatly when it was too late could have shown their appreciation better by putting a place to live at his disposal.[25]

MacBryde was inconsolable. Francis Bacon gave him money to go to Spain, but according to Cronin, with whom he stayed there, he scarcely drew a sober breath.[26] London was now a desolate city for him with Minton also dead, and Fitzrovia in the hands of tourists and property developers. He drifted to Dublin where, after a prolonged drinking bout with another of Fitzrovia's doomed Celts, the Irish poet Patrick Kavanagh (1905–67), he fell under a car and was killed in 1966. At their deaths MacBryde was fifty-three and Colquhoun forty-seven.

At first sight it is tempting to see the disorderly and wasteful lives of The Two Roberts as the stuff of romantic fiction. Here are gifted men staggering from crisis to crisis until artistic paralysis sets in, their doom overtakes them and their premature deaths swiftly follow. Anecdotes of their violence and rudeness cluster round their memories, as if any work they produced was almost in a fit of absence of mind between debauches – but this takes no account of the mass of the work and its quality. Romantics not only admire energy, they possess it. There must have been long periods of domestic calm between them and unspectacular hours of quiet work at their easels, though this, of course, does not make for good gossip. Neither artist allowed the turbulent periods of their lives to cross over into their pictures, being like Minton in this. MacBryde, in particular, produced bright, highly wrought, cheerful works all his life with no sign of *angst*.

MacBryde plays second fiddle in this chapter, and in all other accounts of the two artists that I have read or heard. This is partly because, for my purposes, there seem to be only a couple of minor pictures that could be related to the Neo-Romantic movement, and partly because I do believe Colquhoun was the more interesting painter. Nevertheless, MacBryde is not a negligible artist. Colquhoun received the invitations to exhibit or illustrate or design, and MacBryde was content to exhibit in mixed shows, or alongside his friend in two-man shows, or help in collaborative ventures such as stage design.* His work is harder to find than Colquhoun's and this makes judgement more difficult, though I would, on balance, agree with Ayrton's early estimate of him in 1944 when he said MacBryde painted with all the charm that Colquhoun had discarded, and 'his pictures, mainly still-lifes, possess lovely qualities of colour and surface. Their weakness lies in a certain derivative formal monotony, but most of the new paintings have a technical virtuosity, a deli-

* He had a single one-man show, at the Lefevre Gallery in 1943.

cacy and a succulence which would make the possession of one a pleasure without strain.'[27] Josef Herman claims he saw MacBryde doing better pictures after Colquhoun's death when he no longer felt under his friend's domination. I have been unable to verify this.

In 1949 MacBryde made his only public declaration of his intentions as an artist, alongside Colquhoun's statement already quoted:

> I set out to make statements, in visual terms, concerning the things I see, and to make clear the order that exists between objects which sometimes seem opposed. I do this because it is the painter's function, generally speaking, to explore and demonstrate in his work the interdependency of forms. This leads me beneath the surface appearance of things, so that I paint the permanent reality behind the passing incident, the skeleton which is the basic support of the flesh. In doing this I perceive a 'pictorial logic' which dictates that, if a certain line or colour exists in a painting, there must be certain other lines and colours which allow the completed painting to be an organic whole.[28]

This reads oddly, partly because one suspects he never talked like this, but also because it reads like a Neo-Platonist manifesto ('permanent reality behind the passing incident'), or at least a statement by someone who has heard about Clive Bell on 'significant form'. It also suggests that, like Adler, he has made himself rules to follow to achieve a preconceived end, following his 'pictorial logic' and allowing for no accidents along the way. There are few MacBryde drawings available in which we can check his preliminary thoughts, but the finished pictures retain a freshness which suggests the above might be a reluctant formulation of a process which, in practice, was much more instinctive. He learned from the same sources as Colquhoun and owed even more to Picasso's portraits of the 1930s and heavily outlined still-lifes of the 1940s. He also obviously studied closely the table-top works of Braque and Juan Gris. Most of all, of course, he learned from Colquhoun. Many of the works are in singing, heraldic colours, vigorously segmented by outlines like the lead in church windows or the metal strips in *cloisonné* work. At their best they equal anything of Colquhoun's and, as the *Manchester Guardian* critic put it, 'They have the lovely logic of a fugue.'[29]

REFERENCES

1. Rothenstein, John, *Modern English Painters*, Vol. III (London, 1976), p. 182.
2. Shone, Richard, Catalogue to 'Robert Colquhoun and Robert MacBryde' exhibition, Mayor Gallery, February-March 1977, p. 2.
3. All letters quoted in this chapter are in the Imperial War Museum archives.
4. Herman, Josef, *Related Twilights: Notes from an Artist's Diary* (London, 1975), p. 87.
5. Baker, George, 'Funeral Eulogy for Robert Colquhoun', quoted in John Rothen-

stein, *Modern English Painters*, Vol. III (London, 1976), p. 189.

6. Cronin, Anthony, *Dead as Doornails: A Chronicle of Life* (Dublin, 1976), p. 131.

7. Adler, Jankel, 'Paul Klee', *Horizon*, Vol. VI, No. 34, October 1942.

8. Herman, Josef, op. cit., p. 70.

9. Ayrton, Michael, *Spectator*, 15 March 1946.

10. Colquhoun, Robert, *Picture Post*, Vol. 42, No. 11, 12 March 1949.

11. Robertson, Bryan, Catalogue introduction to 'Robert Colquhoun, an exhibition of paintings, drawings and prints from 1942 to 1958', Whitechapel Art Gallery, March-May 1958.

12. Shone, Richard, Catalogue introduction to 'Robert Colquhoun and Robert Mac-Bryde', Mayor Gallery, London, February-March 1977.

13. Lewis, Wyndham, the *Listener*, 23 October 1947.

14. Ibid.

15. Rothenstein, John, op. cit., p. 183.

16. Turner, W. J. and Shannon, S. (Eds.), *Poems of Sleep and Dream* (London, 1947).

17. Lewis, Wyndham, the *Listener*, 23 October 1947.

18. Heron, Patrick, *New Statesman and Nation*, 4 September 1948.

19. Sylvester, David, *Art News*, 16 December 1950.

20. Rothenstein, John, op. cit., p. 187.

21. Todd, Ruthven, 'Fitzrovia and the Road to the York Minster', catalogue for Michael Parkin Fine Art (London, 1973), unpaginated.

22. Cronin, Anthony, op. cit., p. 174.

23. Robertson, Bryan, catalogue to 'Robert Colquhoun, retrospective exhibition', Whitechapel Art Gallery, March-May 1958, p. 7.

24. *The Times*, 21 September 1962.

25. Maclaren-Ross, Julian, *Memoirs of the Forties* (London, 1984), p. 204.

26. Cronin, Anthony, op. cit., p. 182–4.

27. Ayrton, Michael, *Spectator*, 3 November 1944.

28. MacBryde, Robert, *Picture Post*, Vol. 42, No. 11, 12 March 1949.

29. *Manchester Guardian*, 29 October 1949.

<center>*8*</center>

<center>

KEITH
VAUGHAN

</center>

K EITH VAUGHAN was born in 1912 which made him only nine years junior to Piper and Sutherland and ten years older than Craxton. Nevertheless, he needs to be grouped with the younger Neo-Romantics because he began his career as a painter very late, and not really as a full-time artist until after his release from war duties in 1946. He claimed he was over twenty-seven before he handled oil paint with real application. It would be wrong to give the impression in talking of two generations of Neo-Romantics that Nash, Piper and Sutherland were separated from their younger admirers by a gulf of years: all three were late starters and Minton, Ayrton and Craxton were so precocious that the gap between them was less than might be expected. Piper and Sutherland were only just beginning to receive wider recognition for their war-works as the younger men began to look around for mentors.

Vaughan was born in Sussex, at Selsey Bill, but the family moved to London soon after. The home was comfortable, cultured and musical, though his civil engineer father left them in 1922 and died in 1935. The mother was evidently an emotionally dominant and demanding woman and continued to be so all Vaughan's life, dying only shortly before his own tragic demise. His only brother, Dick, a nervous and clinging child, took up much of Vaughan's time and attention whilst they were young until he learned to stand on his own feet, and eventually, when he joined Keith at boarding school, he surpassed his older brother in athleticism and popularity. This school was Christ's Hospital near Horsham in Sussex and Vaughan remembered the organ music and the Frank Brangwyn murals there as consolations to a sensitive boy in an otherwise hostile environment.* In his journal entry for 19 September 1964 he records a return visit to the chapel:

> I looked again at the Brangwyns. It was like looking at my own face – at something so familiar it was part of me. Nothing surprised. I had carried away no false illusions. They were exactly the same. In each one were the same details which particularly pleased or displeased me, and the same secret thoughts and

* Piper also derived early inspiration from the work of this richly decorative and painterly artist (1867–1943).

Self Portrait (1950), pencil

fantasies which I had left there years ago when I had stared at them day after day for eight years.[1]

He must also have seen more obviously modern works than Brangwyn's lush anachronistic visions on several youthful trips to Germany, and on a 1937 trip to Paris where he later recalled seeing Gauguin's work. Though he was showing talent as a draughtsman by the time he left school, the depressed thirties did not seem auspicious years in which to begin the career of full-time artist. Instead he joined Lintas, the advertising section of Unilever, as a trainee in the Art Department. At least here he found enthusiastic fellow weekend-painters to talk with and the leisure to develop a lifelong love of ballet and the music of Mozart, Debussy, Poulenc and Schumann. He was already a competent pianist and in later, unhappier times, this provided him with some consolation. This safe, ordinary existence might have continued undisturbed had not war intervened. Knowing that he would be 'called up' Vaughan resigned his job in 1939 and tried painting full-time, concentrating on *plein air* landscapes and nude male figures by the sea, many of them based on photographs he had taken of his brother and friends. Several designs for imaginary ballets, both sets and costumes, survive from this period.

Vaughan had emerged from this unremarkable but emotionally turbid background as a rather lonely young man. He was melancholy, sexually obsessed, misanthropic and acutely unsure about his own attractiveness. He was also desperate for love and close male companionship but, simultaneously, was chary of intimacy. If Minton could be seen as a manic-depressive in psychoanalytical terms then Vaughan had, and continued to have all his life, the characteristics of a schizoid as Anthony Storr describes them.[2] We can make statements about Vaughan's inner life with such certainty because in 1939 he began a remarkably frank journal, which he maintained sporadically until the last few moments of his life in 1977. He began it because he did not believe he would live to see another birthday; the writing would therefore be therapeutic and consolatory:

The desire to make this journal grew out of the sense of my failure to live a life. When war came I felt that all further hope of success or achievement was over and that there remained only one task, to keep a log book of the last remaining days of the stricken vessel and try to discover what went wrong. If I could do that I felt that failure would lose some of its bitterness.[3]

He was twenty-seven when he wrote this entry for 3 September 1939: 'At eleven o'clock this morning England declared war on Germany. The insane calamity whose fear has overshadowed most of my conscious life has happened; has become actual, real and present.' He foretold the misery war would bring him, 'but peacetime living was not worth the living to me.' At least it forced this indecisive and unhappy young man into a decision. He joined the St. John's Ambulance Brigade until his call-up papers arrived and made gloomy notes as the Germans rampaged through Europe and Scandinavia. Torn between his lack of enthusiasm for the struggle and the

fact that 'it is more my reason that is offended by the war than my conscience', he dithered whether to go along with the majority and perhaps gain the purpose and male chumminess which had so far eluded him, or whether to observe it all as a conscientious objector.

Then, on 9 June 1940, he helped his ambulance brigade unload a train full of hideously wounded soldiers rescued from the shambles of Dunkirk.* Three days later came the news that his brother Dick had been killed in action with the RAF. Ten days later still he saw raw young soldiers marching off to war and reflected that they were the targets for hostile guns. He then describes how those deadly guns are made – it could be a Sutherland furnace picture he is painting in words:

An iron door opens and a tongue of flame leaps a hundred feet into the raftered ceiling. Sparks fall in showers as though the heavens themselves had collapsed at the blast of a trumpet. Men step backwards and shield their faces against the intolerable heat. An iridescent pillar of steel moves slowly across the arena of fire. Cold hammers drop a thousand tons from the sky and stamp on the white metal, flattening it like stiff butter. Flakes the size of a palm sweat off the tormented metal. Rollers squeeze and drag out its length like pastry. It passes through each thundering apartment of the giant inferno built by man and takes shape exactly to his calculations. Cools. Passes through lathe and drill rooms. Is polished, turned to micrometric exactness. Becomes a gun barrel, recognizable, docile in chains.[4]

By this stage his mind is made up: his conscience will not allow him to kill.

Conscientious objectors in World War II received more humane treatment than those in World War I, though the moral necessity of opposing Nazism was surely easier to accept than all the muddled and fallacious motives which sent youths off 'doomed to die as cattle' at Ypres and Mons. As Connolly pointed out in an *Horizon* editorial, the pacifists' position, once we were at war, looked a weak one since 'it suggests no other means of getting rid of Hitler except surrender to him – for a victorious Hitler would bring a persecution hardly distinguishable from war. It is therefore only the Pacifist-Martyr whose position is impregnable.'[5] Intellectuals, he claimed, were recoiling from the war in disdain, as if it were a bestseller! Though they, of course, represented the very culture being defended. Four times more men asked not to bear arms this time round – 59,192 in all – and possibly the authorities were anxious not to make martyrs of so many. Applications by creative people were usually treated sympathetically so, for example, both Benjamin Britten and Victor Pasmore were unconditionally exempt on the grounds of their talents and vocations. Michael Tippett, on the other hand, was jailed for three months because he would not even accept the second option, offered to nearly half the applicants, of being exempt arms-bearing on condition they undertook work in agriculture or other approved areas. The next possibility was to be sent to non-combat duties in the Forces, and the final verdict available was to have the application rejected and to

* This account was published in *Penguin New Writing*, No. 12, April 1942.

Barrack Room – Sleep I (1943), pen, ink, wash with white bodycolour

be called directly into the armed services. Only 12,204 men received this final command from the tribunals. Vaughan faced his four-man tribunal on 12 August 1940 and was told he need not bear arms, but he must serve in the Royal Army Medical Corps. In fact by some muddle he ended in the Pioneer Corps, the outfit with the very least prestige in the whole of the Forces. Vaughan thus became the only artist of those we are considering who came under military discipline for the duration of the war, all the others escaping on medical grounds or into commissioned work for the WAAC.

The journal tells us that this was perhaps the happiest period of Vaughan's life with its male camaraderie, physical work and a closed, classless, intimate society. 'Conchies' tended to be cleverer than average, as Vaughan noted: 'university students, school masters, young dons from Oxford and Cambridge. The daily routine of coolie labour keeps our bodies occupied but not our minds. Talk is mostly on the Big Subjects, art and life, literature, truth and philosophy.' The historian, Cosmo Rodewald, was a friend of this period who introduced Vaughan to Peter Watson and Neville Coghill, the Chaucer scholar, and after the war commissioned Vaughan's *Green Bathers* painting. Vaughan was thus able to complete his education, and learn his craft as an artist, without the distracting necessity of having to feed, clothe and house himself by plodding work at Unilever.

There was little chance to set up an easel or work in oils, but Vaughan could transport in his knapsack cheap pencils, brushes, inks, wax crayons, water-colours and gouache, and tiny (7 inches × 5 inches) Rowney 'Spirax' notebooks. With this equipment he could jot down sketches and colour notes of his fellow Pioneers spud-bashing, eating, washing, smoking or just lying exhausted on their bunks after a day's forestry, harvesting, quarrying or digging ditches.* Men at work as a subject is not infrequent in art but Vaughan must be one of the very few artists who drew work he was actually engaged in, rather than observing it as a clean-handed spectator. In this isolated but warm little community friendships grew, as Vaughan had hoped they would, and one of the best of these early works shows the rough, clasped hands of two soldiers.[6] These are warm, intimate little documentary records, but they have been striven for; there is none of Minton's easy command or Craxton's early facility here and compared to sketches by Sutherland, which he was studying intensely at this time, they are overworked. The small-scale mixed-media approach must have been encouraged by what he knew of Sutherland's Pembroke series, and it is evident from the wax crayon and overlay ink technique that he had learned something too from Moore's *Underground Sleepers*. Brief leaves in London and such publications as *Horizon* and *Penguin New Writing* kept him in touch with the work and thoughts of his contemporaries. The Homintern network led him to Peter Watson and through him to the other artists, and John Lehmann as editor of *Penguin New Writing* was soon publishing both his prose pieces and reproductions of his sketches as the magazine's first ever illustrations. Lehmann showed the originals to Kenneth Clark who got the WAAC to purchase twelve of them. This was

* The Imperial War Museum has acquired several of these sketch-books recording life in Bulford, Shere and Codford camps.

Hands (1944), ink and gouache

Vaughan's first sale, and, what is more, they went on display in the National Gallery exhibition of War Art alongside those artists such as Sutherland, Moore and Piper whom he admired so much. In spite of this unexpected reward Vaughan still did not feel he had the talent or character to become a 'real' painter like those friends in London. All the same, 'often in bed at night I feel the desire to live and think and feel in terms of paint with an intensity that is almost sexual.'[7]

By this time he had found his chief subject. As he later put it, 'I believe a painter has only one basic idea which probably lasts him a life time. Mine is the human figure.'[8] Or, more accurately, the male human figure, usually nude. Sometimes he set it in imaginary situations such as crucifixions or flagellations, or in weird, surreal other-worlds as when he illustrated the poems of Rimbaud in his notebooks. A 1941 series of drawings entitled *Voyage à Cythère* is as stagey and freakish as any of Ayrton's works of the St. Anthony series. Sometimes a curled-up, foetal nude reflected his psychological stress as the war progressed. For the most part, however, he wanted to continue exploring the male figure as he saw it, nude or clothed, in recognisable settings. This led him back to painting landscape, usually as a frame for his figures, but sometimes for its own sake. At no time did he show any interest in the Impressionistic depiction of the wash of light over the surface of things in an illusionistic way. His landscapes, however closely based on reality,

were always there as vehicles for mood and atmosphere.

British landscapes were not, during the war years, just neutral vistas of greenery; they had strategic significance so that recording their appearance might appear to a paranoid bureauocrat like aiding the enemy, and thus to be a treasonable act. Vaughan did not know this when he set up his easel before a hole in the ground in September 1940. This ludicrous story is worth repeating here because it shows us something about the jittery state of the populace at this time, and also reveals how selective the Neo-Romantics must have been in their depiction of England's green and pleasant land.

Agriculture had been in steady decline throughout the Depression years of the twenties and thirties with people leaving the land at the rate of 10,000 per year as farmers went bankrupt, and their labourers' tied cottages continued to lack piped water, sewers and electricity. In short, the way of life of the agricultural labourers had not improved dramatically since the eighteenth century when Burke went seeking the Sublime amongst them, or the nineteenth century when Palmer saw his vision of Paradise in the Kent wheatfields. It seems there was always a mismatch between how the artists perceived life in the country, and how the people who worked there saw it. Now, in wartime, the pastoral idyll became even harder to sustain. Suddenly in September 1939, when urban bombing seemed imminent, 827,000 schoolchildren plus teachers, toddlers, pregnant women and blind and handicapped people were evacuated from the main cities and dumped in the villages. Many had drifted home again by the time the air raids actually began in spring 1940, but other waves of evacuees came and went throughout the war. In addition 80,000 landgirls, prisoners-of-war, conscientious objectors and Irish labourers were sent to 'Dig for Victory', or as Vaughan put it, 'tear the upholstery of landscape'. Open-cast mines, aerodromes, factories, Government Departments, American troop camps all added to the rural population and increased its tensions.[9]

Under Government orders to mechanise production and plough up grasslands, fens, moors and hillsides to grow wheat and potatoes the appearance of the land itself changed more than it had done at any time since the Enclosure Acts. During 1940, when enemy invasion by landing-craft, glider or parachute was hourly expected, every beach and flat field or hilltop in the south of England was scattered with 'hazards' such as logs, old cars, bedsteads or concrete blocks. Lanes had barricades to hold up invaders' movements; names were taken off all stations and signposts to confuse them; pill-boxes were erected, and tank traps dug across open country. It was one of these last which had caught the eye of Keith Vaughan, 'a deep square trench which had been dug along the edge of a wood and across the nearby sloping fields. Its sharp geometric lines contrasting with the gentle undulating lines in the landscape interested me and I resolved to return during my off-duty period and make a painting of it.'[10] It sounds rather a Paul Nash subject. However, the local constable spotted him at his easel, called up three reinforcements and clapped Vaughan into Guildford prison, where he remained for eight days whilst they ransacked his mother's flat in London and interrogated him about his pre-war visits to Germany and the subversively pacifist opinions in his journal.

Midnight, Codford Camp (inscribed 24.00, 31st January 1942), ink and wash over wax resist

Although stunned, I remained confident that at any moment they would realize they had made a mistake and would come with smiling apologies and let me go. But slowly the truth of the situation became clear. They would not come back and they had not made a mistake. For weeks the papers had been full of stories of fifth-columnists. They were dropping from the sky dressed as nuns. They were lurking in woods dressed as gamekeepers. They came in coffins disguised as corpses. And at last they had caught me, and at Guildford of all places, disguised as an artist and caught red-handed in the act of making a plan of a tank trap.[11]

He was taken from his cell and in open court confronted with his picture.

It was the first picture of mine ever to be publicly exhibited. It was a fairly large canvas and as I had only worked on it for about an hour it was almost completely abstract. It looked rather like a late Cézanne watercolour (or so I hoped). It was scrutinized by each member of the bench in turn. They nodded approval. 'I think there can be no question at all what the picture represents,' announced the chairman and the bench agreed. This surprised me. It seemed unusually perceptive. Would they have been so certain, I wondered, if the picture were being considered

for the local Art Gallery? It was not a time when abstract art was very popular in the provinces.[12]

He was found guilty, fined £25 and had his picture confiscated perhaps, he speculated, to repose for ever in the Black Museum at Scotland Yard.*

The interest of this episode, apart from revealing his nicely understated humour, is the reference to Cézanne. His early reading in art had been the works of Roger Fry and Clive Bell and from them he had picked up a reverence for all things French, including of course their hero Cézanne. Vaughan was to find continuous stimulus from this artist when he came to specialise in similar themes such as bathers in landscapes. During his stay in the police cell Vaughan read Proust and throughout the war years he records snippets from his readings in Gide, Sartre, Flaubert, Claudel, Alain-Fournier, Verlaine and Rimbaud. After his Guildford experience he also, rather foolishly, began to annotate his sketches in German. Though he could still read Continental writers he was cut off from Continental art and had to turn to a home-grown exemplar – Graham Sutherland. In 1942 Peter Watson, who on first seeing Vaughan's work had exclaimed, 'It was all just cribbed from Sutherland,'[13] introduced him to Sutherland. After talking about art with the older man Vaughan would rush away to record every bit of the wisdom he had acquired in the pages of his journal. Later, in 1947, he was to give it as his considered view that:

> What Picasso did to the human figure Graham Sutherland is doing to the English landscape. I think he is the first painter to relate the full discoveries of the twentieth century in France to the English romantic tradition.[14]

By then Vaughan considered he was doing the same thing. However, before considering the full impact of Sutherland's influence on Vaughan's art it is necessary to record a literal change of scene in his life.

In July 1943 he was sent 'spinning up the backbone of England'. He noted in superb little word pictures how the views changed as his train moved north. By now he had developed a knack that any novelist might envy of evoking a scene, or 'hitting off' a person's appearance, in a few apt words. Eventually his squad of conscientious objectors disembarked in Yorkshire and walked out into a new world:

> As we came up the incline from Keithley† the landscape became mysterious and exciting. Village cotages are built in rows like slum houses, not mean but hard and clamped into a hard landscape. They break out from the thinly covered rock

* Sutherland was harassed whilst drawing bomb damage and Piper preferred to paint churches because he was less interfered with by 'spy-conscious constables'. James McBey while sketching by a river in Aberdeen 'had got up from his stool to stretch himself and been arrested for signalling to German submarines' (M. and S. Herries, *The War Artists*, footnote 7, p. 289).
† Keighley?

slopes like vertebrae. They have no individual distinction. Each is the same simple stone cube. At first they suggest rows of village police stations. There is none of the prettiness of the south; no decoration, no trimmings, no striving to be different from each other. The landscape has a tremendous sense of spaciousness. At any point one is standing level with the foundations of one house, and looking down the chimneys of others.[15]

This elemental pared-down landscape is the one which will appear in the mature works, with no prettiness, no trimmings and the cube-like buildings – though the vast scale of Yorkshire's scenery he never attempted to portray.

This posting to the north was in order to establish a prisoner of war camp for captured Germans and Vaughan's duties were to act as clerk and, later, as an interpreter. He continued in both sketch-books and journal to record the landscapes, the towns and the actions of his fellow conscripts and their prisoners. The POW camp now became his art school. His studies of Sutherland broadened his scope so that the notebooks now contained flower studies, roots, shell fragments and buildings on fire, and the boulders he drew somehow acquired faces. These profiles in the rocks were essentially rather literal-minded transcriptions of Sutherland, but whereas the older man could suggest human aggression in two opposed oak trees,

Dale Cottage, Derbyshire (1943), pen, ink, gouache

Seligkeit (1945), pen and black ink with red wash

or a shriek of agony or rage in a blasted trunk, without having to draw eyes, noses and mouths on them, Vaughan was less subtle and the images are consequently less suggestive because we need to bring less of ourselves to them. Sutherland, he noted, had dispensed with the horizon in many of the Pembroke works and had returned landscape painting to its origins, 'to the conception of nature as substance and weight and growth'. He also had a tentative try at Sutherland's colour range, producing a drawing in ink and red wash entitled *Seligkeit* (1945) complete with a bend in a lane and textured rocks. This was a rare use of red, a colour he avoided as too aggressive and emotional until quite late in his career. A drawing of bombed-out moonlit houses must also have had its origin in Sutherland, or Piper, since there were none near his rural barracks to study first-hand. Piper's influence began to appear in such a work as *Hesselton House** which is so textured, black-skied, multi-media'd and arbitrary in its lighting that it could be from the hand of Piper himself. Several other drawings of the country houses in the surrounding dales are in a similar manner.

* Reproduced in *Penguin New Writing*, No. 23, 1945

Through his talks with Sutherland and with the younger Neo-Romantics in London, and through Grigson's articles in *Horizon*, Vaughan's attention was also drawn to Palmer. He began to produce tiny, densely textured landscapes of the Malton area. Sometimes these continue his studies of houses amongst trees, and sometimes he echoes Palmer's *Magic Apple Tree* (1830) in studies of orchards or individual fruit trees – though the mood is less fecund than Palmer's, more Yorkshire than Kent. Besides one of these thumb-nail sketches he reminds himself: 'DO NOT enlarge purely abstract shapes which appear right in miniature.' These works were indeed miniatures, not just in their literal dimensions, but in their conception. The vast skies, fells and moors of his Yorkshire surroundings did not appeal to Vaughan. Like Sutherland, and Palmer too, he needed to create enclosed spaces; houses shielded by trees, figures in front of landscapes rather than distanced and dwarfed by them. Of all the Neo-Romantics only Piper could rise to the challenge of this kind of grandeur and space.

Vaughan's literary and artistic connections with John Lehmann brought him a commission to provide lithographs for an edition of Rimbaud's *Une Saison en Enfer*, with a parallel English text translated by Norman Cameron.[16] These lithos are

Night in the Streets of the City (1943), pen, ink, watercolour

macabre and Fuseli-like in the extreme, as befits the overwrought writing. They are sooty black with, here and there, pale gleams of ochre or blue-grey which reveal agonised figures in hell, or clambering along thin ribbons of track. Apart from the intensity which comes from his own heated imagination he has also borrowed from Blake's *Songs* and Sutherland's illustrations to Francis Quarles and David Gascoyne. In an essay on English illustration he wrote for *Penguin New Writing* he praised both these artists extravagantly, and of Sutherland's lithos for Gascoyne's poems wrote. 'I think it would be no exaggeration to say that nothing so ambitious as this has been attempted in the art of illustration since the time of Blake.'[17] Evidently Rimbaud and his hellish visions meant a lot to Vaughan as he returned to further gouache interpretations of his poetry (and Baudelaire's) towards the end of his life. Whilst admiring the French habit of commissioning artists, rather than illustrators, to decorate their de luxe editions, as Vollard did with Picasso, Bonnard, Rouault, Chagall, Maillol and Derain, he still preferred Blake's and Sutherland's fusion of the two arts into one indissoluble whole on the page – he compares it to the way a song-writer combines words and music. Later, back in 'civvy street', he was to teach illustration both at Camberwell Art College and then, from 1948, at the Central School, but he never received such a congenial challenge again as he did with the poetry of Rimbaud.

Vaughan was demobbed on 16 March 1946, though the ending of the war brought no joy to his melancholy soul. 'Despair,' he wrote the day before, 'as the roots are slowly drawn after five years in the warm earth,' and, he notes, 'Rapid disintegration of personality. Integrity melting like ice in the sun. All poise, stature, crumbling away. Increasing difficulty in maintaining upright position. Automatic disposition to regain the pre-natal crouch.'[18] But now he could move to London and join those friends such as Peter Watson, Minton, Lehmann, Craxton, Colquhoun and MacBryde who had admired his writings and drawings. In 1945 he had exhibited alongside the other Neo-Romantics in a Lefevre Gallery show of 'Young British Artists', and in 1946 had his own first exhibition of paintings at the same gallery. The reviewers rightly pointed out his obvious debts to Sutherland, Moore and Palmer. Vaughan acknowledged these borrowings but it did not worry him since 'in one's early years one does many paintings which are more directly inspired by other paintings than by events in one's life. But this is only because looking at paintings is probably the most vivid experience at that time.'[19] Later he had no doubts at all that 'Art is abstracted from life and not from art.'[20]

In 1947 Vaughan was invited to offer 'A View of English Painting' to the readers of *Penguin New Writing*. This is another of the key texts of the Neo-Romantic movement to be placed alongside Piper's little book on Romantic artists and Ayrton's reviews. Naturally artists sift the past for ideas they can use in their own works in the present, and admire most those artists whose concerns foreshadow their own. Gainsborough, for example, Vaughan admired, especially his *Mr and Mrs Andrews*, where 'neither the figures nor the landscape predominate but each is related to the other in a natural and gracious harmony'. Constable too he thought supreme for his 'immensely solid construction' and his 'absolute cohesion' – a 'power of

organization that is not seen again until Cézanne; more instinctive, more poetic, far less profound'. This growing obsession with the girders and joists of picture construction led Vaughan to take an unexpected and newly unfashionable line on Turner and to agree with Fry that:

... Turner outlived the achievement of his best work, The full and expressive structure of his early landscapes slowly dissolved through his overmastering obsession with light. His forms became more and more abstract without retaining their identity until he could no longer find anything to contain his sensations, and his canvases were steeped in poetic vagueness. In spite of the dramatic excitement of his last Petworth paintings I think there is less real sense of illumination than in a small monochrome by Palmer. With Palmer one feels the light moving round the objects, moving in and out and around and making space for itself amid the solidity. With Turner there is no tension, nothing to oppose the light, objects dissolve in it as in a corroding fluid. Everything is demolished. There remains only so much pigment, like a river that has burst its banks, inundating the canvas.[21]

He has much to say in praise of Blake who, in spite of denying using his eyes to observe mere vegetable Nature, must derive his sinuous, pulsing designs from 'a memory stored with and steeped in the rhythms of nature; rhythms not of any specific forms, not delineating individual differences in things, but affirming the basic unity of all life, uniting the curve of a human figure, the bend of a tree, and the sweep of a line of hills, rhythms that flow like rivers through all created and creative things.'[22] Blake differs fundamentally from Palmer in that area which is beginning to preoccupy Vaughan's interest more and more – in structure. A comparison between the Virgil wood-cuts and Palmer's Shoreham works makes this plain:

Blake for all the intensity and visionary brilliance that he compresses into those minute areas, cares nothing for the structure of his landscapes, or the way things grow. Whereas with Palmer the whole organization is much more complex. The separate identities of things are better preserved. The trees have roots.

Palmer ran out of steam because 'when an imagination nourishes itself too long at the roots of literature it may outgrow the store of its visual experience and run to seed in self-generating romanticism.' As for the Pre-Raphaelites, 'literature had got a stranglehold' and 'only in a country where the traditions of classical painting were completely lacking, could such pathetic travesties have been made in the name of painting.'[23]

Like Piper and Ayrton before him Vaughan tries to define the Englishness of English art. In terms of character he speculates, 'Surely there is a touch of the brilliant amateur in more than one great English artist; the view that takes painting as just one of the good things in life; a refusal to be ridden by one's talents, or to become obsessed with anything.'[24] He notes too that in our richest period the two Cozens, Towne, Rowlandson, Blake, Bewick, Palmer and Cotman, to mention

a few, were engravers, etchers or water-colourists rather than oil-painters. They thus avoided the struggle to grasp three-dimensional spatial composition which oils demand. Without this grasp it is easy to lapse into literary illustration.

> The inability to conceive things spatially and a love of precision and exactness often go hand in hand throughout English painting. Blake expressed it exactly when he said: 'Grandeur of ideas is precision of ideas.' It accounts partly for the tendency to prefer a graphic medium to a plastic one. This tendency is understandable if one keeps in view the fact that to a large extent English painting grew from a tradition that had excelled in manuscript, whereas painting in Europe developed out of architecture and architectural fresco.[25]

Vaughan brings the story up to date with compliments to Picasso for transforming figure-painting, and to Sutherland who is doing to the English landscape what Picasso did to the human figure. He ends with a plea to fellow practitioners and patrons:

> In painting, as in most other civilized activities, we learn much from France, but our roots are not there; and I would plead that we become not over-fascinated with her genius to the neglect of fertile ground nearer home.[26]

In 1946 Minton gave up sharing a house with the Two Roberts and set up home and studios with Vaughan in Hamilton Terrace, St. John's Wood. With Julian Trevelyan the pair of them then exhibited at the Lefevre gallery. Eric Newton, reviewing for *The Sunday Times*, commented on the growing austerity of Vaughan's work: 'Every painting has the inevitability of good counterpoint, but his line is so taut, his colour so bitter that one longs for a touch of sensuousness, even of carelessness that comes with maturity.'[27] The *Times* critic thought it remarkable that he was beginning to use the language of abstraction, yet still managed to cope with depicting labourers at work. The *Evening Standard* merely complained, 'Too much green'.

Minton helped further by obtaining a post for Vaughan as a teacher of illustration at Camberwell, Minton himself having just vacated a similar position to teach at the Central School. Vaughan followed him there in 1948 and from then onwards the exhibitions began to multiply – joint, mixed and one-man, in the Reid and Lefevre Gallery, the Redfern, through the Arts Council, the British Council, to New York, Buenos Aires and Europe. Meanwhile, still in 1946, he had visited the London exhibitions of Picasso, Braque and Matisse and been jolted into new ways of thinking. He now had second thoughts about the over-textured, wriggly-lined, umbrageous Neo-Romanticism which had carried him through the war years. He began to take liberties with anatomy in the way Picasso did, to flatten and stress rhythm and colour for their own sakes in ways reminiscent of Braque and Matisse. His 1947 essay already referred to indicates his loyalty to Palmer, Blake and Sutherland, but also his growing awareness that he needed to go elsewhere to learn about pic-

Figures by a Torn Tree Branch (1946), oil on canvas

torial structure. He began to clear his works of documentary clutter, to stress the pillars and rafters of composition, and now that at last he had space and leisure he began to struggle with oil paint. This was a less fluid and spontaneous medium than his favourite ink or gouache and at first his handling of it was stiff and mechanical. By December 1948 he had completed thirty big oils to show at the Lefevre. 'Unutterably boring,' thought the *Scotsman*: 'Trees are represented by a single branch which might just as easily be a piece of garden hose.'[28] Others applauded the signs that he was now shaking off Sutherland and rediscovering Cézanne in these 'bullet-headed boys in orchards and on the foreshores'. His limited range of cold colours was not liked by people who had had enough of wartime austerity and wanted a bit of sparkle. His palette of dull greens ('boiled spinach', grimaced Eric Newton), ochre, white, black, brown and blue he had derived directly from the cool English landscape, and using this limited range he sought to establish strong, simple shapes held in equilibrium. Not only was he studying Braque and Picasso's still-lifes and the figurative Cubism of painters like de la Fresnaye, but he was reaching further back to those early pioneers of austere structural painting, Giotto, della Francesca and the Florentine School. The voluptuous Venetians, however, with their lolling Venuses, had little to offer him. In a 1949 interview he explained his quest:

I find myself constantly drawn towards objects of the natural world in which conflict is apparent. By conflict I do not mean active violence, but simply a state of tension which results when two different things of different natures are brought together. A figure in a landscape, the natural world and the human world, a man lighting his cigarette from the butt of another's – the essential separateness of individuals momentarily united in a single gesture – these to me are situations of conflict. In painting I seek for reconciliation. I seek a common unit of construction with which, while each individual object retains its essential identity both can be built anew together in order and harmony.[29]

Living now amongst like-minded friends he naturally learned from them too. There are occasions when he slices the picture surface into arbitrary colour divisions in a similar way to Colquhoun, and both share an interest in simplified pairs of figures who fail to communicate across the space between them, as in Vaughan's *Interior with Figures at a Table* (1948) or *Theseus and the Minotaur* (1951). Several of the tipped-up table tops in his interiors show he has learned something too from MacBryde's approach to still-life painting. Minton, his closest friend, must have had some initial influence, but temperamentally Vaughan needed things to be orderly, elemental, stripped down, in a way very different from Minton's urge to decorate forms and tell stories. Because of personalities, too, the gap began to widen, as Vaughan ruefully notes in his journal as early as August 1948:

One of my mistakes during the last two years has been trying to model my behaviour on Johnny – to emulate his debonaire, easy, irresponsibility. As though his success with people in this way could somehow be passed on to me, like an infection. It was always easier to tag along in his wake than to strike out on my own. Now my growing resistance to his way of life (of which I disapprove but also envy) takes the form of making me peevish and morose; and thinking less well of him than he deserves. Since it is impossible for me to live naturally in his ambience I should, of course, pack up and clear out. But what exactly is my way of life? Do the people I would like to know simply not exist – or do they exist but not here – or do they exist here and now and I, through some defect in myself, fail to make contact with them?[30]

These were insecurities which troubled him all his life. Even though success now flowed steadily in his direction he continued to be full of self-disgust, unfulfilled longings for love and deep pessimism about the human race. Friends, who had no access to his private writings, noticed nothing of this darker side though he was obviously less the 'all-licensed fool' in company than Minton; did not care so much for the Fitzrovia dives as the Roberts; and in spite of being equally well-read, had less to say than the loquacious Ayrton. The younger painters, such as Prunella Clough and John Craxton, and the numerous students he taught found him approachable and helpful, and it was evident to all that he was a cultivated, intelligent and attractive man, yet in the secrecy of his journal he agonises over the dull

impression he must make, how his eyes must appear too cold and how his baldness must repel the people he met. It would be unfair to suggest that the published journals are unmitigatedly gloomy : there are witty asides, observations on art, and records of enjoyable excursions and social events, but it is obvious he turned to his diary writing more often when his painting or personal life were not going well. When he was happy and occupied he had no need for his confessional outlet, and this sunnier side of his life went unrecorded. However, as time went by the balance of his life slowly tipped over towards self-doubt and it became easier to find excuses for staying at home, rather than to accept invitations into company and suffer agonies of apprehension and then pangs of regret.

Vaughan continued to have a fondness for forked roads, moons, overhanging branches, dark nooks and blank-windowed houses well into the 1950s, but essentially by the late 1940s he had shaken off most traces of his Neo-Romantic apprenticeship and emerged as a strong artist with his own characteristic subject matter and style. He switched from being basically a graphic artist who solved his problems in drawings and then enlarged these on to canvas to be coloured in, to one who handled oil paint in an increasingly interesting way and who was now more preoccupied by structure than illustration. The fine later works are the ones on which

Landscape with Tree Root (c1945), ink and wash

his reputation deservedly rests, but for our purposes the last twenty years of his career can be covered quite briefly. Male figures remained his foremost preoccupation but these soon lose any particularity, detail drops away and formal preoccupations stifle their original erotic impulse. He drew from the model but painted alone. As he noted himself, 'The trouble has always been that I insist on being in control all the time. I have a fear of spontaneity and mistrust what I probably regard as "accidents".'[31] This is no longer a Romantic writing but an out-and-out Classicist.

Henry Scott Tuke (1858–1929) is the only other English artist of note to be so concerned with the male nude in an open-air setting. Plainly Tuke's bold bare boys larking about by the sea are meant to titillate the spectator and to remind the painter himself of pleasures past. Renoir, who said, 'My concern has always been to paint nudes as if they were splendid fruit' – presumably inciting us to sink our teeth into them – also is supposed to have explained their sexual charge by saying he painted them with his penis. Vaughan has nothing to say on Tuke, but I am sure he would have condemned him since he has this to say of Renoir:

> Renoir: he indulged a purely personal delight which happened to be shared by others. He painted in the same way as one might outline in one's memory recollections and fantasies of pleasure. Because he was utterly unconcerned with any other aspect of painting beyond manufacturing mementoes, his mementoes acquire a compelling power, and he is rated a great painter. But it really is not very difficult to paint this way. No struggle or search is required, no reaching out, no surpassing. Just the caressing brush, over and over again – the same beloved, longed-for forms. And like Brahms, the same lushness, the same apparent profundity and richness which in the end leaves only a feeling of indigestion and a smell of cigar smoke (the F minor piano quartet, but not the songs). It is not enough that he did it supremely well. There must be some quality measured in the ambition.[32]

Now this is a remarkable attack from a man whose journal reveals an overwhelming preoccupation with 'recollections and fantasies of pleasure', and who in his prose manufactured mementoes of all his sexual encounters, and even of his masturbations. The man was privately a self-confessed sensualist, but the public painter was a tight-lipped puritan who shunned any display of passion – all was buttoned down and subdued for purely formal ends. True, a certain preferred physical type emerges with splendid legs, broad back, long arms, deep navel and tiny brainless cannon-ball head, but these youths remain types rather than emerge as individuals. After the chumminess of the Pioneer Corps, portraits do not figure in his *oeuvre* and the interchangeable young men parade before us, their physical power bought at the expense of losing their souls. They stand, stretch, bathe or sit in uncommunicating pairs or groups, their aloof gazes never interlocking with each other, or with us, and their bodies rarely touching. Significantly when Vaughan came to rework many of his earlier canvases he always depersonalised them further, often by painting out the figures' faces. Certainly their stilted encounters are not sexual ones, and

Deposition (1949), ink and wash

even if they were, the figures would be singularly ill-equipped since genitals are usually omitted or suggested by a smudge. The colour range too serves to chill any ardour they, or we, might feel: this is no Mediterranean Arcadia with sun-scorched sands and azure sea, nor is it a spotlit Nazi stadium full of Aryan pin-ups. This greeny-silvery light is English and the water these young men gather beside is often black. No sunlight has bronzed their bodies which remain sallow, their angular limbs the colour of newly peeled twigs. As Vaughan told E. M. Forster, he wanted nothing to do with painting 'come-to-bed nudes'.* Sometimes there is a perfunctory attempt to get them to form a tableau of Cain and Abel, The Prodigal Son, St. Sebastian, or Lazarus, but these are totally without religious feeling and are indistinguishable from other assemblies of figures. They aspire to no meanings beyond themselves. David Thompson summed them up on the occasion of Vaughan's 1962 retrospective exhibition at the Whitechapel Gallery:

Vaughan . . . is outside the whole 'romantic' modern British tradition. His styliza-tions or distortions of the figure are either purely pictorial in origin – they conform,

* Though Vaughan did make homo-erotic drawings for his own pleasure.

that is to say, to some demand of the composition as a whole, such as the lurching rectangularity that often characterizes his design – or else they are emphasizing some aspect of a stance or an action, such as the columnar support given by a leg, the long tense arc of an arm like a strong bow, or the way a bullet-like head turns on a muscular neck. In other words they are formal, not expressionistic or metaphorical distortions. They also tend towards that generalization of statement that distinguishes a classical from a romantic bias. 'Classic art,' as Wölfflin said, 'sacrifices actuality for the essential.'[33]

But Romantic art, as John Piper insisted, 'deals with the particular'.

Whilst Vaughan would not deny this interpretation, which stresses his intellectual, formal preoccupations, he continued to hope his 'Assemblies' retained a human dimension. He wrote:

These compositions rely on the assumption (hard to justify perhaps, but none the less real to me) that the human figure, the nude, is still a valid symbol for the expression of man's aspirations and reactions to the life of his time. No longer incorporated in the church or any codified system of belief the *Assemblies* are deprived of literary significance or illustrative meaning. The participants have not assembled for any particular purpose such as a virgin birth, martyrdom, or inauguration of a new power station. In so far as their activity is aimless and their assembly pointless they might be said to symbolise an age of doubt against an age of faith. But that is not the point. Although the elements are recognisably human their meaning is plastic. They attempt a summary and condensed statement of the relationship between things, expressed through a morphology common to all organic and inorganic matter.[34]

In 1953 Vaughan saw an exhibition of paintings by Nicholas de Staël (1914–55) at Mattiesen's Gallery. This artist was a Russian who had trained in Belgium, worked in Paris, served in the Foreign Legion during the war, and who drifted into abstract painting when he took up work again. By 1951 he had tired of it and tried to bring back into his nudes, still-lifes and landscapes the lessons he had learned from abstraction in combination with his feeling for thick, buttery paint. Vaughan probably saw works where de Staël had palette-knifed his paint on or applied it in thick tessellated slabs. In the last year of his life before he committed suicide de Staël thinned his paint down again whilst still retaining its brilliance, but it was his use of juicy paint which had caught Vaughan's eye. Here was an outlet for his innate sensuality which the puritanical side of his nature would permit him to indulge, nor did he need to sacrifice his concern with the structural organisation of the picture surface. Yet, he reminded himself, he must still start from the observation of nature, from 'felt knowledge or real experience, which is limited to the capacity of the human senses'.

Several of Vaughan's works in his later years may appear to be totally abstract, but they are always traceable back through a series to drawings made before a

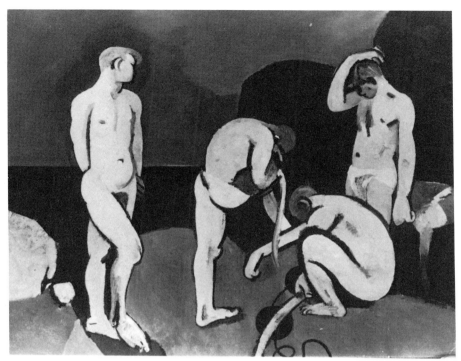

Second Assembly of Figures (1953), oil on board

real model or an actual landscape – they are abstracted *from* nature and not abstract
in their first conception. Total abstraction did not seem a way out of his frequent
impasses to Vaughan, since 'for me painting which has not got a representational
element in it hardly goes beyond the point of design'.[35] More pithily he quotes
Kandinsky's dictum: 'The impact of an acute triangle on a sphere generates as much
emotional impact as the meeting of the figures* of God and Adam in Michelangelo's
Creation,' and comments, 'Not to me, boy.'[36]

Between 1958 and 1962 Vaughan made about fourteen canvases of single figures
facing the spectator, of which *Bather* (1959) is one of the best. In these the land-
scapes behind the nude begin to congeal into tilted rectangles, flat strips, with here
and there boomerang shapes which might have begun as branches or gable-ends
but now only serve formal necessities. The figures break up into patchworks more
slowly but Vaughan reminded himself in notes made whilst painting the *Bather*:
'Necessity for compositional structure to run right through the edges – disregarding
identity of forms – not enough simply to balance shapes within the area. This is
a sublimely obvious fact of which I have only just become conscious in words.'[37]

* Surely Vaughan must have intended to write 'fingers'?

It is as if he had suddenly seen the point of all that wartime camouflage! His old aversion to the red end of the spectrum is now overcome and the canvases bloom in the lushest pinks, purples, peaches and creams. Line disappears, black is banished and these works, it seems to me, are amongst the most sumptuously painted in British art, yet for all their surface gorgeousness they are built on a firm scaffolding. If Neo-Romanticism had been about the inter-relationship of Man and Nature then it could be taken no further than this, where the figure and the landscape fuse, interpenetrate, and there is no longer a boundary line to separate them. The *genius loci* no longer emerges from the trees, but rather the human observer is absorbed by them and conforms to their rhythms and colours.

Vaughan's 1962 retrospective exhibition at the Whitechapel Gallery enabled him to survey his own progress from those autobiographical sketches in the Pioneer Corps, the spooky mansions, the talking stones, the Rimbaud theatricality, and the slow paring away of decoration until he arrived at near-abstraction after his return from Greece in 1960. In the journal he tried to sum up where he had got to by the age of fifty.

> The problem – my problem is to find an image which renders the tactile physical presence of a human being without resorting to the classical techniques of anatomical paraphrase. To create a figure without any special identity (either of number or gender) which is unmistakably human: imaginative without being imaginary. Since it is impossible to conceive a human form apart from its environment, an image must be found which contains the simultaneous presence and interpenetration of each. Hence the closer and closer interlocking bombardment of all the parts, like electrons in an accelerator, until the chance collision, felt rather than seen, when a new image is born.[38]

In the same exhibition were a few landscapes made whilst teaching for six months at Iowa University in 1959. This new flat landscape where 'pink pigs burst out of the black earth like truffles' inspired him to work just as his restless travels around Brittany, Tuscany, Ireland, Cornwall, Spain, Mexico, Greece and North Africa had led to paintings, usually painted back in London from his on-the-spot sketches. On the whole, however, his stay in America seems to have affected his work less radically than his earlier experience of American painting at the Tate Gallery in 1956. We have seen that Abstract Expressionism threw Minton into deep depression and Ayrton attacked it as being even more subversive of our native painting than the School of Paris. Vaughan was also shaken, but he was at the same time impressed and found things within it he could learn from.

When Paul Nash visited America in 1931 he was more interested in meeting James Thurber than any American artist – indeed it is unlikely he had seen the work of any living American painter before he went there. Had he bothered to enquire he would have found them busy with regionalism and politically inspired realism, for the most part derived from European sources. There was no traffic the other way, only a profound ignorance and indifference here about what the

Americans were doing.* When the Germans had entered Paris they discovered that most of the School of Paris had transferred to New York determined to re-create Paris on Hudson. There they were given hero status but somehow failed to make very intimate contacts with the New York artists themselves. In a way the newly opened museums of modern art where European works were on show made more impact than did the presence of the artists themselves – and of course the greatest, Picasso, Braque and Matisse, had been left behind in France. The New York artists, several of whom were immigrants themselves, decided to make their own destinies without any acknowledged leader. Their art was to be non-literary, non-political and non-realist, so they were also rejecting pre-war American values as well as Surrealism and Cubism and the whole European human-ist tradition. Art was to be made in studios and was to be about art. By 1947 Jackson Pollock ('Jack the Dripper') had made dribble paintings and de Kooning, Kline and Francis soon followed into what became known as Action Painting. They eliminated pre-drawing and craft to make large-scale, gestural works which relied a good deal on 'accident' (i.e. how the paint hit the canvas), and their own subjectivity which told them which colour to splash on next and when to stop working and call the work finished.

Formidable critics and publicists took up this group of painters and began to hustle their works throughout America and Europe. At the Venice Biennale of 1948 de Kooning was represented, and in 1950 Arshile Gorky and Jackson Pollock. The ICA showed Pollock's works in London in 1953 in a mixed exhibition and had a one-man show of Mark Tobey's 'white writing' in 1955. However, it was the sixteen works in the final room of the 'Modern Art in the United States' show at the Tate Gallery in 1956 which really brought the Abstract Expressionists to the notice of English artists and critics. Many of these were still looking towards Paris for a lead and were surprised and resentful to be overwhelmed from the rear like this. Others, including a new generation of abstractionists such as Peter Lanyon, Patrick Heron and Roger Hilton who had emerged from St. Ives and had rebelled against Nicholson's hard-edged geometric style, claimed they were well on the way to Abstract Expressionism themselves, and indeed had probably influenced the Americans. No matter whether one loathed or admired this new abstraction, there was no way of ignoring it in the 1950s, and it would not go away.

Vaughan acknowledged his admiration for de Kooning who managed to retain a semblance of a figure in the midst of his slashed and churned-up paint, and for the Canadian-born Philip Guston who influenced his later, more freely handled, works. Like Ayrton, Vaughan had the wit and word power to cut through the hyper-bole surrounding the works, and to take only what he needed from them. He found, for example, the movement's 'romantic, narcissistic self-delusion' that it was expressing the artist's true feelings, an embarrassment. He had little time either for the other branch of the movement represented by Rothko's floating rectangles

* Ten years later when John Rothenstein reported to *Horizon* readers (No. 18, June 1941) on 'Painting in America' he included only one very minor artist who was born in the twentieth century. All the others mentioned were the old regionalists and realists of the 1920s.

of colour or Newman's intense colour fields zipped across by a single stripe. He thought these painters:

> . . . depicted on a magnified scale the simpler human emotions to a society which had lost touch with such things. The tranquil mysterious warmth of a Rothko, the brassy clash of a Kline, the squashy sensuous drip of a Guston came across with the impact and immediacy of a well-designed poster. There after it has nothing more to say. Like a drug it operated on the law of diminishing returns. But since nothing has been required from the spectator in the first place, he cannot complain if he gets little in return.* The futility of the search for the Absolute – symptom of an age without religion which cannot tolerate the anxieties and insecurities of relative and purely human values.[39]

Vaughan seems to be saying here that behind the ballyhoo, Rothko, Newman and the others are engaged in a serious quest for absolutes, or some spiritual bedrock in a world of shifting sands. This was the claim of Robert Rosenblum in his survey of Northern Romanticism from Friedrich to Rothko which we summarised in the introduction to this book. Vaughan differs from Rosenblum in finding they failed to fill the void and only left us more perplexed than ever: ultimately the Abstract Expressionists were false prophets.

> Its main sources were anarchy and a sense of decoration. Its achievement was to show how much could be done with so little. Its failure was that it brought no disciplines, no restrictions which would enable growth. It offered the artist perfect freedom, the kiss of death. It tried to express directly the prime values of painting which, like happiness, are the by-product of a search for something else. Since it had no aesthetic it had to substitute historical or dramatic values – the painting as record of an event, the artist as hero unarmed before his canvas. Such fantasies can appeal only to a society deeply frustrated by having had its spiritual problems transposed into economic ones.[40]

Vaughan's was the voice of sanity and experience in an art world swept by gusts of fashion, but eventually, in spite of his own increasing acclaim within that world, his growing self-doubts began to make his voice less confident. In the same year as the Tate exhibition of American works, Richard Hamilton made the first 'Pop' picture, *Just what is it that makes today's homes so different, so appealing?* and exhibited it in the 'This is Tomorrow' show at the Whitechapel. Asked to define Pop in 1957 Hamilton said it was: 'Popular (designed for mass audience)/Transient (short-term solution)/Expendable (easily forgotten)/Low cost/Mass produced/Young (aimed at youth)/Witty/Sexy/Gimmicky/Glamorous/Big Business.' If this was tomorrow then Keith Vaughan, and any other surviving Neo-Romantic, had no place in it. Soon the Slade students he taught seemed to see the world in a way he could no longer

* Ayrton's criticism, it will be recalled, was that it left *everything* to the spectator who had to impose his own meaning on the works by 'working on himself' in a masturbatory way.

Man with Insect (undated), pen and ink

understand or sympathise with. They were content with the most banal subject matter, had no existential doubts and bashed away at painting with 'a bland, positive, hard-edged assurance'. He began to have the same awful doubts about his own value that Minton had suffered in 1956.

> After all one's thought and search and effort to make some sort of image which would embody the life of our time, it turns out that all that was really significant were toffee wrappers, liquorice allsorts and ton-up motor-bikes. So one could have saved oneself the trouble. I understand how the stranded dinosaurs felt when the hard terrain, which for centuries had demanded from them greater weight and effort, suddenly started to get swampy beneath their feet. Over-armoured and slow-witted they could only subside in frightened bewilderment. One hoped, I suppose, in the end to hand on to someone who saw further, had more talent, more youth, energy, more time before him, to complete what one had started, or relayed from the past. But not this. Perhaps it is the iron curtain between the generations, which one had always heard of but thought to apply only to the past, across which no comparisons are valid.[41]

He still retained some friends amongst the talented young, notably David Hockney and Patrick Procktor, both noticeably less reticent than Vaughan in their depiction of young male nudes. However, from the late 1960s he steadily withdrew into loneliness and inertia, doubting the worth of his own works, his teaching and his very

existence. His mother, now approaching ninety and still demanding his attentions, lived in their old flat in West Hampstead and needed to be visited frequently. Alan Ross tells us also that 'a long-standing homosexual relationship had degenerated over the years into a state of appalling tension and hostility'[42] though Vaughan's partner was set up in a cottage near Ayrton's home in Essex. Though he continued to have admiring and devoted friends who loved his company and wry humour, he loathed mankind at large – 'Christ was a fool. Love mankind indeed. As soon love a nest of ants.' The final decade of the journal shows drink, pills, pornography and self-abuse encroaching more and more on his working hours. Just as Minton hated his own facility in producing more 'Johnny Mintons', Vaughan suspected that now he was merely going through the motions of creating:

> During the day, after the normal clerical and domestic chores, I go through the movements of painting, but without much zest or conviction. My mind easily wanders to other things (usually sexual). This distresses me less than it did. I feel I can and shall paint again when the urge is strong enough.[43]

But the urge never did return because first he had severe kidney trouble, then terminal cancer began to ravage his body and radiotherapy left him more depressed than ever. Looking back to those years when he was a member of the old Fitzrovia gang alongside Minton, Colquhoun, MacBryde and the others, he saw it as a Golden Age: 'For a time there was real life and gaiety. Real things were happening and being done. People were alive. Nothing seemed impossible or too vast to attempt.' The last few years of journal entries make depressing reading as one sees a fine mind toying with trifles, and the most formidable talent of all the younger generation of Neo-Romantics fading away for lack of conviction and application. At the age of sixty-five he, like Minton, took a massive mixture of drugs and alcohol. Ross writes:

> Vaughan's suicide, the journal recording the very taking of the overdose and the last seconds of sensation, could have been interpreted, at any earlier time of his life, as a philosophical decision. There are references to suicide years before illness drove him to it. But coming when it did – after hope of full recovery had finally been abandoned – it was less a way out from despair at an intolerable life than an exit from continued humiliation and pain.[44]

Ten years before his death Vaughan wrote: 'I may be able to say in the end, like Gide's Thesée "J'ai fait mon oeuvre." But I shall not be able to add, alas, "J'ai vécu."'[45]

REFERENCES

1. Vaughan, Keith, *Journal and Drawings 1939–1965* (London, 1966), p. 201.
2. Storr, Anthony, *The Dynamics of Creation* (London, 1972), Chapter 5. p. 50f.
3. Vaughan, Keith, op. cit., p. 32.
4. Ibid., p. 27.
5. Connolly, Cyril, editorial in *Horizon*, No. 5, May 1940, p. 311.
6. Vaughan, Keith, op. cit., p. 76.
7. Ibid., p. 32.
8. Barber, Noël, *Conversations with Painters* (London, 1954), p. 79.
9. All figures and background information from Angus Calder, *The People's War: Britain 1939–1945* (London, 1982).
10. Vaughan, Keith, op. cit., p. 36.
11. Ibid., p. 37.
12. Ibid., p. 38.
13. Hastings, Gerard, 'Neo-Romanticism: its Roots and its Development', unpublished MA thesis (Aberystwyth, 1984) unpaginated.
14. Vaughan, Keith, 'A View of English Painting', *Penguin New Writing*, No. 31, 1947, p. 144.
15. Vaughan, Keith, *Journal and Drawings*, p. 66.
16. Rimbaud, Arthur, *A Season in Hell/Une Saison en Enfer*, trans. Norman Cameron, published by John Lehmann (London, 1949).
17. Vaughan, Keith, 'Some Notes on the Art of Illustration', *Penguin New Writing*, Vol. 22, 1944, p. 159.
18. Vaughan, Keith, *Journal and Drawings*, p. 111.
19. Vaughan, Keith, in *Ark* 28, 1960, quoted by Hastings, op. cit.
20. Vaughan, Keith, Catalogue to retrospective exhibition, March–April 1962, Whitechapel Gallery, London, p. 38.
21. Vaughan, Keith, 'A View of English Painting', *Penguin New Writing*, No. 31, 1947, p. 136.
22. Ibid., p. 138.
23. Ibid., p. 140.
24. Ibid., p. 141.
25. Ibid., p. 143.
26. Ibid., p. 145.
27. The *Sunday Times*, 15 December 1946.
28. The *Scotsman*, 11 December 1948.
29. *Picture Post*, 12 March 1949.
30. Vaughan, Keith, *Journal and Drawings*, p. 113.
31. Ibid., p. 184.
32. Ibid., p. 134.
33. Thomson, David, Catalogue to Keith Vaughan's retrospective exhibition, March–April 1962, Whitechapel Gallery, London, p. 17.

34. Vaughan, Keith, 'Painter's Purpose', in *Studio*, August 1958, p. 53.
35. Barber, Noël, *Conversations with Painters*, p. 80.
36. Vaughan, Keith, Catalogue to retrospective exhibition, p. 41.
37. 'Keith Vaughan: Images of Man, Figurative Paintings 1946–1960' catalogue. Geffrye Museum, London, May–June 1981, p. 49.
38. Vaughan, Keith, *Journal and Drawings*, p. 199.
39. Ibid., p. 190.
40. Ibid., p. 190.,
41. Ibid., p. 198.
42. Ross, Alan, Introduction to 'The Journals of Keith Vaughan 1967–1977', *London Magazine*, Vol. 22, No. 12, March 1983, p. 4.
43. Ibid., p. 20.
44. Ibid., p. 7.
45. Ibid., p. 13.

PRUNELLA CLOUGH

O NE of the friends who continued to break through Keith Vaughan's self-imposed seclusion was Prunella Clough. They first met at the Leicester Galleries in the early 1950s when both were trying to catch up some of the artistic ground lost during the war years. After his death she became one of the executors of his estate. Vaughan, as we have seen, achieved in his mature years a powerful fusion between the figurative and the abstract elements in his works, and managed to combine a rich paint surface with an austere sense of composition. Prunella Clough followed a similar development but pushed it further and faster, so that by the 1970s she had acquired a reputation amongst critics as a totally abstract artist of great delicacy and restrained power. Unlike her friend Vaughan, however, she kept no journals, made few public statements, had few exhibitions, and jealously guarded her privacy which means we are allowed no insights into any inner struggles which might have accompanied this steady unfolding of her art. Her period as a fully figurative Neo-Romantic was a brief one and is not well documented, but it produced some interesting works and it is worth retracing our steps to take up her story.

That story is soon told. In her retrospective exhibition catalogue the biographical notes were pared down to six terse sentences – probably at her own insistence. She was born in 1919 in London. Her father was a Civil Servant at the Board of Trade, though he would rather have been a writer. Her mother's sister was Eileen Gray (1879–1976) the well-known designer of furniture and interiors.* The family background was not, therefore, inimical to the arts. After various private schools in London she went to Chelsea School of Art in 1938 to study sculpture and graphics. She recalls it as a lively place with Moore, Julian Trevelyan, Sutherland and Ceri Richards all coming in to give instruction to the students. This came to a halt when the school was evacuated at the beginning of the war and Prunella Clough had to leave, without taking her diploma, to do war work. This meant a series of office jobs including engineering draughtsmanship for a branch of the American military forces. Oddly enough this establishment was in the basement

* Sutherland bought his house at Menton from Eileen Gray, who had designed it and lived there herself.

Self Portrait (early 1950s), pen and ink

of Selfridge's department store. In the evenings it was easy to make the short journey to Soho where she made friends with Colquhoun and MacBryde, and through them soon met more of the Neo-Romantic gang. This gathering was far from being a nightly occurrence – they were too poor and too serious about their work for that – but they were all living in flats or bed-sitters or, as she was, with parents, where entertaining was difficult, so the pubs offered warm, cheap and companiable havens.

Prunella Clough remembers it as a time of hard drudgery at war work and short-ages of everything, including art materials. Living conditions were austere and often dangerous, but she remembers the optimism of the small artistic community, its youthful ambition and generosity in sharing ideas. Of course there were fewer artistic hopefuls emerging from the colleges before the war and none during it, and those who were still left in London were the men who had been rejected by the Army as physically unfit for active service. The slightly older ones who might have been expected to lead them were dispersed abroad or, like Sutherland and Piper, travelling on behalf of the WAAC.

Prunella Clough's memories of this period reveal, she says, no very clear patterns emerging in art that she was aware of at the time. They had all been taught to revere French paintings and continued to circulate pre-war *Cahiers d'Art* magazines because there were few other publications they could turn to. 'Being English,' she writes, 'there was an enormous time lag, people still getting upset by Cézanne and more or less totally misunderstanding Cubism (as I did).' They were cut off from

Paris and felt their isolation keenly: 'Hence the over-influence of people like Jankel Adler who had actually come from Paris.'[1] Hence also their admiration for Sutherland as an accessible modern whose works were on show and who was willing to chat with several of them about their work and his own. She recalls seeing modern Continental works just before the war began in Lea Jaray's gallery, and at E. L. T. Mesen's London Gallery, the home of the English Surrealists. The post-war Picasso, Matisse and Braque exhibitions she saw, as everybody did, but remembers more clearly the Paul Klee exhibition in 1948. Keith Vaughan reviewed this enthusiastically in *Penguin New Writing* (consulting Jankel Adler to check his facts), admiring the way in which each of these small quiet works 'challenged the logical world with an improbable statement'. He notes it is 'a world of excitement and innocence where monsters terrify but never hurt; where all the parts are changed and small things play important rôles; where all things have the same share of vitality because everything is believed in and nothing is diminished by prejudice or inflated by sentiment.'[2] It is not difficult, with hindsight to see how some of these qualities would appeal to Prunella Clough.*

I have been unable to trace any of the traditional still-lifes Clough was working on during the war years, and it seems unlikely that she completed any very solid paintings in the brief hours available to her after a long day's work and at the weekends. 'What I did was well worth forgetting,' she informed me and we must believe her. That she was doing some work and making advances is evident from the first works which are datable, because these are remarkably confident and certainly not the efforts of a beginner. Her first characteristic range of subject matter was of East Anglian beach scenes. This was not the seaside of day-trippers and fun-fairs which was, anyway, still not re-established after the war when the beaches had been our tank-trapped and barbed-wired first line of defence. Her *Closed Beach* (1945) shows one such beach with its hard spiked forms of iron and concrete set against sand and spray and a distant horizon. *Seascape and Bone* (1945) is even bleaker, showing an animal jawbone placed on a decaying post with, behind it, a cold sea pounding and an overcast sky. On the distant sea line a ship's smoke is blown horizontally. It is a picture full of wind and weather. A third picture of this period in East Anglia is *The White Root* (1946), again with a high sea horizon but this time the sky, sea, and sand only appear in a narrow left-hand margin. The rest of the picture is a still-life of a bleached root set against rough and gritty planking. All three of these pictures are remarkably assured in the handling of paint, subdued colour range, their sudden contrasts of coarse textures with smooth, and their austere vision. They continue the mood and colouring of Paul Nash's *Winter Sea*, though the liking for marine flotsam still-lifes might have been picked up from the works of the semi-Surrealists John Tunnard and Edward Wadsworth, or from Bryan Wynter's Cornwall works of the same period. Nevertheless this is a very personal view which in its chill and spikiness is a world away from Palmer's cosy walled

* The same edition had a reproduction of Clough's oil *Fisherman with Skate* (1946).

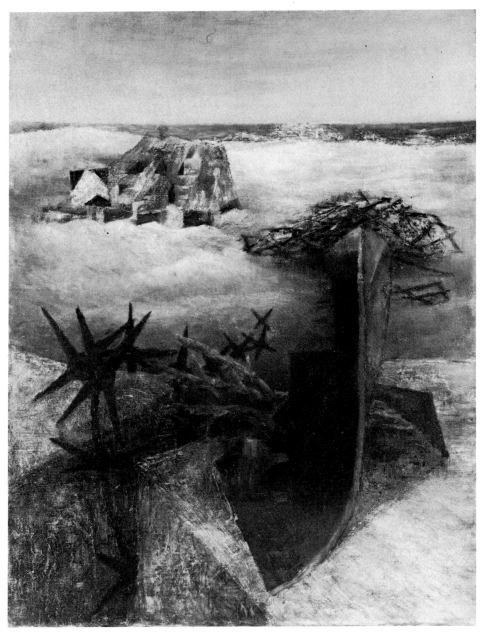

Closed Beach (1945), oil on canvas

The White Root (1946), oil on board

gardens. Even Sutherland's view of Nature as a sinister force was expressed in bright colours, but here the dead iron, bone and root are stark black, grey and white.

When people are included in these early works the view is still detached, but now Colquhoun seems a closer influence. There is the same flattened-out, post-Cubist treatment of objects and figures, though the sombre range of colours remains her own. *Fisherman in a Boat* (1949) might serve as our example here. Edges rather than volumes are stressed and the generalised figures interlock closely with baskets, boats, jetties and dockside litter. Though the forms are tilted up and simplified and there is no attempt at aerial perspective, the objects do seem to overlap and diminish towards the typically high horizon. Through her friend Colquhoun she had been led to admire the hard-edged unsentimental works of Wyndham Lewis, and it is not too far-fetched to see inklings of his tough discipline in this and subsequent works. Whereas the sea-shore pictures had been full of textural interest she is now more concerned with flat patches with clearly defined edges in the Colquhoun manner, and with arranging these into a rhythmic vertical design.

From the sea-shore and the fishing fleets of Lowestoft and Yarmouth she made her way back to the London docklands where Ayrton and Minton were also exploring. From there she journeyed on to the unlovely industrial suburbs of London and the Midlands. This seemingly unpromising sprawl of gasworks, power stations, wharfs, chemical factories, cooling towers, slag heaps, scrap-yards and bypasses she made her own. There were no competitors. Many painters from Constable and Palmer onwards had shown rural labourers in their everyday tasks, and there were many Victorian pictures of workers in the newly emerging heavy industries. More recently Moore and Sutherland had shown miners burrowing under the land, and Vaughan and Sutherland depicted quarrymen hacking its surface, but few artists had ever considered urban light industry as a fit subject for their attention. Even on trips to see her friends Bryan Wynter, Patrick Heron and David Hougton in the now thriving St. Ives art colony, Prunella Clough drew the tin-mines rather than the more obviously attractive coastline, moors, ports or tors of Cornwall. The lushness of Minton's Surrey picnics or Piper's spotlit mansions, or Ayrton's Grand Guignol obviously held no attractions for her pictorially. Only Sutherland's wartime factory sketches foreshadow her treatment of the industrial scene, but the older painter's works are full of flames, writhing girders and flickering colours compared to her static machines and immobile workers. Colquhoun's dead-pan depictions of women weaving army cloth come nearest to her in mood and style.

The titles Prunella Clough gave her works during the 1950s, such as *Lorry Drivers*, *Manhole*, *Road by Gasworks*, *Factory Interior*, *Wharfs*, *Yard with Scrap Metal*, *Coke Yard*, *Scrap in Yard* and *Bypass*, may suggest that she was blazing the trail for the 'Kitchen Sink' realism of Bratby, Smith, Middleditch and Greaves, or that she had some Social Realist programme to follow. Nothing could be further from the truth. Here there is no pity, no indignation, no patronising, no politicising, no sentimentalising and no preaching.

Most Britons are city-dwellers, and all our major cities are ringed by sour blighted landscapes where people manufacture goods. This, after all, is where our wealth,

Dead Bird (1945), oil on canvas

Fishermen in a Boat (1949), oil on canvas

energy supplies and material comforts come from, though we have trained our eyes not to see these factories, goods yards and warehouses. We only begin to look with interest again when we are transported into the green country beyond them. Somehow the Romantics have persuaded us that the city with its squalor corrupts us, whilst the beauty of trees, fields, rivers and hamlets uplifts us and heals us. Ask English people to define Beauty, and like as not they will begin to describe a green English landscape, or, failing that, a garden. Prunella Clough is tougher-minded and does not believe this comforting myth: she has stepped in close to examine the coking plant and the scrap-merchant's yard and found in them an unexpected poetry. The people in her industrial works are integrated into the pictures' structures making them no less, but no more, interesting than the fan heater, pile of swarf or coiled wire they stand beside. Their individuality is subordinated to formal ends, just as Vaughan's nudes in their landscapes were.

One of the few public statements wrung from this private woman is this one made when she was twenty-eight:

> Each painting is an exploration in unknown country, or as Manet said, it is like throwing oneself into the sea to learn to swim.
>
> Anything that the eye or the mind's eye sees with intensity and excitement will do for a start; a gasometer is as good as a garden, probably better; one paints what one knows.
>
> To record this experience the original experience must be reconstructed; it grows as a crystal or a tree grows, with its own logic. Drawings work out the idea in many ways, slowly feeling towards clarity and order; stone or wood, oil paint or watercolour, these have the last word.
>
> Whatever the theme, it is the nature and structure of an object – that and seeing it as if it were strange and unfamiliar, which is my chief concern.[3]

Reading this makes one regret that she did not write more and offer further insights into her art as it developed in new directions. Here we can note the balance between the initial warm emotion ('intensity and excitement') and the cool intellectual control ('reconstruct', 'logic', 'clarity and order'), yet she allows the nature of the medium to help shape the final vision of something 'strange and unfamiliar' – an echo of Surrealism, or at least of Nash and Sutherland's versions of it.

Prunella Clough's works moved inexorably towards abstraction, though for a long time they retained their brutal realist titles, *Lorry and Cranes, Man with Blowlamp* and so on. Each work has a starting point in observed reality, whether the bend in a heating pipe, a rusty sheet of metal or the complex silhouette of a machine whose function we shall never know. 'The titles provide the spectator with just enough clue to enable his contemplation to range back in the direction of that same starting point where the painter's own contemplation began,' as Michael Middleton pointed out. 'They serve to measure the degree of daring of the visual metaphor employed, and to establish a tension between concept and image without which the latter would appear flabby and inert.'[4]

Nocturnal Landscape (1946), watercolour

At her major retrospective exhibition at the Whitechapel Gallery in 1960 the critics were approving but rather baffled. Her last solo exhibition had been at the Leicester Gallery in 1953, and before that there had been only those at the Roland Browse and Delbanco Gallery (1949) and the Leger Gallery (1947), though her work appeared frequently in mixed shows in the West End. Clough now seemed to surprise people by how far on she had moved from those early landscape and fishermen pictures. She had never been easy with the Neo-Romantic label ('Who are the classicists we were being Neo-Romantic against?' she asks) and now she had emerged as a cool formalist, more classical than Romantic in her search for a quiet order even when painting fragments of industrial muddle. Reviews were full of words like 'subtle', 'unflamboyant', 'perfectionist', 'calmness and rationality', 'refined', but also 'uningratiating', 'dry elegance', 'hermetic', 'formalist', 'narrow' and 'inhuman'. Eric Newton, one of the respected older critics, whilst generally sympathetic seemed to miss any passion: 'She has produced a rather inhuman world, cold, calculated in its design, exquisite in its narrow range of colour, but never abstract – always a description of an object – and sometimes the objects are human beings though their humanity is the last quality that strikes me.'[5] John Russell of *The Sunday Times* summed the exhibition up for most reviewers when

he wrote: 'This intelligent, unemphatic, ruminative, solitary and authentic artist emerges much enhanced from the ordeal of a large-scale display.'[6] Other writers unkindly pointed out that she had survived the Whitechapel retrospective test much better than the brasher, wider-ranging Ayrton had in 1955.

Clough, like Keith Vaughan, had always favoured a narrow colour range even in the early still-lifes of dead birds and jawbones on breakwaters, or the paintings of fishermen unloading their catches. The reviewers commented at length on this restraint, though several note that, if you let them, colours did emerge in rich gleams from the general drabness of greys, browns, smoky blues, earthy yellows and off-whites. There was evidently a strong controlling intelligence infusing these works and here and there came hints that this was surely a bit, well, unexpected, in a *woman* artist. The *Tatler* reviewer had to go to these lengths to excuse their lack of prettiness and to reassure her readers:

> On the face of it this may seem a curious world for a woman and Miss Clough's palette of sober colours and low tones does nothing to dispel this feeling. But her intimate approach to her subjects and her detachment from their mechanical functions are feminine. So, too, it might be argued, is the way in which she paints men whose identities are submerged in their machines or inseparable from the rubbish they create.[7]

The best analysis of her work of this period, it seems to me, remains that of Michael Middleton. He points out the early links with Sutherland and Colquhoun and Lewis, and the later lessons learned from Dubuffet's figures, Roger Hilton's 'uncouth shapes', Mondrian's early pictures of trees, Max Ernst's 'world of petrified vegeta-tion', and the release offered from her tendency to over-deliberation by the infor-mality of Abstract Expressionism. Yet such trace elements in her work are of little importance, 'for never was anyone less in the grip of the fashion neurosis'. Her vision is consistently her own and by now can be clearly identified:

> Certain visual themes and images recur again and again. She likes seeing *through* things: glass, for example, and nets and space frames of one kind and another. There is an early *Greenhouse* to be seen here, a later series of landscapes through a window; the early fishermen's nets find their equivalent in last year's wirescapes. She likes the sudden intrusion of something hard, and usually rect-angular, into softer areas of indeterminacy. She is fascinated by the conjunction of sky and land, or sky and man-made object on the land. All her work has a considered, static, quality. It might almost be said that she turns everything into still-life. Movement occurs but it is generally no more than the pattern of small-scale movement within a larger, static container: the flutter of birds, a waterfall of fish, the convolutions of barbed wire in a lumpish heap, the surface swirl and belch of liquid in a vat. This enlivening of the flat surface of a shape with a flicker of textural intricacy is one of her most characteristic tricks. Her figures, when they occur, loom heavily and motionless. Man she sees as cast into anonymity

Lowestoft Harbour (1951), oil on canvas

by an identification with his labour or his surroundings so great that it is not always easy at first to disentangle him: his feelings, skills, memories have been subordinated to his existence as a statistic, a producer of man-hours, a figure in a cloud of steam, the instrument and product of a pattern of society too complex for the old humanities.[8]

With typical modesty and acumen Prunella Clough summarises her own work up to this time by saying, 'I like paintings that say a small thing edgily.' Paul Klee might have said the same.

There was never any likelihood that Prunella Clough could be interested in recreating Palmer's cosy Eden, or Blake's mystical visions full of sweeping nudes and histrionic gestures, or Turner's apocalyptic wars of the elements. Hers was a still, small voice. Nor did she choose to follow her friends along the well-trodden paths of English Pastoralism which led to the overgrown ruins, or upwards to the picturesque viewpoint. In a way their task was too easy. After nearly 200 years of Romanticism every sunset, mountain, laden apple tree, harvest moon, calm or stormy sea, and crumbling castle is already half-symbolic. The *frisson* as we recognise each of these as somehow *significant* is already there as we stand before them in reality – indeed we seek them out for this very reason – and the artist's task is only to preserve this and, if possible, enhance it, or give it a new twist. The Neo-Romantics were able to exploit a way of seeing the world that their audience already shared with them.

Prunella Clough took a workmen's bus out to the sodium-lit factories. Here was a new subject matter which usually evokes revulsion, indifference or guilt for its man-made ugliness. There were no green thoughts in a green shade here because there was no grass and no trees. The *genius loci* had long since fled and money was king. But, as Philip Larkin said of his own art:

I think a poet should be judged by what he does with his subjects, not by what his subjects are . . . Poetry isn't a kind of paint spray you use to cover selected subjects with. A good poem about failure is a success.[9]

Prunella Clough's paintings wrest poetry from what had previously been unloved and neglected, and in selecting such subjects she must have felt both a greater challenge than her contemporaries in having to bend them to her purposes, and a greater freedom in making them her own. Walter Sickert claimed that 'the artist is he who can take a flint and wring out attar of roses', and in extending our idea of the beautiful Prunella Clough has done just that.

Eventually the people disappeared from her works and soon it was more and more difficult for the spectator to deduce the original starting point of each work. Her titles now directed the spectator's attention to events on the canvas surface rather than to situations in the world outside, so we find *Grey Quadrant* (1968–73), *Oblique* (1973), *Black Edge* (1974), *Red Cycle* (1975), and so on. The first painting she remembers which was totally unrelated to specific sources was called *Double*

Industrial Plant II (1956), oil on canvas

Diamond (1973). They appeared new-minted and unpredictable – she was still as pluckily throwing herself into the sea in order to learn to swim as she had done at twenty-eight, and continues to do so today. Colquhoun had been unable to follow the implications of his way of painting into complete abstraction, consequently the humanity drained out of his figurative works as he sliced and shuffled them, trying desperately to preserve a recognisable image whilst his mind was more on formal problems. Clough made the transition to abstraction before her people were reduced to ciphers, and the release this gave her has been triumphantly justified in the works she has produced since. Now, if she feels the necessity, she can use a full-blooded colour range, or she can insert a random texture, a shape flirting with the very edge of the canvas, or a sudden gestural violence. When her friends left England in the 1950s for more exotic landscapes than the English with blue seas, palm trees, well-covered tables and sunlight spread as thick as butter, she stayed at home in Fulham. There was no attempt to diversify into ballet design, or posters, or stained glass, or illustration, or collecting trusteeships, only a steady concentration on the work on the easel, or on graphics. She taught at her own old college, Chelsea, and later at Wimbledon. She travelled little abroad but, gradually, her works did and

she acquired a solid reputation amongst those whose opinion she valued. By staying true to her own rather narrow, rather austere vision she has now emerged as a classicist in the way Dégas meant when he said, 'A classicist is a romantic who has arrived.'

REFERENCES

1. Letter to author, 11 May 1986.
2. Vaughan, Keith, 'Paul Klee', *Penguin New Writing*, No. 34, 1948, p. 117.
3. Clough, Prunella, *Picture Post*, Vol. 42, No. 11, 12 March 1949.
4. Middleton, Michael, Introduction to 'Prunella Clough', catalogue to retrospective exhibition, Whitechapel Art Gallery, 1960, p. 10.
5. Newton, Eric, *Guardian*, 21 September 1960.
6. Russell, John, *Sunday Times*, 25 September 1960.
7. *Tatler*, 12 October, 1960.
8. Middleton, Michael, op. cit., p. 9.
9. Larkin, Philip, *Required Writing* (London, 1983), p. 74.

JOHN CRAXTON

JOHN CRAXTON and Lucian Freud were both born in 1922, the former in London and the latter in Berlin. This made them the youngest artists associated with the Neo-Romantic movement and during their formative years both received much fatherly advice from Graham Sutherland, patronage from Peter Watson, Cyril Connolly, John Lehmann and other influential style-makers, and more dubiously, fraternal guidance round the dives of Fitzrovia by Colquhoun, MacBryde and Francis Bacon. Their most impressionable years were the wartime ones when European, particularly Parisian, ideas were cut off and the London galleries full of the works of those artists we have described in this book. This gave them the advantage of a coherent viewpoint to begin with and, in the person of Sutherland, an older artist to admire who seemed to combine the best aspects of European modernism and traditional English virtues. Furthermore, Sutherland seemed willing, even anxious, to assume the role of leader and to make himself available to younger artists. Later, when they had both found their own very different subject matter and styles, Neo-Romanticism would be something to rebel against and kick away, so that Craxton could look back on those war-years as a claustrophobic period of his life, and Freud could deny ever having been a Neo-Romantic, even by association.

Craxton's father, Harold, was a distinguished musicologist, accompanist and Professor of Pianoforte at the Royal College of Music from 1919 to 1960. His mother, the daughter of an art publisher, was also a violinist, and his sister Janet a renowned oboist. It is not surprising, therefore, that music, especially twentieth-century music, was to inspire Craxton and later bring him commissions for ballet décor and costumes. It was obviously a very supportive background from which to embark upon an artistic career. Even his schooling was propitious as his art mistress at Betteshanger preparatory school was a close friend of Frances Hodgkins and passed on the message that art was both a serious and a marvellous pursuit; to reinforce this the pupils were taken on painting expeditions all round Kent. The boys even had an exhibition in 1932 at the Bloomsbury Gallery officially opened by Professor Tonks from the Slade, so Craxton effortlessly broke through into the London art world at the age of eleven. Later he followed Ayrton through Abingdon School

Portrait of Lucian Freud (c1945–6), pencil

and spent some of his vacations with the son of Eric Kennington, one of the great realist war artists, active, like Paul Nash, in both wars. Another holiday was spent with his boy-scout troop in Paris where he seems to have found time to view Picasso's *Guernica*, Calder's mobiles and Miró's *The Reaper*, as well as some of the French Neo-Romantics.

The first mild set-back to this charmed and privileged life came in 1938 when Chelsea Art School, and several others, refused him entry because he was too young to draw naked ladies. He returned to Paris, therefore, to draw from life at La Grande Chaumière (where a model was provided but no tuition), to reconnoitre the museums and to admire the glass of La Sainte-Chapelle. Back in London the gallery tours continued until, on the walls of the Lefevre Gallery, he encountered Sutherland's Pembroke water-colours and fell in love with them. Unbeknown to him several were bought by Peter Watson, a man who was later to have a considerable influence on his career. Eventually Craxton was old enough to see nude figures in an English college and he began to attend classes at both Westminster Art School and the Central School, but war began, classes were curtailed, and in spring 1942 the Craxton family home in St. John's Wood was made uninhabitable by a 2,000-pound bomb in the next-door garden which smashed all the drains. The parents, six children and two grand pianos were now packed into one small flat, so that an offer from their family acquaintance Peter Watson to pay for a studio in nearby Abercorn Place was gladly accepted by Craxton. Lucian Freud, another beneficiary

Self Portrait (1943), oil on canvas

of Watson's generosity, was working alone in Stephen Spender's empty flat nearby and so was invited to share with Craxton the two available floors of a large Regency house.*

When Craxton and Freud first met Freud had already achieved some fame in artistic circles by following Moore and Sutherland as the third artist to be reproduced in *Horizon* (April 1940). The chosen work was an unremarkable pen-and-ink self-portrait of the seventeen-year-old. He had gone on to make crude but recognisable portraits of the magazine's two literary editors, Cyril Connolly and Stephen Spender.

* Studios were not difficult to find after the savage bombing of 1941. Many houses were deserted or to let as the population fled. By June 1943 London had lost 24 per cent of its pre-war population.

To these patrons and their friends, John Russell tells us, Freud seemed 'Like Tadzio in *Death in Venice*, . . . the magnetic adolescent who seemed by his very presence not only to symbolize creativity but to hold the plague at bay'.[2] Looking at the childish, technically inept works he was producing then one finds it difficult to see why they should have had this confidence, though of course in the long run they have been proved triumphantly right.

Craxton now had a flat-mate, beautiful to look at, Russell tells us, but 'fly, perceptive, lithe, with a hint of menace'. He had been raised in the cultured middle-class Freud family, but had also enjoyed the anarchic street life of Berlin during the first ten years of his life. Had he but known it his future friend Francis Bacon was also sampling Berlin's more grown-up pleasures around the same period and soon after came Auden, Isherwood, Spender, Lehmann and the young Keith Vaughan. There is no evidence that the schoolboy Freud showed any precocious interest in the art around him in Berlin, but curiously the style in vogue there in the late 1920s, *Neue Sachlichkeit*, especially that of Christian Schad (1894–1982) foreshadowed several features of his own first mature works: both have a disturbing sexuality, a relentless analysis of the appearance of things and people, an impatience with metaphysics or symbolism, and a coldly detailed style achieved with small brushes and an immaculate finish.

Freud's architect father brought the family to England in 1932 to escape Germany's rising inflation, unemployment, the drift towards Fascism in politics, and the mounting pressures on Jewish intellectuals. After various schools, including the progressive private one of Dartington, Freud spent some time in 1939 learning painting from Sir Cedric Morris (1889–1981) at his East Anglian School of Painting in Dedham, Suffolk. Morris was Paris-trained and worked under Léger and Friesz, and on his return to England came to know Ben Nicholson, Christopher Wood and Frances Hodgkins with whom he exhibited in the 7 & 5 Society. It was probably these credentials, rather than the opportunity to work on Constable's and Gainsborough's home pastures, which attracted Freud to Morris's studios. He next spent five months as a seaman aboard a merchant ship, the SS *Baltrover*, on the dangerous Atlantic run and then, having been invalided out of further service, settled down to make himself into an artist by sheer will-power. The Freud family name and connections meant that London's intelligentsia took a close interest in his progress. 'Everything was expected of him', John Russell recalled. 'Opinion was divided as to whether he would have a career comparable to that of the young Rimbaud, or whether he would turn out to be one of the doomed youths who cross the firmament of British art like rockets soon to be spent.'[3]

Craxton was also exempt from military service because of pleurisy, so apart from minor irritations such as nightly bombing, blackouts and rationing they had no more distractions from following apprenticeships in their chosen career. Peter Watson supplied the joint studio, some of the funds, connections with patrons, and introductions to Graham Sutherland. The older artist pulled strings to get them into life-classes at Goldsmiths College, but this institution was rather depleted by the war so that, apart from occasional visits by Paul Drury, they did not encounter

Hare in Larder (1943), conté crayon

the Palmeresque etchers who had worked there with Sutherland in the 1920s. Other family links led Craxton to Oxford literary circles where he met Lord David Cecil and Vaughan's friend Neville Coghill who gave him a book on Blake to whet his appetite for that artist's works. He also knew Paul Nash there and had earlier seen him at work on *Totes Meer.* No two young artists had ever begun with so much support and such direct access to the taste-makers of the day.

The works they produced in Abercorn Place have been exhibited recently, alongside the juvenilia of Minton and Ayrton.* So closely were Craxton and Freud working then that the two artists are themselves in dispute as to who did certain drawings. Most works on show were small drawings, often in shared sketch-books or on envelopes, and reveal them experimenting in line and occasionally using a careful speckle of dots for shading. Sometimes Craxton attempted to model still-lifes in heavily cross-hatched ink shading. Both were delaying the encounter with colour until they had mastered line. Apart from drawing each other, friends and spiky plants they shared an enthusiasm for dead animals which they obtained from local butchers, a pet shop and a veterinary surgeon's. Hares, geese, chickens, a heron, a stuffed zebra head and a shaggy bison were amongst their 'pet' subjects. Some

* Christopher Hull Gallery, London, 1984.

were eaten, and others such as a decomposing monkey continued to pose long after they were pleasant to have around. Are those actually maggots amongst the breast-feathers of Freud's *Chicken in a Bucket* (1944)? Like the young Ayrton and Minton they experimented with surreal games and Picasso double-profiles, but Freud's *Homage to Sutherland* (1943) and Craxton's *Study for Entrance to a Lane* (1944) clearly acknowledge that the strongest influence was much nearer home.

Craxton was at this stage a more talented and fluent draughtsman producing, for example, immaculately observed textures and contours in his conté studies of a goose, and his drawing of a dead hare comes near to rivalling Dürer's famous water-colour in the tactility of its fur – though Craxton's is very dead indeed. This use of conté on tinted paper became a favourite medium with Craxton, but Freud took it over – and some of Craxton's careful rendering of surfaces – in a later (1948) portrayal of the whiskery jowls and towelling robe of the French Neo-Romantic painter and stage designer Christian Bérard. Both young men were doing these exercises in order to train themselves to look and to record, but already during the period they shared studios (1942–4) Craxton was pushing on further from the set-pieces in front of him into more poetic realms. He produced drawings with titles such as *Fisherman with Boat and Moon, Sleeping Figure with Rocks* and *Man in Moon in Tree* which bore no relationship to life in St. John's Wood. Having mastered the realistic recording of *nature morte* he now needed to depict what was alive inside himself. Freud, however, stayed prosaic and earthbound, struggling and hacking away with his crude line at the people and objects before him, staring at them with a frightening intensity.

The two young men seemed to have all doors open to them and to be positively petted by their elders. Craxton recalls Piper, Moore, Sutherland and Kenneth Clark all dropping into their studios to encourage them. Amongst the refugees from Europe they met Jankel Adler, Geza Szobell, Kurt Schwitters and several others at the Surrealist dinners at the Casa Pepé. Craxton was also on visiting terms with Roland Penrose and his American photographer wife Lee Miller, whilst Freud later briefly joined the Cecil Beaton set. Their most consistent support, however, came from Peter Watson, and since he gave the same bountiful help to all the Neo-Romantic painters he deserves mention at some length in a book on their work.

Since Renaissance times artists had depended for much of their patronage on a small, privileged and wealthy minority of the population who had a high level of taste, or at least knew how to get good advice on what to buy. This continued to be the case in England between the wars and even afterwards when Sir Osbert Sitwell would commission works from Piper, or the shipping magnate Sir Colin Anderson would buy Colquhoun's work and that of several others of the group. In America too wealthy patrons such as Peggy Guggenheim and Katherine Dreier did much to swing fashionable opinions towards modern painting by assembling seminal collections. During the war years a feeling grew up in some quarters that after the war, in a more egalitarian society, patronage should not depend on the inherited wealth of the favoured few. With the formation of the WAAC, then the Arts Council and the British Council, the State became increasingly important as

Bird Among Rocks (1942), pen, ink, brush

a purchaser of works and the maker of reputations. Later the Festival of Britain committee distributed important commissions to most of the artists we have mentioned, and the Church reappeared as an important sponsor when Piper was asked to provide windows and Sutherland the world's biggest tapestry for Coventry Cathedral. Later still business corporations purchased works of art for prestige or tax or charitable purposes. In an age when art began increasingly to rely on patronage like this Peter Watson appeared something of an anachronism. He was a wealthy man (his father had invested in margarine) and he was an avid buyer of art, but more importantly he brought like-minded people together, provided encouragement, and with the younger artists filled in those gaps in their knowledge of music, literature and art which their war-interrupted educations had left.

Watson was born in 1908 which made him nearer in age to Sutherland and Piper than to Colquhoun, MacBryde, Vaughan, Craxton, Minton and Freud who all looked up to him. After being sent down from Oxford he went to study in Munich and for a time seems to have joined the Art-Smart set as just another languid homosexual playboy drifting round Europe. He inspired the love of many men including the conductor Igor Markevitch and the photographer Cecil Beaton who pursued him despairingly for nine years.[4] Nevertheless he was learning steadily about art during his travels in the 1930s and getting to know Giacometti, Dali, de Chirico, Klee, Rouault, Miró, Braque and Picasso, often buying works direct from their studios. At Beaton's request he sat for a portrait by Tchelitchew, but otherwise seems not to have been very impressed by the Parisian Neo-Romantics. When the war came his wonderful collection was left behind in Paris and subsequently sold off piecemeal by a lover who had been left in charge of it. Unabashed by this, Watson returned to London to work in Zwemmer's bookshop and gallery in Charing Cross Road and steadily began to accumulate a new collection, though this time with a stronger English flavour. He was an early and enthusiastic collector of Sutherland, owning at one time *Gorse on a Sea Wall* and *Entrance to a Lane*. When Craxton admired *Steep Road* on Watson's wall he promptly took it down and gave it to Craxton. He was evidently a man of astonishing generosity when it came to encouraging art and literature. He funded *Horizon* from January 1940 to its close in January 1950, subsidising Connolly's extravagance and incurring heavy losses in order to keep ideas fermenting and the connections to European art and literature open. In 1947 he jointly founded the Institute for Contemporary Art (ICA) with another rich and cultivated man, Roland Penrose, and Herbert Read, all three of them anxious to promote French ideas of modernism in England. Many individual writers such as Dylan Thomas and David Gascoyne benefited from his creative use of money and everyone seems to have regarded his flat in Palace Gate as a little haven of Parisian chic during the bleak war years. There they would go to listen to his records of Stravinsky, Webern and Berg, or to hear him chat about literature, or to borrow his volumes of Kafka or Rimbaud or Baudelaire. There too were pre-war copies of *Revue Blanche, Minotaure, Verve* and, best of all, *Cahiers d'Art*, first published in January 1926, in Paris, but with the declared intention of being 'the avant-garde review in all countries'. Geoffrey Grigson recalled it '. . . unlocked and lavishly

Poet in a Landscape (1941), pen and wash

exhibited secret gardens of world art, at a time when the English elect, convention-
ally, were held to be Augustus John and Dame Laura Knight. *Cahiers d'Art* was
the great eye-opener; it was divine visual food for those so long on a dull diet.'⁵
On Watson's walls were works by Miró, Picasso, de Chirico and Roger de la Fresnaye
and a constantly growing display of works by his friends such as Christopher Wood,
Piper, Sutherland, Frances Hodgkins, Minton and all the other young artists who
came to his Aladdin's Cave. The talk was part of the attraction too. In 1985 Craxton
was still recalling fragments of it:

> Perhaps I *am* a romantic and romantic painters make pictures as extensions of
> themselves; they cannot be accused of being objective. I think nostalgia can be
> a motivating force. A pure classical painting *is* objective and nothing is left to
> accident. Peter Watson and I argued all this out years ago, and agreed that classi-
> cism and romanticism were not opposing forces but two facets of the same thing,
> like hot and cold water.⁶

In 1941 Craxton produced two pen and wash drawings entitled *Poet in a Land-
scape** and *Dreamer in a Landscape* which Watson reproduced in *Horizon*,⁷ and Suther-

* Once owned by Peter Watson, but now in the Tate Gallery.

land praised by saying to the artist, 'I wish I'd been able to do something like that when I was your age.' They are significant works in his development and they alone would justify our inclusion of Craxton within the Neo-Romantic group. Samuel Palmer had made a sepia and gum drawing of a man reading in a tranquil country setting, *The Valley Thick with Corn* (1825)*, which had been reproduced together with *Early Morning* (1825) as illustrations to Geoffrey Grigson's article on Palmer in *Horizon*.[8] Craxton had been shown these Palmer reproductions, and others, by Watson before they were published and had been enthused by Palmer's dense overall working of the picture surface and the charged atmosphere of his visions. Craxton adopted the rapt figure of the reading poet, but round him Nature rages and boils in a way Palmer never would have attempted. Craxton describes the work:

> There are these garlic or onion plants and various other pieces of vegetation. Tree roots crash through the undergrowth – it was an amalgam of things. It was certainly a self-portrait although it was posed by my sister. It was a portrait of someone who had detached himself from a wild landscape. He is sitting there calm, totally calm, reading a book. I had painted myself in a landscape which was very wild, stormy, full of terror and fear.[9]

* See page 17.

Dreamer in a Landscape (1942), ink, chalk on paper laid on board

The menace of the clawing branches, the nightmare thorns which pierce through the fleshy leaves and the heavy use of black are taken directly, and unashamedly, from Sutherland, and the densely textural lines from Samuel Palmer, but he is using these sources to say something about himself and his own predicament as a young man growing up in a world torn by war. Several other drawings of the period continue to explore single figures in a spiky landscape, though Craxton somehow came to see these malignant plants as offering solace after the bombs of the city – deep down these are war drawings:

> Between 1941 and 1945, before I went to Greece, I drew and occasionally painted many pictures of landscapes with shepherds or poets or single figures. The landscapes were entirely imaginary; the shepherds were also invented – I had never seen a shepherd – but in addition to being projections of myself they derived from Blake and Palmer. They were my means of escape and a sort of self-protection. A shepherd is a lone figure, and so is a poet. I wanted to safeguard a world of private mystery, and I was drawn to the idea of bucolic calm as a kind of refuge.[10]

In these works he has moved beyond his apprentice struggles to record exact appearances and textures towards deriving art from his own fantasies and his studies of other artists. The plant forms in his works now swarm with jungle fecundity, develop conical branches or leaves like sickles, and instead of Palmer's top-heavy wheat, things like skittles or knife-blades pierce through the earth. He told Grigson, 'It is not the leaves in Palmer I like but the leafy *ness*, that essence of leaf that presses against my senses. Take away the poetry and you're left with Pre-Raphaelism at its dullest.'[11] In the catalogue to a 1985 exhibition he looked back to those early works to comment:

> I think you have to look at what I did, to see the influence: Palmer took the essence of something and paraphrased it so that one had a poetic image of it. It was a distillation of nature, and I suppose that I wanted that clarity of purpose. You might say my work is 'escapist' art and, somehow, it became an antidote to the war in the same way that Palmer's was an antidote to his times.[12]

'Essence' and 'distillation' now became Craxton's watchwords, as much as *'genius loci'* had been for Nash or 'paraphrase' had been for Sutherland.

Sutherland himself was by this time well past his Palmer period and had embarked upon his war drawings and the Pembroke water-colours. In 1943 Watson and Craxton left London to accompany Sutherland to St. David's Head in Pembrokeshire. There Craxton sketched alongside the older man and learned from him how to 'paraphrase' an entire landscape in one intensely observed fragment of it, whether a rock, a tree root, or a sprig of gorse. He even sat in the identical spot that Sutherland had used for his 1939 *Entrance to a Lane* and drew several versions for himself, though he simplified the forms and omitted the spiky overhang of foliage – which Sutherland had added from elsewhere anyway. He began, like Sutherland, to carry

Entrance to a Lane (1944–5), oil on canvas

a notebook everywhere in order to jot down details of natural forms and thus began to emerge from his imaginary shepherd- and poet-haunted landscapes into the real world of nature once again. Not that he became a humdrum realist under Sutherland's tutelage, as this exchange makes clear:

Craxton: 'Would you say paintings were made of two facets, flesh and bones?'
Sutherland: 'No, flesh and spirit.'[13]

The Pembrokeshire weather was benign in summer 1943.

> There were cloudless days and the land was reduced to basic elements of life: rocks, fig trees, gorse, the nearness of sea on all sides, a brilliant clear light. Everything was stripped away – all the verbiage, that is – to the essential sources of existence. Sitting and talking there one day with Peter Watson, I was told that the landscape was like Greece, and this was possibly the crystallization of my desire to travel to Greece.[14]

The seed was sown, but meanwhile he had to work up his Welsh sketches into a series of estuary, farmhouse and root pictures which mixed the influence of Sutherland, less and less of Palmer, and something of the mild Surrealism of Nash's monster pictures.

Sutherland admired some of Freud's drawings which were reproduced in *Horizon* so Craxton introduced them to each other. In turn Sutherland said to the two younger men, 'I want you to meet this fantastic painter, Francis Bacon. He's like a cross between Vuillard and Picasso,' and he contrived to bring them all together at his White House home.[15] Bacon had scarcely begun as a painter at this time, 1943, but Sutherland's admiration for him was genuine and later, when he included figures in his own compositions, he learned much from Bacon, as we have seen. Freud who had a similarly tortured psyche became Bacon's lifelong friend, but Craxton's sunny and optimistic view of the world prevented him from borrowing much from Bacon's misanthropic canvases.

By 1944 Freud and Craxton had made another Pembrokeshire expedition with Sutherland, had met Ben Nicholson in St. Ives and had done some painting at Alderholt Mill in Devon. These expeditions were usually subsidised by Watson. In this year they were evicted from their joint studio and set up separately. Both began to exhibit, Craxton at the Leicester Gallery in 1944 and Freud at the Lefevre. Piper was generous in his reviews but Ayrton wrote of Freud, 'The human figure defeats him because he does not observe it as he does dead birds, but merely lets his pleasant line wander trickily round the form without relevance to construction.'[16] It was a comment which could at this stage be applied to either artist. Nevertheless, they were by now largely accepted as fully-fledged rather than being merely 'promising' so that the Lefevre Gallery invited them, in 1946, to exhibit alongside Sutherland, Nicholson, Bacon, Colquhoun, MacBryde and Julian Trevelyan.

Peter Watson's bounty continued to flow and he sent Freud and Craxton off to paint in the Scilly Isles, the nearest one could get to 'abroad' in 1945. Freud was never a landscapist by temperament, his natural subject being the portrait, and his environment rather squalid interiors, but Craxton found the change of scene beneficial. 'Tresco was less organic than Pembrokeshire,' he recalled, 'but it seemed more full of poetic imagery. Also I felt more on my own in the sense that Graham

Sutherland had not already interpreted this landscape.'[17] The landscapes he brought back to exhibit were sparser in detail, brighter in colour, and divided into those flat triangles and trapezoids which look so much like sheets spread over the contours of the land, and which derived from late Cubism via Adler and Colquhoun. When he showed them at the St. George Gallery it was his turn to be patronised by Ayrton: 'In that they cleverly combine the styles of Graham Sutherland and Picasso with a fairly original method, these minor works indicate that Craxton is gifted, but in that they lack a direct visual reaction to nature they are empty.'[18] The most infuriating thing about Ayrton's reviews was that they were often right.

Craxton was now fully accepted into the gang. The Two Roberts protected him through Fitzrovia as if he was a younger brother. Minton who used to walk past Craxton's family home, all elbows and knees, on his way to St. John's Wood Art College encouraged him and introduced him to his flat-mate Keith Vaughan. Only Ayrton irritated Craxton by his attacks on Picasso and his claim that he could draw just as well himself. Other non-artist friends were also helpful. One of these was the Scots poet, failed painter, novelist and Blake expert Ruthven Todd (1914–78). He had been helped to settle in London before the war by Wyndham Lewis, served for a time as secretary to John Lehmann at Leonard Woolf's Hogarth Press, and worked at Zwemmer's gallery and bookshop. In addition he had edited the classic Gilchrist biography of William Blake for the Everyman Library, loved Palmer, and was then researching his book, *Tracks in the Snow*, full of arcane delvings into the mythological sources of Blake's poems and pictures as well as the works of Fuseli and John Martin.[19] It is still fascinating reading, and Todd's account of his researches as he propped up the bars of Fitzrovia must have fallen on the receptive ears of young Craxton. Todd let Craxton have a Blake original at a bargain price – and later when Craxton did some illustrations for him paid him with a Miró.

Todd's book on Blake had been dedicated to John Piper and another great Blake enthusiast, the poet and reviewer Geoffrey Grigson. Time seemed to sour friendships for Grigson who in his *Recollections: Mainly of Artists and Writers* (1984) called Todd unemployable, squalid, a petty thief, an ecto-parasite, an unhealthy-looking grey oddity who frequented the purlieus of scholarship. 'Blake was his man – and Blake, to be sure, does attract a scholarly pseudoism, a scholarly parasitism.'[20] Evidently there were tensions beneath the surface of Fitzrovia's bibulous *bonhomie*! Todd eventually worked for several American scholarly foundations and also became the companion of Robert Graves in Majorca. Grigson gave Craxton a Palmer print and then commissioned him to provide sixteen lithographs for his anthology *The Poet's Eye*. It was an inspired choice and a daring one as Craxton was still only twenty-two years old. Bryan Robertson thought, 'The later "Poet's Eye" drawings confirmed Craxton's gifts: I still think they are among the finest decorations made for any English book this century.'[21] Indeed several are very impressive, particularly those on his favourite themes of dreamers in moonlit landscapes, rock-strewn bays and gnarled trees. A couple of attempts in the Nash manner to make tree forms suggest human features are less successful. The colours are strong and the drawing bold and angular, but they are still clever pastiches of other men's styles. In the same

year Freud contributed pen drawings to one of Peter Watson's publications, *The Glass Tower*, poems by Nicholas Moore.[22] The dead fish, monkeys, birds and stuffed zebra head have nothing at all to do with the overly-lush lyrics which surround them, but they do reveal Freud's growing mastery of line and the way he and Craxton were steadily growing away from each other at this period.

The Scilly Isles trip was the beginning of Craxton's gypsy rovings. As soon as poor old Europe was convalescing well enough to be visited, Craxton (with Watson's help) set off, and during 1946–7 passed through Paris, Zurich, Berne, Athens, Poros, the Cyclades, the Dodecanese, London, Paris, Marseilles, Piraeus and Poros again, yet still managed to find time for a joint exhibition with Freud at the London Gallery in October-November 1947. By 1948 he had found Crete and it felt like a homecoming. His works were travelling too since the British Council selection committee had approved them as worthy to represent British culture in Zurich (1946) and Athens (1946 and 1949). Craxton must have felt like a newly surfaced pit-pony and continued to kick his heels high across the sunlit fields of Europe, shaking off his harness as he did so:

> Through the war years I had been very conscious of Poussin, as well as the North African journal of Delacroix, and bearing in mind my concern for people living in a landscape, and the obvious need for sun and light after the war years, I also wanted to re-orientate myself and get away from the possible limitations of the English tradition – at any rate, the circumscribed area as it was during the war years. Above all I wanted to get direct first-hand experience of what I knew I needed from life, and a real place and people, rather than through art. I felt that only a drastic uprooting would give me the stimulus I needed.[23]

This was the end of his Blake-Palmer-Sutherland-second-hand-Cubism apprenticeship and now he was his own man. Grigson writing in a 1948 monograph on Craxton suggested both what he had achieved and what he had left behind him:

> . . . a painting innocent but not naïve, tender but not saccharine, and above other things, comprehensive but not abstract; painting it seems to me therefore, of a kind uncommon and welcome among, at second-hand, so many blasted trees recumbent under so many black heavens and symbolizing the too subjective agonies, or among the various dogmatisms emergent from the values of Cubism and Surrealism.[24]

Not everybody like it of course: Wyndham Lewis in his curmudgeonly way seemed to resent all this Mediterranean light getting into young men's paintings:

> He [Craxton] does not deviate idiosyncratically from many exponents of this type of monotonously bright painting – as Vaughan does so markedly depart, for instance, so that the moment you see one of his works you recognize it as a Vaughan. Craxton is like a prettily tinted cocktail, that is good but does not quite

House by the Sea No 2 (1946), crayon on paper

kick hard enough. He is very young and will probably become more taut and individual.[25]

On the other hand Frederick Ashton found these new Greek-flavoured works ideal for his purposes and in 1951 asked Craxton to design the sets and costumes for his *Daphis and Chloë* ballet at Covent Garden.

Craxton continued his indefatigable travelling all through the fifties and sixties, eventually adopting Xania in Crete as his home and returning to London only infrequently, or when the regime of the notorious colonels became unbearable. He and Freud were by now no longer friends. New fashions and new reputation-makers came and went on the London art circuit and Craxton seemed to sink out of sight.* In 1967, however, he was offered a retrospective exhibition at the Whitechapel Art Gallery and it was possible for the critics to assess his progress from those dark early landscapes with introspective poets to the dazzle of Hydra, or Cretan gorges. The critics were at their sourest. Ayrton had offended them by being too clever and versatile; Prunella Clough by being too unfeminine; Vaughan by not being colourful enough; and Colquhoun for painting stiff figures which looked like playing cards. Craxton's sin was to be too happy. 'These elaborate compositions, heaped thin and high, push hard against the handicap of happiness,' wrote John Russell in *The Sunday Times*, perhaps with some sympathy.[26] Others sneered that they were too colourful, too artificial, too shrill, sharp, flat, linear, sentimental, poetic, decorative, soft, mannered, elaborate, simple, banal, charming, patterned or had 'a fatal hint of the best type of Chelsea restaurant mural'. Perhaps mid-January was not the most tactful time to offer hedonistic views of Greek sunlight to reviewers bound to their London desks. More spiteful ones made innuendoes about Craxton's preferences for sailors, soldiers and goatherds as models. The experience can only have confirmed Craxton's determination to live 'in an atmosphere where life is considered more important than Art – where life itself is an Art. There I find it's possible to feel a real person – real people, real elements, real windows – real sun above all. In a life of reality my imagination really works. I feel an émigré in London and squashed FLAT.'[27] Here again is the old Romantic conviction that the metropolis is vile and reality dwells amongst shepherds and fisherfolk.

Having found his ideal home Craxton could now settle down to many years of depicting the everyday life of Xania, his Cretan village. There is no hint of classical Greek art in his work which takes its immediate start from the goats, scrawny cats, thorns, vines, gorges and the white huddled seaside villages of the Greek islands. He has never contracted Ayrton's obsessive preoccupation with Greek myths. Mixed in with these landscapes and tasty still-lifes are straightforward line portraits of sailors, soldiers, old men, girls, boys, shepherds and goatherds drawn with a panache to equal Minton at his best. What these sensuous works have lost, however,

*His greatest supporter, Peter Watson, drowned in his bath in 1956. Cecil Beaton wrote in his diary for 6 May 1956: 'He became respected by the most intelligent writers, his judgement revered, his fairness impeccable. With his feet in the gutter, he had indulged in every vice, except women, but he was really like a saint.'

Elegaic Figure (in memory of Peter Watson) (1957–9), oil on canvas

is that extra emotional charge which his earliest depictions of imaginary shepherds in weird invented landscapes possessed. In short, he has now ceased to be a Neo-Romantic.

No other English artist is making works like these, but there are parallels to be found in the subject matter, colour, linearity and paint quality of the Greek artist Ghika (b. 1906) who is Craxton's friend and several of whose works he owns. Ghika had been reproduced in *Horizon* in 1946 and *Penguin New Writing* in 1947, and

held up as a progressive painter in Herbert Read's book *Art Now*, so that Craxton knew of his work before he left England. Ghika also exhibited in London immediately after the war where he was welcomed as one of the Europeans who had learned so much from Picasso, Braque and Gris. These Parisian influences (he trained there in the 1930s) he managed to combine with Byzantine ones, and a high-keyed palette to cope with the pellucid Greek light. Ghika gained a European reputation as a stage designer, painter and graphic artist and acquired many British patrons through his London exhibitions during the 1950s and 1960s, including several of those who were also buying Craxton's works.[28]

The compositions Craxton has produced since the 1950s still trail hints of Sutherland's liking for the spiky forms in landscapes, and Picasso and Miró-like distortions of figures and still-lifes. On top of these, however, he has absorbed more exotic sources than English painters can usually draw upon. Crete is, after all, the birthplace of El Greco who combined the hieratic styles of Byzantium with the freer, more humanistic ones of Renaissance Italy. Craxton writes with awed admiration for those Byzantine mosaic works he has seen in Istanbul, Italy and Greece and admits he has learned a lot from the mosaicists' respect for the flatness of their working surface, the sensuality and emotion they manage to convey with the clumsiest of materials, and the intense radiance of their colour. In short, 'this encounter with Byzantine art was a disruptive and strengthening experience.'[29]

Above all, Byzantine mosaics forced him to think about perspective. Traditional Renaissance illusionistic perspective had never held much charm for him after his apprenticeship period in Abercorn Place. Already in his 1946 *Greek Farm* he was distorting figures so that they had tiny heads, normal arms and one of their legs shot to the front base of the picture in a way that made it impossible to locate them in the picture space in the normal way. Tchelitchew had picked up the same trick from photography, and Picasso and Miró had similarly turned space into a distorting mirror. Sutherland had experimented with flattened perspectives and heaped-up forms, but Nash, Piper, Ayrton and Minton had all retained those routine sleights of hand which make their figures appear to inhabit a space which recedes to the sky line. However, these artists, and the early Vaughan, had all taken as their subjects the misty rolling landscapes of England where objects dim away to a blue horizon. Craxton now had a different problem to cope with:

Don't expect to find any perspective in and around the Aegean. Perspective is conveyed only by size and not by a change of tone, since a tree or a rock can be seen at a distance of fifteen miles or fifteen feet with exactly the same clarity. The ambiguous lines of the mountains. The lines of the first range of hills become the lines of the second, and the last: so that a complicated movement of lines all appearing to be one range and one group dance with a static movement. Is this static movement, or 'held' quality perhaps the essence of Greek sculpture? The moment caught from right inside of the form and held with an internal and external pressure.[30]

Many of his works avoid the problems of recession by taking on the aspect of a frieze with animals or people backed by a wall, the sea, a tilted-up screen of foliage, or rocks. No opportunity is lost to exploit bright flat colours and the punning interplay of profiles. A rhythmic boundary line separates these unmodelled patches of colour, then swoops or wriggles across forms and on out of the picture. These boundaries spring from an aspect of Craxton's character: 'I like always to be very precise about where one thing ends and another thing begins: it's only from this point of departure that a truthful boundary can begin.'[31] This, he admits, is a development of ideas he received as a youngster from reading Blake's attack on the Italian *sfumato* approach to painting and his insistence that 'the more distinct, sharp and wiry the bounding line, the more perfect the work of art'.

Craxton works from small sketch-books and then knits and knots his linear network at the easel when 'line is used to make volume expressive rather than to express volume'. Sometimes these lines multiply crazily – so in one picture of Greek fishermen he worked on through 1952, 1956, 1958 and 1959 there are concentric red, white, blue, yellow and orange lines round a single form. The latest works, shown in London in 1985, are still exploiting this switch-back line and are more razzle-dazzle in colour than ever. Abstraction might seem a way forward but he draws back from that: 'I would find abstraction too limited for my needs.' Another unexplored avenue might be looser control and the admission of accident into his work, but again Abstract Expressionism passed him by since he temperamentally needed to control every contour, craft every shape left between forms, and polish every pun he made between the shape of a sailor's hat and his plate on the table before him. These works look effortlessly hedonistic, but their insouciance is striven hard for.

This analysis of Craxton's unfolding development will seem over-long to those critics who still believe he is a decorative lightweight who paints travel posters. 'As a man is so he sees,' wrote Blake, and it is obvious enough that Craxton is a thorough-going sybarite fashioning his art out of the things which give him pleasure – crayfish, cigarettes, ouzo, squid, bread, lemons, whitewashed walls, the male figure, café society, scrubby goat-nibbled hillsides, and the everyday life of his community who share the same blue sea and dazzling sun. He is a self-confessed Arcadian (but without Calvert's or Palmer's religiosity), bidding us throw off all that English gloom and introspection and come over to his view of life. 'If I enhance lives, then that pleases me,' he declares. Of course this simple hedonism does make for a narrow range of mood in his *oeuvre*: a lack of interest in anguished confession, in voyeuristic sexuality (he has retained his English proprieties), in metaphysics, in politics, in the trappings of commercial society, or in any of the other fashionable eye-catchers of post-war painting. He is bright, supremely decorative, figurative, unambiguous and optimistic – all terms usually applied more frequently to French painters such as Dufy or Matisse than to someone who was born and grew up in London. By now he is an English painter only in the literal passport sense, and his Neo-Romantic period of moonlight and creepy undergrowth is long since behind him.

Meanwhile, back in London, Freud had dug in and slowly fulfilled the promise his influential friends had predicted for him. The harder he peered at his still-lifes the sharper they came into focus. At first sight the early works seem to play orthodox surrealist's tricks of scale and juxtaposition so, for example, a plaster head, a lump of coal, red cloth and two Chelsea buns meet on an open-air table to compete for our attention. In *The Painter's Room* (1943) a spiky plant, a Freudian couch, a top hat, more red cloth and an enormous zebra's head thrusting through the window make a disturbing collection. Yet Freud disclaimed any surreal intentions: 'Much as I admired early Chirico and Miró, I objected to the fact that under the laws of doctrinaire surrealism as approved by Mesens it was easy for people of no talent to practise art'[32] and also, 'I wanted things to look possible, rather than irrational, if anything eliminating the surrealist look.' In fact, the pictures are accurate transcriptions of the separate objects assembled in front of him, like several discrete still-lives scattered over one canvas. Even the zebra's head was not imagined but a favourite possession that he was photographed stroking for *Penguin New Writing's* gallery of glamorous young Neo-Romantics.[33] The objects continued to be painstakingly recorded in slightly tart yet realistic colours, but besides tricking the eye they were prickly on the skin and astringent on the tongue with subjects such as thistles, gorse, sea-holly, sea-urchin and squid, a sardine and aloe, and from his Greek trip with Craxton an unripe tangerine and two lemons.

From objects, Freud turned his intense scrutiny on to people. Now he wanted to count eyelashes, freckles and the exact markings in each iris. His tiny, finnicky brush tickled its way over his sitters' faces like a fly. Like the Pre-Raphaelites he kept every inch of the canvas in sharp focus, loading it with information. Before this implacable gaze his main sitter, his young first wife (daughter of the sculptor Epstein), begins to quail and into her exaggeratedly wide eyes comes an increasing apprehension and then distress, as if she feared the visual interrogation would be followed by a physical attack. These are unsettling pictures which tell us not just how hard the artist looks, but also how the sitter experiences that looking. In English art only the lunatic Richard Dadd (1818–87) had painted such vulnerable eyes as these.

The objects which surround these portraits are carefully chosen. Minton's and Sutherland's old mannerism of dipping foliage in from the top edge of the picture is now used with a hint of malice as a leaf-point ends just at the edge of a wide moist eyeball. Elsewhere the woman's grip tightens round the neck of a kitten, or round a phallic rose. By the time she poses with a bull terrier, exposing one breast and clutching the other, she seems openly terrified.* When Freud himself appears in the works, as in *Hotel Bedroom* (1954), it is only to show how wide the gap in communications is between him and his partner. These pictures are illustrations to a personal narrative, totally different from the estranged but generalised couples in Colquhoun's works. Perhaps it was these fraught but immaculately finished works which led Herbert Read to call Freud 'the Ingres of Existentialism'.

* *Girl with White Dog* (1951/2), Tate Gallery.

By the early 1950s Freud had found his subject matter, and it was a world away from the concerns of the Neo-Romantics out seeking meaning in the countryside:

My work is purely autobiographical. It is about myself and my surroundings. It is an attempt at a record. I work from the people that interest me, and that I care about and think about, in rooms that I live in and know. I use the people to invent my pictures with, and I can work more freely when they are there.[34]

Unlike Sutherland, the only other portraitist of the period of similar stature, he avoids portraying public figures, in spite of the entry to influential circles his family name and second marriage gave him. Instead he paints unnamed models, Paddington friends, local toughs, his mother, children, or fellow artists such as Bacon, Michael Andrews, Frank Auerbach, Bérard and the photographer of Fitzrovia's Bohemia, John Deakin. His portrait of Minton (1952) must be one of the most poignant in art, stripping away as it does the grin of the clown to show us the lost soul behind. These are more disturbing works than Sutherland achieved, in my view, but the older artist had shown the way and suggested unconventional poses, that flesh could be rendered as detailed texture like rock, and that a cold long hard stare produced works of more intensity than the glance of affection or flattery. Apart from the vulnerable-looking Sackville-West, Sutherland usually tackled celebrities with outsize egos who could stare back, but Freud seeks out sitters, especially women, who appear to wince away from his interrogative eye – the men, on the other hand, seem mostly chosen for their toughness and poise.

Apart from a view of a factory and a glimpse into a squalid back-garden dump, Freud's is a totally indoor world, and usually a night-time one lit by bare electric bulbs. He is certainly no Arcadian like Craxton, and claims to have 'a horror of the idyllic'. As if repudiating his bourgeois childhood he now prefers rooms with uncarpeted floorboards, exposed plumbing, flaky plaster and very old furniture leaking stuffing. The only thriving things in these seedy compartments are giant pot-plants. In *Interior in Paddington* (1951) one specimen squares up to a man in a dirty mackintosh, its razor leaves holding more threat than his clenched fist. Beneath another lies a nearly naked child, but this is no fairy-tale gooseberry bush, and it could swoop down and throttle the infant at any moment. A later one has taken over the whole picture surface, but dimly seen, groping his way through the leaves, is the naked artist, one hand cupped to his ear like a deaf Tarzan. Nash's log monsters, Sutherland's belligerent oaks and sinister gorse, and Craxton's spiked trees have their urban counterparts here in the terraced houses of Paddington. There is no hint of poetic whimsy about these scrupulously observed botanical specimens – they are as dangerous as Triffids.

Freud would vehemently deny any connection between his early works and those of the Neo-Romantics, and after 1957 he moved into new areas of subject matter that no Neo-Romantic would have felt even remotely tempted to try. A kind of ocular depravity set in. Now he abandoned sables for hogs-hair brushes and small canvases for large coarse ones, using lead-heavy paints which he dragged and

clotted across forms with no care for clean edges or carefully differentiated textures. With the rougher paint surface came less refined subject matter. The early girl sitters had been uneasy, but were decorously posed and delicately painted: the later ones are flung across beds or a beaten-up couch so that their genitals are exposed to the harsh light and their eyes can no longer meet the painter's or the spectator's. In these 'Naked Portraits', as he calls them, Freud is exploring sexuality as tenaciously as his grandfather did on his clinical couch in Vienna, though his attitudes towards it seem to swing unpredictably between repulsion and fascination, tenderness and sadism. Working always direct from the model he claims: 'I feel more free; and I take liberties which the tyranny of memory would not allow. I would wish my work to appear *factual*, not literal.'[35] He also strives to make the paint 'work as flesh', and so it does, which gives these works their shocking impact. Kenneth Clark made a distinction between the 'naked' and the 'nude' – the 'huddled defenceless body' on the one hand, and 'the balanced, prosperous, confident body: the body re-formed' on the other.[36] If we compare Freud's figures with any of those by Minton, Ayrton, Vaughan or Craxton then Clark's distinction becomes instantly clear.

Freud's friend Francis Bacon is similarly obsessed by the fraught human drama in the closed room. Both disclaim any interest in painting anything other than people on the grounds that people are what people are interested in. Bacon puts landscape at the bottom of any scale of subject matter. If Freud has a horror of 'the idyllic', Bacon's strongest term of condemnation in art is 'illustration' this immediately distances them from the Neo-Romantics who cheerfully embraced both.

Bacon's earliest paintings are apparently from around 1929 and John Russell tells us that they 'have a look, long discarded, of English pastoral surrealism as it was practised by Paul Nash: stylized vegetation, multiple perspective, fragments of classical architecture, and floorboards that swoop up and away from the picture plane. All that soon went.'[37] What came in their place was *Three Studies for Figures at the Base of a Crucifixion* (1944), and Bacon's claim that it was a totally secular crucifixion because there were no spiritual values or 'valid myths' for the modern painter to relate to. All he could now do was record his 'exhilarated despair' and transfer his bodily sensations as directly as possible on to the canvas. Critics could only explain his obsession with 'the armchair of meat' and his disgust by saying he was embodying the recent anguish of the war. This was a time when the death camps were opened, Hiroshima was bombed and Europe was full of starving refugees. The documentary works submitted to the WAAC and the deserted vistas of Sutherland and Piper never confronted the human agony of war, but surely Bacon's did? Wyndham Lewis, one of his earliest supporters, thought Bacon 'one of the most powerful artists in Europe today and he is perfectly in tune with his time'.[38] His screaming mutants seemed to speak for us all.

Now, over forty years later, he is still painting man as a gibbering beast wracked by terror, lust and depravity, much given to vomiting, excretion, torture and hoggish couplings. Over the intervening years it has become clear that Bacon speaks

Pastoral for PW (Peter Watson) (1948), oil on canvas

less for mankind than for himself and his own idiosyncratic obsessions, and that his view of his fellow men is every bit as partial as Palmer's was of the English peasantry. His focus on anguished mouths ('like Turner vibrant with delicious colour'), disembowellings, 'beautiful wounds', blood and sinister erotic encounters in closed rooms can only come from a sadism which links sex with violence. Though there are female nudes in Bacon's *oeuvre* his avowed interest is in 'the voluptuousness of male flesh'. There is a brutal frankness about his grappling nudes which the homosexual Neo-Romantic artists would never have dared to attempt, or felt it necessary to try. 'I want to give a shock, a visual shock,' claims Bacon, but he has been doing it so long now that he has had to escalate the horrors and mutilate his figures more and more extremely to get any response from himself, or his jaded followers.

Freud paints his portraits, including Bacon's, direct from life: Bacon paints his portraits, including Freud's, from photographs. Tactfully he sends the subjects away before he gets the cleavers to work on their images. 'If I like them I don't want to practise the injury that I do to them in my work before them. I would rather practise the injury in private by which I think I can record the facts of them more

clearly.'[39] This is a world away from Minton's or Vaughan's affectionate portrayals of their young men or Sutherland's respectful records of the great. Bacon's justification for blurring and slicing the heads so much is that 'you have to abbreviate into intensity'. Sutherland said something similar about landscape and Piper wrote of Romantic painting, 'Intensity is all,' but how low a wattage each of the Neo-Romantics seems to generate when we compare their visions with those of Freud and Bacon.

Bacon is admired by other artists for the way he handles paint. This is applied direct to large unprimed canvases with no preliminary drawing and can vary within any one work from large flat areas of background applied like house-painter's emulsion, to blurred flurries of brush strokes round the central protagonists, to sharp outlines on the beds or chairs or platforms which make up a room's fittings. There may also be gobs of white paint thrown across the picture suggesting mucus or semen, though these 'accidents' are by no means as uncontrolled as the Abstract Expressionists' dribbles from which they may have derived. Bacon was convinced enough of his own status not to be worried by the Americans' eruption into the British galleries in the 1950s. Pollock's work he dismissed as 'like bits of old lace' and Rothko's spiritual mauve rectangles as 'deeply depressing'. He suffered none of Minton's or Vaughan's self-doubts. He does believe, however, that 'there is an area of the nervous system to which the texture of paint communicates more violently than anything else,' but this does not tempt him into abstraction, presumably because he also believes there is another area of the nervous system which is agitated by images of mutilated bodies on blood-stained beds.

Bacon and Freud are perhaps the most distinguished figurative artists Britain has produced since the war. Both, it seems to me, are making art out of their own private hatreds, loves, obsessions, sexualities and assorted hang-ups, though a wide public seems able to relate to these self-revelations and to share their profoundly pessimistic view of that poor forked creature, Man. Neither takes anything from the English tradition of painting, but they do not owe much to French art either – if there are links it seems to me they are to German Expressionism.

As we have stated earlier, neither of these artists had more than social links with the Neo-Romantics, but by holding their violent, convulsive works alongside those of Nash, Piper, Sutherland and the rest we can perhaps see both the limitations and the virtues of the Neo-Romantics. Obviously there is a subtler tingle along the nerves caused by the *genius loci* or a 'standing form' than by Freud's sprawled women or Bacon's bloody meat. Outdoors, in the pastures and woods of the southern counties, or the beaches of Pembroke, or on the crags of Snowdonia, the air is cleaner and more bracing. There one can take a healthier, more optimistic view of man and put a more spiritual interpretation on nature. Comparing these painters with the German-born Freud and the Irish-bred Bacon makes one realise too how much they were constrained by traditional English reticence and good taste.

REFERENCES

1. *Horizon*, No. 4, April 1940.
2. Russell, John, Introduction to 'Lucien Freud' catalogue, Hayward Gallery, January-March 1974 (London, Arts Council), p. 7.
3. Ibid., p. 7.
4. Vickers, Hugo, *Cecil Beaton: The Authorized Biography* (London, 1985).
5. Grigson, Geoffrey, *Recollections: Mainly of Artists and Writers* (London, 1984), p. 116.
6. Quoted in Catalogue to 'John Craxton: Paintings and Drawings 1980–1985', Christopher Hull Gallery, June–July 1985, p. 22.
7. *Horizon*, No. 27, March 1942.
8. Grigson, Geoffrey, 'Samuel Palmer: The Politics of an Artist', *Horizon*, No. 23, November 1941.
9. Hastings, Gerrard, 'Neo-Romanticism: its Roots and its Development', unpublished MA thesis (Aberystwyth, 1984), Chap. VI, footnote 12.
10. Quoted in catalogue to 'John Craxton: Paintings and Drawings 1941–1966', Whitechapel Art Gallery, January-February 1967, p. 6.
11. Grigson, Geoffrey, *John Craxton: Paintings and Drawings*, published by *Horizon*, 1948, unpaginated.
12. Quoted in catalogue to 'John Craxton: Paintings and Drawings 1980–1985' p. 21.
13. Berthoud, Roger, *Graham Sutherland* (London, 1982), p. 111.
14. Quoted in catalogue 'John Craxton: Paintings and Drawings 1941–1966' p. 6.
15. Berthoud, Roger, op. cit., p. 111.
16. Ayrton, Michael, *Spectator*, 1 December 1944.
17. Quoted in catalogue to 'John Craxton: Paintings and Drawings 1941–1966, p. 6
18. Ayrton, Michael, *Spectator*, 8 June 1945.
19. Todd, Ruthven, *Tracks in the Snow: Studies in English Science and Art (Blake, Fuseli, Martin)*, (Grey Walls Press, London, 1946).
20. Grigson, Geoffrey, *Recollections: Mainly of Artists and Writers*, p. 44.
21. Catalogue to 'John Craxton: Paintings and Drawings 1941–1966', p. 4.
22. Moore, Nicholas, *The Glass Tower* (London, 1944).
23. Quoted in catalogue to 'John Craxton: Paintings and Drawings 1941–1966, pp. 6–7.
24. Grigson, Geoffrey, *John Craxton* (London, 1948), unpaginated.
25. Lewis, Wyndham, the *Listener*, 14 July 1949.
26. Russell, John, the *Sunday Times*, 22 January 1967.
27. Quoted in Grigson Geoffrey, *John Craxton*, (London, 1948), unpaginated.
28. Zervos, Christian, *Ghika: Paintings, Drawings, Sculpture*, texts by Stephen Spender and Patrick Leigh Fermor (London, 1964).
29. Quoted in catalogue to 'John Craxton: Paintings and Drawings 1941–1966', p. 10.

30. Ibid., p. 8.
31. Ibid., p. 8.
32. Gowing, Lawrence, *Lucian Freud* (London, 1984), p. 23.
33. *Penguin New Writing*, No. 35, 1948.
34. Russell, John, Introduction to 'Lucien Freud' catalogue, Hayward Gallery, January-March 1974 (London, Arts Council), p. 13.
35. Ibid., p. 5.
36. Clark, Kenneth, *The Nude* (London, 1956), p. 1.
37. Russell, John, *Francis Bacon* (London, 1971), p. 19.
38. Lewis, Wyndham, the *Listener*, 17 November 1949.
39. Russell, John, *Francis Bacon*, p. 139.

Vignette from *The Poet's Eye* (1944), pen, ink, brush

CONCLUSION

Iɴ Chapter 4 we left Britain exhausted at the end of the Second World War, but also hopeful of a new social order under a Labour Government, and poised to become the cultural leader of Europe, and hence of the Western World. Neo-Romanticism which had flourished during our wartime isolation would obviously play an important rôle in that ambition. Unfortunately, something went wrong along the way, and by the mid-1950s Neo-Romanticism had turned up its toes and died, and the ambition was never achieved.

To everyone's disappointment wartime austerity continued for several years after peace came as the Labour Government struggled to cope with severe winters, droughts, dock strikes, rising world prices, a devalued pound, and splits within its own party. By the end of the 1940s the world was divided into two hostile camps separated by an 'Iron Curtain', as Churchill called it. The Berlin Crisis, the Korean War, atom-bomb tests, spy trials and MacCarthyism all followed on from that unhappy fact, and helped the growing sense of disillusion which seemed to creep into intellectual discourse.

In 1950 both *Penguin New Writing* and *Horizon* closed down. Connolly reproduced Francis Bacon's *Three Studies for a Crucifixion* in the final edition and in his last editorial Comment attempted a summary of the previous decade:

> One can perceive the inner trend of the Forties as maintaining this desperate struggle of the modern movement, between man, betrayed by science, bereft of religion, deserted by the pleasant imaginings of humanism against the blind fate of which he is now so expertly conscious that if we were to close this last Comment with the suggestion that everyone who is now reading it may in ten years' time, or even five, look back to this moment as the happiest in their lives, there would be few who would gainsay us. 'Nothing dreadful is ever done with, no bad thing gets any better; you can't be too serious.' This is the message of the Forties from which, alas, there is no escape for it is closing time in the gardens of the West and from now on an artist will be judged only by the resonance of his solitude or the quality of his despair.[1]

Perhaps this tells us as much about Connolly, now approaching fifty and no masterpiece written, as it does about the age. But there were other, weightier voices offering the same gloomy diagnosis: T. S. Eliot the most respected of the right-wing mandarin writers wrote in 1948 that, 'We can assert with some confidence that our own period is one of decline; that the standards of culture are lower than they were fifty years ago; and that the evidences for this decline are visible in every department of human activity.'[2]

In spite of the nationalization of industries, the Beveridge Report, and the creation of the Health Service, all those hopes of the 1930s for a fairer state run on socialist lines did not seem to many to be much nearer fulfilment. Shortages and deprivations which had been bearable, even bracing, in wartime were not so tolerable now we were supposed to have won the war. Grumbling became widespread. In the 1950 election Labour's majority was cut from 146 in 1945 to 5, and in the 1951 Election Churchill took over power, just in time to benefit from a recovery in world trade.

In painting the picture was not all gloom. The war artists had enjoyed Government support during hostilities and the British Council and the Arts Council continued to subsidise the favoured ones after the war, but commercial galleries selling modern English art were still all within a square mile in London's West End. In effect there were seven only: Redferns, the London, the Mayor, Reid and Lefevre, Tooth's Gallery, Roland, Browse and Delbanco, and the Leicester Gallery. Beyond that a young painter could hope to get noticed in mixed exhibitions at the Royal Academy or with the New English Art Club or the London Group, none of them very progressive. London still kept its stranglehold on the art trade, though as restrictions relaxed the artists themselves began to disperse, usually making a trip to Paris their first priority and, as we have seen in the case of Sutherland and Craxton, eventually going into voluntary exile. As the circumstances which had given rise to Neo-Romanticism changed so did the artist's work so that in the end only Piper remained a steadfast Romantic landscapist. Having tasted Abstraction once he was not tempted to sample it again when Nicholson and Hepworth re-emerged from their wartime isolation in St Ives to continue European hard-edged abstraction where it had left off in 1939. Trailing after them from St Ives came a younger group of painters committed to a looser, brighter, more painterly form of abstraction which related more closely to the land and sea of the south-west peninsula: Peter Lanyon, Bryan Wynter, Terry Frost, Patrick Heron and Alan Davie. They were to dominate the 1950s in English art.

But first the nation obviously needed a party to take its mind off things. The Festival of Britain, subtitled like a book 'The Autobiography of a Nation', was planned for 1951. Fifty architects and a hundred designers were involved, and the Arts Council had its budget boosted by an extra £400,000. Predictably, the Beaverbrook press who had seen little cause for subsidising culture during wartime saw all this as a waste of money in peacetime too. The Neo-Romantics were the obvious people to call upon to help with the design and decoration of the site on the south bank of the Thames. Piper in particular played a major rôle, contributing a mural to the Homes and Gardens Pavilion, designing, with Osbert Lancaster, the Battersea

Grand Vista in bamboo cane-work (yet another medium for him to master), and also getting credit for Entrance Towers, Arcades, Rotundas, Tea Houses, Lakes and a Fern House. He revelled in the chance to build follies instead of just painting them.[3] Vaughan did a male-nude *Theseus* mural for the Dome of Discovery (later bulldozed), Minton a leafy one called *Explorations*, Ayrton an histrionic one called *The Elements as the Sources of Power*, and Sutherland's *Origins of the Land* was slashed by a vandal. None of them really knew how to paint on a large scale like this and the results are not amongst their best works: Sutherland's for example, which is now in the Tate Gallery, is meanly painted in oranges and lemons and seems a recapitulation of all his previous motifs of standing forms, flames, eroded rocks, roots and fossils all set out for display on shelves. Only Colquhoun and MacBryde seemed not to have been invited, though their simplified edgy forms would have blended in well with the Festival's overall style. Wyndham Lewis in his book *Rotting Hill* (1951)* records a meeting in the street: 'Colquhoun is not at all himself: I feel that he stagnates, there is something the matter. . . . He has been excluded from the Festival of Britain, he has not been invited to send a picture and he feels bitterly this strange slight.'[4] Lewis had not been asked either.

The Arts Council, to add to the jollifications, offered free canvas to sixty artists if they would contribute a picture at least $45'' \times 60''$. Colquhoun and MacBryde did receive an invitation to this and submitted a characteristic figure study and still-life respectively. Ayrton offered his Italian picture, *The Captive Seven*, Prunella Clough *Lowestoft Harbour*, Minton *Jamaican Landscape* based on his holiday trip, and Vaughan three nudes entitled *Interior at Minos*. None of them were were amongst the five winners whose works were each bought for five hundred pounds, though Freud's *Interior near Paddington* was one of these.

The six million people who saw the Festival events on the London site over its five months' existence seemed to enjoy it, and those who stayed at home could join in more local events but, as we mentioned earlier, this did not buy the Labour Government popularity. They were defeated by the Conservatives before the Festival closed and the whole place was demolished within the year, leaving us only the Festival Hall.

In 1951 Basil Spence, who had designed the Sea and Ships Pavilion for the Festival, received the commission to build a new cathedral at Coventry to replace the one fire-bombed in 1940. Another architect said of his design that 'it carried the Festival Style deep into the surprised Sixties, but this was less an example of long-term influence than a fossilized survival. Influence-wise the Festival died a-borning.'[5] It can also be seen as the last large-scale exploitation of that Neo-Romantic device, derived from Sutherland's Thorn Head paintings, of placing spiky uncomfortable forms against uniform fields of colour. Looking around for an artist who could tackle large-scale religious themes for a modern church setting Spence must have realized that Sutherland was the only candidate.

As usual Sutherland took the task very seriously, and at his own pace. He had

* A bad pun on the decaying neighbourhood where he and the Two Roberts lived.

to provide a design of Christ enthroned in glory to be made into a tapestry weighing over one ton. His researches and difficulties are recorded in a series of lengthy interviews.[6] It is a physically impressive work, but one wonders if Sutherland was temperamentally suited to portray a Christ triumphant, rather than suffering in his crown of thorns. Think what he might have done with an 'Agony in the Garden' on this scale!

Piper had made the most memorable image of the old cathedral's empty window sockets and so he seemed the most appropriate person to provide new windows. He chose to do them in an abstract way, having achieved Turner's life-long ambition of painting with pure light. Other furnishings such as the weathered boulder-font, the Crown of Thorns screen to the Gethsemane chapel, the linear Minton-style angels engraved in glass by John Hutton, the angular branching choir stalls, and another thorn crown in the Chapel of Christ the Servant all seem to echo forms and styles associated with the Neo-Romantics. By the time the building was finished and consecrated in 1962 that style had been superseded by several others, and it has become the sport of critics to make a mockery of it ever since. For less hypersensitive souls however, such as those who actually work and pray there, it remains a fine building with a feeling of light, space, air, texture and colour which add up to an environment conducive to Christian worship.

By the time Coventry Cathedral was consecrated Piper, Sutherland, Moore, and Nicholson were middle-aged and fast attaining the status of Elder Statesmen. The passing of time had meant the rebellious works of their youth had been absorbed, at least by the art world, and no longer gave off shock waves. Young artists looking for radical leaders willing to hack out new areas for art to cultivate were not going to turn to men who now received commissions from the State and Church for prestigious public monuments, and who were being pressed to accept retrospective exhibitions, Orders of Merit, honorary degrees, Companions of Honour, Fellowships, and trusteeships of the Tate and National Galleries by the bourgeois establishment. Even Herbert Read, professed anarchist and espouser of every shocking new movement over the previous thirty years, accepted a knighthood in 1953. That lone provoker of arguments, Wyndham Lewis, also seemed to become more benign with age and was honoured by a Tate retrospective just before he died in 1957. Of course none of the Neo-Romantics, of either generation, had ever aspired to the status of insurgents in the way Read and Lewis had: they had worked within a tradition rather than against it. Quite suddenly, however, that tradition began to crumble away.

If we had to carve a final date on the gravestone of Neo-Romanticism the year 1956 would do as well as any. The world was then in turmoil with Khrushchev first denouncing Stalin's brutality at the Twentieth Soviet Communist Party Conference, then brutally ordering the invasion of Hungary. Meanwhile French and British Forces occupied the Suez Canal zone but were forced to withdraw. Castro invaded Cuba, and Martin Luther King began to lead the desegration campaigns in America. It was a confusing time for those on both the Left and the Right – perhaps after all a neutral tone was best. In literature there was a marked turn

away from the values of Dandyism with its camp playfulness, complacency and nostalgia. Kingsley Amis's *Lucky Jim* (1954) poured scorn on intellectual pretentions, and Colin Wilson's *The Outsider* (1956) made heroes of those who were alienated from society. The 1955 English production of Samuel Beckett's *Waiting for Godot* had made the poetic dramas of T. S. Eliot and Christopher Fry look hollow, and John Osborne's *Look Back in Anger* (1956) expressed the utmost contempt for what the mandarin classes represented, whilst simultaneously regretting there were no good brave causes left to fight and die for. In that same year the poetry anthology *New Lines* appeared in which Robert Conquest, Kingsley Amis, Philip Larkin, Elizabeth Jennings, D. J. Enright, Donald Davie, Thom Gunn, John Wain and John Holloway took up a deliberately anti-Romantic stance, aiming to be drily cerebral and sardonic in contrast to the emotional exuberance of the poets who admired Dylan Thomas. In Philip Larkin's *Church Going* he mocked those, like Betjeman and Piper, who 'tap and jot and know what rood lofts were', those 'ruin bibbers, randy for antique'. There is no feeling now of love for the fabric of our tradition, only a wry embarrassment about it. Amis could write a poem called *Against Romanticism*, and Donald Davie on *Remembering the Thirties*, both of which dismiss their forebears but with an undertow of regret that perhaps in keeping experience at arm's length they might be missing something. In this tougher, more cynical world there was little demand for the kind of book illustrations, jackets and posters that Minton, Ayrton, Vaughan and Craxton did so well.

In art, as we have seen, there had already been a brief Realist movement in England during which, as its spokesman John Berger put it, 'we saw that art was not exempt from class distinctions'.[7] The effects on Neo-Romantic painters of the Abstract Expressionists' claims in 1956 that 'there is nothing left in nature for plastic arts to explore' (Clement Greenberg) have also been touched upon. The pretention that it was an 'abolitionist' style, liberating the artist from all values, whether political, moral or aesthetic, and dismissing the whole history of art with one wet swipe across the face of the canvas turned out to be not so redeeming, after all. New York failed to follow up with a second wave of equally strong ideas, and soon the honour of being the world's premier art city was open to contenders again – though Paris was no longer seen as a serious challenger. Figurative art took another direction in 1956 with the beginning of Pop Art, claiming to unite popular 'admass' culture and the old High Culture. This gleeful plunge into the dehumanized urban glitter went against everything the Romantics had tried to warn us against for nearly two hundred years. Suddenly the Neo-Romantic's style and subject matter began to look passé to the newer critics and art students.

Even the old haunts of the Neo-Romantics had become unrecognizable by 1956. Soho and Fitzrovia had turned into tourist traps and property developers had moved in. Poor Nina Hamnett, the 'Queen of Fitzrovia', sank into alcoholic decay and was found impaled on the railings forty feet below her lodging's window. Minton, once one of her fans, killed himself five weeks later. Televisions had invaded the pubs and blared above the bars. Even Bohemia had been desecrated. Moreover, its function as a rendezvous for homosexuals was no longer so vital after the Wolfenden

Committee's Report of 1957 eased restrictions on this group. Julian Maclaren-Ross, writer and Fitzrovian, summed up the 1950s for his kind and his generation: 'It was a decade I could well have done without.'[8]

Bryan Robertson, who as Director of the Whitechapel Gallery had done so much to keep the Neo-Romantics in the public eye through the early 1950s, could write by 1965 in the catalogue to *The English Eye* exhibition: 'The seductive impasse of the English landscape convention has been by-passed . . . as mainly an irrelevance to current pre-occupations.' By the 1970s we were living in a myth-free world where art was minimalist, conceptual, and the enjoyable squidge of paint under a brush was a forgotten sensation – or at least amongst the newest recruits to the avant-garde. Paintings were addressed to other painters asking what is style? what is painting? what is this discipline we are indulging in? Even Picasso was in eclipse. The number of galleries displaying modern art had doubled between 1950 and 1960, and probably again since, but people who lived and worked outside studios, art colleges and galleries seemed excluded from the debate – which is not an accusation that could be made against the Neo-Romantics. Paint seems to have been redis-covered in time for the 1980 *New Spirit in Painting* show, and one or two artists are now working in and with the English landscape again, though not many seem to feel the urge to take a box of watercolours off to Pembrokeshire to see if they can conjure up a presence from round the bend of a lane.*

Neo-Romanticism seemed dead and forgotten, but then in 1972 and 1973 William Feaver exhumed it and wrote two near-identical articles about this 'peculiarly insular and now little-known phenomenon'. He obviously enjoyed adop-ting a mocking tone in discussing most of the artists, except for a grudging admira-tion for the late works of Keith Vaughan.[9] He rightly stressed that Neo-Romanticism was 'never precisely definable, never more than a tendency', though it was 'a signifi-cant undercurrent in war-time Britain', but he was surely mistaken to say it became merely 'a compensation for the rigours and shortcomings of the time' – it was always tougher-minded and less escapist than he makes it seem. Feaver draws some useful connections between the painters' preoccupation with rough weather, moonlight, urban dereliction, significant shadows, pleasing decay, churchyard trees, and iden-tical features in such films as Olivier's *Hamlet*, Orson Wells's *The Third Man*, David Lean's *Great Expectations* and *Oliver Twist*. Even Dylan Thomas's radio play *Under Milk Wood* and Benjamin Britten's opera *Peter Grimes* seem to conjure up Neo-Romantic echoes. Sutherland's 'Freudian topography' he also discovers in the books of the time such as *Rebecca, Cold Comfort Farm, The Hobbit, Titus Groan* and *The Borrowers* in their 'condensed, alternative worlds, crammed with sudden terrors and compensating close-up wonders'. It was there too in John Wyndham's bestseller in which 'Sutherland's *Standing Form Against Hedge* was pushed aside as the hedgerow itself revolted and tottered forward, flailing, rattling and devastating in *The Day of the Triffids*: Ayrton's "sense of unremitting war fought by trees" at last

* This biased and over-simplified history takes no account of those artists who continued to be both painterly and figurative, no matter what the current fashion – painters such as Piper, Bacon, Freud, Herman, Bomberg, Kossoff, Andrews, Auerbach, and others.

endorsed by sci-fi.'[10]

A book Feaver offers in both articles as the epitome of Neo-Romanticism is Geoff-rey Household's thriller *Rogue Male* (1946) in which the fugitive English hero literally goes to earth beneath a hedgerow in a Dorset lane, digging through the roots and covering his bolt-hole entrance with thorn bushes. True, all the props are there, but not the spirit since the landscape remains prosaically factual – a place from a map rather than a mind. A better candidate might be Herbert Read's only novel, *The Green Child* (1935), a kind of folk tale raised to the level of fantasy, which Graham Greene praised warmly in the pages of *Horizon*. The hero-narrator returns to his Yorkshire village to find the river now flowing backwards to its fountain-head. He rescues the Green Child, a kind of embodied *genius loci*, from her brutal husband and together they sink beneath the moonlit waters of the river's source only to re-emerge in another world hidden beneath the limestone Dales of Yorkshire. This is more the landscape where a Craxton poet might dream, or Vaughan's boys plunge into black pools downstream from Piper's Gordale Scar, or Nash stumble on a Nest of Wild Stones or Nightmare's Tails. It is a precursor of the later literary fashion for Magic Realism – and that, in retrospect, might have been a good appellation for some aspects of the movement we have been studying.

Feaver's articles, brief and flippant as they were in tone, represent the only critical notice taken of Neo-Romanticism between the 1950s and the Fischer Gallery exhibi-tion of their works in July 1983. Then older reviewers welcomed these reminders of their own youth and told the public the movement was 'not just a momentary, unserious escape into fantasy, but a real reflection of the tone of the times, a dark dream which many artists, major and minor, to some extent shared.'[11] 'A show to be savoured and pondered,' they urged, 'On no account to be missed.' Several of the younger critics who scarcely remembered the war, and who had been used to turning an annual volte-face to cope with each new trend, were in some diffi-culties trying to respond to this group of individualists who appeared to be both escapist and making official war propaganda; who presented Nature at her most idyllic, but also saw the menace in a sprig of gorse; who glanced nostalgically back to Palmer and Blake for inspiration yet freely borrowed effects from the latest Con-tinental developments, and who successfully steered a course between the safely academic and the wildly avant-garde. Here were artists who made no pretensions to cosmopolitanism, and produced works which were unfashionably inoffensive, literary, unpolitical and treated the past without irony.

The *Guardian* critic was more sympathetic than many, but after viewing Minton's *London Street* (1941) and Keith Vaughan's lumpen figures wrote:

Since its demise in the early Fifties it has been difficult to view British Neo-Romanticism with any degree of affection, or to wish sincerely for its critical rehabilitation. It still seems too intense, too obsessively pessimistic for the modern age. We have tried to forget it for the same reasons that we have tried to forget the times it came from. Its colours are the colours of camouflage paint. Its emo-tions were the loud, sobbing, barely controllable emotions of the war years.[12]

I cannot share his belief in their narrow range or wild pessimism, and neither would Peter Fuller, a critic who welcomed the re-appearance of Neo-Romanticism, or English Pastoralism as he preferred to call it, as a sign of hope and sanity in our own disjointed times since: 'it stands as a continuing secular image of man's reconciliation to himself, of reconciliation between man and man, and, indeed, between man and nature.'[13]

In early 1987 a major exhibition of 'British Art in the Twentieth Century' was mounted at the Royal Academy – a long overdue sequel to their 1934 exhibition of 'British Art 1000 to 1860 AD' which Fry had so dismissively reviewed. The sub-title of this new exhibition was 'The Modern Movement' and the catalogue began with a Fry-like claim that,

> The strongest theoretical tendency guiding the formative years of modern art was the growing sense that painting and sculpture speak for themselves – that the full and proper use of shapes, lines and colour has meaning in itself without literary or metaphorical interpretation.[14]

The works chosen for display largely demonstrate how the English tradition was gradually subordinated to this view by large borrowings from the Modernist movements in France, Germany and America. One of the organizers took the view that,

> ... British art needs a constant influx of new ideas from abroad; history is littered with the corpses of artists who exhausted their talents quickly because they were not nurtured by the wider scene. The problem of British art is seen as one of expressive energy and vigour: when isolated from Europe, British Art becomes febrile and enervated; it is the way foreign influences have reinforced native traditions that is of special interest.[15]

Using these criteria Nash was well represented at the Royal Academy as a war-artist and a Surrealist, Piper appeared only as the painter of one abstract work, and Sutherland's four landscapes were seen as examples of 'metamorphic Surrealism'. All the other Neo-Romantics were evidently considered too insular to be included in an exhibition of 'The Modern Movement'.

Many reviewers regretted this omission. Peter Fuller returned to the defence of British art by saying its reputation for 'politeness, provincialism, and even timidity' was a travesty, and its failure to make a significant contribution to international Modernism might actually be seen as one of its strengths. He continued:

> The argument I want to put forward here is that – criticism notwithstanding – the best British art of this century has, in fact, adopted a stance of informed resistance towards Modernity: though it has often made use of Modernist devices, it has done so in order to replenish and develop a specifically British tradition. This tradition has affirmed aesthetic values quite other than those of Modernism; values which are, at bottom, conservationist, even conservative: and herein lies

the strength of British art, and indeed, its potential relevance to the 'Post-Modern' world.[16]

Typically our twentieth-century painters, and here Fuller must have the Neo-Romantics strongly in mind, have been grudging in their accommodation of Modernism: 'in particular the British tradition has consistently rejected those aspects of Modernism which seem to lead away from nature: our artists have shown a preference for an aesthetic derived, ultimately, from imaginative response to natural form rather than from 'significant form', mechanical form, abstract form, or whatever.'[17] The researches for this book have led me to the same conclusion.

As if to compensate for the Royal Academy exhibition's neglect six weeks later the Barbican Art Gallery opened 'A Paradise Lost: The Neo-Romantic Imagination in Britain 1935–55'.[18] As with the 1983 Fischer exhibition the reviewers' reactions were mixed for it seems that, as yet, there is no critical concensus as to the status of the Neo-Romantic painters. My own belief is that they were far from negligible. They responded seriously to a need for an art which would help us define our national identity when that need was most urgent. To do this they drew upon a long and honourable English tradition, translated it into accessible, but twentieth-century terms, and left it healthy and enriched ready for the next group of painters who might wish, one day, to take it up and carry it forward again.

REFERENCES

1. Connolly, Cyril, *Horizon*, Vol. XX, Nos. 120–121, December 1949–January 1950.
2. Eliot, T. S., *Notes Towards a Definition of Culture*, (London 1948), p. 19.
3. Piper, John, 'A Painter's Funfair' in *A Tonic for the Nation*, (London 1976), p. 123.
4. Lewis, Wyndham, *Rotting Hill*, (London 1951), Envoi p. 30.
5. Banham, Reyner, 'The Style: "Flimsy . . . Effeminate?" ' in *A Tonic for the Nation*, (London 1976), p. 194.
6. Révai, Andrew (Ed.), *Sutherland: Christ in Glory in the Tetramorph*, (London 1964).
7. Berger, John, 'Looking Forward' in catalogue to *The Forgotten Fifties* exhibition, Graves Art Gallery, Sheffield, March 1984, p. 46.
8. Maclaren-Ross, Julian, *Memoirs of the Forties* (London 1984), p. xv.
9. Feaver, William, 'Rogue Males,' *London Magazine*, June/July 1972, pp. 124–136, and 'Wartime Romances,' *Sunday Times Magazine*, May 20, 1973, pp. 74–85.
10. Feaver, William, ibid., *Sunday Times*, p. 85.
11. Taylor, John Russell, *The Times*, July 19 1983.
12. Januszczak, Waldemar, the *Guardian*, August 3, 1983.
13. Fuller, Peter, 'Neo-Romanticism: A Defence of English Pastoralism' (1983),

republished in *Images of God: the Consolations of Lost Illusions* (London 1985), p. 89.

14. Gore, Frederick, 'Introduction' in *British Art in the 20th Century: The Modern Movement*, catalogue, (London 1987), p. 9.

15. Causley, Charles, 'The Modern in British Art' in *Art and Design*, Vol. 3, No. 1/2 1987, p. 49.

16. Fuller, Peter, 'British Art An Alternative View' in *Art and Design*, Vol. 3, No. 1/2 1987, p. 57.

17. Fuller, Peter, ibid., p. 60.

CHRONOLOGY
1930–1956

IN 1930 the major individuals mentioned in this book had attained the following ages: Roger Fry 64, Wyndham Lewis 48, Paul Nash 41, Herbert Read 37, Ben Nicholson 35, Henry Moore 32, John Piper 27, Graham Sutherland 27, Kenneth Clark 27, Francis Bacon 20, Keith Vaughan 18, Robert MacBryde 17, Robert Colquhoun 16, John Minton 13, Prunella Clough 11, Michael Ayrton 9, John Craxton 8. (In the following outline of the major artistic and national events, the nine artists who have been the main subjects of this book (Nash, Piper, Sutherland, Vaughan, Colquhoun, Minton, Clough, Ayrton and Craxton) will be referred to by initials only.)

1930

P.N. Death of father. Visits Paris and Toulon. Moves to Rye in Sussex. Begins to illustrate *Urne Buriall*. First asthma attack. Takes up photography.

J.P. Painting Sussex shore and Cinque Ports.

G.S. Visits Dorset and Devon. Begins to use oils after collapse of etching market, also much design work for the next decade. 1927–1939 two days per week teaching at Chelsea School of Art, first etching, then book illustration. Living with wife (m. 1927) in Farningham, Kent.

K.V. Leaves boarding school in Sussex. Begins to work in advertising agency. Weekend painting to 1938.

R.C. At school in Kilmarnock. Robert MacBryde working in factory in Maybole.

J.M. At Reading School, Berkshire.

P.C. At school in London.

M.A. At school in London.

J.C. At school in London.

W. Lewis: *The Apes of God*; T. S. Eliot: *Ash Wednesday*; E. Sitwell: *Collected Poems*; W. H. Auden: *Poems*, E. Waugh: *Vile Bodies*.

1931

P.N. Visits USA as English representative on International Jury of Pittsburg Carnegie Exhibition.

J.P. Exhibits with London Group. Studies Segonzac. Begins to make 'constructions'.

G.S. Moves to Eynsford in Kent. Visits Dorset. Commutes to teach at Chelsea College – Henry Moore also on staff.

K.V. Working at advertising agency.

R.C., J.M., P.C., M.A., J.C. continue at school.

Henry Moore's first one-man show. Picasso exhibition at Lefevre. Herbert Read: *The Meaning of Art*. Ben Nicholson living in Hampstead (1931–9) alongside Read, Moore and Hepworth. Matisse: *The Dance*. W. Lewis writes articles supporting Hitler. Epstein carves *Genesis*.

1932

P.N. Becomes President of Council of Society of Industrial Artists. Begins to write art criticism for *The Listener*, alternating with Herbert Read. *Urne Buriall* published (Cassell).

J.P. Exhibits with New English Art Club (1932–4), London Group and 7 & 5 Society.

G.S. Continues to teach at Chelsea. First Shell-Mex posters. Continues to design fabrics, ceramics, glass, posters, etc. to outbreak of war.

K.V. Working at advertising agency.

R.C. Wins scholarship to Glasgow School of Art. Meets Robert MacBryde. Both study in Glasgow until outbreak of war, with occasional trips to Paris.

J.M., P.C., M.A., J.C. At school – though J.C. takes part in Bloomsbury exhibition of paintings opened by Professor Tonks of the Slade.

Exhibition of French Art 1200–1900 at the Royal Academy. Picasso painting series of sleeping women – also has Paris retrospective. Auden: *The Orators*, John Strachey: *The Coming Struggle for Power*. Lucien Freud arrives in England from Berlin. Aldous Huxley: *Brave New World*. Hunger marches. British Union of Fascists founded. Unemployment: Great Britain 2·8 m, Germany 5·6 m, USA 13·7 m.

1933

P.N. Serious asthmatic condition begins. Founds Unit One (June). Sees Avebury for first time. Sells house in Rye. In winter 1933–4 visits Paris, Riviera, Spain and North Africa.

J.P. Making collages. Begins as art and theatre critic for *The Listener* and *New Statesman*. Friendship with Ivon Hitchins begins.

G.S. Moves to Sutton-at-Hone in Kent. Visits Cornwall and Dorset. 'Expelled' from Royal Society of Painter-Etchers and Engravers.

K.V. At advertising agency.

R.C. At Glasgow Art College. Others still at school.

Nicholson has one-man show at Lefevre (others in '35, '37, '39, '45, '47, '48, '50, '52, '54) – also introduced to Mondrian by Moholy-Nagy. He and Hepworth visit Paris and join international Abstract-Creation group. Nicholson makes first all-white abstract relief. Artists' International Association (AIA) founded to oppose Fascism and bring art to the people. Herbert Read returns to London after two years as Professor of Fine Arts in Edinburgh. Roger Fry accepts Slade Professorship at Cambridge. Herbert Read: *Art Now*. Hitler becomes German Chancellor. Bauhaus closed. German intellectuals and artists begin to leave Germany. Orwell: *Down and Out in Paris and London*.

1934

P.N. Stays in Romney Marsh area. Winter in Isle of Purbeck, Dorset. Avebury paintings.

J.P. Elected to 7 & 5 Society, becomes secretary with Nicholson as chairman. Makes abstract 'constructions'. Meets Myfanwy Evans and begins work with her on *Axis* magazine.

G.S. Makes first visit to Pembrokeshire – returns again in '35, '36, '37, '38, '39. Meets Kenneth Clark and patron Colin Anderson.

K.V. At advertising agency.

R.C. At Glasgow Art College. Others at school.

Unit One exhibition in April and accompanying publication has introduction by Herbert Read. Nicholson marries Barbara Hepworth. 7 & 5 exhibition at Leicester Gallery in March. British Council founded with grant aid for 1935 of £6000. Death of Fry. K. Clark appointed Director of National Gallery. H. Read: *Art and Industry*. Dylan Thomas moves to London and *18 Poems* is published. J. B. Priestley: *An English Journey*. Hitler becomes Führer. British Fascist Party has peak membership of *c*. 30,000.

1935

P.N. Compiles *Shell Guide to Dorset*. Unit One disintegrates. Exhibits water-colours at Redfern.

J.P. Visits France. Impressed by Picasso's 1912–19 papiers-collé in Paris. Visits Arp, Helion, Brancusi and Calder. Impressed by Dufy. First abstract paint-

ings, shown in last exhibition of 7 & 5 Society at Zwemmer Gallery – England's first totally abstract exhibition. Helps Myfanwy Evans publish quarterly *Axis* – runs to winter 1937. Moves to Fawley Bottom, Henley, his home to this day. Broadcasts for first time.

G.S. Painting in Kent and Pembrokeshire.

K.V. Still only a weekend painter but begins to read Gide.

R.C. At Glasgow Art College.

J.M. Leaves school to study at St. John's Wood School of Art, London to 1938.

M.A. Leaves school to begin travels in Europe.

P.C. and J.C. at school.

AIA's first major exhibition 'Artists Against Fascism and War.' Moholy-Nagy and Gabo arrive in England. David Gascoyne: *A Short Survey of Surrealism*; Herbert Read: *The Green Child*; Cyril Connolly: *The Rock Pool*; Auden and Isherwood: *The Dog Beneath the Skin*. Penguin Books founded. Picasso makes *Minotauromachie* etching and weeping women paintings. Italy invades Abyssinia. S. and B. Webb: *Soviet Communism: A New Civilization*. British Council founded.

1936

P.N. Moves to Hampstead. Joins organising committee for International Surrealist Exhibition in London and has twelve exhibits.

J.P. Makes first television programmes on art. Takes part in first International Exhibition of Abstract Art (Oxford, Cambridge, Liverpool, London). Helps organise Contemporary Lithographs. Collage landscapes of torn paper. Meets Betjeman. First painting visit to Wales.

G.S. Rents house in Trottiscliffe, Kent. Has two oils in International Surrealist Exhibition. Writes 'A Trend in English Draughtsmanship' in *Signature*.

K.V. Weekend painting.

R.C. Glasgow Art College.

J.M. St. John's Art College.

P.C. At school.

M.A. Studying in Vienna. Father dies.

J.C. Visits Paris and sees Picasso and Miró works.

British Surrealist Group founded. Herbert Read edits *Surrealism*. Dylan Thomas: *25 Poems*. Victor Gollancz begins Left Wing Book Club. Spanish Civil War begins (July). John Lehmann founds *New Writing*. Edith Sitwell: *Selected Poems*. Stalin purges 'Old Bolsheviks'. Abdication crisis in England. Nazis achieve wide success in elections.

1937

P.N. Exhibits at Redfern. Asthma worsens.

J.P. Marries Myfanwy Evans. Visits Wales and Ireland. Friendship with Nash and Frances Hodgkins. Writes 'Lost a Valuable Object'. Begins return to figurative painting. With Myfanwy produces *The Painter's Object*. Visits Paris and meets Calder. Sees Picasso's *Guernica*. Six television broadcasts.

G.S. Moves into White House, Trottiscliffe, his English home for the rest of his life. Visits Pembroke. Contributes 'An English Stone Landmark' to *The Painter's Object*.

K.V. Visits France. Sees Gauguins and French Impressionists.

R.C. Influenced by Wyndham Lewis's works on show in Glasgow. Still in College.

J.M. At St. John's Wood Art College.

P.C. At school.

M.A. Visits Brussels and Paris.

J.C. at school.

Nicholson, Naum Gabo and J. L. Martin publish *Circle*, a survey of international constructivist art. Euston Road School of realist painters founded. Mass Observation founded. Wyndham Lewis exhibition at Leicester Gallery. Picasso paints *Guernica* after this village is bombed in Spanish Civil War. Mosley's Fascist marches. Orwell: *Road to Wigan Pier*. 'Degenerate Art' exhibition in Munich. Hitler opens 'Great German Art' exhibition. Herbert Read: *Art and Society*; Auden and Isherwood: *Ascent of the F6*; W. Lewis: *Blasting and Bombardiering*. Paris World Fair.

1938

P.N. Exhibits in Paris International Surrealist Exhibition. Also in English Pavilion Venice Biennale. Part-time teaching at Royal College. Visits Gloucester and Forest of Dean.

J.P. One-man show at London Gallery of abstracts and collages (catalogue introduced by Nash). Writes *Shell Guide to Oxfordshire*. Designs scenery for Stephen Spender's *Trial of a Judge*. Visits Wales. Begins occasional radio work on art until 1939.

G.S. One-man show at Rosenberg and Helft Gallery, London (catalogue introduction by K. Clark). Visits Pembroke. Sees *Guernica* when it is shown in London in October – most artists see this.

K.V. Still in advertising agency.

R.C. Wins travel scholarship and leaves for Italy and France with MacBryde.

J.M. Leaves art college and spends eight months in France, some of it with M.A.

P.C. Attends Chelsea School of Art to study sculpture and graphics.

M.A. In France with J.M. Visits studios of de Chirico and Berman.

J.C. Refused entry to Chelsea School of Art. Sees work of G.S. for first time.

W. Lewis's portrait of T. S. Eliot rejected by Royal Academy. Mondrian moves to London. Hoard of Turner canvases found in National Gallery, whilst rehearsing evacuation of treasures in case of of war. B. Falk: *Turner the Painter: His Hidden Life*; Orwell: *Homage to Catalonia*; Graham Greene: *Brighton Rock*; Cyril Connolly: *Enemies of Promise*; H. Read: *Poetry and Anarchism.* Germany mobilised. Franco enters Catalonia.

<p style="text-align:center">*1939*</p>

P.N. Moves to Oxford. At outbreak of war organises Arts Bureau to involve artists in war effort. Visits Wales. Asthmatic condition worsens.

J.P. Visits Shropshire with Betjeman to research Shell Guide. *Brighton Aquatints* published. Designs first cover for *Horizon.* Paints at Hafod in Wales, Stourhead, Fonthill and Brighton. With his wife joins Church of England.

G.S. Continues to teach one day per week at Chelsea until June 1940. Stays for twelve months as guest of Kenneth Clark in Gloucestershire. Visits Pembroke in winter. Paints *Entrance to a Lane* and *Gorse on Sea Wall.*

K.V. Excursions to Pagham near Selsey – photographs male nudes. Leaves Lintas to paint full-time before call-up, mostly landscapes in Surrey.

R.C. Returns from France as war declared. Paints in Ayrshire.

J.M. Returns to London as war begins. Collaborates with M.A. on stage designs for *Dido and Aeneas.*

P.C. Has to leave Chelsea Art College to do war work until 1945. Mainly clerical.

M.A. Returns from France with J.M. First works shown in mixed exhibition at Zwemmers.

J.C. Returns from Paris where he had studied in Louvre and drawn from life.

New Verse stops publication. *Horizon* magazine founded. Closure and evacuation of main London art colleges. London galleries begin to close, many for duration of war. *Poetry London* begins. A. J. Finberg: *The Life of J. M. W. Turner.* Auden and Isherwood leave for USA. National Gallery evacuated 3,000 treasures to Wales. War Artists' Advisory Committee (WAAC) founded with K. Clark as chairman and grant of £10,000. Council for Education in Music and Arts (CEMA) founded. Isherwood: *Goodby to Berlin.* Nicholson and Hepworth move to St. Ives. Conscription announced in April. End of Spanish Civil War as Franco enters Madrid. Urban evacuations begin June-September. Hitler and Mussolini sign ten-year 'Pact of Steel'. England and France declare war on Germany 3 September. Communist Party of Great Britain achieves highest ever membership. Russian-Nazi Non-Aggression Pact. Picasso remains in Paris for duration of war. R. Fry's *Last Lectures* (ed. Kenneth Clark). Freud and Yeats die.

1940

P.N. Asthma now acute. Resigns from teaching. Appointed Official War Artist to Air Ministry in January.

J.P. Appointed War Artist to Ministry of Information and Ministry of War. Exhibits Welsh paintings at Leicester Gallery. Works for Recording Britain. November, paints bombed Coventry Cathedral. Later bombed churches in Bristol and London. Meets Osbert Sitwell. Reading nineteenth-century poetry, collecting early guidebooks on picturesque.

G.S. Exhibits at Leicester Gallery. Made Official War Artist. Paints airfields in Wiltshire, tin-mining, quarrying, bomb damage in Swansea. Visits Pembroke. Designs décor and costumes for *The Wanderer* ballet, produced in London January 1941.

K.V. Now in Pioneer Corps as non-combatant conscientious objector, after some months in Medical Corps. Arrested for painting a tank trap near Guildford.

R.C. Conscripted into Royal Medical Corps. Stationed in Edinburgh, then Leeds. MacBryde rejected for service as unfit.

J.M. Registers as conscientious objector. Painting moonlit London dockland and street scenes.

P.C. War work as draughtswoman and clerk.

M.A. Exhibition of paintings at Zwemmer Gallery.

J.C. Studies briefly at Westminster and Central Schools of Art, London.

Worst winter for forty-five years (January–February). Moore begins Shelter Drawings. Adler and Herman arrive in Glasgow. First exhibition of war art in National Gallery. Koestler: *Darkness at Noon*; Dylan Thomas: *Portrait of the Artist as a Young Dog*. Death of Klee. Battle of Britain. Blitz begins. London bombed for fifty-seven consecutive nights in autumn. Evacuation of children from cities. Fall of France (June). Dunkirk evacuation. Germans enter Paris. Picasso works on unscathed. Germans invade Norway, Denmark, Holland, Belgium and Luxembourg. Churchill replaces Chamberlain as Prime Minister. *Horizon* magazine first issue (January). G. Greene: *The Power and the Glory*; V. Woolf: *Roger Fry* (biog). Tate Gallery bombed. Food rationing begins. Lehmann's magazine becomes *Penguin New Writing*.

1941

P.N. Working on paintings for WAAC. Visits Wales in July.

J.P. Makes Windsor Castle water-colours for Queen Elizabeth. Also paints Sitwell's Renishaw (and continues to do so on and off through war years). Exhibits with G.S. and Moore in Leeds and London. Paints bombed Houses of Parliament (May). Also paints Seaton Delaval and ruined cottages and barns.

G.S. Exhibits with J.P. and Moore. Visits Pembroke. Painting bombed buildings in London and Cardiff.

K.V. With Pioneer Corps in various camps in south and Yorkshire. Drawing in small sketch-books scenes of army life.

R.C. Collapses and invalided out of army (February). He and MacBryde move to London and stay with Peter Watson. Meet other young painters. Move to own studio in Notting Hill. R.C. continues as part-time ambulance driver in Civil Defence. Paints at night.

J.M. Withdraws objections and joins Pioneer Corps. With MA designs décor and costume for Gielgud's *Macbeth* (produced 1942).

P.C. War work.

M.A. Serving in RAF. Interest in occult begins. Paints Minton's portrait.

J.C. London home destroyed by bombs. Meets Peter Watson. Rejected for military service. Paints still-lifes and animals. Studies at Goldsmiths College to 1942.

Moore's Shelter drawings. H. Read: *To Hell with Culture*. Euston Road group exhibit in Oxford. Severe rationing begins. Bombing of cities continues. Suicide of V. Woolf. Death of Joyce. Germans invade Russia. USA enters war. House of Commons bombed (May). Worst raids on London so far on 16 April (450 planes drop 100,000 tons of bombs in 8 hours). Again three days later and worse in May. Heavy civilian casualties. Winter 1941–2 very severe with fuel shortages. A year of defeats and hardships.

1942

P.N. Continues as War Artist. Exhibits water-colours at Redfern Gallery.

J.P. Paints front cloth for revival of Edith Sitwell's *Façade*. Paints Sitwell's Renishaw Hall. *British Romantic Artists* (Collins) published. Paints bombed churches in Bath and Gordale Scar, Yorkshire. Betjeman commissioned by K. Clark to write monograph on Piper for Penguin Modern Painters series.

G.S. Visits Wales and Cornwall. Paints tin-mines. 'A Welsh Sketch-Book' published in *Horizon* (April).

K.V. Gets to know Minton, Peter Watson and Graham Sutherland. Small exhibition of drawings at Lefevre Gallery.

R.C. Still showing Lewis's influence. R.C. and MacBryde both in 'Six Scottish Painters' exhibition at the Lefevre.

J.M. Shares joint exhibition with M.A. at Leicester Galleries.

P.C. War work.

M.A. Invalided out of RAF. Teaches life drawing and theatre design at Camberwell. Lives with Joan Walsh to 1949. Begins series of St. Anthony pictures which continue to 1946.

J.C. Visits Wales and Dorset. Shares studio with Lucien Freud – to 1944. Peter Watson introduces him to G.S. Small exhibition of drawings at Swiss Cottage.

Tate Gallery exhibits ten newly acquired works by Blake. Geoffrey Grigson: *The Romantics.* Tate is bombed and closed. *New Writing and Daylight* begins and published to 1946. E. Waugh: *Put Out More Flags*; Edith Sitwell: *Street Songs.* Francis Bacon rejected for military service. Germans reach Stalingrad and control whole of France, also launch V2 rockets. Loss of Singapore. *Life of William Blake* by A. Gilchrist re-issued (ed. R. Todd). Beveridge Report. Severe rationing. Third bad winter with continued fuel shortages. Baedeker raids begin (April).

1943

P.N. Exhibition of Applied Design at Ashmolean Museum, Oxford. Retrospective exhibition with Hepworth in Leeds.

J.P. Décor and costume for Ashton's ballet *The Quest.* Visits Snowdonia. War work: window blasting experiments. Illustrates O. Sitwell's autobiography Vol. 1. Paints in Devon and Cornwall.

G.S. Visits Wales and Derbyshire. J.C. and Peter Watson join G.S. during summer painting expedition in Pembrokeshire. Illustrates D. Gascoyne's poems. *Graham Sutherland* by E. Sackville-West published in Modern Painters Series.

K.V. Influenced by conversations with G.S. Begins to study English nineteenth-century painters.

R.C. Jankel Adler moves into studio in same house as R.C. and MacBryde. Exhibits at Lefevre. Visits Cornwall to stay with poet Sidney Grahem.

J.M. Discharged from Army. Teaches illustration at Camberwell 1943-6. Period of Palmer influence via G.S. Shares studio with R.C. and MacBryde to 1946.

P.C. War work, though now friends with R.C. and through him meets other artists.

M.A. Teaching at Camberwell. Influenced by Nash. Paints *Joan in the Fields.* Shows *Temptation of St. Anthony* in first one-man show at Redfern.

J.C. Drawing dead animals. Visits Dorset then Pembrokeshire with G.S. and Peter Watson.

AIA open cultural centre in Charlotte Street, directed by Marxist critic F. D. Klingender. National Gallery exhibition of war art. Moore's *Madonna and Child.* H. Read: *Education Through Art.* George Barker returns to UK. D. Gascoyne: *Poems 1937–1942.* German retreat from Russia begins. Allies land in Italy. Enthusiasm for Russians grows after defeat of Germans at Stalingrad in January.

1944

P.N. *Paul Nash* by Herbert Read in Penguin Modern Masters published.

J.P. Paints Cardiff transport and shipping subjects for WAAC. Illustrates *English, Scottish and Welsh Landscapes 1700–1860* by Betjeman and G. Taylor.

Appointed Tate trustee. *John Piper* by Betjeman in Penguin Modern Painters series. Resigns as art critic of *Spectator*, M.A. takes over.

G.S. Visits Wales – in Pembroke with J.C. and Freud. First trip abroad to paint RAF bombing damage at Trappes (November). Visits Paris on way home. Commissioned to paint a *Crucifixion*.

K.V. First one-man show at Lefevre of drawings. Articles on Klee and British Art in *Penguin New Writing*.

R.C. One-man show at Lefevre. Commissioned to paint a factory making army cloth in Peebles.

J.M. Draws *Surrey Landscape* and other works under Palmer influence.

P.C. War work.

M.A. Broadcasts attack on Picasso 'The Master of Pastiche' – later printed. Visits Nash. Shares house with Constant Lambert. Designs ballet *Le Festin de l'Araignée*. Becomes *Spectator* art critic after J.P.

J.C. One-man show at Leicester Galleries. Visits Dorset and Pembroke with G.S. Moves into own studio in Clifton Hill. Begins *Poet's Eye* illustrations. Visits Swanage. Under Nash's influence.

Henry Moore by Geoffrey Grigson in Penguin Modern Painters Series. E. Sitwell: *Green Song*. Olivier's *Henry V* film. Nicholson retrospective at Leeds City Art Gallery. J. Bronowski: *William Blake*. Moore made Hon. D. Lit. at Leeds, his *Madonna and Child* installed in Northampton. Normandy landings. Paris liberated. Allies enter Rome. D-Day: 156,000 troops go into France 6 June. Warsaw rising suppressed. Flying bombs fall on London from June and V2s from September. 'Blackout' restrictions relaxed (September). Death of Pissaro and Kandinsky. Picasso joins Communist Party. Coldest Christmas in fifty years.

1945

P.N. Exhibits water-colours at Tooth's Gallery. Painting sunflower pictures. Sent to nursing home to rest (November). Does 'sunset' water-colours.

J.P. Designs scenery for Olivier's *Oedipus Rex* at Old Vic. Exhibits *Sitwell Country* at Leicester Galleries. O. Sitwell's first volume of autobiography appears with J.P's illustrations.

G.S. Visits Wales. Friendship with Francis Bacon begins. Buys White House at Trottiscliffe. Begins series of Thorn Heads.

K.V. Still clerk and interpreter in Yorkshire POW camp. Reading French literature. Included in mixed show of Young Painters at Lefevre.

R.C. Visits Wivenhoe, Essex. Animals and boating themes.

J.M. One-man show at Roland Browse and Delbanco. Also at Lefevre.

P.C. Living with parents in London but visits East Anglia. Starts beach scenes.

M.A. Exhibits at Redfern. Illustrates *Poems of Death* and *Duchess of Malfi*. Visits Wales and meets G.S. there. Apple-tree drawings influenced by Palmer.

J.C. Visits Pembrokeshire. Also Scilly Isles with L. Freud. Both visit Nicholson

in St. Ives who is now doing linear still-life and landscape paintings rather than reliefs.

Bacon's *Three Figures at Base of a Crucifix* shown (April). Dresden fire–bombed (14 February). Picasso and Matisse exhibitions in V & A Museum, London, in autumn. National Gallery reopens with fifty paintings. Wyndham Lewis returns to England and lives near R.C. CEMA becomes Arts Council. Labour victory in election. Orwell: *Animal Farm*; E. Sitwell: *Song of the Cold*. Britten: *Peter Grimes*. Hitler and Mussolini die (April). Germany surrenders (May). Japan atom-bombed (August) then surrenders. K. Clark ends period of National Gallery Directorship. Concentration camps opened (April). 355,000 Britons killed in war at home and abroad. Severe food, housing shortages – rationing continues.

1946

P.N. Develops acute pneumonia (January). Dies of heart failure in sleep (11 July).

J.P. Designs Britten's *Rape of Lucretia* for Glyndebourne. Illustrates J.M. Richard's *Castles on the Ground*. Summer spent in Snowdonia. Appointed trustee of Tate Gallery (1946–53, 1953–61, 1968–74).

G.S. First New York exhibition. Short summer visit to Paris. Autumn finishes *Crucifixion* after eighteen months of studies. Teaching part-time at Goldsmith's College.

K.V. Demobbed. Minton obtains post for him teaching illustration at Camberwell. One-man show of paintings and gouaches at Lefevre. Shares studio with Minton until 1952. Shares Lefevre show with Julian Trevelyan.

R.C. Spends eight weeks in Ireland. Begins monotypes. Beggars and women with cats series. Adler strong influence now. Third exhibition at Lefevre.

J.M. Leaves Camberwell to teach drawing and illustration at Central School until 1948. Leaves R.C. and MacBryde's house to share with K.V. at Belsize Park until 1952.

P.C. Lives in London but frequent visits to East Anglia. Beach scenes and fishing.

M.A. *British Drawings* published. Gets to know W. Lewis. Illustrates *Clausentum*. Final version of *Temptation of St. Anthony*. Visits Pembroke and G.S.. Designs masque, *The Fairy Queen*, for Covent Garden. Visits Italy for first time.

J.C. British Council exhibition of his works in Athens. Visits Paris, Zurich, Berne, Athens, Poros, Greek Islands, Paris and back to London. In group show at Lefevre.

British Council organises tours of British paintings round European capitals. W. Lewis becomes art critic of *The Listener*. K. Clark Slade Professor of Art at Oxford to 1950. Braque and Picasso exhibitions in reopened Tate Gallery. Turner touring exhibition sent around Europe. Tate buys first Surrealist work (Ernst) and first Cubist (Gris). Ruthven Todd: *Tracks in the Snow*; Dylan Thomas: *Deaths and Entrances*. Robin Ironside mentions 'Neo-Romanticism' in *Since 1939* booklet. Arts Council

tours exhibition 'Four Young British Painters' (Ayrton, Minton, Vaughan, William Scott). Mervyn Peake: *Titus Groan*. Picasso working on pottery in Vallauris.

1947

J.P. Designs Britten''s *Albert Herring* at Glyndebourne. Begins water-colour series of Romney Marsh (published 1951). Buys cottage in Snowdonia. Goes with O. Sitwell to Montegufoni, Italy.

G.S. First visit to South of France. Paints palms, cacti, vines, cigale, etc. Meets Picasso and Matisse. Sees Picasso Museum at Antibes.

K.V. Illustrates *Tom Sawyer* (pub. Elek).

R.C. Evicted from Bedford Gardens studio. Exhibits at Lefevre – Irish themes. Offered working space and lithographic facilities in Lewes, Sussex. Illustrates *Poems of Sleep and Dream*.

J.M. Designs and illustrates *The Wanderer* by Alain Fournier. Also *Treasure Island* (pub. Lehmann). Visits Corsica with Alan Ross.

P.C. First solo exhibition at Leger Galleries.

M.A. Visits Italy with Constant Lambert. Studies Pisano sculptures and Renaissance fresco art. Lambert marries and leaves their shared house. Illustrates Nash's *Unfortunate Traveller*. One-man exhibition at Redfern Gallery.

J.C. Shares exhibition with L. Freud at London Gallery.

Peter Watson, Roland Penrose and Herbert Read found Institute of Contemporary Art (ICA) – first exhibition called '40 years of Modern Art'. WAAC disbanded and works distributed. Geoffrey Grigson: *Samuel Palmer: The Visionary Years*; E. Sitwell: *The Shadow of Cain*. Summer drought followed by terrible winter. Economic crisis and austerity intensifies.

1948

J.P. Designs Vaughan Williams' ballet *Job* with Blake-inspired motifs. New York exhibition. Designs *Il Trovatore* for Sadler's Wells. *Murray's Architectural Guide to Buckinghamshire* (with Betjeman). Exhibition at Leicester Gallery. Painting in Portland and Snowdonia.

G.S. Appointed Tate trustee. Exhibits at New Hanover Gallery and in New York. Meets Maugham at St. Jean Cap Ferrat.

K.V. Moves from Camberwell to Central School of Art (to 1957). Visits Paris and is impressed by de la Fresnaye retrospective. Exhibits in New York. Also exhibits at Lefevre.

R.C. Lefevre exhibition of drawings. Commissioned by Massine to design ballet *Donald of the Burthens*. George Barker suggests they make a book on Italy to be published by Lehmann. Still living at Lewes.

J.M. Lefevre exhibition. Leaves Central School to teach painting at Royal College

of Art (to 1956). Exhibits in New York. Travels in Spain. *Time Was Away* published.

P.C. Impressed by Klee exhibition in London. Still painting coastal themes.

M.A. *Paintings by Michael Ayrton*, introduced by J. Laver, published. Illustrates *Portrait of Dorian Gray*. Portraits of William Walton and Norman Douglas. Visits Italy again. One-man show at Hanover Gallery.

J.C. Does series of portrait drawings. Travels through Paris, Athens, Poros, Crete.

Paul Nash memorial exhibition in Tate Gallery March-April. H. Read *Art Now* (enlarged edition). British Council exhibition in Paris: G.S., J.C., K.V., J.M., all represented. Victor Pasmore abandons landscapes for abstraction. M. Wilson: *The Life of William Blake*. Moore wins international Prize at Venice Biennale. Pollock begins drip paintings. Left Book Club dissolved. Olivier's film *Hamlet*. Auden: *The Age of Anxiety*. 'Cold war' begins. Berlin blockade. T. S. Eliot: *Notes Towards a Definition of Culture*. End of bread rationing. Pollock paints *Composition No. 1*. Betjeman: *Collected Poems*.

<div align="center">

1949

</div>

J.P. Designs *Sea Change* ballet. *Murray's Architectural Guide to Berkshire* (with Betjeman). Drawings of Snowdonia to be engraved by Reynolds Stone. Murals for British Embassy, Rio de Janeiro. Buys new cottage in Snowdonia.

G.S. Visits Braque. Paints first portrait – Somerset Maugham. Phase of 'presences' begins and continues to 1957.

K.V. Visits Brittany. Shares Manchester exhibition with J.M., R.C., and MacBryde. Illustrates Rimbaud's *Une Saison en Enfer.*

R.C. Visits Italy with MacBryde and George Barker. The planned book does not materialise but R.C. works on Italian paintings and lithos.

J.M. First works shown in Royal Academy – criticised by President. Lefevre exhibition. Elected member of London Group.

P.C. Own show at Roland Browse and Delbanco. Leaves home to set up own studio.

M.A. Visits Italy. Breaks with Joan Walsh. 'Vine' paintings. First retrospective at Wakefield Art Gallery.

J.C. Istanbul, Athens. British Council exhibition in Athens of his work. Travels in Spain.

Death of Jankel Adler. W. Lewis has retrospective exhibition at Redfern Gallery. Moore has retrospective exhibition in Paris. Nicholson and Hepworth form Penwith Society of Artists in St. Ives for abstract painters only. Pasmore: *Spiral Motifs*; Kenneth Clark: *Landscape into Art*; Orwell: *1984*. Pound devalued. Russia explodes atom bomb.

1950

J.P.　Exhibits in New York. Painting in Portland, Isle of Wight and South Wales. *Romney Marsh* published.

G.S.　Works in South of France. Robert Melville: *Graham Sutherland* published. First trip to Venice but from now on returns most summers for the rest of his life. Begins *Origins of the Land* also *Standing Form Against Hedge*. Experiments with sculpture.

K.V.　Visits Italy. Exhibits in Buenos Aires. Also at Redfern Gallery.

R.C.　Living at Tilty Mill Essex with George Barker. Draws domestic animals. Exhibits at Redfern Gallery.

J.M.　Lefevre exhibition. Spends six months in West Indies. Illustrates Elizabeth David's *Book of Mediterranean Food* (pub. Lehmann).

P.C.　Continues to work and teach in London. Painting urban subjects based on London suburbs and visits to Midlands.

M.A.　Visits Italy. Marries Elizabeth Balchin and acquires three stepdaughters. Roman window series. Visits Paris and meets Giacometti.

J.C.　Still travelling – Paris, Rome, Naples and Crete where he remains for a whole year. One-man show at Mayor Gallery.

Horizon closes down (January) after 121 editions. *Penguin New Writing* closes down (July) after 40 editions. Death of Orwell. Picasso attends Peace Conference in Sheffield. *The God that Failed* (R. H. S. Crossman *et al.*). Labour wins General Election narrowly. Korean War. Auden: *Collected Poems 1930–1944*; W. Lewis: *Rude Assignment*; T. S. Eliot: *The Cocktail Party*.

1951

J.P.　Designs *Don Giovanni* for Glyndebourne, ballet *Harlequin in April* for Sadler's Wells. Exhibition at Leicester Galleries. *Billy Budd* for Royal Opera House. Exhibition in Philadelphia. Paints mural and (with Osbert Lancaster) does many designs for Festival of Britain. *Guide to Shropshire* (with Betjeman) published.

G.S.　Retrospective exhibition at ICA Gallery. One-man show at Hanover Gallery. Broadcasts 'Thoughts on Painting'. Works most of year in South of France. *Beaverbrook* portrait. *Origins of the Land* painting shown at Festival. Offered tapestry commission for Coventry Cathedral.

K.V.　Visits South of France. One-man show at Lefevre. Makes mural *Discovery* for Festival's Dome of Discovery.

R.C.　Still living in Essex and drawing pigs, horses, dogs. One-man show at Lefevre a critical failure. R.C. and MacBryde share exhibition at Redfern. *Donald of the Burthens* produced.

J.M.　Exhibition at Lefevre Gallery.

P.C. Works based on industrial scenery begin.

M.A. Illustrates *Macbeth*. Paints *The Elements as Sources of Power* for Festival. Makes film of Leonardo's drawings. Moves to Bradfields in Essex. Begins to sculpt.

J.C. Designs ballet *Daphnis and Cloë*. One-man exhibition at Leicester Gallery. Visits Paris.

W. Lewis goes blind and stops reviewing – his friendship with Ayrton increases. Death of Constant Lambert. Basil Spence commissioned to build new Coventry Cathedral. Art Council's '60 Paintings for '51' exhibition. Herbert Read: *Contemporary British Art*. Turner centenary exhibition at Tate Gallery. Conservatives win General Election with Churchill as Prime Minister. W. Lewis: *Rotting Hill*.

1952

J.P. Illustrates Wordsworth's *Guide to the Lakes*, Betjeman's *First and Last Loves*. Member of Arts Council panel.

G.S. One-man show at Redfern Gallery. Visits Jersey, Paris and Venice. Wins prize at Venice Biennale where his works are shown in British Pavilion. These works tour to Paris, Amsterdam, Zurich and in 1953 to the Tate Gallery. BBC make film of him at work.

K.V. Moves out of shared studio with Minton to own in Belsize Park. Begins 'Assembly' theme. Holds two exhibitions in London and one in New York. Very impressed by de Staël exhibition at Matthiesen Gallery, London.

R.C. Still living at Tilty Mill in Essex.

J.M. Travels in Morocco and Scandinavia. Moves to Kensington.

P.C. Industrial paintings continue.

M.A. Visits Venice Biennale. Writes *Tittivulus* (published 1953). Exhibits in Paris, London and Edinburgh.

J.C. Travels in Italy, Chios, London.

Nicholson awarded first prize for painting in Carnegie 39th International Exhibition. Young Contemporaries exhibition – 'Kitchen Sink' school. 'Looking Forward' exhibition of realist painting at Whitechapel Gallery arranged by John Berger. 'Recent Trends in Realist Painting' at ICA. De Kooning paints *Man on a Bicycle*; Pollock: *Convergence*. Dylan Thomas: *Collected Poems 1934–1952*; E. Waugh: *Men at Arms*. Elizabeth II crowned. Economic recovery begins.

1953

J.P. Designs Britten's *Gloriana* at Covent Garden. Exhibits at Aldeburgh Festival. 'Foliate heads' series begins. Britten dedicates *Winter Words* to J.P. and wife. Retrospective in Cambridge. Works in Paris on lithographs.

G.S. One-man show in New York. Portrait of Sackville-West. BBC film (directed

by Herbert Read's son John) is broadcast. Paints *Christ Carrying the Cross.*

K.V. Exhibits at Leicester Gallery. Visits Ireland.

R.C. With MacBryde designs *King Lear* produced by George Devine at Stratford.

J.M. Visits Middle East. Draws Jerusalem.

P.C. Leicester Gallery exhibition.

M.A. Begins series of still-lifes. Publishes book on Giovanni Pisano.

J.C. Travels in Holland, Greece, Turkey. Winters in Poros.

Kenneth Clark becomes Chairman of Arts Council, also publishes *The Nude: A Study of Ideal Art.* AIA deletes political clause in its constitution. Herbert Read knighted. Dylan Thomas dies in New York. John Wain: *Hurry on Down.* Pollock paints *Blue Poles.* Matisse: *Escargot.* Reg Butler: *Unknown Political Prisoner.* Death of Stalin. Korean War ends. Henry Moore: *King and Queen.*

1954

J.P. Designs Britten's *Turn of the Screw.* Window for Oundle School. Paintings based on Portland Bill, Dorset. Visits Venice. Studies glass-making at Bourges and Chartres.

G.S. Resigns as Tate trustee after row with Director. Paints portrait of Churchill which is presented 30 November and then disappears. Retrospective exhibition travels to Vienna, Innsbruck, Berlin, Cologne, Stuttgart, Mannheim and Hamburg. Visits Venice. Reverts to Thorn Tree theme.

K.V. Makes abstract ceramic screen for Corby New Town – later covered over. Visits Ireland and Berwick. Becomes visiting artist at the Slade from this time to his death.

R.C. Returns to London from Essex.

J.M. Lefevre exhibition. Visits Spain with Rodrigo Moynihan.

P.C. Industrial themes becoming more abstract. Teaching at Chelsea.

M.A. Begins bone and wax sculptures. Large *Shepherd* sculpture. Visits America.

J.C. Winters in Greece. Works in London. Exhibits at Leicester Gallery.

Nicholson, Bacon and Freud represent Britain at Venice Biennale. John Bratby paints *Dustbins,* Dubuffet paints *Les Vagabonds.* Deaths of Matisse and Derain. Kenneth Clark writes *Moments of Vision.* Dylan Thomas: *Under Milk Wood. London Magazine* begins (February) edited by John Lehmann. K. Amis: *Lucky Jim*; W. Golding: *Lord of the Flies*; W. Lewis: *The Demon of Progress in the Arts*; T. S. Eliot: *The Confidential Clerk.* American troops sent to Vietnam. French defeat at Dien Bien Phu.

1955

J.P. New York exhibition. Visits France. Edits *Murray's Lancashire Architectural Guide.* First major book on Piper by St. John Woods (Faber). Hostile

review by Douglas Cooper in *Times Literary Supplement* (17 June). Exhibits in Leicester Gallery. TV film on Piper by John Read.

G.S. Buys La Villa Blanche at Menton as his main home. Exhibits Arthur Jeffrey's Gallery London and Sao Paulo Biennale. 1955-1961 mainly working on portraits and Coventry tapestry. Visits Venice.

K.V. Revisits Yorkshire and St. Ives. Exhibits at Leicester Gallery. Becomes painting tutor at Central School.

R.C. No settled home. Work only intermittent.

J.M. Becomes increasingly depressed about his own work.

P.C. Industrial themes. Teaching.

M.A. Visits Spain and Germany. Illustrates the three volumes of W. Lewis's *The Human Age* with monotypes.

J.C. Exhibits Crane Gallery, Manchester. Returns to Greece.

Moore made Companion of Honour and Trustee of National Gallery. Suicide of de Staël. E. Waugh: *Officers and Gentlemen*. Bratby: *Still Life with Chip Fryer*. Rauchenberg: *Bed*. Picasso's variations on Delacroix's *Femmes d' Alger* and retrospective exhibition in Paris. W. Lewis: *The Human Age*; H. Read: *Icon and Idea*. Churchill resigns as Prime Minister to be replaced by Eden. Gaitskell becomes Leader of Labour Party. Conservatives gain increased majority at General Election. Samuel Beckett: *Waiting for Godot*.

1956

J.P. Exhibits in Amsterdam. Invited to design college chapel glass at Eton. Scenery for *Cranks* ballet, also *Magic Flute* at Royal Opera House.

G.S. Living and working in Menton, South of France.

K.V. Retrospective exhibition, Hatton Gallery, Newcastle upon Tyne.

R.C. Fortunes of R.C. and MacBryde at a very low ebb. Doing little work.

J.M. Resigns from Royal College. Crisis of confidence after failed exhibition at Lefevre. Commits suicide 22 January 1957.

P.C. Painting and teaching in London.

M.A. Visits Cumae and henceforth devotes himself to exploring Greek legends in graphics and sculpture. Writes 'A Reply to Myself' on Picasso.

J.C. Living and working in Crete.

Death of Peter Watson and Nina Hamnett. W. Lewis retrospective at Tate (dies 1957). Museum of Modern Art, New York sends exhibition of 'Modern Art in the United States' to the Tate Gallery – the Abstract Expressionists are seen for the first time in quantity in London. Richard Hamilton makes first 'Pop Art' collage for 'This is Tomorrow' exhibition at Whitechapel Gallery. Colin Wilson: *The Outsider*; John Osborne: *Look Back in Anger*. *New Lines* (ed. Robert Conquest). Alan Ginsberg: *Howl*. Stalin denounced by Khrushchev. Hungarian invasion. Suez crisis. Wolfenden Report on Homosexual Offences in preparation.

ACKNOWLEDGEMENTS

IT would have been impossible for me to write a book of this length and complexity without a great deal of help from people and institutions.

Prunella Clough, John Craxton and John Piper allowed me to interview them and I also recall valuable discussions with Dr John Ball, Joan Foa, Dr Gordon Hargreaves, Christopher Hull, the late John Lehmann, Bryan Robertson, Alan Ross, James Trimble, and above all with my friend Josef Herman. All these people added greatly to my store of facts and ideas, though any errors or distortions in the book are entirely of my own creation.

The owners and staff of galleries all over Britain have been most cooperative in allowing me to browse through their archives and picture stores and in supplying me with photographs. The following were particularly supportive: The Arts Council, Austin/Desmond Fine Art, The British Council, The Dick Institute Kilmarnock, Fischer Fine Art, Garton and Cooke, Glasgow Museums and Art Galleries, Graves Art Gallery Sheffield, Hayward Gallery, Christopher Hull Gallery, Imperial War Museum, Gillian Jason Gallery, Laing Art Gallery Newcastle-upon-Tyne, Lefevre Gallery, Mayor Gallery, National Portrait Gallery, Piccadilly Gallery, Tate Gallery and the Whitechapel Art Gallery. Other places where I was hospitably received were the *Spectator* newspaper, and behind the scenes at Sotheby's and Christies.

Individual friends and acquaintances have come to my aid in ways it would be tedious to list here: Kathleen Barratt, Enfys Chapman, David Cheetham, Gerrard Hastings, Audrey Hudson, Maureen Parker, Elfreda Powell, Peter and Renate Rhymes, Ingrid Swenson, Patrick and Eyvor Schauman, and Ann Wright have all earned my gratitude. In addition Douglas Hall ran a critical eye over an early draft of my manuscript, and Robin Baird-Smith has been my very supportive editor.

My wife Mavis has displayed admirable patience and stamina during four long years of checking my numerous drafts and revisions, and to her goes my final tribute.

MALCOLM YORKE
Newcastle-upon-Tyne
1987

INDEX